Collective Creativity and Artistic Agency in Colonial Latin America

COLLECTIVE CREATIVITY
AND ARTISTIC AGENCY
IN COLONIAL LATIN AMERICA

EDITED BY

Maya Stanfield-Mazzi and Margarita Vargas-Betancourt

University of Florida Press

Gainesville

Publication of this work is made possible by a Sustaining the Humanities through the American Rescue Plan grant from the National Endowment for the Humanities.

Funding was also provided by the Harn Eminent Scholar Chair in Art History (HESCAH) endowment at the University of Florida.

Figures 3.1, 4.6, 4.7, and 5.2 are used by permission of Mexico's Ministry of Culture and its Instituto Nacional de Antropología e Historia (INAH). Further reproduction of the images is prohibited without prior permission of INAH.

28 27 26 25 24 23 6 5 4 3 2 1

Library of Congress Cataloging-in-Publication Data
Names: Stanfield-Mazzi, Maya Selama, 1972– editor. | Vargas-Betancourt,
 Margarita, editor.
Title: Collective creativity and artistic agency in Colonial Latin America
 / edited by Maya Stanfield-Mazzi and Margarita Vargas-Betancourt.
Description: Gainesville : University of Florida Press, [2023]. | Includes
 bibliographical references and index.
Identifiers: LCCN 2022045668 (print) | LCCN 2022045669 (ebook) | ISBN
 9781683403524 (hardback) | ISBN 9781683403661 (paperback) | ISBN
 9781683403937 (pdf) | ISBN 9781683403784 (ebook)
Subjects: LCSH: Art, Colonial—Latin America. | Art, Latin
 American—History. | Artists—Latin America—History.
Classification: LCC N6502.2 .C65 2023 (print) | LCC N6502.2 (ebook) | DDC
 709.8—dc23/eng/20221021
LC record available at https://lccn.loc.gov/2022045668
LC ebook record available at https://lccn.loc.gov/2022045669

UF PRESS

UNIVERSITY
OF FLORIDA

University of Florida Press
2046 NE Waldo Road
Suite 2100
Gainesville, FL 32609
http://upress.ufl.edu

Contents

List of Illustrations vii
Acknowledgments ix

1. Introduction: Artists as Agents beyond the Frame 1
 Maya Stanfield-Mazzi and Margarita Vargas-Betancourt

2. Artists as Activists: The Development of Indigenous Artists' Rights during the Sixteenth Century 18
 Maya Stanfield-Mazzi

3. Indigenous Artistic Practice and Collaboration at the Colegio de Santa Cruz in Mexico City (1536–1575) 53
 Jennifer R. Saracino

4. The Pochtecatl Angelina Martina: Supplying Mexico City's Art World in the Sixteenth Century 80
 Margarita Vargas-Betancourt

5. The Power of Expertise: Artists as Arbiters of the Miraculous in New Spain 107
 Derek S. Burdette

6. The Brush and the Burin: Copies, Originals, and True Portraits in Juan María de Guevara y Cantos's *Corona de la divinissima María* (Lima, 1644) 137
 Emily C. Floyd

7. Art-Making and Art-Breaking in the Era of Andean Insurgencies 169
 Ananda Cohen-Aponte

8. Paint and Poison: Black Artists and Elite Anxieties in Eighteenth-Century Havana 199
 Linda Marie Rodriguez

9. Conclusion: Artistic Presences in Colonial Latin America 228
 Aaron M. Hyman and Barbara E. Mundy

List of Contributors 239
Index 241

Illustrations

Figures

1.1. *The Arts of Painting, Sculpture, and Embroidery in the Service of God and the Church*, in *El primer nueva corónica y buen gobierno*, circa 1615 5

2.1. *Sublimis Deus*, 1537 26

2.2. *Mass of Saint Gregory*, 1539 27

2.3. *Tribute Paid to Don Diego de San Francisco Tehuetzquititzin*, circa 1553–54 32

2.4. *The Virgin of Guadalupe*, circa 1550 34

2.5. *Events in the Years 1563 and 1564*, in Xiuhpohualli of Tenochtitlan Codex, 1576 37

2.6. *Tapestry Mantle with Inca Toqapu and Other Patterns*, circa 1700 38

2.7. *Jesus at the Age of Twelve*, 1590–1600 44

2.8. *The Virgin Mary Weeping*, 1590–1600 45

3.1. The *acamallotetl* plant and roots, in the Badianus Herbal, compiled 1552 64

3.2. The Uppsala Map, circa 1540 68

3.3. Different styles for human figures, the Uppsala Map, circa 1540 71

3.4. *Pochteca*, in the Florentine Codex, 1545–90 73

3.5. Human figures with different accoutrements, the Uppsala Map, circa 1540 74

4.1. *Diorama of Tlatelolco's Market*, 2022 83

4.2. *Pochteca Discussing an Expedition*, in the Florentine Codex, 1545–90 84

4.3. *Pochtecatl Buying a Slave*, in the Florentine Codex, 1545–90 84

4.4. *Pochtecatl Buying Utensils for a Banquet*, in the Florentine Codex, 1545–90 85

4.5. *Cotton Cape Seller*, in the Florentine Codex, 1545–90 91

4.6. *Commemoration of Philip II's Coronation in 1557*, in the Tlatelolco Codex, circa 1562 96

4.7. *Santiago Tlatelolco Governors, Including Feathered Tabernacle*, in the Tlatelolco Codex, circa 1562 98

5.1. Title page of *Maravilla americana*, 1756 116

5.2. *The Virgin of Guadalupe*, 1766 117

5.3. *Christ of Ixmiquilpan (El Señor de "Santa Teresa")*, circa 1750–60 122

6.1. *True Portrait of the Virgin Mary*, 1644 139

6.2. Frontispiece to *Santuario de N. Señora de Copacabana en el Peru*, 1641 146

6.3. *Annunciation*, early seventeenth century 148

6.4. *Triumph of the Risen Christ*, circa 1615 149

6.5. *Saint Michael Archangel*, 1615 150

6.6. *Saint Francis and the Tertiaries*, 1615 151

6.7. *Magnificat anima mea dominum*, 1644 152

6.8. *N.ª S.ª de Atocha de Madrid*, circa 1626 157

6.9. *Crown of the Virgin*, circa 1626 158

6.10. Signature of Diego de Figueroa from *True Portrait of the Virgin Mary*, 1644 163

7.1. *190 años después Túpac Amaru está ganando la guerra*, 1968–70 172

7.2. *Portrait of Don Marcos Chiguan Topa*, 1740–45 174

7.3. *Santiago Mataincas*, circa 1600–1800 175

7.4. *Virgin of Sunturhuasi*, eighteenth century 176

7.5. Two-real coin, 1780 185

7.6. *Virgen del Carmen with Souls in Purgatory*, eighteenth century 188

7.7. Male figure, *Virgen del Carmen with Souls in Purgatory* 189

7.8. Female figure, *Virgen del Carmen with Souls in Purgatory* 189

7.9. *Virgen del Carmen with Donors*, eighteenth century, pre-restoration 191

7.10. *Virgen del Carmen with Donors*, eighteenth century, postrestoration 192

8.1. Map of the walled city of Havana, 1798 209

8.2. Mural painting of landscapes, Tacón Street 12, circa 1762–68 213

8.3. Mural painting of a landscape, Amargura Street 65, late eighteenth century 214

8.4. Detail of mural painting with Greco-Roman figure, Obrapia Street 158, late eighteenth century 216

8.5. Detail of mural painting with floral pattern, Obrapia Street 158, early nineteenth century 217

8.6. *Holy Trinity*, eighteenth century 220

Table

8.1. Materials sold or owned by Pedro Dionisio Muñoz de Carballo 211

Acknowledgments

Various individuals and entities helped this book come together as an innovative examination of what it meant to be an artist in colonial Latin America. The Harn Eminent Scholar Chair in Art History (HESCAH) program in the School of Art and Art History at the University of Florida (UF) allowed us to gather our contributors and supported the culmination of the project as a book. Susan Verdi Webster was a vital participant in the project's early stages, as outlined in our introduction. Macarena Deij Prado helped conceive of the volume's topic and coordinate the scholars' visits to the University of Florida.

Several scholars helped us craft the volume's introduction and thus expand its scope, including Paul Niell and Emily Thames. The decolonial theory reading group convened by Derek Burdette, with the support of UF's Center for the Humanities and the Public Sphere, provided theoretical inspiration and scholarly camaraderie. Ananda Cohen-Aponte was also key in ensuring that we centered a decolonial methodology. As part of this she proposed including the chapter by the late Linda Marie Rodriguez and helped edit it. We thank especially Rodriguez's heirs, who entrusted us with her manuscript and gave permission for us to publish it. Rachel Polinsky provided copyediting and created the Havana map. Joseph Hartman helped us locate photographs of the Havana murals.

Stephanye Hunter and other staff at the University of Florida Press have been encouraging, creative, and patient. We are grateful to the book's three anonymous reviewers for their thoughtful feedback and criticism. Victoria Masters in UF's College of the Arts assisted us with accounting and image permissions. The Latin American and Caribbean Collection of the UF Libraries helped host our initial gathering and has continued to support the project. On the occasion of the collection's seventy-fifth anniversary we are happy to publish the "true portrait" of the Virgin Mary from the library's copy of *Corona de la divinissima María* (Lima, 1644), which is not known to exist elsewhere in the world. As shown by Emily C. Floyd, the portrait was the result of a far-flung collaborative project, to which various individuals contributed based on their unique skills and expertise. The same is true of this volume, which is both a celebration of collective creativity and a result of intellectual collaboration.

1

Introduction

Artists as Agents beyond the Frame

MAYA STANFIELD-MAZZI AND
MARGARITA VARGAS-BETANCOURT

This volume offers a return to the artist in the study of colonial Latin American art, from a decolonial perspective. The very concept of the "artist" is indebted to Eurocentric ways of thinking that privilege the individual. This notion of the artist has shaped modern histories of the arts of the postconquest Americas, as some of the field's founding scholars took a biographical approach, charting the life's work of the relatively few artists whose names were recorded (Vargas Ugarte 1947; Toussaint 1965). The decolonial project demands that we interrogate modern paradigms of knowledge and understand how they developed by way of the coloniality of power (Quijano 2000). By reexamining the concept of the artist as applied to colonial Latin America, we intend in our analyses of colonial Latin American art to delink ourselves, *desprendernos* in Aníbal Quijano's words, from the biographical paradigm (Quijano 2007; Mignolo 2007). We seek to better understand how human creators acted in society in times and places when colonial power and its accompanying prejudices were still being forged and negotiated. What were the roles, rights, and statuses of individuals who operated in the world of the visual arts? How did society conceive of them, and how did they see themselves?

Our approach does not mean that specific people are not named or recognized, but it does imply a rejection of the individualistic and patriarchal life-story biographical method. Instead of describing individuals working alone to chart new paths in the arts, we identify human relationships and exchanges. The artist is no longer singular, but rather an individual who when mobilized with others was an essential actor within colonial society.

We identify, on the ground, many of the damaging dynamics outlined by decolonial theorists and historians (Seed 1995; Mignolo 1995; Wynter 2004; Quijano 2007). These dynamics include the submission of the conquered, the enslavement of people classed as *indios* and *negros*, and the concomitant development of racism. We also identify the imposition of the Christian supernatural and the suppression of non-European knowledge and beliefs, the continued subordination of women to men, and the debasement of nature to culture. We offer texture and nuance to these developments in regard to artistic society. In various times and places, visual artists and their associates worked together to alternately reify and challenge the dynamics they perceived. In this volume artistic society emerges as a dialogic and contentious realm in which artists, as part of collectives, projects, and coalitions, saw themselves and were perceived as important voices.

Through a decolonial approach, we propose a new methodology that centers the sites of resistance and ambiguity between the colonized and the colonizer, the spaces that Gloria Anzaldúa defines as *mestizaje* or borderlands (Silva 2021, 344). This concept, which María Lugones (2010, 754) refers to as a fractured locus, contests the dichotomies of colonized/colonizer and nonhuman/human by emphasizing the heterogeneity, complexity, and fluidity of the minoritized people who inhabit the colonial space. In doing so, the border approach does not cast aside the European framework. It only decenters it in order to center, instead, people that Western forms of knowledge obscure. Anzaldúa and Lugones's decolonial feminism demonstrates that to render visible Black, Indigenous, and other minoritized women, it is first necessary to recognize how colonialism and coloniality deny their existence as humans and as women, making them invisible to Western thought. Like Anzaldúa and Lugones, we challenge the limitations imposed by the Western concepts of art, artist, and aesthetics on the study of colonial Latin America. We do so by expanding the concept of the colonial Latin American artist to embrace the heterogeneity and complexity of the activities and cosmologies connected to the production of what we now define as art.

Inspirations for the Project

We have been inspired by a small set of recent art historical publications, whose authors also helped formulate this project and contributed further research to this volume. First is Susan Verdi Webster, the scholar to whom we dedicate this volume on the occasion of her retirement after a distinguished teaching career.[1] Webster's first book (1998) focused on the art and ritual of

Holy Week in seventeenth-century Seville, Spain, illuminating how penitential confraternities orchestrated spectacular displays of piety in the form of polychrome sculptures. Her emphasis on the community-based roots of artistic production has echoes in many of our chapters, and her explications of Catholic ideology as expressed in Spain's port to the Americas help us better understand the Catholicism that was imposed in Spain's American colonies. Even more, Webster's extensive later work on the art of Quito, Ecuador, inspires our desire to maintain the humanness of the art maker. This humanness stands in contrast to "Manness," the version of humanity offered by an overly determined Occidental point of view (Wynter 2004). Webster's scholarship (including three books) on the painters, architects, and masons within the territory known as the Audiencia of Quito in the sixteenth and seventeenth centuries provides the key to our starting point of humanness. Modeling creativity and diligence in archival research, Webster (2017, 214) combed through colonial-era handwritten notarial documents for traces of artists and their lives, an effort that allowed her to "recount the human stories" of dozens of previously unnamed creators, most of whom she found were Indigenous Andeans.

Webster's findings highlight the agency and the centrality of Andeans in the art world of Quito, in ways that serve as a vital counterpoint to overly broad assumptions by scholars about the implications of Spain's colonization of the Americas (Quijano 2000, 536). While European and specifically Spanish émigré artists played an important role in the development of the arts in the Spanish Americas and often had a privileged position in the labor market, that was not always the case (Alcalá 1998). In Quito and in many other colonial centers, Indigenous, Black, and multiracial artists filled the ranks of artistic society. As shown by Webster (2017, xvii) in the cases of sophisticated artists such as the painter Andrés Sánchez Gallque, they found success by deploying the languages and literacies of empire. They were protagonists in the colonial matrix, but the threads of this matrix were many. In Quito, artists utilized not only the knowledge systems of the Spanish Empire. They also built colonial artistic society on the patterns of the Inca Empire. The craft economy had been centered since Inca times on the residence of the ruler Atahualpa, and it continued to be located in the same neighborhood in the sixteenth century. Inca patterns also informed the very conception of the artist, whose role was perceived under the rubric of *quilca*, a Quechua term that referred to the entire universe of graphic production (Webster 2017, 37, 85; Cohen Suarez 2016, 14–16; Brokaw 2014). Webster shows us that artists, as technicians of ideology, held a privileged place in society. Yet, insofar as they figured into the colonial written record, they mainly appeared as actors in

the local economy. Webster manages to read the archive against its colonial limitations, as many of our authors also do.

Especially vital for this volume's perspectives has been Barbara E. Mundy and Aaron M. Hyman's 2015 article "Out of the Shadow of Vasari: Towards a New Model of the 'Artist' in Colonial Latin America." Mundy and Hyman outline the development of the field of colonial Latin American art, which only began in earnest around 1930, in terms of its reliance on the "life-work model" that was established by the Italian artist and writer Giorgio Vasari in his *Lives of the Artists*. Reflecting a particular conception of the individual creator that was developing in mid-sixteenth-century Italy, Vasari's model was emulated by other early modern European authors in the following century, including Spain's Vicente Carducho and Francisco Pacheco. Their approach was to present an artist's biography in a linear fashion, punctuating it with the artist's works to chart a teleology of style and highlight creative genius (Guercio 2006; Mundy and Hyman 2015, 287). After being revived by nineteenth-century art historians and expanded into the form of the monograph, the life-work model, as Mundy and Hyman show, was adapted for Mexican colonial art (i.e., that of New Spain). The art of Spain's Caribbean and South American colonies has been approached similarly, so that compendia of artists' names and single-artist monographs have been foundational for the field and continue to be produced (Tapia y Rivera [1855] 1967; Groot 1859; Pareja y Diez Canseco 1952; Gisbert and Mesa Figueroa 1961; Delgado Mercado 1983; Benavente Velarde 1995; Amerio 2018). The artists discussed in these works are invariably male, and tend to be European or *criollo* (Creole), the latter denoting a person of European descent. Modern authors have been biased toward these types of creators as they look to find extensions of European patterns in the Americas, and are overly inclined toward written (especially alphabetic) sources such as artists' signatures and contracts for works of art. This has led to an incomplete picture of the arts, considering first that there was no Vasari or Pacheco for artists of the Americas so we lack much of the firsthand information that such authors provided (Mundy and Hyman 2015, 297). The conditions of colonialism, its "wildly divergent social milieu," were so limiting that such author biographers could hardly have existed—neither as authors themselves nor as individuals capable of esteeming the artistic production of the colonial, and more often than not *colonized*, residents of the Spanish viceroyalties (Mundy and Hyman 2015, 302). Even a writer and artist as perceptive as Felipe Guaman Poma de Ayala, who projected for himself a distinguished persona as an author in his seventeenth-century chronicle of Andean history, portrayed other Indigenous artists as pious anonyms (Adorno 1992; Alcalá 1998, 103).

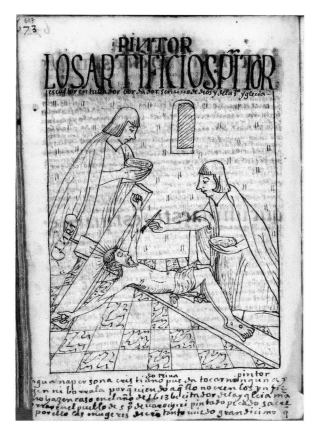

Figure 1.1. Felipe Guaman Poma de Ayala, *The Arts of Painting, Sculpture, and Embroidery in the Service of God and the Church*, in *El primer nueva corónica y buen gobierno*, fol. 673 [687]. Peru, circa 1615. Ink on paper, 14.5 × 20.5 cm. The Royal Library of Copenhagen.

In a section of his book that encourages the creation of artworks to promote Christian doctrine, Guaman Poma depicts two men painting a sculpture of Christ crucified (figure 1.1). He takes care to render the men's haircuts and clothing in ways that indicate they are Andeans, thus highlighting the role of Indigenous artists in the creation of colonial society. But he also declines to identify them by name, thus emphasizing the anonymous, collaborative nature of their work. As shown by Clara Bargellini (2004), Catholic art had an overarching importance within the colonial context, where the aims of evangelization could overshadow artistic recognition. Our volume heeds Mundy and Hyman's (2015, 304) call to art historians to "think more carefully about the complicated subject positions that viceregal artists could occupy and the particular epistemologies of making to which they could respond."

Continued adherence to the Vasarian model perpetuates the centering of Italy in histories of early modern art. Ananda Cohen-Aponte offers a rejoinder to this predisposition in her 2017 essay "Decolonizing the Global

Renaissance: A View from the Andes." She suggests we "take the trauma of conquest and invasion as the ground zero for an art history of the colonial Americas rather than Renaissance Italy or an expansionist late medieval Spain" (74). Doing so acknowledges the histories of violence that undergirded the development of such celebrated art movements as the Cusco School of painting. Scholars have repeatedly claimed the importance of a document written in 1688 that suggests that Indigenous artists broke away from Spanish artists to create their own guild, thus founding the Cusco School (Gisbert and Mesa Figueroa 1982, 53; Villanueva Urteaga 1985; Damian 1995). Yet recently Fernando Valenzuela (2013) has criticized the reasoning behind this claim, suggesting it may have been guided by a mistaken assumption that the guild system of Spain had been successfully implanted in Cusco, without any challenges to its authority. Whether or not a painters' guild had truly been established as a regimenting force in the trade, the Indigenous painters' perspective reflected by the 1688 document is that they were being mistreated and segregated from the city's Spanish artists. Cohen-Aponte (2017, 79) helps us better understand the basis of the alleged mistreatment. She takes a broad sample of artists' contracts from the seventeenth century, not to rehearse a biographical approach but to discuss racialized inequity in the wider setting. Such a consideration is possible because race, especially when used to categorize individuals as inferior, was literally written into the contracts. It was the first identifier for Indigenous artists, whereas Spanish artists were granted the privilege of being racially unmarked. By comparing rates of pay for Indigenous, Spanish, and mixed-race artists, Cohen-Aponte (2017, 88–89) shows that Indigenous artists were paid substantially less for the same work. Manifesting the profound inequity at the root of Cusco's seventeenth-century art world, she helps us better understand the basis for the 1688 petition, and notes that by the eighteenth century artists were coming to define perfection and beauty on their own terms, in contrast to European expectations. This alternate version of beauty can be understood as a decolonial esthesis, since it developed largely before the Western concept of aesthetics and was an alternative to Western standards of beauty that arose at the margins of empire (Mignolo and Vázquez 2013, 15–16). Several of our authors chart other decolonial estheses, tracking the ways in which art developed uniquely despite the grave conditions of inequity imposed by the colonial milieu. By discussing cases ranging from the sixteenth to the early nineteenth centuries, the volume as a whole heeds Cohen-Aponte's (2017, 89) call to consider "issues of power as well as periodization." We approach artists as subjects across the various stages of the colonial regime, including in contexts in which colonial rule was being rejected.

We thank Cohen-Aponte for pointing us to the work of the late Linda Marie Rodriguez, whose essay we include with the permission of her heirs. Rodriguez passed away in 2018. Cohen-Aponte, Emily C. Floyd, and the editors of this volume made the final edits to Rodriguez's chapter. As further outlined below, Rodriguez's important contribution significantly broadens our scope, namely in its consideration of late colonial Havana and the agency of Afro-Cuban artists there.

Shared Themes

The authors in this volume who address the sixteenth century demonstrate that not only did imported European structures such as the guild system inform the foundation and development of artistic society, but preexisting societal patterns held sway as well. These authors contribute to art historical debates about the relative continuity and rupture of native cultures after the Spanish invasion (Bailey 2010, 15–43). The divisions of craft economies and intellectual society that had prevailed in Aztec and Inca territories were maintained to some extent, and were relied on to produce stunning artworks. While Spanish colonial rule often blurred the divisions between nobles and commoners that had existed under the Aztec and Inca Empires, we also see those divisions surviving and contributing to the formation of colonial artistic society. They informed who became an artist and who had potential for success in the art world. As also demonstrated by Webster for Quito, they informed the spatial organization of colonial cities.

All of our authors consider the ways in which colonial society defined artists and the ways in which they defined themselves. They address the fact that for most of the colonial period visual artists were classed as artisans, or *artífices*, though they were more commonly known by craft-specific names such as *pintores* and *escultores* (painters and sculptors). Artists had much in common with others of the artisan class such as shoemakers—or, as craft categories developed out of Aztec and Inca dress patterns, sandal makers (Durand-Forest 1994, 175; Rostworowski de Diez Canseco 1975, 332). Our authors consider the boundaries around specific artistic roles, in terms of medium and genre, and in relation to how artists overlapped with and collaborated with other professionals such as merchants, authors, intellectuals, healers, and priests. Due to colonial challenges as well as opportunities, being an artist was often not a lifelong profession. While some artists were forced to work in other arenas, others used their skills as part of, or to lead to, roles in colonial government.

One of the most valuable contributions of this volume is the examination

and periodization of attitudes and policies related to race and ethnicity. The highly specialized and in-demand skills of some Indigenous, Black, and mixed-race artists may have allowed them to escape some of the damaging dynamics of racial discrimination that the larger colonial regime developed. Admiration for exceptionally talented artists, such as the sculptor Juan Tomás Tuyru Tupac, allowed a few individuals to accede to the "unmarked" status accorded to Spanish artists, where their racial identification was not used as a precursor to their name (Cohen-Aponte 2017, 80). Yet there was a central paradox, illuminated recently by Javier Chuquiray Garibay (2020, 81), in that even as these artists' creative output was sought after, they were hampered by race-based labor hierarchies in crucial aspects such as wages and job security.

Being that our volume stretches from the sixteenth to the early nineteenth century, various ethnoracial dynamics are explored. Maya Stanfield-Mazzi's consideration of Indigenous artists' rights begins with the period in which Indigenous slavery was widespread, and engages with authors that consider Amerindians' legal rights and categorization. Jennifer R. Saracino addresses the wider social mobility afforded to Indigenous members of Spanish educational institutions in the sixteenth century. Emily C. Floyd and Derek S. Burdette address the seventeenth-century dynamics of the "unmarked" *criollo* artist, often cast as a named expert alongside a pious yet anonymous *indio pintor* who nevertheless was a known and respected artist in other circles (Rappaport 2012, 609). Linda Marie Rodriguez considers the fate of Black artists during a crucial period in Cuba, when they had come to dominate the painting trade but their livelihoods and reputations were threatened due to wider Cuba's transition to a slave society.

The fact remains that extremely few women artists have been identified in colonial Latin America, and there has been no extensive treatment of them. Historian Margarita Vargas-Betancourt models an alternative approach, considering the roles of women in other areas of society that bordered on or influenced art-making. Her contribution thus joins previous work on women's art collecting and the artful agency of nuns in creating their surroundings (Stanfield-Mazzi 2009; Córdova 2014; Pacheco Bustillos 2017). While these earlier studies focus on the seventeenth and eighteenth centuries, Vargas-Betancourt offers an important intervention for the sixteenth century.

A particularly pernicious aspect of the life-work model as it has been applied to colonial Latin America is its enshrinement of the ideas of creativity, invention, and artistic genius, with the assumption that those capacities were only inherent in white male artists. Our authors greatly broaden the

range of ways that creativity can be understood, and largely move beyond the relatively circumscribed concept of invention as used in early modern Europe to indicate the unique arrangement of figures on a pictorial surface for narrative purposes. Floyd shows us that while Andean artists could indeed "invent" compositions, to the point that they were used as models for subsequent artworks, this creativity went unremarked due to colonial ways of seeing Indigenous artists as creators of sacred art. By preferring the concept of agency instead of the more circumscribed creativity, other authors show that artists' achievements had many facets. Stanfield-Mazzi, Saracino, and Cohen-Aponte show that artists functioned as political figures, activists, and revolutionaries. Burdette demonstrates that artists defined the contemporary canon, and Vargas-Betancourt and Rodriguez discuss artists as agents in commerce.

Materials and Methodologies

Our volume's focus on the under- and misrepresented, the underprivileged, and the marginalized intersects with post- and decolonial, ethnic, African American, Latinx, and women and gender studies. Yet it overlaps the most with Indigenous studies in the Americas, specifically Native American and Indigenous Studies (NAIS) and the New Conquest History (NCH) (Mt. Pleasant, Wigginton, and Wisecup 2018; Restall 2012). Although both of these schools study the colonial period (and NAIS goes beyond), NAIS has focused on early US history and NCH on early Latin America. Both schools begin with the recognition that to privilege materials and methodologies "defined by Euro-American disciplines" results in centering colonial representations while ignoring the agency and centrality of Indigenous people (Mt. Pleasant, Wigginton, and Wisecup 2018, 236). Even when the object of study is the Indigenous, the use of colonial archives and colonial categories of thought such as Eurocentric geographic and temporal borders reinforces colonialism and, more dangerously, "the categories of human difference embedded in colonial language" (Mt. Pleasant, Wigginton, and Wisecup 2018, 218). In other words, scholars need to challenge previous forms of inquiry or run the risk of producing colonialist scholarship.

Instead, these schools propose centering both methodology and object of study onto the Indigenous or the Black experience. First, they encourage a revision of European sources, like chronicles and archives, in order to find hidden voices in texts with colonialist agendas; second, they urge an expansion of the archive in order to study Indigenous knowledge through Indigenous sources. They also propose interdisciplinary research—archaeological,

genealogical, philological, linguistic, and visual—allowing scholars to analyze Indigenous culture and forms of knowledge that do not include alphabetic texts. Finally, they propose the creation of new geographic and temporal borders based on Indigenous principles in order to overcome a European and colonialist conception of time and space (Restall 2012, 155–56; Mt. Pleasant, Wigginton, and Wisecup 2018, 223, 230–34).

Both NAIS and NCH, like previous scholarly trends such as the New Indian History and the New Philology (Mihesuah 1996; Restall 2003), challenge the idea of the "conquest" of Indigenous people as an epic event led by white actors, as well as the assumption of a complete annihilation of Indigenous peoples and cultures (Schroeder 2007, 7). In a similar way, challenging the Vasarian model connotes casting aside the concept of an "epic" artist to highlight, instead, the diversity and heterogeneity of the people and contexts involved in the production of art in colonial Latin America. A work in this vein is Mundy's *The Death of Aztec Tenochtitlan, the Life of Mexico City* (2015), which, like three of our volume's chapters, is set in Mexico City. Mundy analyzes the way in which the Mexica's monumental art brought together landscape, ritual, and power in the city of Tenochtitlan-Tlatelolco. The protagonists of her book are not only the *tlatoque* (Indigenous rulers) who wanted to engrave their historical legacy into the city's monuments and rituals but also the anonymous artists who undertook such memorials. During the viceroyalty, Indigenous artists continued to mark the city with their art, both permanent and ephemeral, but this time they followed, negotiated, and/or contested the agenda of Spanish authorities and the church. The Indigenous population and its art were evident not only in the Indigenous republics of San Juan Tenochtitlan and Santiago Tlatelolco but also in the Spanish *traza* (grid), the residence of Spaniards and the Mexica elite and the site of Indigenous markets. While Mundy looks at the alphabetic archival record, she also uses novel interdisciplinary sources like the ones mentioned above. Her conclusion is that against the common assumption that the so-called conquest destroyed the Indigenous megacity and annihilated its population, both Tenochca and Tlatelolca continued to inhabit and shape it. In fact, Indigenous culture created the colonial city as much as Spanish culture did. This impact is evident even today as illustrated by the names of the city's subway stations.

Like Mundy, the authors of this book illustrate the call from NAIS and NCH regarding methods and materials. Just as NCH demands we recognize the heterogeneity of the people who participated in the war against the Mexica and later in the expansion of Spanish control north- and southward, the authors here expand the concept of art in colonial Latin America to include

the different specialists who participated not only in artistic production but also in activities associated with art. Yet like fellow scholars, they also face the limitations of the sources. Despite a decolonial approach, the sources analyzed here necessarily include colonial productions, both archival documents and artistic artifacts. To overcome this challenge, authors read against the grain to find hidden stories, and they use interdisciplinary methodologies such as philology of Indigenous languages, archaeological models, and modern ethnographic studies of the production of Indigenous crafts. Above all, they depart from the paradigm of universalism by focusing on local stories contextualized in specific times and regions, depicting in this way a pluralist world.

Content Overview

In chapter 2, Stanfield-Mazzi analyzes the impact of artist corporations in the evolution of Indigenous rights in New Spain and Peru. She grounds her work in European treatises on Indigenous rights but also in the Indigenous archive. By examining the complaints raised by various Indigenous artists—especially those documented directly by Indigenous scribes in the sixteenth-century *Anales de Juan Bautista*—she centers the narrative on the experience of Indigenous people fighting against forced labor. Stanfield-Mazzi demonstrates that through their trade corporations, Indigenous artisans had a significant role in the success of the struggle. For example, Indigenous painters demanded to be exempt from public work and to stop paying tribute to Indigenous noble rulers. Through concerted activism they obtained some victories both in New Spain and in Peru. At the same time, Stanfield-Mazzi reveals the heterogeneity of circumstances and the conflicting relationships between different segments of the Indigenous population. In New Spain, Spanish authorities began to demand monetary tribute instead of in kind. This transition was the result of the artisan corporation's demand; the artisans argued that the new policy would allow them to focus on their trades and to pay with the income they got from their commissions. However, monetary tribute proved to be a great burden for Indigenous people who did not have easy access to currency.

In chapter 3, Saracino analyzes three jewels of the Nahuatl archive—the Florentine Codex, the Badianus Herbal, and the Mapa Uppsala—to propose an expansion of the concept of art production. In line with Stanfield-Mazzi's emphasis on the impact of Indigenous corporations, Saracino first delineates the collaborative quality of the artistic process. The actors involved also included agents excluded from the Western conception of the artist, such as

scholars and scientists (*tlamatinime*) for the production of the Florentine Codex, healers and herbalists (*titicih*) for the production of the Badianus Herbal, and cartographic experts for the production of the Mapa Uppsala. Interestingly, Saracino identifies *pochteca* or Aztec merchants as experts in the geographic and hydrographic knowledge of the basin who assisted the artists in the creation of the map. In addition to utilizing an inclusive approach to art production, she also offers a philological analysis of the word *tlacuilo* or manuscript painter. She explains that this term was translated and defined differently in Nahuatl than in Spanish. Saracino concludes that the Aztec conceived of the trade as intellectual in addition to mechanical, while for the Spaniards, it was only mechanical. To center Indigenous understanding, it is necessary to use an expansive definition of art production that corresponds more closely with native realities.

The rest of the chapters also propose broader concepts of art, art production, and the artist. In chapter 4, Vargas-Betancourt examines the role that Indigenous women played as dealers of featherwork and textiles in the luxury "art world" of early colonial Mexico City. She revisits the testament of Angelina Martina (1580), a Tlatelolca *pochtecatl*, to reconstruct hidden histories of underrepresented historical protagonists. Like Saracino, she also compares and contrasts the definition of the *pochteca* and the role of women as principal merchants as seen in the three components of the Florentine Codex: the Nahuatl text, the Spanish text, and the pictorial illustrations. In this way, she challenges the dominant representation of Indigenous women in scholarship on colonial Mexico, which describes women's economic activity as limited to the sale of the surplus of their domestic production. Vargas-Betancourt goes beyond historical analysis, using anthropological and art historical sources to explain the cosmological meaning of featherwork and textiles, and thus the cosmological importance of these art forms in the pre-Hispanic world, before they were adopted into Catholic practice.

In chapter 5, Burdette analyzes the concept and context of miraculous art and, in doing so, expands the action field of artists and reveals the role of race in colonial Latin American sacred art. As popular devotion to specific religious images developed, colonial authorities sought to regulate local religion by establishing official investigative processes that validated real miraculous images. Artists had an essential role in these processes: to determine whether an artwork defied natural laws or whether it was an artistic scam. To make such determinations, the church called on master artists whose expertise was based in officially recognized associations such as guilds and metropolitan workshops. During the process, the artists performed a ritual that was based on their aesthetic, technical, and legal expertise. Burdette's consideration of

this ritual expands the field of artistic practice to include performance. In turn, the artists' participation in the examination shaped their professional and individual identities and in general that of their profession. Beneath the need to regulate the sacred nature of artworks was a racialized ideology: European artists sought to control the "improper or indecent" art produced by Indigenous artists, and, at the same time, Spanish authorities sought to censor idolatry. Although there were exceptions, most of the artists chosen as experts were European.

In chapter 6, Floyd follows the topic of sacred art; she examines the genre of true portraits, purported products of divine intervention. Their creators, who were usually Indigenous, were alienated from their creations because they were considered mere conduits of the divine. Floyd analyzes the case of the true portrait reproduced in Juan María de Guevara y Cantos's 1644 devotional text *Corona de la divinissima María*. Guevara y Cantos, a Spanish bureaucrat who worked in South America in what is now Ecuador, hired an Indigenous painter to create a true portrait of the Virgin, and later a gold-smith who, based on the painting, cut plates for an engraving to include in the book. Guevara y Cantos qualified the painting as a true portrait, and his role in its production as that of an intermediary with the divine. In the process of having the painting and engraving created, he discounted the roles of the painter and the engraver, whom he did not name. Floyd analyzes archival and textual sources in Guevara y Cantos's book and contrasts his narrative with a creation process that reveals the agency of the artists. Floyd not only concludes that the author of the original painting was the seventeenth-century *quiteño* (Quito resident) painter Mateo Mexía, but also reconstructs the sources that Mexía might have used. Her analysis reveals that Mexía's portrait was an original invention, after which the engraver Diego de Figueroa created the plate to be printed. Floyd's study of the production of this portrait and of the narrative that surrounded it challenge the assumption that most Spanish colonial art consisted of copies of European works.

Chapters 7 and 8 not only stretch the concepts of art and artist, but also propose innovative methodologies to challenge colonialist approaches and to center underrepresented groups. In chapter 7, Cohen-Aponte proposes methods like historical projection, critical fabulation, and insurgent art histories to understand the intersection between art and political violence, and to understand the critical role that Indigenous and Afro-Indigenous artists had as "artists, subjects, and publics." Cohen-Aponte begins with an analysis of two portraits of the leader of the 1780s Tupac Amaru Rebellion in the Viceroyalty of Peru. She then uses critical fabulation based on insurgent art from the Haitian Revolution to hypothesize what would have happened to

artistic production if Tupac Amaru's revolt had triumphed. Cohen-Aponte also proposes that the crystallization of artworks as "completed" pieces is a myth, one that is especially evident in Latin America, where limited resources and "politicized interventions" resulted in constant recycling and repainting of art. She then puts forth a call to expand the concept of art to include the physical, violent, and creative processes of effacing or reconstructing artworks. This expansion would also increase the diversity of actors involved in colonial Latin American art.

In chapter 8, Rodriguez uses the 1791 trial of Pedro Dionisio Muñoz de Carballo as a case study to analyze the intersection of racism, racialization, and the artistic sphere as well as details of art production in Cuba during the late eighteenth century. Muñoz de Carballo, a free man of color and owner of a painting supply shop in Havana, was accused of selling lethal substances. The Muñoz de Caraballo case took place during a period of great racial conflict. After the Haitian Revolution, the Spanish government allowed open slave trade in an effort to expand sugar production. At the same time, fears of slave revolts increased. When this transition was taking place, Black Cubans dominated the art sphere, and this caused racial anxiety and white fear. The case against Muñoz de Carballo was intended not only to ensure order and progress, but also to exclude Black people from Cuba's art world. Art was marshaled as an effective tool to justify and reinforce the political economy of slavery built on white supremacy. Royal authorities used strategies such as the development of an aesthetic of *buen gusto* (good taste), the establishment of a fine arts academy, and the organization of artists into guilds. These measures ensured a rigid hierarchy that served as a glass ceiling for Black people and *mulatos*. Rodriguez not only discusses art and race, but offers a clear picture of the material culture related to art in Cuba around 1800.

All of our authors offer fresh, new perspectives on colonial Latin American artworks, some well known and others heretofore overlooked. Yet they only rarely recur to the usual art historical methods of formal analysis and iconography. We thus contend that they offer us a *new* method, one in which a decolonial lens is used to examine artists' engagement in society and their impact within it. These artists actively formed colonial society, with the works they created as well as through their actions beyond the frame. In the volume's concluding essay, Aaron M. Hyman and Barbara E. Mundy point to some of the limitations of this project, noting for example our continued reliance on notaries, those creators of the alphabetic record. They also offer a new perspective on the utility of the word *artist* when concerns over identity come to the fore. We can use the gender-neutral and colorless term today to discuss all of the possibilities of identity, thus avoiding reinstating

the inequities of the past. For the authors of this book, bringing to light the voices hidden by colonial realities and by Western ways of knowledge has never been more urgent. The COVID-19 pandemic has highlighted race-based inequity across society. Even more, the murders of Indigenous environmental activists such as Berta Cáceres in Honduras, as well as the killing of numerous African American people including George Floyd in the United States, have revealed that the stories of people who once experienced colonialism and who continue to be oppressed are still obscured.

Note

1. Most recently Webster was the Jane Williams Mahoney Professor of Art History and American Studies at the College of William and Mary.

Reference List

Adorno, Rolena. 1992. "Don Felipe Guaman Poma de Ayala: Author and Prince." In *Guaman Poma de Ayala: The Colonial Art of an Andean Author*, edited by Mercedes López-Baralt and Rolena Adorno, 32–45. New York: Americas Society.

Alcalá, Luisa Elena. 1998. "'Fue necesario hacernos más que pintores': Pervivencias y transformaciones de la profesión pictórica en Hispanoamérica." In *Las sociedades ibéricas y el mar a finales del siglo XVI*, edited by Luis Miguel Enciso Reyes and Fernando Checa Cremades, 85–105. Madrid: Sociedad Estatal Lisboa '98.

Amerio, Elena. 2018. "Demócrito 'Bernardo' Bitti, SJ: Un pintor de Las Marcas hacia el Nuevo Mundo." *Sílex* 8 (2): 17–42.

Bailey, Gauvin A. 2010. *The Andean Hybrid Baroque: Convergent Cultures in the Churches of Colonial Peru*. Notre Dame, IN: University of Notre Dame Press.

Bargellini, Clara. 2004. "Originality and Invention in the Painting of New Spain." In *Painting a New World: Mexican Art and Life, 1521–1821*, by Donna Pierce, Rogelio Ruiz Gomar, and Clara Bargellini, 79–91. Denver, CO: Denver Art Museum.

Benavente Velarde, Teófilo. 1995. *Pintores cusqueños de la colonia*. Cusco: Municipalidad del Qosqo.

Brokaw, Galen. 2014. "Semiotics, Aesthetics, and the Quechua Concept of Quilca." In *Colonial Mediascapes: Sensory Worlds of the Early Americas*, edited by Matt Cohen and Jeffrey Glover, 166–202. Lincoln: University of Nebraska Press.

Chuquiray Garibay, Javier. 2020. "Vicisitudes económicas y sociales del oficial tallista en Lima en la primera mitad del siglo XVII: Pleitos y restricciones gremiales." *Atrio: Revista de Historia del Arte* 26:60–87.

Cohen-Aponte, Ananda. 2017. "Decolonizing the Global Renaissance: A View from the Andes." In *The Globalization of Renaissance Art: A Critical Review*, edited by Daniel Savoy, 65–94. Leiden: Brill.

Cohen Suarez, Ananda. 2016. *Heaven, Hell, and Everything in Between: Murals of the Colonial Andes*. Austin: University of Texas Press.

Córdova, James M. 2014. *The Art of Professing in Bourbon Mexico: Crowned-Nun Portraits and Reform in the Convent.* Austin: University of Texas Press.

Damian, Carol. 1995. "Artist and Patron in Colonial Cuzco: Workshops, Contracts, and a Petition for Independence." *Colonial Latin American Historical Review* 4 (1): 25–53.

Delgado Mercado, Osiris. 1983. *Francisco Oller y Cestero (1833–1917): Pintor de Puerto Rico.* San Juan, Puerto Rico: Centro de Estudios Superiores de Puerto Rico y El Caribe.

Durand-Forest, Jacqueline de. 1994. "The Aztec Craftsman and the Economy." In *Chipping Away on Earth: Studies in Prehispanic and Colonial Mexico in Honor of Arthur J. O. Anderson and Charles E. Dibble,* edited by Eloise Quiñones Keber, 173–76. Lancaster, CA: Labyrinthos.

Gisbert, Teresa, and José de Mesa Figueroa. 1961. *Bernardo Bitti.* La Paz: Dir. Nacional de Informaciones de la Presidencia de la República.

———. 1982. *Historia de la pintura cuzqueña.* Lima: Fundación A. N. Wiese.

Groot, José Manuel. 1859. *Noticia biográfica de Gregorio Vasquez Arce i Ceballos: Pintor granadino del siglo XVII: Con la descripción de algunos cuadros suyos en que mas se da a conocer el merito del artista.* Bogotá.

Guercio, Gabriele. 2006. *Art as Existence: The Artist's Monograph and Its Project.* Cambridge: MIT Press.

Lugones, María. 2010. "Toward a Decolonial Feminism." *Hypatia* 25 (4): 742–59.

Mignolo, Walter D. 1995. *The Darker Side of the Renaissance: Literacy, Territoriality, and Colonization.* Ann Arbor: University of Michigan Press.

———. 2007. "Delinking: The Rhetoric of Modernity, the Logic of Coloniality and the Grammar of De-Coloniality." *Cultural Studies* 21 (2–3): 449–514.

Mignolo, Walter, and Rolando Vázquez. 2013. "Decolonial AestheSis: Colonial Wounds/ Decolonial Healings." *Social Text Online*, July 15, 2013. https://socialtextjournal.org/.

Mihesuah, Devon A. 1996. "Voices, Interpretations and the 'New Indian History': Comment on the *American Indian Quarterly*'s Special Issue on Writing about American Indians." *American Indian Quarterly* 20 (1): 91–108.

Mt. Pleasant, Alyssa, Caroline Wigginton, and Kelly Wisecup. 2018. "Forum Materials and Methods in Native American and Indigenous Studies: Completing the Turn." *William and Mary Quarterly* 75 (2): 207–36.

Mundy, Barbara E. 2015. *The Death of Aztec Tenochtitlan, the Life of Mexico City.* Austin: University of Texas Press.

Mundy, Barbara E., and Aaron M. Hyman. 2015. "Out of the Shadow of Vasari: Towards a New Model of the 'Artist' in Colonial Latin America." *Colonial Latin American Review* 24 (3): 283–317.

Pacheco Bustillos, Adriana. 2017. "The Nuns of Colonial Bolivia and the Art of Painting / Las monjas en la Bolivia colonial y el arte de la pintura." In *The Art of Painting in Colonial Bolivia / El arte de la pintura en Bolivia colonial,* edited by Suzanne L. Stratton-Pruitt, 317–46. Philadelphia: St. Joseph's University Press.

Pareja y Diez Canseco, Alfredo. 1952. *Vida y leyenda de Miguel de Santiago.* Mexico City: Fondo de Cultura Económica.

Quijano, Aníbal. 2000. "Coloniality of Power, Eurocentrism, and Latin America." *Nepantla: Views from the South* 1 (3): 533–80.

———. 2007. "Coloniality and Modernity/Rationality." *Cultural Studies* 21 (2–3): 168–78.

Rappaport, Joanne. 2012. "'Asi lo paresçe por su aspeto': Physiognomy and the Construction of Difference in Colonial Bogotá." *Hispanic American Historical Review* 91 (4): 601–31.

Restall, Matthew. 2003. "A History of the New Philology and the New Philology in History." *Latin American Research Review* 38 (1): 113–34.

———. 2012. "The New Conquest History." *History Compass* 10 (2): 151–60.

Rostworowski de Diez Canseco, María. 1975. "Pescadores, artesanos y mercaderes costeños en el Perú prehispánico." *Revista del Museo Nacional* 41:311–49.

Schroeder, Susan. 2007. "Introduction: The Genre of Conquest Studies." In *Indian Conquistadors: Indigenous Allies in the Conquest of Mesoamerica*, edited by Laura E. Matthew and Michel R. Oudijk, 5–27. Norman: University of Oklahoma Press.

Seed, Patricia. 1995. *Ceremonies of Possession in Europe's Conquest of the New World, 1492–1640*. Cambridge: Cambridge University Press.

Silva, Vivian da Veiga. 2021. "Dialoguing with the Wild Languages: Gloria Anzaldúa's Contributions to Thinking about Decolonial Feminism / Dialogando com as línguas selvagens: Contribuições de Gloria Anzaldúa para pensar o feminismo decolonial." *Revista Ártemis* 31 (1): 336–53.

Stanfield-Mazzi, Maya. 2009. "The Possessor's Agency: Private Art Collecting in the Colonial Andes." *Colonial Latin American Review* 18 (3): 339–64.

Tapia y Rivera, Alejandro. (1855) 1967. *Vida del pintor puertorriqueño José Campeche*. Barcelona: Ediciones Rumbos.

Toussaint, Manuel. 1965. *Pintura colonial en México*. Mexico City: Imp. Universitaria.

Valenzuela, Fernando. 2013. "La debilidad institucional del gremio de pintores de Cusco en el período colonial: Un estudio historiográfico." *Colonial Latin American Historical Review* 1 (4): 381–402.

Vargas Ugarte, Rubén. 1947. *Ensayo de un diccionario de artífices coloniales de la América Meridional*. Buenos Aires: Talleres Gráficos A. Baiocco.

Villanueva Urteaga, Horacio. 1985. "El nacimiento de la escuela cusqueña de pintura." *Boletín del Archivo Departamental* 1:11–13.

Webster, Susan Verdi. 1998. *Art and Ritual in Golden Age Spain: Sevillian Confraternities and the Processional Sculpture of Holy Week*. Princeton, NJ: Princeton University Press.

———. 2017. *Lettered Artists and the Languages of Empire: Painters and the Profession in Early Colonial Quito*. Austin: University of Texas Press.

Wynter, Sylvia. 2004. "Unsettling the Coloniality of Being/Power/Truth/Freedom: Towards the Human, After Man, Its Overrepresentation—An Argument." *CR: The New Centennial Review* 3 (3): 257–337.

2

Artists as Activists

The Development of Indigenous Artists' Rights during the Sixteenth Century

MAYA STANFIELD-MAZZI

In the Americas, like in Europe, to be a visual artist in the sixteenth century was to be a craftsperson. Painters, sculptors, stonemasons, and embroiderers belonged to the same social category as shoemakers, bakers, carpenters, and tanners. This status also involved organizing, articulating, and fighting for natural and legal rights in the workplace and in society. Craftsmen in sixteenth-century Europe, as members of male-dominated artisan guilds, fought for better pay, improved opportunities, and political representation (Farr 2000, 165, 197).[1] In Italy painters struggled to maintain the educational opportunities offered by the guild system as well as expand access to it. By proposing that their art should be considered of a higher level, superior to that of the other mechanical arts, the Italian artists implicitly acknowledged that they continued to be classified as artisans (Williams 2007, 96–101).

In parts of the Americas colonized by Spain, craftsmen also fought for their rights, but they did so in markedly different ways due to the nature of colonial rule. Indigenous artisans, who will be the focus of this essay, first found themselves subject to wider debates as to whether Amerindians should have the basic human rights of life and liberty. Later, when those rights were largely (though not universally) established, they and their advocates fought for further elements of liberty. These included the right to work as artisans without being forced to do other sorts of labor, and the right to be paid in money for their work. The struggles of the sixteenth century took place within a historically novel labor context in which the European guild system was introduced and combined with the forced-labor and tribute-based economy instituted by Spanish colonialists, yet also melded with the models of craft specialization and the accompanying artists' rights

that had existed in the Aztec and Inca Empires. In a broader environment in which Indigenous peoples' rights were severely curtailed, and Western discourses on human rights were nascent, it is instructive to consider the various aspects of artists' rights that were under negotiation. There was dialogue around human rights, around legal rights pertaining to Spain's colonial government, and around the sort of rights that have come more recently to be articulated as belonging to Indigenous peoples. Artists, who due to their skills and community linkages operated from relative positions of privilege, can be considered as activists in the field.

Alessandra Russo (2014–15) has recently argued that when sixteenth-century Europeans such as Bartolomé de las Casas esteemed the artistic intelligence of peoples outside of Europe, they helped develop a new concept of humanity that contributed ultimately to the modern idea of the artist as a free creator. While she points broadly to a conceptual shift that took at least two centuries to achieve, I will focus more closely on the incremental development of Indigenous artists' rights within the Spanish viceroyalties of New Spain and Peru, and look to the testimonies of artists themselves. For the purposes of my argument it is still useful to look at visual artists as craftspeople, as they allied with other members of that class to achieve shared goals. As we will see, artisans as diverse as fishermen and ceramicists made claims for rights that were intersecting and mutually informing.

Since the territories of New Spain and Peru were largely overlays onto what had been the Aztec and Inca Empires, we must first reflect on the status of craftspeople under those regimes. Although there were differences between the situations in the two pre-Hispanic empires, certain similarities influenced the approaches taken toward the craft economy by Spanish officials in the new colonial territories. The policy approaches were also similar in each viceroyalty since ultimately the same Spanish Crown and courts drove them, and upper-level officials often had experience in both colonies. A more relevant distinction found in both viceroyalties was likely that between cities (or less-urbanized craft centers) and the countryside (Kagan 2000). Since in cities artisans did not own lands, they were more vociferous and successful in claiming their right to work full-time as craft producers.

Craft Specialists in the Aztec and Inca Empires

The diversified economies, hierarchical class structures, and high levels of urbanization in both pre-Hispanic empires allowed for a wide spectrum of craft specialization. In small towns and rural areas of the Aztec Empire, artisans were household-based part-time specialists, partly dedicated to

agriculture in order to manage risk and provide themselves with reliable sustenance (Brumfiel 1987, 107, 111). They were exempt from collective work requirements (*tequitl*) but required to give material tribute, either in the goods they produced or in the general currency of cloth and cacao, which they obtained by selling their produce (Brumfiel 1987, 109; Durand-Forest 1994, 175). In the island capital of Tenochtitlan, creators of luxury goods, although commoners, held a status just below that of the nobility, on a level similar to that of merchants or *pochteca* (see chapter 4). Their high status suggests that artisans and their communities considered their role to be valuable and thus deserving of certain privileges, the most significant being exemption from communal labor.

As power was consolidated in Tenochtitlan after 1430, elite crafts expanded and the number of full-time specialists there increased. Still household-based, these urban craftspeople (who included women) had easy access to the city's extensive market and to that of Tlatelolco, the city on the northern part of the island. Early colonial accounts suggest that knowledge was passed from fathers to sons and from mothers to daughters (Durand-Forest 1994, 173). Artisans in the capital made a wide array of luxury goods and worked directly for elites and rulers. They included metalsmiths, lapidaries, featherworkers (*plumajeros*), and flowerworkers, as well as the painters of books (*tlacuiloque* in Nahuatl; see chapter 3) and stone sculptors. All were known as *toltecah*, thus associated with the ancient Toltec people, whose rich culture was understood as the forebear to that of the Aztec (Feinman 2001, 192). Some specialists, including painters, singers, and musicians, came from the elite class, as some early colonial records refer to them as *pipiltin*, or hereditary nobles (Reyes García 2001, 31, 48). The concentration of artisans in Tenochtitlan led to high levels of skill and the innovation of new art forms such as feather mosaic (Russo 2015). Artisans congregated by type in special neighborhoods adjacent to those of complementary craftspeople, and directed religious devotion to unique tutelary deities (Sahagún 1577, 734–41). The works they created were largely items of dress and personal adornment that were vital to the elites' expression of their power. The ability to create these socially significant works gave artisans an elevated position in society and a certain political capital (Brumfiel 1987, 117; Durand-Forest 1994, 175).

In the Inca Empire (Tawantinsuyu), craft specialists were known in Quechua as *kamayuqkuna*. The term *kamayuq* literally means "animator" or "one able to charge (things) with being," and it denoted a person with specialized, guarded knowledge (DeLeonardis 2011, 446–48).[2] A prefix was added to the root word specifying the particular craft or job (while *kuna* is the plural suffix). The most famous are the *khipukamayuqkuna*, specialists

in charge of creating, recording information on, and reading the Inca knot records known as *khipus*. Kamayuqkuna related to food production, such as fishermen and salt producers, were highly valued, and there were also religious and military kamayuqkuna. Several types of kamayuqkuna, such as *q'ompikamayuqkuna* or tapestry weavers, correspond to categories that also existed among European artisans. However, painters, sculptors, and dyers were likely grouped together, all known as *killkakamayuqkuna*, since they were all understood as making purposeful marks (*killkakuna*) on surfaces (Webster 2017, 34–40). Kamayuqkuna, as a social class, appear to have been full-time specialists who were brought to the Inca capital of Cusco and dispatched to different parts of the empire. In the city of Quito, which at the time of the conquest was being established as a second capital for the empire, artisans were settled around the residence of the ruler, Atahualpa (Webster 2017, 85).

As much as the kamayuq was an Inca creation, the grouping of artisans into specialties may have been inspired by the Inca Empire's late fifteenth-century conquest of the coastal Chimú kingdom, which had clear groups of specialists known as *yunga*, including ceramicists and silversmiths (Rostworowski de Diez Canseco 1975; DeLeonardis 2011, 469). Like in the Aztec Empire, kamayuqkuna paid tribute to local chiefs but were not required to contribute the obligatory imperial labor, known in Tawantinsuyu as *mit'a*. They also do not appear to have had noble status, but to the extent that they created high-status goods that supported the elites, and as evidenced by the way that they were garbed in imperial dress when dispatched to different parts of the empire, kamayuqkuna held an important position in Inca society (DeLeonardis 2011, 450). Like merchants, they had freedom of movement in order to practice their crafts and were organized according to internal hierarchies (Rostworowski de Diez Canseco 1975, 341). While in the Aztec Empire artisans were given the idealized ethnic identity of Toltec, Inca kamayuqkuna did not maintain their original ethnic (or *ayllu*-based) identities but instead served as representatives of the empire.

Craft Specialists in Spain

Like in other parts of Europe from the eleventh century, artisans in Spain were organized, protected, and regimented under the guild system (Farr 2000). Having begun with artisans gathering as part of religious confraternities, craft-specific guilds began to form in their own right in early fourteenth-century Spain. Masters (*maestros*) in the trade were usually married male householders and stood at the top of the guild hierarchy. They were

permitted to take on apprentices, who after successfully completing their training joined the ranks of journeymen (*oficiales*), a larger, mobile group, only some of whom attained the status of masters. Separate from these guild members was a large group of "unskilled" wage workers who were hired to assist masters as needed. While women were increasingly excluded from guilds (Parker 1986), the widows of masters were often given provisional status to continue their trades, and many women likely served in the ranks of wage workers or as partners with journeymen. Guilds were regimented by way of their ordinances (*ordenanzas*), written documents that accompanied their founding and were approved by city and royal officials.

Guilds were largely an urban phenomenon, and in some cities artisans made up the majority of the population. In 1561, 58 percent of the inhabitants of Cuenca were artisans, while Seville may have had an even greater proportion by the sixteenth century since its artisans began to produce for New World markets in addition to local ones (Farr 2000, 97; Turmo 1955, chap. 3). There were many differences in the ways guilds operated between cities, and generally the cities of Spain were less connected than those in other parts of Europe. Nevertheless, the common denominator was that each guild had local privilege and legal status (Farr 2000, 295; Lis, Lucassen, and Soly 2019, 30).

While guilds began as corporate entities meant to protect their members, they also excluded others. The "skill" that they authorized was more a relational quality that had to do with being inside or outside a guild (Farr 2000, 42). Artisans could be members of one guild and practice the skills of another—in the visual arts this meant that a painter could also work as a sculptor or gilder. Furthermore, craftsmen usually married women associated with trades different from their own, and the sons of guild members became artisans but in different trades. This process consolidated the artisan class rather than any particular guild. At the same time, certain guilds were more powerful and wealthy than others, while poorer yet in-demand trades were quite open to outsiders (Farr 2000, 245–46, 249).

Since monarchs saw guilds as important for disciplining society and regulating economies, they increasingly supported them. In 1249 James I of Aragon gave guildsmen in Barcelona the right to participate politically, and in the late fifteenth century Ferdinand and Isabella of Castile allowed guild corporations to multiply as long as they were under strict Crown control (Farr 2000, 20, 27).

Apart from the gender-based restrictions already noted, religion, ethnicity, and race increasingly came to bear in excluding people from guild status. In Christian territories of Spain, those wishing to become masters had

to prove their Christian heritage by presenting baptismal certificates and proof of *limpieza de sangre* (purity of blood, i.e., absence of Jewish or Muslim ancestry) (Farr 2000, 35). While Jewish artisans had practiced in Spain for centuries, the expulsion of Jews in 1492 led to their removal from many crafts and the subsequent collapse of many industries, such as the silk craft in Zaragoza. Islamic (or newly Christian, *morisco*) artisans dominated silk guilds in the Kingdom of Granada for centuries, until being dispersed after the rebellion of the Alpujarras (1568–71) (Garzón Pareja 1972, 95, 128; Nutting 2018). Guild masters also used the labor of enslaved people, whether Black people brought from Africa or Muslims captured during periods of repression in Granada, and those people were excluded from guild membership. The best-known example is that of Juan de Pareja, the enslaved *morisco* assistant of the Spanish painter Diego Velázquez. Pareja worked as a painter throughout his life, but he never became a journeyman or master in his own right, even after Velázquez granted him his freedom in 1650. Pareja later worked for the painter Juan Bautista Martínez del Mazo (Montagu 1983, 684).

Velázquez is notorious for having attempted to surpass the commoner status of painter and attain knighthood. The success of his case hinged in part on whether he or his family members had exercised any "vile, low, or mechanical trade" and whether he operated his own shop and sold his paintings. He only prevailed by presenting himself as an exceptional figure, an aide and painter to the king (Cowans 2003, 178). Most Spanish guild artisans, including painters, were solidly of the lower and middle class, especially prior to the seventeenth century (Cherry 1996, 69). Nevertheless, they were seen and saw themselves as important members of society (MacKay 2006, 46–71). They advocated for specific rights: broader political representation, the reduction of taxes, and increased access to mastership. The fourteenth-century *révolution des métiers* (revolution of the professions) which spread throughout western Europe and included the Mediterranean cities of Spain, gained craftsmen a level of representation in city governments (Farr 2000, 167–71, 175). In 1520 the widespread *comunero* revolt of inland Castilian cities included many artisans and rallied communities for better political participation locally (Farr 2000, 182–83). Apart from these examples of outright rebellion, artisans were usually able to utilize the corporate structure of guilds to make their demands known. Only sometimes did they directly appeal to the courts or to the upper levels of government (Farr 2000, 217–18). This situation was reversed in the Americas, where artisans' corporate power was limited and they were forced to appeal directly to upper-level officials. Apart from demanding access to mastership, European journeymen also desired to maintain their mobility, being able to work for different masters and (though

less in Spain than in other parts) freely move from city to city (Farr 2000, 203).

There were perhaps more similarities than differences between artisans in the Aztec and Inca Empires and the medieval and Renaissance kingdoms of Spain. All were organized as groups with internal hierarchies, and individually attained a certain level of social status, albeit not one equivalent to that of the ruling classes. Importantly, while all paid taxes or tribute, many were allowed (and to some extent encouraged) to devote themselves exclusively to their crafts. While Spaniards and Indigenous people alike recognized that postconquest society was new and different, in a case of "double mistaken identity" their defense of continuities from the craft economies of their ancestral societies (whether Spanish, Aztec, or Inca) probably aided in the establishment of the colonial craft economy (Lockhart 1985, 477).

Struggles for Life and Basic Liberty in the Americas before 1550

In the first half of the sixteenth century Indigenous artisans' rights were not well established, despite the fact that their work was in high demand. Craftspeople faced being enslaved, otherwise forced to work without compensation, or forced to work on tasks outside their crafts. The outright enslavement of native people was widespread, albeit being officially condemned by the Spanish Crown (Van Deusen 2015, 2). Even more broadly, land grants called *encomiendas* entitled Spanish conquistadors to the labor of people on those lands, without requirements to compensate them or limit the work they could be forced to do. This labor, often called *servicio personal* or personal service, was also demanded by the Catholic Church, Spanish government officials, and Indigenous elites who had received labor tribute in pre-Hispanic times. Tribute in goods was also required of native people, as an annual head tax that Spain adopted from Islamic law and justified as its right to levy on conquered peoples (Seed 1995, 77–82). The bodies, labor, time, and resources of Indigenous artisans were thus exploited by these various demands.

Nevertheless, in schools and workshops founded by missionary friars in both urban centers and rural villages, arts that had flourished under pre-Hispanic regimes were adapted, primarily to serve the aims of evangelization. New arts such as oil painting and polychrome sculpture were also taught for the creation of Catholic art. In 1527 the Flemish friar Pedro de Gante gathered the Nahua sons of native lords in Mexico City into the school of San José de Belén de los Naturales, attached to the newly founded Franciscan convent (*Códice Franciscano* 1941, 206). The youths were encouraged to cultivate native arts such as singing, painting, and featherwork in ways that

expressed the Christian faith. The convent setting appears to have protected them from labor tribute, though they likely performed many services within this communal environment and did not have liberty of movement. Similar schools were founded in other areas, such as the Franciscan Colegio de San Juan Evangelista in Quito (Webster 2017, 11).

Many of the friars involved in cultivating native arts, who often praised Amerindians' artistic abilities, also advocated against the inhumane conditions native people were being subjected to, the worst of which was chattel slavery. The most influential of these friars was Bartolomé de las Casas, a former *encomendero* (encomienda owner) who later became a Dominican priest and the first bishop of Chiapas (Las Casas 1967, chaps. 62–63, 65; 2001). Institutions such as the Second Real Audiencia or high court of Mexico began to take a harder stance against Indigenous chattel slavery in 1531, and eventually, with Las Casas's urging, the Spanish Crown outlawed this form of slavery in its New Laws of 1542 (Zavala 1984, 25, 31). An important and public, if not legally binding, step toward the abolition of Indigenous slavery had been Pope Paul III's encyclical of 1537, entitled *Sublimis Deus* (figure 2.1). It decreed that since "Indians of the West and South" were "true men" capable of receiving the Christian faith, "they . . . must not be deprived of their liberty or ownership of their possessions; and moreover, that they can use, possess, and enjoy freely and lawfully their liberty and dominion, nor must they be reduced to servitude" (Friede and Keen 1971, 316).

In 1539 featherworkers within Gante's school of San José de Belén de los Naturales created a work of feather mosaic as a gift for Paul III in acknowledgment of his decree (figure 2.2) (Estrada de Gerlero and Martínez del Río de Redo, 1990). It depicts the scene known as the Mass of Saint Gregory, in which a vision of Christ appears while the pope, Gregory I, is saying mass in order to convince a doubter of the doctrine of transubstantiation (Estrada de Gerlero 2015, 301–2). Surrounding the scene is an inscribed frame also in featherwork, naming Gante and the Indigenous governor don Diego de Alvarado Huanitzin, and stating that the work was created in Mexico City for Pope Paul III (Russo 2013, 471). The exquisite craftsmanship of the piece, as well as its doctrinally attuned Christian theme and display of literacy, must have been meant to serve as a confirmation of Pope Paul III's sentiment toward the humanity and right to freedom of native Amerindians. However, the creators of the work themselves are not acknowledged, nor have they ever been identified. It is likely that they were not directly compensated for creating the piece, and instead were obliged to produce it under the "personal service" model. Alvarado Huanitzin (r. 1537/38–41), a nephew of Moteuczoma II who was favored by Viceroy Antonio de Mendoza and

Figure 2.1. *Sublimis Deus*, encyclical issued by Pope Paul III in 1537, Rome. Wikimedia Commons.

retained many of the hereditary privileges enjoyed by pre-Hispanic Mexica rulers, must have been a primary commissioner of the work (Mundy 2015, 100–107). But surely Gante's intervention was also key, since the feather-workers would have been from his school and church officials also regularly commissioned artworks as personal service. As much as the work survives as a celebration of Indigenous artistry, the invisibility of its creators makes it emblematic of the state of artisans' rights prior to 1550.

Spanish Attitudes toward Indigenous Crafts

The first guilds were established in the viceregal capitals in the late 1540s, sometimes less than a century after such guilds had been founded in Spain,

Figure 2.2. *Mass of Saint Gregory*, Mexico City, 1539. Feathers, paint, wood, 56 × 68 cm (wood 23 cm deep). Musée de Jacobins, Auch, France.

with ordinances based on the Spanish models but also tailored to the colonial setting (Barrio Lorenzot and Estrada 1920; Carrera Stampa 1954; Quiroz Chueca and Quiroz Chueca, 1986).[3] The ordinances often outlined differential access to guild status for Indians (*indios*) and Black people (*negros*). The stipulations betray a growing, yet not clearly defined, desire on the part of Spaniards (*españoles*) to establish artisanal hierarchies based on ethnoracial difference (Baber 2009; Rappaport 2012). The statuses of master and journeyman were often reserved for Spanish emigrants, and many Indigenous artisans were employed in crafts only as slave labor (Zavala 1984–85, 1:308, 1:314). While people of African and Asian heritage continued to be enslaved, the New Laws initiated a decline in Indigenous slavery and allowed more space for free Indigenous artisans within guilds.[4]

The roots of these changes, and the increasing allowance of Indigenous oficiales, can initially be interpreted as a result of broad currents in Spanish colonial policies that were rooted in European jurisprudence, esteem for guilds carried over from the Middle Ages, and the ideals of the Renaissance. This last would usher in what Russo (2014–15, 359) terms "a new concept of humanity," elicited in part by Las Casas and others in their estimations of Indigenous artisanry. The changes also related to colonial officials' ideas about how colonial society and its economy should be established, in ways that privileged the goals of the Crown over those of the more baldly profit-driven encomenderos.

The debate about whether to allow Indigenous slavery, and the subsequent dispute about whether it was just to wage war against Amerindians in order to convert them to Christianity, relied on the European legal framework of natural law versus the "law of nations," *ius gentium*. Most simply, Las Casas's arguments for the freedom and rights of Amerindians were based on natural law. In religious circles natural law had been invoked in the thirteenth century when Franciscans claimed the right to poverty but also the ability to sustain themselves materially (Mäkinen 2005). This led to the development of the right of subsistence, which as an economic right may have undergirded support for Indigenous artisans' right to pursue their livelihoods. At the Valladolid debate (1550–51), Las Casas argued against the concept of "just war" as applied to Amerindians, and more broadly for their right to autonomy. His opponent, Juan Ginés de Sepúlveda, rooted his arguments in the law of nations, claiming that the culture and practices of Amerindians were so depraved that they should be subjugated. Nevertheless, as a Renaissance thinker who had published a definitive Latin translation of Aristotle's *Politics*, he thought native peoples should become civilized and progressively

gain more rights and freedoms. As much as he denied Indigenous rights in the near term, he seems to have imagined a cultured society in which artisans would have a major place (Alvira and Cruz 1997, 101). Similarly, in his memoirs of 1576, the conquistador Bernal Díaz del Castillo greatly admired the crafts that developed after the conquest, citing the presence of Indian metalworkers, stoneworkers, painters, weavers, haymakers, surgeons, plant healers, and toy and musical instrument makers (Zavala 1984–85, 1:314–15).

Earlier, at the convent schools in the early sixteenth century, native men were taught Latin along with other arts by the teacher-friars. The reason for this broad education went beyond the idea of fostering an artisan class, and reflected the short-lived aim of cultivating an Indigenous leadership class (Zavala 1984–85, 1:26; Webster 2017, 23). But in 1537, in a more economically driven vein, the bishops of Mexico, Guatemala, and Oaxaca wrote to the king to say that Indigenous artisans should be encouraged since doing so would cause the prices of goods to go down, and suggested that a school be founded in which Spanish artisans would teach *oficios* (trades) to Indians (Zavala 1984–85, 1:309). Thus, while disparate, some seeds for the expansion of Indigenous artisans' rights were present in the first half of the century, but it would not be until 1550 that the situation truly began to change. Prior to 1550 we see mainly the perspectives of Spaniards pointing to change, but after the midcentury we can access more directly the perspectives of Indigenous artisans themselves.

Advancement in New Spain after 1550

The crucial developments at midcentury were that Indigenous slavery was publicly outlawed, and labor tribute without pay began to be phased out. The replacement for the latter was the *repartimiento*, a system of forced labor tribute that ostensibly paid workers a daily wage. Our clearest window into Indigenous artisans' struggles for their own rights is when they advocate for freedom from this new form of labor tribute, often still called personal service. In their arguments, artisans hark back to their relative statuses under the Aztec and Inca Empires, especially the fact that they were not required to give labor tribute and, in key cases, had existed as part of an artisan class that did not have productive lands. They do not presume to be free from colonial tribute altogether, but instead demand to be paid for their work, preferring money over goods, so that they can make monetary tribute payments. This situation would allow them to spend their time as artisans. Within the context of Spanish jurisprudence it seems to be based in the right of subsistence

as well as what Silvio Zavala (1984–85, 2:12), the historian who closely charted personal service, called "el derecho a la disposición de persona," or the right to freely dispose of one's person.

We begin to see the Crown and Spanish officials in the colonies allowing artisans freedom from labor tribute, thus reserving a place for an Indigenous artisan class. In New Spain these developments coincided with the term of Viceroy Luis de Velasco (r. 1550–64), so his influence is clearly seen, while in Peru (and later in New Spain) members of the Audiencias were significant in helping advance artisans' rights. An unfortunate byproduct of the encomienda debate, calculated as it was to shore up conquistadors' investments and further their profits (Legnani 2020), was the conviction among Spaniards that *indios* were lazy and needed to be obliged or encouraged to work. Ironically, however, this led to some protections for artisans. In 1550 Crown instructions stated that "since Indians are naturally lazy . . . those that are artisans [*oficiales*] should focus on and dedicate themselves to their crafts, while those who are agriculturalists should work the land" (Zavala 1984–85, 2:13). Then, in 1551, Viceroy Velasco issued a decree that all artisans in Mexico City (including carpenters, stonemasons, tailors, painters, and blacksmiths) should not be occupied with personal service, but rather, "should be allowed to practice their crafts with no restrictions." The decree was in response to a case brought in the same year against the governor don Diego de San Francisco Tehuetzquititzin (r. 1541–54, grandson of the Aztec emperor Tizoc), who was accused of obtaining undue personal service from carpenters, painters, and other artisans (Reyes García 2001, 33–35).

In contrast to the prior governor, Huanitzin, Tehuetzquititzin presided during a period in which native lords' hereditary rights to unpaid labor and goods began to be questioned, both by Spanish officials such as Velasco and, perhaps more importantly, by native producers (Mundy 2015, 156). Just before Tehuetzquititzin's death in 1554, the customary examination of his tenure was begun by the Indigenous judge don Esteban de Guzmán. Included within the resulting dossier was a document now known as Genaro García 30, which charts the goods given to Tehuetzquititzin by craftspeople from the four Indigenous parts of Mexico City, many of whom were not paid for their wares. The manuscript is arranged by craft specialty, often dedicating a double-page spread to each profession. Female weavers and spinners in the city are shown to have received compensation for most of the thread and woven cloth that they rendered. However, sculptors and painters appear not to have received compensation for the dozens of drinking vessels that they gave to Tehuetzquititzin. One page recounts the painters' contributions, identifying them by a figure at the top of the page: an arm painting the *ilhuitl*

or double-hook symbol that stood for painter-scribes (figure 2.3; Peterson 1993, 49). The goods they rendered are documented in solely native terms, by way of either traditional or newly invented pictographs, and divided according to the city's four Indigenous *parcialidades* (neighborhoods). The primary neighborhood of San Juan Moyotlán, at top (indicated by the cup of Saint John the Evangelist), is noted to have given twenty gobletlike painted cups and five other vessels, seemingly shaped in the form of birds (Mundy 2015, 126, 149–56). While the value of these goods in Spanish currency was twenty-six pesos (indicated by baglike symbols, where a group of twenty is denoted by a flag), the fact that the monetary symbols are not filled in with color indicates that the cups were not paid for. And while this document was part of a Crown inspection, it seems to offer an even more direct complaint by producers themselves about not being compensated for work rendered to a native ruler.

Perhaps influenced by such complaints and also wishing to limit the power of native governors, Velasco continued to emit decrees protecting certain artisans in the practice of their crafts. These included tack and rope makers, candlemakers, and tailors (Zavala 1984–85, 2:223–28). Then, in 1555, he acted more specifically in favor of Indigenous artisans' access to guild structures, albeit suggesting that certain crafts should be practiced by Indians and others by Spaniards. This separation reflected the nebulous idea of two "republics," one of Indians and one of Spaniards, which emerged as colonial rule was consolidated (Levaggi 2001, 426). Velasco's decree stated that native artisans should work "their" crafts, and that to create a proper guild framework they should study such crafts, have ranks of apprentice and journeyman, and employ guild examiners. Apart from paying tribute, they should not have to do other jobs or occupy themselves outside of their crafts. Yet the division between republics was not strictly upheld, and by the end of the decade Velasco moved to break down the boundaries between Spanish and Indigenous craft professions. In 1559 he lifted the existing prohibition against Indigenous smiths working with gold, thus allowing them to compete with Spanish goldsmiths (Zavala 1984–85, 2:234).[5]

Despite these developments, personal service continued to be demanded of artisans throughout the decade and into the 1560s. Furthermore, tribute was still generally required to be paid in goods and not in money, an unfavorable situation for artisans. Fray Pedro de Gante wrote to Charles V in 1552, decrying the new repartimiento system, under which Indians were "hired against their will." He said that when labor was needed Spaniards would look ten leagues around, gathering all possible people, wage workers and artisans alike, and forcing them to leave their families and work under

Figure 2.3. *Tribute Paid to Don Diego de San Francisco Tehuetzquititzin*, Genaro García 30, fol. 10v. Mexico City, circa 1553–54. Ink and color on paper, 10 × 32 cm. Benson Latin American Collection, LLILAS Benson Latin American Studies and Collections, University of Texas at Austin.

terrible conditions. At the same time, Gante opined that tribute should be in the goods that people produced—this view, held by religious leaders longer than by secular ones, made sense for agriculturalists but not for artisans (Zavala 1984–85, 2:93).

The debates about personal service and the form in which tribute should be given were intertwined, and reached a critical point in the mid-1560s in Mexico City. A remarkable text in alphabetic Nahuatl known as the *Anales de Juan Bautista*, translated to Spanish by Luis Reyes García, further documents the debates from a native point of view. It shows that in 1565 artisan groups successfully advocated for their rights to be freed from personal service, paid in money for their work, and allowed to pay tribute solely in money. The account, completed in 1582, mainly compiles events, presumably culled from various documents, that took place in San Juan Moyotlán from 1564 to 1569.[6] While various trades are mentioned, and often the different groups had different demands, the most prominent and successful group was that of thirty-six painters, or *tlacuiloque*. While a Spanish-style painters' guild had been founded in 1557 (Barrio Lorenzot and Estrada 1920, 19–23), the Moyotlán tlacuiloque were not likely part of that entity, since Spanish painters would have been located in the sector at the city's center. Even so, the tlacuiloque clearly functioned as a corporate body, choosing to document their activities in alphabetic writing rather than in pictographs. Their ranks were defined in Nahuatl terms adapted from pre-Hispanic usage. For example, the word *huehue*, meaning "person of advanced age," was used to indicate a craftsman with wide experience. Such a person might have been called an *oficial* in Spanish (thus holding the rank of journeyman), but the retention of the Nahuatl word maintained an association with advanced age and Indigenous understandings of status. Nevertheless, the Spanish loan word of *capitán* was used to describe the painter Juan Icnotzin as a guild official in 1569, thus suggesting an increasing approximation (and acculturation) to Spanish guild norms and status markers (Reyes García 2001, 48).

Among the thirty-six painters in the group was Marcos Cipac de Aquino, to whom scholars attribute the original painting of the Virgin of Guadalupe (figure 2.4). That painting is not signed, but people at the time mentioned Marcos Cipac in ways that suggest he was a well-known and leading painter, and allow him to be connected to what later became Mexico's most famous artwork (see chapter 5; Peterson 2014, 115–18, 289n73). The painters were closely tied to the Franciscan convent in the city, and indeed Gante is mentioned in negotiations about tribute. There are also multiple references to painters' progress on church projects such as altarpieces, and occasionally

Figure 2.4. Marcos Cipac de Aquino. *The Virgin of Guadalupe*, Tepeyac, Mexico, circa 1550. Oil and tempera on cloth, 109 × 175 cm. Basilica of Our Lady of Guadalupe, Mexico City.

their lack of progress is blamed on tribute and work requirements (Reyes García 2001, 274–75).

The first monetary tribute was levied on native people in New Spain in 1549, in the amount of two *tomines* (a *tomín* was one-eighth of a peso). Payment in goods such as maize and forage was also required, as was personal service for Indigenous nobles, churches, and city works. The situation reached a tipping point in early 1564, when tribute was raised to eleven tomines but other obligations were not removed. Artisans explained that since they all made things by hand and were not farmers, they did not have productive lands from which to draw the staples required as tribute (Reyes García 2001, fol. 20v).[7] They began to advocate for freedom from both personal service and tribute in goods, but multiple points of view were in play, and initially the painters were not all in agreement. The debates, which took place over the course of 1564 and early 1565, involved tears, fights, and the imprisonment of those refusing to pay tribute. Some common laborers (*macehualtin*) who could not (or refused to) pay the monetary tribute were even "sold" as part of their punishment. Apparently they were either literally sold into slavery or punished with obligatory labor. This occurrence caused much regret for the painters leading the move toward solely monetary tribute (Reyes García 2001, fols. 44r, 48r).[8]

Various officials were also staunchly against the change. Friars such as Gante—seemingly as advocates of common laborers, who also saw their tribute increased, but also as beneficiaries of both personal service and tribute in kind—argued that the painters should retire their demands in order to keep tribute down to four tomines, and that tribute in the form of goods and service should remain (Reyes García 2001, fol. 30v). They blamed the artisans for the rise in tribute, saying that the artisans' petitions had reached the courts in Spain and led to the change (Reyes García 2001, 130, fol. 44r). We see an unfortunate situation in which demands on common laborers and agriculturalists were increased due to artisans' advocating for their rights. Indigenous nobles in the colonial government also resisted the shift to solely monetary tribute, presumably because they still stood to gain from personal service, as was the case with Governor Tehuetzquititzin. They exhorted painters to remember their noble backgrounds and obligations to their lineages and communities (*altepeme*), instead of resolving to only serve the "emperor" of Castile (Reyes García 2001, fols. 20v, 31v). While this argument gained some traction, and makes clear that many painters were part of the noble class, it was ultimately rejected.

On September 21, 1564, the painters, as well as groups of goldsmiths and shoemakers and their community representatives, presented a petition to the

president of the Audiencia, Francisco Ceinos, stating their desire to pay tribute only in money. Ceinos had been in New Spain as an Audiencia member (*oidor*) since 1530, and in 1564–66 he led the Audiencia, which served as an interim government in the absence of a viceroy. He was initially angered by the petition and rejected it (despite having expressed support for the artisans' demands the previous month), but he later accepted a second version and proved to be an ally for the craftsmen (Reyes García 2001, fols. 31v, 47v). The questions of public work and the forms that tribute should take were intertwined. When in October people of the neighborhood of San Pablo Teopan were rounded up for public work, they said, "What public work? Have we not paid with our money? Wasn't public work meant to disappear if we paid tribute?" (Reyes García 2001, fol. 48v).

Ultimately the painters' block retained a united front, and in February 1565 painters of all four quarters of the city resolved to abandon public work and tribute in kind, sticking solely to their work of painting so nothing else could be required of them (Reyes García 2001, fol. 54r). No subsequent events are recorded in relation to tribute negotiations. We thus see that in the context of Mexico City, with a strong noble class and intense craft specialization from Aztec times, artisans were able to win some key labor rights. Their victory entailed rejecting some pre-Hispanic models, such as rendering service and tribute to noble rulers. It involved undertaking outright rebellion but also, perhaps more effectively, acting as a corporate body to approach upper-level government officials and the courts. Individual painters who were members of the Indigenous noble class and might have been able to gain tribute exemptions based on that status decided to accept tribute in exchange for corporate unity.

While her analysis does not focus on the tribute negotiations, Santa Arias (2006, 36, 48) notes that the artisans of the *Anales* contributed to the construction of a hybrid viceregal culture.[9] A page from the Xiuhpohualli of Tenochtitlan Codex of the same period underscores this point, and shows how artisanal labor, tribute, governance, and artists' livelihoods were intertwined. Likely created by a painter from the same group as the *Anales*, this codex was begun in 1562 and recounts events from pre-Hispanic times up to 1596 (Dibble 1963, 13). On the page for 1564 (fol. 54r, at right in the two-page spread), the first entry notes the painting of the church of San José with lime (figure 2.5). It is followed by a poignant first-person statement by the manuscript's creator, reinforced by a conventional house symbol: "On Monday May 29 I began my little house." One of just five first-person entries in the entire manuscript, this entry highlights the economic benefits to artists of having paid work without onerous tribute requirements (Dibble 1963, 12).

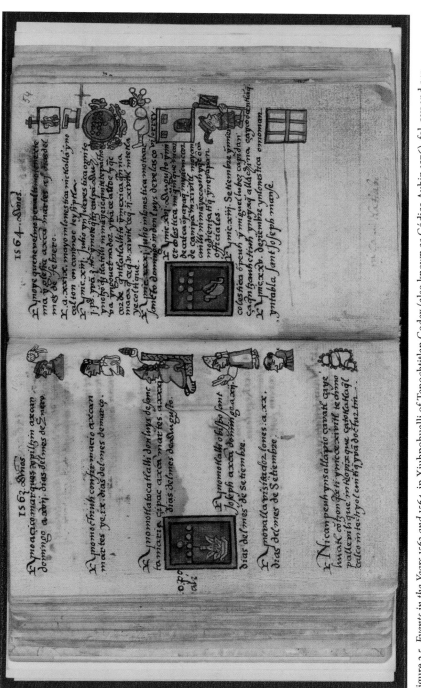

Figure 2.5. *Events in the Years 1563 and 1564*, in Xiuhpohualli of Tenochtitlan Codex (also known as Códice Aubin 1576), fol. 53v and 54r. Mexico City, 1576. Ink and color on European paper, 13.4 × 15.5 cm. The British Museum, London.

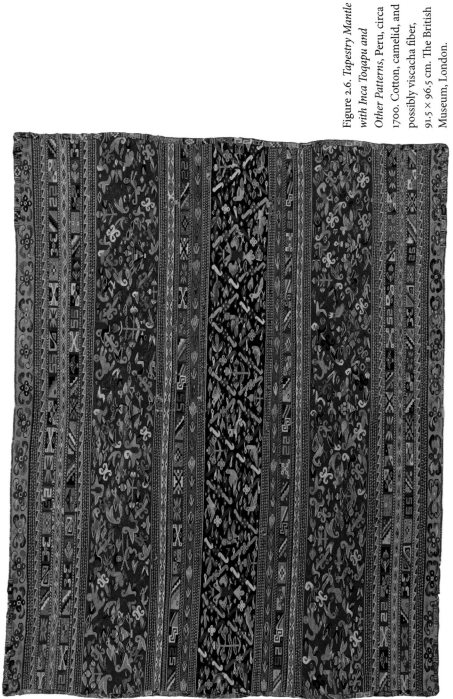

Figure 2.6. *Tapestry Mantle with Inca Toqapu and Other Patterns*, Peru, circa 1700. Cotton, camelid, and possibly viscacha fiber, 91.5 × 96.5 cm. The British Museum, London.

The very next entry documents the raise of the tribute requirement to eleven tomines and says that for that reason people threw stones at the houses of the governor and an Indigenous *alcalde* (official). A symbol of eleven tomines is surrounded by stones to indicate as much. Even more directly than the *Anales*, the text says that people were sold into slavery as a result of their protests (Dibble 1963, 75–76). The death and burial of Viceroy Velasco are documented next, as well as the transfer of Spanish officials to a new building. The final entry on the page records the completion of a significant artwork, achieved by the same tlacuiloque during the same months they were demanding to pay tribute in cash and focus on their art: the altarpiece for the chapel of San José de Belén de los Naturales in Moyotlán, depicted as a golden grid. The gilded framework would have been filled with paintings of Christian saints, and the *Anales* record in detail the preparations, costs, labor distribution, and iconography of this monumental artwork (Reyes García 2001, fols. 20v, 48r).

A remarkable artistic milieu thus comes into focus, one including painters who could create illustrated books as inheritors and adapters of the Aztec tradition, as well as craft Renaissance panel paintings and altarpieces. In chapter 3 we will see the multifaceted personas of tlacuiloque in another part of the city, Tlatelolco. It is also the case that Mexico City's tlacuiloque created a hybrid society with the legal protections they built for themselves. They did not reject Spanish tribute demands outright, since they judged that to be a losing proposition.[10] They instead attained an arrangement that protected their mode of work in various ways, albeit reflecting continued colonial inequities.

Analogous Developments in the Viceroyalty of Peru

While the same general progress occurred in Peru, including the abolition of Indigenous slavery and the move toward the repartimiento system of forced but paid labor, most developments happened at least a decade later than in New Spain. The shift toward monetary tribute, for example, occurred mainly in the 1570s. References regarding artisans' rights are more sparse, as are modern studies of the same. For example, Zavala produced one volume about personal service in sixteenth-century Peru, as opposed to three volumes on that century in New Spain. Nevertheless, there are some dimensions of the struggle that we see more clearly in Peru. The first is a move toward contracts for artworks; clear terms (even if not written) and payments became expected, the latter keyed to monetary tribute amounts

(Ramos 2010, 127). Certain craft models from Inca times continued to inform artisans' status as it developed.

Much as the unique craft of feather mosaic was maintained in Mexico, other distinctive crafts continued forward in Peru. In the realm of the visual arts, this included the weaving of camelid-fiber tapestry, q'ompi. Perhaps since this craft was so rooted in Inca models (and possibly because many women counted among its masters), its practitioners never organized into Spanish-style guilds. Yet it was a widely respected art, especially since q'ompi weavers were able to create bold symbols of both Inca and Spanish status in their discontinuous webs. As such, we see there the development of the right to independently contract for one's work. The Spanish jurist Juan de Matienzo referred to tapestry commissions in his 1567 book of observations on the governance of the viceroyalty. He noted that if Spaniards wished to commission tapestry hangings (reposteros) from Indians, they should contract for these works directly instead of using the provincial leaders (caciques) as intermediaries (Zavala 1978, 55). His intentions may have been less to protect workers than to curtail the power of Indigenous elites.

Gabriela Ramos (2010, 127) has found ample evidence of contracts with weavers, even though they were not written down and often did not include Spaniards as contracting parties. Weavers were brought to patrons' homes, given raw materials, and asked to weave specified garments. At the end of the 1560s doña María Cusi Rimay had an agent contract weavers to create three different women's mantles (llicllas), for which she paid two baskets of coca, as noted in her will. Although none of their creators' names are known, many stunning llicllas of this type survive today, bearing symbols of Inca nobility (geometric toqapu designs), Spanish heraldry, and patterns related to elite Spanish visual culture like those on woven silks (figure 2.6). While Cusi Rimay paid the weavers in coca, a common medium of exchange in the absence of coinage, in later years monetary payments became customary. For example, in 1611 doña Ana Quispe Asarpay paid two weavers fourteen pesos to make her an acsu (wraparound dress) with toqapu symbols. By that time the annual tribute per household was set at five pesos two reales (i.e., tomines), so each weaver would have been able to use some of their earnings to pay their family's debt that year (Ramos 2010, 127). While Quispe Asarpay requested toqapu symbols, the richness and complexity of surviving cloths also suggests that a certain freedom was allowed to weavers, by virtue of the cloths' designs not being specified in contracts (Russo 2014–15, 361).

As found by María Rostworowski de Diez Canseco (1975, 314), some of the best and earliest information on artists claiming their rights before Spanish

officials in Peru comes from the area that had been a craft center since the time of the Chimú kingdom, the Indigenous towns along the coast around the Spanish-founded city of Trujillo. A special category of artisans, and one that may have been protected by Spanish officials from early on, was fishermen. Strung along the coast, these people did not own lands and had been excused from labor tribute in Inca times. But there were also craft categories that correspond to the visual arts, including silversmiths and potters. The Lima Audiencia member Dr. Gregorio González de Cuenca began to judge cases from the north coast in the late 1560s. In 1566 he ordered the cacique of Jayanca (in the Lambayeque valley) to allow craftspeople—including q'ompi weavers, sandal and shoemakers, rope makers, silversmiths, and carpenters—to freely practice their crafts. They should not be required to serve the mit'a, serve in the houses of encomenderos, or serve as guides or porters. That is, they should be freed from personal service (Rostworowski de Diez Canseco 1975, 323). It seems that González de Cuenca's decree was motivated by the petitions of various artisans, who approached him to ask for "licenses" to practice their crafts. We do not see artisans functioning as corporate groups (although clearly they belonged to such groups); rather, we see them being forced to approach the government official as individuals. For example, the potter Alonso Chut, from the Indian potters of Lambayeque, requested the right to be freed from the mit'a, which would have required him to raise cattle, and to be allowed to "trabajar a su oficio," or work his craft (Rostworowski de Diez Canseco 1975, 324). In the 1570s González de Cuenca made an official review (*visita*) of the Trujillo region just to the south and noted various craft groups there. These may have been extended family groups settled in particular areas, since he describes them as ayllus. Since, like for Mexico City, the fishermen declared they had no lands, González de Cuenca said they should be allowed to freely practice their oficios. For them the issue of tribute in kind was not a problem, as long as they were allowed to pay in dried fish, a widely valued staple, rather than maize (Rostworowski de Diez Canseco 1975, 318–19). Rostworowski de Diez Canseco (1975, 326) notes that it was vital for long-standing craft specialists on the coast to be able to continue their crafts, since unlike in the highlands they could not switch to working lands. But this was also the case in some mountain areas such as Chucuito, where there were specialists such as q'ompi weavers, and in cities such as Cusco, where there were silversmiths who had been relocated there from the coast in Inca times.

Rostworowski de Diez Canseco (1975, 326, 333) and Susan Verdi Webster (2017, 73–77, 85–88) show that in the principal Inca cities of Cusco and Quito,

artisans formed strong associations based on family linkages and did not fully adopt Spanish guild patterns. Among painters in Quito the terms *oficial* and *maestro* were used, but there were no written guild ordinances and painters had the autonomy to practice several trades at once. Many resided in the same neighborhood previously inhabited by the Inca ruler. These sophisticated, literate painters seem to have secured early on the rights to dedicate themselves to their craft and be paid in money.

The era of Viceroy Francisco de Toledo (r. 1569–81) was one in which native autonomy was increasingly restricted, as Indigenous uprisings were put down, people were forced to live in designated towns (*reducciones*), and Christian evangelization was intensified. Yet by requiring native people to reside in towns Toledo increased levels of urbanization, and also supported craft specialization as part of his policies. His viceroyalty-wide orders issued from Arequipa in 1575 encouraged native authorities to allow craftsmen to practice their trades ("que los indios que fueren oficiales usen sus oficios"), while noting that *others* should work fields and raise livestock. However, this decree continued to reflect the attitude that *indios* needed to be required to work in order to avoid laziness ("que no sean holgazanes") (Zavala 1978, 143). Previously, in 1572, Toledo had attempted to regulate the craft professions in Cusco following a more Spanish model, ordering that craftsmen pay a tax (*arancel*) to the city council. But he also betrayed the ethnoracial differences involved, stating that *negros, mulatos,* and *indios* should pay lower fees, presumably because they earned less or were required to make tribute payments (Zavala 1978, 138). While Indigenous artisans' fights for freedom from labor tribute and for the right to pay tribute in money are less obvious in Peru, it generally appears that they obtained such privileges, especially the former (Rostworowski de Diez Canseco 1975, 327; Stern 1982, 134, 152).

Continued Fights and Other Rights at the Turn of the Century

By the end of the sixteenth century some form of craft guilds had been founded in most viceregal cities, and it appears that the status of oficial was widely established for Indigenous and mestizo craftsmen. In some places artisans working in the visual arts came to have public personas, proudly signing their works. Yet colonial demands, including personal service, still infringed on their basic rights. Artisans also struggled for other rights in order to continue their work in ways favorable to them.

In Michoacán, Mexico, craft professions that had been encouraged by early evangelizers continued, with artisans emerging as professionals outside of monasteries (Stanfield-Mazzi 2021, 165–67). In the town of Pátzcuaro (an

important P'urhépecha center that housed the bishopric of Michoacán until 1580) featherworkers, many with noble surnames, created stunning feather mosaics on commission (López Sarrelangue 1965, 163; Anders 1970, 14–16). In 1590 fourteen plumajeros there petitioned Viceroy Luis de Velasco (the second of that name, r. 1590–95) for exemption from the repartimiento in order to continue practicing their craft. One petitioner, Juan Yracu, said that he was occupied with various important works from which he could not raise his hands ("de las cuales no puede alzar la mano"), and that going to the repartimiento would cause him harm. As is also suggested by the Florentine Codex's portraits of artists (Russo 2014–15, 360–63), it appears that having one's hands busy at work was a Mesoamerican metaphor for complete dedication to one's craft. In 1592 the viceroy extended freedom from personal service to a great range of artisans in Pátzcuaro: featherworkers, painters, silversmiths, stonemasons, and potters (Paredes Martínez et al. 1994, 390). Yet, at the very end of the century, two Michoacán shoemakers still had to request a similar waiver (Martínez Baracs 1999, 189).

Among the other featherworkers named in the 1590 petition are Juan Bautista de la Cerda and Juan Cuiris, surely the same men who signed two exquisite feather paintings that were sent to Rudolph II in Prague at the end of the century (figures 2.7 and 2.8). The artists used as their models two French engravings by Philippe Thomassin, also issued around 1590 (Estrada de Gerlero 2004). But the engraver's signature and the name of the designer Giulio Clovio, which appear at the base of the frames depicted surrounding each figure in the original French prints, are replaced in the feather paintings with the signatures of their respective creators. The mosaic of Jesus is signed "Joan Bapt[ista] me Fecit Michuac[an]," and that of Mary "Juanes Cuiris Fecit Michuac[an]." The image of Mary is also different from the print original in featuring heads of cherubs in its four corners, instead of scrollwork. Juan Bautista's signature in particular employs abbreviations and a mixture of upper- and lowercase letters—rendered with tiny feathers, no less—that is a sophisticated display of literacy. Webster (2017, 129, 138) finds a similar display in a work by Quito painter Andrés Sánchez Gallque, who made use of an even more elaborate system of abbreviation. Webster (2017, 145) argues that Gallque's signature, appearing in a triple portrait of the Afro-Indigenous nobles Francisco de Arobe and his sons Pedro and Domingo, constitutes a fourth portrait and is a self-confident way of claiming his status in Quito society.

Late sixteenth- and early seventeenth-century documents present artisans also fighting for more specific, though no less necessary, rights. One was the right to operate in public shops—a commonplace for European guild

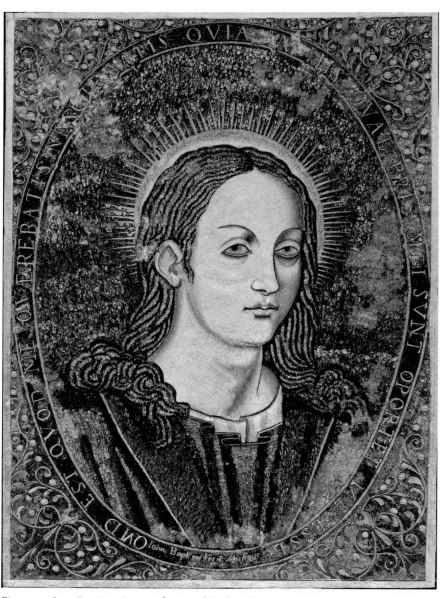

Figure 2.7. Juan Bautista, *Jesus at the Age of Twelve*, Pátzcuaro, Mexico, 1590–1600. Feathers on copper, 18.2 × 25.4 cm. Weltmuseum, Vienna, Austria. Photograph courtesy of KHM-Museumsverband.

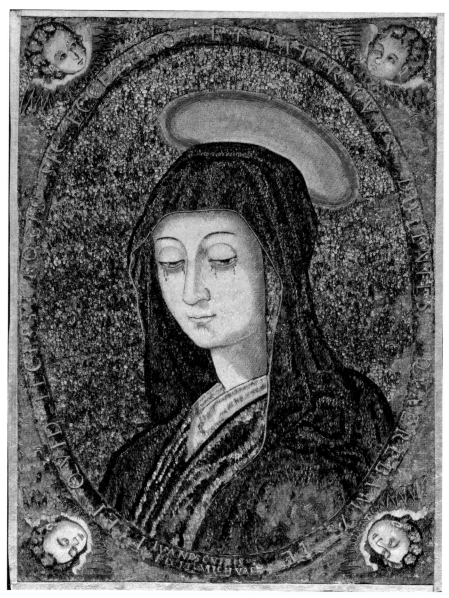

Figure 2.8. Juan Cuiris, *The Virgin Mary Weeping*, Pátzcuaro, Mexico, 1590–1600. Feathers on copper, 18.2 × 25.4 cm. Weltmuseum, Vienna, Austria. Photograph courtesy of KHM-Museumsverband.

members that was supported by government officials since it allowed for public scrutiny of their activities (Farr 2000, 21, 60). In New Spain, Viceroys Mendoza and Velasco in 1549 and 1551 had protected the ability of Indian saddle makers and tailors, respectively, to maintain shops in their own right, and Velasco's order of 1555 said there should be specific streets in Mexico City where native artisans could have their shops (Zavala 1984–85, 1:313, 2:234, 2:224). While this right may have thus been established in major cities relatively early on, we find artisans struggling for it in other places. In 1616 in the northern Peruvian city of Chachapoyas, from where Spaniards often mounted invasive expeditions into the Amazon region, native tailors complained that they were constantly being asked to supply such expeditions and not allowed to work in their shops around the plaza. Instead, they were forced to hide and work in their homes. The tailors appealed to the region's colonial magistrate (*corregidor*), who overruled the local alcaldes ("Exp. sobre indios" 1616).

Surely professionals such as tailors, who would have needed to measure their clients and make adjustments, required shops more than others did. Fishermen, in contrast, could easily sell their goods at market. But artisans who relied on raw materials needed to protect their access to resources. Fishermen had to protect their fishing grounds against Spanish policies that opened the ocean to everyone (Rostworowski de Diez Canseco 1975, 319–20). Mat makers in Mexico City needed to defend their crops of cattail reeds, a proposition that surely became more urgent as Lake Texcoco's waters were mismanaged by colonial officials (Zavala 1984–85, 2:224–25; Mundy 2015, 75, 193–94). Potters in the town of Uruapan (Michoacán) brought a suit against a neighboring town in order to retain their rights to a hill from which they got the minerals to paint small drinking vessels (*jícaras*) (Martínez Baracs 1999, 78–79). These appeals for particular lands and resources, often on the basis of ancestral practice, correspond to what we would consider today as Indigenous rights.

A final right that appears is another that European journeymen fought for regularly: the right of mobility. This may have been even more important for Indigenous artisans when they could not have shops and could not accede to the status of masters. Spanish policy accounted for native people in their communities so that tribute could be levied on them, and thus limited their ability to move around. On the Peruvian north coast the potters Juan Llonef, Pedro Ref, and Juan Chonefc had to request from the *visitador* (official reviewer) Cuenca the right to travel from their community of Collique to Jequetepeque, where they had traditionally sold the large jars they made (Rostworowski de Diez Canseco 1975, 324). In Cusco Viceroy Toledo responded

to complaints that native silversmiths were being asked to produce silver for Spaniards without pay, as well as concerns that those Spaniards were not paying the necessary "royal fifth" tax on the silver, with a plan to relocate all the smiths into a large hall (*galpón*) (Rostworowski de Diez Canseco 1975, 326–27). Presumably being in a central location would have protected the smiths from Spaniards' demands and also allowed for collection of the royal fifth. But the plan did not work, either because Spanish demands continued or because the smiths wanted to maintain their autonomy. Ramos (2010, 127) notes that tapestry weavers were highly mobile, moving from patron to patron. Given that identity was often malleable and became more so over time, it is likely that artisans were often required to weigh the benefits of maintaining their status as *indios*, with which they would have access to certain resources, against the mobility that might be allowed if they could be identified as mestizos, *mulatos*, or *españoles* (Tavárez 2009).

Conclusion

Although I (like the other contributors to this volume) am interested primarily in visual artists, a consideration of the craft professions more broadly in the sixteenth century helps the primary issues related to Indigenous artists' rights come to the fore. This also leads to a deeper consideration of what sorts of rights were possible for negotiation at the time. Across the board, the most common challenge for craftsmen was being obliged to do "personal service" labor: work that was often perilous and arduous, as well as badly paid, if at all. The fight for freedom from this service was a natural successor to the pre-1550 struggles for life and liberty. Secondarily, artisans strove to be paid in money in order to be able to dispose of their incomes as they chose and fulfill tribute obligations directly. Such payments (as well as freedom from damaging physical labor) would have allowed artists, such as the anonymous tlacuilo of the Xiuhpohualli of Tenochtitlan Codex who built his own house, to gain financial security. Ultimately we see that artisans had a high opinion of themselves and sorely *wanted* to ply their trades. Underlying that sentiment may have been a desire to exercise creative freedom, but that was never stated outright. Instead, they focused on more concrete goals, becoming activists in their own defense. Despite the challenges they faced, we see artists such as featherworker Jusepe Cuirixan gaining a license to perform his work in 1592, then again in 1606 (Martínez Baracs 1999, 167). Combined with the cases of painters such as Marcos Cipac and Andrés Sánchez Gallque, both of whom had decades-long careers, Cuirixan's case reveals that professional careers were indeed possible, if difficult. Indigenous artisans

continued to suffer the limitations of being classed as tribute-payers under Spanish rule. But they cultivated resources and artisanal neighborhoods on the basis of ancestral ties and thus were able to benefit from *indio* status as well as more European-informed craft identities. It may be that artisans, in confronting a series of challenges and advocating for a specific constellation of rights, contributed more than we have recognized to the legacies of human, and especially Indigenous, rights that we value today.

Acknowledgments

The author thanks Max Deardorff and Margarita Vargas-Betancourt for their helpful feedback on this essay.

Notes

1. Although women were increasingly restricted from guild membership in sixteenth-century Europe, they continued to form part of guilds as journeywomen, and often dominated the textile trades, especially in regard to spinning (Farr 2000, 37–41; Nutting 2018).

2. While the term *kamayuq* is sometimes translated as "master," it was likely meant more as a specialist akin to a journeyman since colonial Quechua dictionaries use the word *yachachik* for "master artisan" (DeLeonardis 2011, 448).

3. An exceptional case is that of the Mexico City silkweavers' guild, which was founded directly on the ordinances from Granada, dated 1526 (Barrio Lorenzot and Estrada 1920, 44).

4. The illegal enslavement of Indians continued well into the nineteenth century, especially in areas peripheral to the viceregal centers (Reséndez 2016).

5. This decree is especially notable since in Europe the goldsmithing trade was one of the most exclusive (Farr 2000, 249).

6. The work's compiler is unknown. It only carries the name of Juan Bautista because the ream of paper was originally meant for the deputy Juan Bautista to record tribute collected from "vagabond" Indians in Mexico City, a task that he was commissioned to undertake by Viceroy Martín Enríquez de Almanza in 1574. For some reason the folder was left unused and then employed by its anonymous author beginning in 1582 (Reyes García 2001, 21).

7. Citations are for the Spanish translation, which is numbered as folios to match the original Nahuatl. I also rely on Reyes García's (2001, 29–40) interpretation of the passages about tribute.

8. Criminals and debtors were commonly forced to work in trades as part of their sentences (Zavala 1984–85, 2:219–22).

9. For further perspectives on the modes of resistance offered in the *Anales*, see also Stear 2014.

10. The bitter impossibility of rejecting tribute outright is reflected in the phrase Reyes García (2001, fol. 36r) chose as the title of his edition of the *Anales*, which was stated in

the context of a gathering to record the tribute collected in October 1564: "¿Cómo te confundes? ¿Acaso no somos conquistados?" (Why do you confuse yourself? Have we not been conquered?)

Reference List

Alvira, Rafael, and Alfredo Cruz. 1997. "The Controversy between Las Casas and Sepúlveda at Valladolid." In *Hispanic Philosophy in the Age of Discovery*, edited by Kevin White, 88–110. Washington, DC: Catholic University of America Press.

Anders, Ferdinand. 1970. "Las artes menores." *Artes de México* 137 (17): 4–45.

Arias, Santa. 2006. "La visión nahua ante la conquista espiritual: Milenarismo e hibridez en los *Anales de Juan Bautista*." In *Ensayos de cultura virreinal latinoamericana*, edited by Takahiro Kato, Luis Millones, and U. Juan Zevallos Aguilar, 33–51. Lima: Fondo Editorial de la Facultad de Ciencias Sociales, Universidad Nacional Mayor de San Marcos.

Baber, R. Jovita. 2009. "Categories, Self-Representation and the Construction of the *Indios*." *Journal of Spanish Cultural Studies* 10 (1): 27–41.

Barrio Lorenzot, Juan Francisco del, and Genaro Estrada. 1920. *Ordenanzas de gremios de la Nueva España*. Mexico City: Secretaría de Gobernación, Dirección de Talleres Gráficos.

Brumfiel, Elizabeth M. 1987. "Elite and Utilitarian Crafts in the Aztec State." In *Specialization, Exchange, and Social Complexity*, edited by Elizabeth M. Brumfiel and Timothy K. Earle, 102–18. Cambridge: Cambridge University Press.

Carrera Stampa, Manuel. 1954. *Los gremios mexicanos: La organización gremial en Nueva España, 1521–1861*. Mexico City: Edición y Distribución Ibero Americana de Publicaciones.

Cherry, Peter. 1996. "Artistic Training in Seville." In *Velázquez in Seville: National Gallery of Scotland, MCMXCVI*, edited by Michael Clarke, 66–75. New Haven, CT: Yale University Press.

Códice Franciscano, Siglo XVI: Informe de la Provincia del Santo Evangelio al visitador Lic. Juan de Ovando. Informe de la Provincia de Guadalajara al mismo. Cartas de Religiosos, 1533–1569. 1941. Mexico City: Chávez Hayhoe.

Cowans, Jon. 2003. *Early Modern Spain: A Documentary History*. Philadelphia: University of Pennsylvania Press.

DeLeonardis, Lisa. 2011. "Itinerant Experts, Alternative Harvests: Kamayuq in the Service of Qhapaq and Crown." *Ethnohistory* 58 (3): 445–89.

Dibble, Charles E., ed. 1963. *Historia de la nación mexicana*. Madrid: J. Porrúa Turanzas.

Durand-Forest, Jacqueline de. 1994. "The Aztec Craftsman and the Economy." In *Chipping Away on Earth: Studies in Prehispanic and Colonial Mexico in Honor of Arthur J. O. Anderson and Charles E. Dibble*, edited by Eloise Quiñones Keber, 173–76. Lancaster, CA: Labyrinthos.

Estrada de Gerlero, Elena Isabel. 2004. "Jesus at the Age of Twelve and Weeping Virgin." In *Painting a New World Mexican Art and Life, 1521–1821*, edited by Donna Pierce, Rogelio Ruiz Gomar, and Clara Bargellini, 102–5. Denver: Denver Art Museum.

———. 2015. "The *Amantecayotl*, Transfigured Light." In Russo, Wolf, and Fane 2015, 298–309.

Estrada de Gerlero, Elena Isabel, and Marita Martínez del Río de Redo. 1990. "The Mass of Saint Gregory." In *Mexico: Splendors of Thirty Centuries*, by the Metropolitan Museum of Art, 258–60. New York: Metropolitan Museum of Art.

"Exp. sobre indios oficiales sastres, etc. que trabajen libremente." 1616. Archivo Regional de Amazonas, Chachapoyas. Exp. 379, December 15, 1616, thirteen folios.

Farr, James R. 2000. *Artisans in Europe, 1300–1914*. Cambridge: Cambridge University Press.

Feinman, Gary M. 2001. "Crafts and Craft Specialization." In *Archaeology of Ancient Mexico and Central America: An Encyclopedia*, edited by Susan Toby Evans and David L. Webster, 191–95. New York: Garland.

Friede, Juan, and Benjamin Keen. 1971. *Bartolomé de Las Casas in History: Toward an Understanding of the Man and His Work*. DeKalb: Northern Illinois University Press.

Garzón Pareja, Manuel. 1972. *La industria sedera en España: El arte de la seda de Granada*. Granada: Archivo de la Real Chancillería.

Kagan, Richard L. 2000. "A World without Walls: City and Town in Colonial Spanish America." In *City Walls: The Urban Enceinte in Global Perspective*, edited by James D. Tracy, 117–52. New York: Cambridge University Press.

Las Casas, Bartolomé de. 1967. *Apologética historia sumaria*. Edited by Edmundo O'Gorman. 3rd ed. Mexico City: Universidad Nacional Autónoma de México.

———. 2001. *Brevísima relación de la destrucción de las Indias*. Edited by Olga Camps. Mexico City: Distribuciones Fontamara.

Legnani, Nicole D. 2020. *The Business of Conquest: Empire, Love, and Law in the Atlantic World*. Notre Dame, IN: University of Notre Dame Press.

Levaggi, Abelardo. 2001. "República de Indios y República de Españoles en los reinos de Indias." *Revista de Estudios Histórico-Jurídicos (Sección Historia del Derecho Indiano)* 23:418–28.

Lis, Catharina, Jan Lucassen, and Hugo Soly. 2019. "Craft Guilds in Comparative Perspective: The Northern and Southern Netherlands, a Survey." In *Craft Guilds in the Early Modern Low Countries: Work, Power, and Representation*, edited by Maarten Roy Prak, Catharina Lis, Jan Lucassen, and Hugo Soly, 1–31. New York: Routledge.

Lockhart, James. 1985. "Some Nahua Concepts in Postconquest Guise." *History of European Ideas* 6:465–82.

López Sarrelangue, Delfina Esmeralda. 1965. *La nobleza indígena de Pátzcuaro en la época virreinal*. Mexico City: Universidad Nacional Autónoma de México, Instituto de Investigaciones Históricas.

MacKay, Ruth. 2006. *"Lazy, Improvident People": Myth and Reality in the Writing of Spanish History*. Ithaca, NY: Cornell University Press.

Mäkinen, Virpi. 2005. "The Franciscan Background of Early Modern Rights Discussion: Rights of Property and Subsistence." In *Moral Philosophy on the Threshold of Modernity*, edited by Jill Kraye and Risto Saarinen, 165–80. Dordrecht: Springer.

Martínez Baracs, Rodrigo. 1999. *La vida michoacana en el siglo XVI: Catálogo de los documentos del siglo XVI del Archivo Histórico de la Ciudad de Pátzcuaro*. Mexico City: Instituto Nacional de Antropología e Historia.

Montagu, Jennifer. 1983. "Velázquez Marginalia: His Slave Juan de Pareja and His Illegitimate Son Antonio." *Burlington Magazine* 125 (968): 683–85.

Mundy, Barbara E. 2015. *The Death of Aztec Tenochtitlan, the Life of Mexico City.* Austin: University of Texas Press.

Nutting, Elizabeth. 2018. "Making a Living in Silk: Women's Work in Islamic and Christian Granada, Spain, 1400–1571." *Journal of Women's History* 30 (1): 12–34.

Paredes Martínez, Carlos S., Víctor Cárdenas Morales, Iraís Piñón Flores, and Trinidad Pulido Solís. 1994. *"Y por mí visto—": Mandamientos, ordenanzas, licencias y otras disposiciones virreinales del siglo XVI.* Mexico City: Centro de Investigaciones y Estudios Superiores en Antropología Social.

Parker, Rozsika. 1986. *The Subversive Stitch: Embroidery and the Making of the Feminine.* London: Women's Press.

Peterson, Jeanette Favrot. 1993. *The Paradise Garden Murals of Malinalco: Utopia and Empire in Sixteenth-Century Mexico.* Austin: University of Texas Press.

———. 2014. *Visualizing Guadalupe: From Black Madonna to Queen of the Americas.* Austin: University of Texas Press.

Quiroz Chueca, Francisco, and Gerardo Quiroz Chueca. 1986. *Las ordenanzas de gremios de Lima (s. XVI–XVIII).* Lima: Artes Diseño Gráfico.

Ramos, Gabriela. 2010. "Los tejidos en la sociedad colonial andina." *Colonial Latin American Review* 29 (1): 115–49.

Rappaport, Joanne. 2012. "'Asi lo paresçe por su aspeto': Physiognomy and the Construction of Difference in Colonial Bogotá." *Hispanic American Historical Review* 91 (4): 601–31.

Reséndez, Andrés. 2016. *The Other Slavery: The Uncovered Story of Indian Enslavement in America.* Boston: Houghton Mifflin Harcourt.

Reyes García, Luis, ed. 2001. *Anales de Juan Bautista: ¿Cómo te confundes? ¿Acaso no somos conquistados?* Mexico City: Centro de Investigaciones y Estudios Superiores en Antropología Social.

Rostworowski de Diez Canseco, María. 1975. "Pescadores, artesanos y mercaderes costeños en el Perú prehispánico." *Revista del Museo Nacional* 41:311–49.

Russo, Alessandra. 2013. "Recomposing the Image: Presents and Absents in the *Mass of Saint Gregory*, Mexico, 1539." In *Synergies in Visual Culture: Bildkulturen im Dialog,* edited by Manuela De Giorgi, Annette Hoffmann, and Nicola Suthor, 465–81. Munich: Wilhelm Fink Verlag.

———. 2014–15. "An Artistic Humanity: New Positions on Art and Freedom in the Context of Iberian Expansion, 1500–1600." *RES: Anthropology and Aesthetics,* 65/66:352–63.

———. 2015. "A Contemporary Art from New Spain." In Russo, Wolf, and Fane 2015, 22–63.

Russo, Alessandra, Gerhard Wolf, and Diana Fane, eds. 2015. *Images Take Flight: Feather Art in Mexico and Europe, 1400–1700.* Florence: Kunsthistorisches Institut in Florenz— Max-Planck-Institut.

Sahagún, Bernardino de. 1577. "Historia general de las cosas de Nueva España." Manuscript, Biblioteca Medicea Laurenziana, Florence. Library of Congress, 2021667837.

Seed, Patricia. 1995. *Ceremonies of Possession in Europe's Conquest of the New World, 1492–1640.* Cambridge: Cambridge University Press.

Stanfield-Mazzi, Maya. 2021. *Clothing the New World Church: Liturgical Textiles of Spanish America, 1520–1820.* Notre Dame, IN: University of Notre Dame Press.

Stear, Ezekiel. 2014. "Voices of the Altepetl: Nahua Epistemologies and Resistance in the

Anales de Juan Bautista." In *Coloniality, Religion, and the Law in the Early Iberian World*, edited by Santa Arias and Raul Marrero-Fente, 51–69. Nashville, TN: Vanderbilt University Press.

Stern, Steve J. 1982. *Peru's Indian Peoples and the Challenge of Spanish Conquest: Huamanga to 1640*. Madison: University of Wisconsin Press.

Tavárez, David. 2009. "Legally Indian: Inquisitorial Readings of Indigenous Identity in New Spain." In *Imperial Subjects: Race and Identity in Colonial Latin America*, edited by Andrew B. Fisher and Matthew D. O'Hara, 81–100. Durham, NC: Duke University Press.

Turmo, Isabel. 1955. *Bordados y bordadores sevillanos (siglos XVI a XVIII)*. Madrid: Laboratorio de Arte, Universidad de Sevilla.

Van Deusen, Nancy E. 2015. *Global Indios: The Indigenous Struggle for Justice in Sixteenth-Century Spain*. Durham, NC: Duke University Press.

Webster, Susan Verdi. 2017. *Lettered Artists and the Languages of Empire: Painters and the Profession in Early Colonial Quito*. Austin: University of Texas Press.

Williams, Robert. 2007. "The Artist as Worker in Sixteenth-Century Italy." In *Taddeo and Federico Zuccaro: Artist-Brothers in Renaissance Rome*, edited by Julian Brooks, 95–103. Los Angeles: J. Paul Getty Museum.

Zavala, Silvio. 1978. *El servicio personal de los indios en el Perú: Extractos del siglo XVI*. Mexico City: El Colegio de México.

———. 1984–85. *El servicio personal de los indios en la Nueva España: 1521–1550*. Vols. 1 and 2. Mexico City: El Colegio de México, Centro de Estudios Históricos.

3

Indigenous Artistic Practice and Collaboration at the Colegio de Santa Cruz in Mexico City (1536–1575)

JENNIFER R. SARACINO

In their foundational essay "Out of the Shadow of Vasari," Barbara E. Mundy and Aaron M. Hyman (2015, 287, 297) discuss how Eurocentric conceptions of the craftsperson and artist might be altogether inappropriate for how colonial Latin American creators saw themselves. To help rectify this historiographical oversight, the authors call for art historians to recast the notions of artist and artwork within their localized social circumstances. This essay addresses both issues, that is, the social circumstances that informed artistic production and the terminology we use to describe and understand the artist in early colonial Mexico City. For this analysis, I focus on the Colegio de Santa Cruz, the first institution of higher education established by Franciscan friars for sons of Indigenous elites, as a site of creative production in early colonial Mexico City.

The Colegio, which was founded in 1536, provides a fitting case study for a consideration of how social practices informed artistic production. The Colegio bore striking similarities to the pre-Hispanic model of the *calmecac*, the Mexica center of intellectual and artistic learning and production (Koboyashi 1974).[1] Because of the opportunities it provided for Indigenous youths, the Colegio functioned as a vital site of Indigenous artistic and literary production throughout the sixteenth century. The linkages between education, literacy, and painting are the subject of Susan Verdi Webster's (2017) substantive work on Indigenous painters in early colonial Quito. Webster's study reveals how Indigenous artists in Quito utilized multiple linguistic and pictorial literacies to negotiate their upward social mobility and forge the visual and linguistic discourses of their milieu. Webster's work builds on Joanne Rappaport and Tom Cummins's *Beyond the Lettered City* (2012,

5), which argues that "Literacy . . . comprise[d] a complex constellation of channels of expression, both visual and alphabetic, which functioned in the colonial Andean world within an ideological system that saw the two as inextricably interconnected." This essay explores similar themes but in early colonial Mexico City, where the Indigenous artists of the Colegio de Santa Cruz similarly contributed to both visual and linguistic production.

In this essay, I analyze aspects of three well-known documents produced by Indigenous artists at the Colegio—the Florentine Codex, the Badianus Herbal, and the Uppsala Map. Through this analysis, this essay offers three new points of consideration in our understanding of artistic practice at the Colegio. First, I propose that because of the continuities between the calmecac and the Colegio, the Colegio not only provided viable opportunities for Indigenous actors to produce knowledge and cultural content in the early colonial period but also facilitated a transformation of the conceptual scope of artistic production. That is, the Colegio afforded opportunities in visual production to those not traditionally understood as artists and fostered an environment that emphasized collaborative artistic production. Second, I argue for a more expansive and inclusive consideration of those who participated in artistic production. Studies regarding the early colonial Indigenous artist and artistic subjectivity in central Mexico often focus on the pre-Hispanic figure of the *tlacuilo* (pl. *tlacuiloque*), meaning "one who writes or paints," the two actions notably being one and the same in the Nahuatl language.[2] However, this essay proposes that by solely considering the tlacuilo as the primary correlate to the early colonial Indigenous artist, we limit the contours of artistic practice and practitioners as they were understood in Nahua culture and society. These Indigenous actors' fluency in multiple visual and linguistic traditions gained them professional opportunities as instructors at the Colegio. In these leadership roles, Nahua scholars both contributed to creative production and created notation for Indigenous languages, forging an indelible legacy of cultural and linguistic preservation (Garone Gravier 2013). For my final point, I argue that these unique skill sets gained them access to administrative titles and entrepreneurial activities beyond the Colegio and Franciscan networks of viceregal New Spain. Ultimately, through its focus on the Colegio, this essay contends that what we might call art-making involved many more individuals of diverse social backgrounds than has been traditionally acknowledged, and that the act of art-making itself at the Colegio provided undeniable opportunities for upward social mobility.

The Foundation of the Colegio de Santa Cruz

From the moment of Spain's conquest of the Aztec capital Tenochtitlan, the Spanish Crown considered it its duty to convert the pagan souls of the Indigenous people to Christianity. The Crown initially chose the Franciscan order as its principal religious emissary to New Spain. To communicate effectively with the natives, some of the first friars learned Nahuatl and other Indigenous languages. To hasten the process of conversion, the friars, supported by the Spanish Crown, established various schools (*escuelas*) for native children. Rather than drawing solely on European models, however, the Franciscans dovetailed European and Indigenous modes of education to create spaces that fostered Indigenous participation and innovation in the formation of early colonial linguistic and visual discourses.

The first Franciscans (Pedro de Gante, Juan de Tecto, and Juan de Aora) learned Nahuatl and taught select pupils in Texcoco as early as 1523 (Mathes 1985, 6). Gante opened the first escuela for Indigenous nobles, San José de Belén de los Naturales, at the Convento de San Francisco de México in 1527 (see chapter 2). In their curricular offerings, the schools provided a blend of primary, secondary, and technical education. In these escuelas, Indigenous students learned how to read and write. They also learned the catechism, as well as various mechanical arts such as carpentry, masonry, and painting (Lepage 2007, 48–49; Webster 2017, 19; Motolinía 1951, 299). The acquisition of these skills led missionaries to solicit the labor of Indigenous artists in the fabrication of religious art, such as altarpieces and murals that lined the church nave, for the many churches and missions that proliferated in early colonial Mexico.

The viceregal authorities' observations of the Indigenous students' academic performance and artistic creations galvanized them to establish *colegios*, centers of advanced education designed for those who had graduated from the escuelas (Nicolau d'Olwer 1987, 14). The rudimentary Franciscan education at the escuelas may have begun as early as age six and lasted until the age of twelve, whereupon exceptional students advanced to the colegios for three more years, concluding their education at about the age of fifteen (Lepage 2007, 53; Mathes 1985, 23). The cultural foundations and expectations that were forged within this initial monastic educational environment would have lasting effects on the trajectory of knowledge production and artistic culture in New Spain.[3]

Viceregal authorities founded the Colegio de Santa Cruz in 1536 in Tlatelolco, a separate city on the island adjacent to and just north of Mexico-Tenochtitlan. The project was supported by New Spain's most influential

leaders: Sebastián Ramírez de Fuenleal, bishop of Santo Domingo and president of the Second Audiencia; Juan de Zumárraga, first bishop of Mexico; and Antonio de Mendoza, the first viceroy. Through the foundation of the Colegio, they sought to create an institution of higher education for the continuing advancement of their star pupils and possibly, as some have argued, to create a class of Indigenous clergymen, something that the Crown would later forbid (Koboyashi 1974).

In their establishment of the school, its founders brought their own humanistic training and background to bear when designing the curriculum (León-Portilla 2002, 97). The educators at the Colegio implemented a three-year course of study after the model of a traditional Franciscan seminary. They taught the trivium of grammar, rhetoric, and logic; and the quadrivium of arithmetic, geometry, astronomy, and music. They also taught reading, writing, philosophy, and Latin (Mathes 1985, 15, 23; Baudot 1995, 113).

However, the Colegio de Santa Cruz also reflected the imprint of precontact patterns of education, particularly in its daily schedules for its pupils. Bernardino de Sahagún (1959–82, 6:209, 6:211) and his informants described the pre-Hispanic calmecac as a place "to be penitent, to live cleanly, to live peacefully, to live chastely, to abstain from vice and filth" and also "a house of penance," indicating that they saw close parallels between the calmecac and the monastery. The calmecac's administrators ensured a strict daily regimen. The young students began their daily chores early in the morning. They would break for prayer and perform the proper penitence to deities. They were required to clean the temples and retrieve maguey tips from the mountains for ritual self-sacrifice (Koboyashi 1974, 79). Their education taught them to be respectful members of society who were dedicated to service to the community, devoted to their deities, and skilled in traditional artistic and cultural practices.

The specificity of the subjects said to have been taught at the calmecac suggests it had an established curriculum. Students studied poetry, rhetoric, and oration, and memorized the divine songs. They learned the art of reading and writing in the sacred books, or codices (Koboyashi 1974, 80–88). The pre-Hispanic codices contained information regarding the calendar, astronomy, cosmology, wars, and history. The books also recorded the days and feasts of the year, dreams, omens, and auguries (Boone 2005, 11). The *tlamatinime* (sing. *tlamatini*, "a wise person, sage, scholar") administered instruction at the calmecac and possessed a wide array of social functions and responsibilities, including serving as priests, astronomers, and diviners (Karttunen 1992, 281; León-Portilla 1990, 20).[4] The breadth of the instruction instilled by the tlamatinime ensured the proper integration of students into

the community, the proliferation of a moral and ethical code, and the continuation of the specialized and esoteric central Mexican pictorial tradition learned by a select few (León-Portilla 1990, 134).

Georges Baudot (1995, 106) has argued that the Franciscans based the model of the educational system established at the Colegio de Santa Cruz in part on the organization of the calmecac to create cultural continuity and facilitate the conversion of native noble students. Various similarities abound between the two institutions. First, the tlamatini was much akin to a Franciscan friar in leading the calmecac in religious, educational, and administrative affairs. Like the Franciscans, the tlamatinime of the calmecac advocated asceticism and denial of worldly pleasures (Roest 2000). The Franciscans also imitated the pre-Hispanic tradition of favoring children of the nobility for admittance. The two institutions mandated a monastic lifestyle that called for constant prayer, devotion, and meditation.

In addition to these similarities, the administrators of the Colegio de Santa Cruz also adopted a system of graduated authority described in the Florentine Codex as an aspect of the calmecac. In this system, if a youth modeled exemplary behavior, then he would become a "ruler of youths" (*telpochtlato*), governing and correcting his peers. The administrators of the Colegio de Santa Cruz continued this practice, promoting the most successful Indigenous pupils of the first generation to faculty members of the school after they completed their training. Sahagún and his team note a continuity from the pre-Hispanic to early colonial period in that Indigenous people who proved to be exemplars of society would graduate to more prestigious positions of authority, even outside of the calmecac or Colegio. For example, Indigenous individuals in good standing could go on to become *alguaciles*, or constables, in local communities of New Spain.[5]

In its adaptation of aspects of Indigenous cultural traditions, the Colegio de Santa Cruz also fostered continuities with pre-Hispanic scribal culture (León-Portilla 2003, 104; Magaloni Kerpel 2014; Peterson 2003). Tlacuiloque or their descendants likely matriculated into the Colegio de Santa Cruz because tlacuiloque were elevated members of Indigenous society whose progeny would have been handpicked to enter the Colegio. However, Eurocentric notions of artist and artistry might be inhibiting our recognition of other members of Indigenous society who participated in what we designate as artistic culture or practice at the Colegio de Santa Cruz. To expand our understanding of who might have participated in artistic production and how it was conceptualized in Nahua culture, I discuss three different pictorial documents produced at the Colegio during the sixteenth century. Each sheds light on the nuances and scope of artistic culture and practice in Mexico City.

The Florentine Codex

A three-volume, twelve-book cultural encyclopedia documenting Nahua cultural customs and beliefs, the *General History of the Things of New Spain* (widely known as the Florentine Codex) is a product of efforts spearheaded by Fray Bernardino de Sahagún but completed with the assistance of an extensive network of Indigenous informants, translators, scribes, and artists. Each page of the manuscript generally contains two columns of text—one in Spanish, and one in Nahuatl—and the entire work contains more than two thousand images. Although the images are a foundational source of study for artistic practice in sixteenth-century Mexico City, here I focus instead on the written text, specifically textual descriptions provided in book 10, "The People." This book describes a number of occupations and roles enacted by members of Indigenous society. For example, the fifth chapter within the book describes honored nobles, and the ninth chapter discusses sorcerers and magicians. By analyzing excerpts from chapter 8, which describes "ways of gaining a livelihood" (Sahagún 1959–82, 10:27), I argue for a more expansive consideration of those traditionally involved in the art-making process and the moral, intellectual, and social implications of engaging in such practice. This, in turn, will refine our understanding of how the Colegio became such a pivotal center of artistic innovation and production as well as social mobility for its Indigenous constituents.

The process of composing the Florentine Codex began in 1558, when Provincial Francisco de Toral charged Sahagún to investigate and document Indigenous culture (Terraciano 2019, 6). The principal aim of the project was to document pre-Hispanic religious beliefs so that colonial authorities could more easily detect and halt customs and beliefs they deemed pagan. Fortunately for us, a detailed description of the team's working process was included in the compilation of the volumes. For the research, Sahagún and his team of Indigenous students, who spoke Nahuatl, Spanish, and Latin, embarked on a series of sojourns throughout New Spain to question the elders of Indigenous society (likely tlamatinime) and collect information regarding their pre-Hispanic customs and daily life. According to Sahagún, he first made an outline of topics to be discussed for the project. Then he and his team conversed with as many as ten to twelve leading elders about the topics. Many of the Indigenous elders he questioned answered in images that the trilingual students then interpreted and translated, writing their explanations at the bottom of the initial images (Sahagún 1959–82, intro.:54). The Florentine Codex went through many stages of revision. Sahagún, after transcribing the oral testimonies of the Indigenous elders, often asked for added

input and revision from other Indigenous people in different locations. Thus, the students trained at the Colegio de Santa Cruz served as indispensable mediators from the outset of the project.

Both historical sources and modern connoisseurship point to the fact that the illustrations within the Florentine Codex were created by a team of Indigenous artists (Peterson 2003; Magaloni Kerpel 2019). The prologue to book 2 names the *gramáticos principales* (principal grammarians) who assisted in writing the twelve books: Antonio Valeriano, Alonso Bejarano, Martín Jacobita, and Pedro de San Buenaventura (Magaloni Kerpel 2019, 152). Using careful formal analysis of the illustrations, Diana Magaloni Kerpel has identified twenty-two Nahua artists, or tlacuiloque, who participated in drafting the pictorial content of the Florentine Codex. Furthermore, she has posited that this group of twenty-two artists was led by four master painters, set apart from the others by the "conceptual sophistication of their paintings and their excellent draftsmanship." She suggests that the four masters may very well have been the four grammarians named by Sahagún (Magaloni Kerpel 2019, 152). The collaborative nature of the project, combined with Magaloni Kerpel's hypothesis of a hierarchical structure of practice, is an important and characteristic feature of visual documents produced at the Colegio, a point I return to with the Uppsala Map. That the Indigenous grammarians who helped Sahagún transcribe the Florentine Codex would also have been master painters makes perfect sense given the highly intellectualized nature of image-making in Nahua culture.

To understand how intimately intertwined painting and intellectual culture were in pre-Hispanic Tenochtitlan, we must return to the way Nahua practitioners described the process themselves. The Florentine Codex provides a great opportunity to plumb the social dimensions of art-making since it devotes several chapters in book 10 to this topic. In Arthur J. O. Anderson and Charles E. Dibble's oft-cited English translation of the description of the tlacuilo, the Florentine Codex notes: "The scribe: writings, ink [are] his special skills. [He is] a craftsman, an artist, a user of charcoal, a drawer with charcoal; a painter who dissolves colors, grinds pigments, uses colors" (Sahagún 1959–82, 10:28). It is worth noting that the first named skill of the tlacuilo is writing, although the scribe thereafter is described as a craftsman. The translation sets up an equivalency between literacy and craft production that was not typical in early modern Spain, where language arts stood apart from visual arts and held a higher position in society (Mignolo 1995, 39). To further complicate matters, the Spanish description of the tlacuilo from the original manuscript describes the tlacuilo as a painter, not a scribe, and never describes the painter's skills as writing but rather refers to an ability "to

draw images with charcoal" or "to grind and mix pigments well."[6] The word "craftsman," or *artesano* or *oficial* in Spanish, is never used.

Anderson and Dibble's use of "scribe" likely came from their translation of tlacuilo. This word is a preterit agentive of the verb *tlacuiloa*, which in turn derives from *cui*, meaning to inscribe (Karttunen 1992, 97). Their term "writings" comes from the Nahuatl *in tlilli, in tlapalli*—a *difrasismo*, or grammatical construction of two separate words that together metaphorically refer to one concept. Tlilli refers to a black contour, and tlapalli to painted ink (Magaloni Kerpel 2012; 2014, 18). Together, these two terms metaphorically refer to Aztec pictographic manuscripts (Boone 2000), rather than to "writings," a point to which I will return later.[7]

Based on the Florentine Codex transcriptions, we can see there is a conceptual slippage within Spanish and English translations of tlacuilo, referred to indiscriminately as either painter or scribe, due in part to the translators' focus on either the manual or intellectual requirements of the position. The tlacuiloque learned the codified language of day signs, number signs, deities, and symbols that conveyed specific words or ideas. Tlacuiloque in training acquired profound knowledge of creation mythology, genealogy, and community history at the calmecac, so they could represent these values on paper according to strict iconographic conventions. Thus, as the Florentine Codex makes clear, the tlacuilo is the most obvious example of a figure in pre-Hispanic society who engaged in artistic activities but who, by virtue of the training necessary to fulfill this occupation, might simultaneously be thought of as a person of letters.[8] This issue has often been dealt with in contemporary scholarship by translating tlacuilo as the hyphenated painter-writer (Terraciano 2019, 4). The reductive nature of translation may explain some of the limits in our understanding of Indigenous graphic culture. By moving away from the English analogs and returning to the Nahuatl, we can regain an appreciation for aspects of the role that merit our attention. So, rather than thinking of the tlacuilo as a craftsman, a word that does not carry the same social import in English or Spanish, we can stay focused on the fact that tlacuiloque likely operated in a higher echelon of Aztec society because of their profound knowledge of cultural history, tradition, and cosmology.

Additionally, it is important to highlight that the tlacuiloque figured into a larger intellectual class of people involved in artistic creation, the *toltecah* (sing. *toltecatl*). The toltecah traced their knowledge and abilities to their Toltec ancestors, hence the conceptualization of the tlacuiloque as part of the toltecah, a word that referred both to "someone from Tula" and to a particular class of elite artisans (Karttunen 1992, 244; Peterson 2003, 226). The Florentine Codex describes the toltecah in books 9, 10, and 11. The toltecah

were known not merely for their specialized artistic skills and capabilities, however, but also for their moral character. Jeanette Favrot Peterson (2003, 237) describes the toltecah, the ancestors of the Mexica, as skilled in their manual dexterity and with a "wisdom and artistic superiority . . . [that] were also imbued with the highest moral character." The toltecah passed down not only scribal arts, but also an immense breadth of cultural, historical, and divinatory knowledge.

Moreover, toltecah as a term is much broader in scope than simply crafts-person; it also encompasses various carriers of wisdom, including the tlama-tinime. The knowledge of the tlamatinime extended to several arenas, and in Mexica society, there was important sociopolitical currency afforded to those with such a breadth of knowledge (Boone 2000, 24–27). They served as members of the elite, priestly class, whose responsibilities entailed guid-ing commoners on numerous practical issues including auspicious days on which to give birth or to harvest. Members of the tlamatinime even served as physicians, whose knowledge was obtained by observation of their sur-roundings and repeated trials of remedies, a point I will return to in the next section (Boone 2005, 15–19). Their knowledge guaranteed them important positions at the calmecac, where they taught the tlacuiloque the cultural, cosmological, and historical knowledge encoded in the graphic writing sys-tem. In the book 10 entry on the tlamatinime, the Florentine Codex notes, "tlile, tlapale, amuxoa, amoxe, tlilli, tlapalli" (Sahagún 1959–82, 10:29), liter-ally: "he/she has black ink, has red ink; uses books, has books; the black ink, the red ink." Thus, what unites the two roles of tlacuilo and tlamatini in Nahua culture is their association with the painted manuscripts and the knowledge they possess to either create, understand, or possess them.[9] The larger term (toltecah) suggests both that the tlacuiloque participated in intel-lectual endeavors beyond that of painter-scribes, and that other intellectuals (tlamatinime) were thought of as engaged in the same artistic work as the tlacuiloque.

Because of their role in teaching the tlacuiloque, and as members of the larger toltecah class, the tlamatinime must be thought of as among those who contributed to and participated in artistic culture. The tlamatinime es-sentially maintained the status quo in Nahua society by serving as sage lead-ers and teaching cultural traditions to subsequent generations. The multiple responsibilities associated with the tlamatinime underscore the intertwined nature of intellectual knowledge (history and science), religion, and power in Nahua society. Moreover, the continuities facilitated by the role of the tlamatini can help us understand how the Colegio became such a pivotal site of artistic creation and innovation in the colonial period.

Elizabeth Hill Boone (2005, 11) has deftly outlined the various responsibilities and facets of knowledge pertaining to the tlamatinime and discussed the importance of the calmecac as a site where their multiple responsibilities converged. As sages and scholars, the tlamatinime were instrumental in the education of future generations, which took place at the calmecac. The tlacuiloque in training possessed the privileged opportunity to attend the calmecac and be taught by the revered tlamatinime, a formula that translated well to the intellectual environment of the Colegio de Santa Cruz. It is important to note then that pre-Hispanic intellectual, cultural, and artistic traditions were remembered and passed on at the Colegio de Santa Cruz not only by descendants of the tlacuiloque, but also by those of the tlamatinime, fostered by an institution and curriculum that largely mirrored aspects of the calmecac. It is clear from the Florentine Codex's descriptions of the artistic process (and of its practitioners from the tlamatinime to the tlacuiloque) that pre-Hispanic artistic structures and culture mapped onto the Colegio quite fluidly and fostered the florescence of other artistic productions in the sixteenth century. In addition, these descriptions tell us that although the tlacuiloque were principally in charge of scribal duties in Nahua society, this necessitated profound cultural knowledge and education, imparted on the tlacuiloque by other members of society, who also thereby largely contributed to artistic creation. By analyzing the textual descriptions in the Florentine Codex, we can expand our conceptions of who might have been involved in artistic production in Nahua tradition as well as the scope of what it constituted. In the next section, I turn to an analysis of the Badianus Herbal as a lens through which to continue our reconsideration of the diversity of Indigenous practitioners who contributed to artistic production and the creative process at the Colegio.

The Badianus Herbal

Spaniards understood the power of Indigenous medicine almost from the moment they entered the Aztec Empire. Letters to the king indicate that Hernán Cortés and his men received medical attention from Tlaxcalans after La Noche Triste (the Sad Night), when the Mexica drove Cortés and his men out of Tenochtitlan (Cortés 2001, 143). When the friars came to New Spain, they also quickly learned that the Indigenous people valued the knowledge of healing and medicine. The native population of early colonial Mexico City faced disastrous episodes of epidemic disease after the Spanish arrival, and these experiences in part explain the friars' keen interest in integrating the instruction of native medicine into the standard curriculum at the Colegio

de Santa Cruz. Gerónimo de Mendieta, a Franciscan working in New Spain who penned a history of evangelization in the Americas, wrote that after the major epidemic of 1545, the faculty created courses in Indigenous medicine (Cruz and Badiano 1964, 312).

In 1552, Indigenous authors Martín de la Cruz and Juan Badiano (Badianus in Latin) collaborated to create an illustrated herbal, the *Libellus de Medicinalibus Indorum Herbis* (i.e., the Badianus Herbal). The manuscript documented Indigenous plants and pharmacopoeia with Nahuatl and Latin alphabetic text and illustrations. Cruz, a physician affiliated with the Colegio de Santa Cruz, wrote the herbal in its original Nahuatl. He had trained as a physician during the pre-Hispanic period and was "of an advanced age" by 1552 (Gimmel 2008, 172). Badiano, also an instructor at the Colegio, translated the Nahuatl into Latin (León-Portilla 2002, 123). An early student of the Colegio, Badiano demonstrated such aptitude with his mastery of Latin that he became a "reader of Latin" at the Colegio. There is no definite record of who rendered the images that accompany the text (Fernández 1991, 104). Both men hailed from the nearby village of Xochimilco, a place with a rich agricultural history where the pre-Hispanic *chinampas* (raised fields) and irrigation canals still exist. Historian of medicine Henry Sigerist proposed that Bernardino de Sahagún and his work with native physicians inspired the production of the Badianus Herbal (Trueblood 1935, x). While no primary source written by the authors can prove this connection, it is possible that the authors of the herbal worked at the Colegio at the same time as Sahagún and his team.

The Colegio friars most likely familiarized the Indigenous authors with the format of a typical European herbal. In western Europe, the format of the herbal derived from the materia medica, or early herbal medical manuals. First produced in classical antiquity, herbals were revised, translated, and copied throughout the medieval period (Hassig 1989, 36). Presented on European paper in the form of a bound book, the Badianus Herbal is divided into thirteen parts with sixty-three folios of texts and drawings (Trueblood 1935, 12). Each section pertains to a particular part of the body and the plants capable of healing it, beginning with the head and concluding with the feet (Hassig 1989, 32). Some argue that this organization stems from the philosophy underlying the Aztec cosmovision and the body's relation to the outside world (Aranda et al. 2003, 17; López Austin 1988, 3).

The herbal contains 184 illustrations of native plant life. Each page is laid out simply, with an orange border marking a one-inch margin on all sides (figure 3.1). The plant illustrations are centered in the top half of the page, with their Nahuatl names, spelled in the Roman alphabet, written above

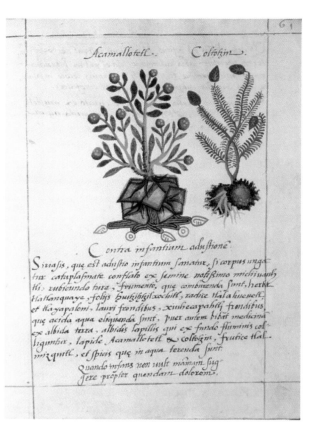

Figure 3.1. The *acamal-lotetl* plant and roots, folio 61r from the Codex Badianus, Martín de la Cruz and Juan Badiano's *Libellus de medicinalibus indorum herbis,* Mexico, compiled 1552. Ink on paper. 15.5 × 20 cm. Códice Badiano, Biblioteca Nacional de Antropología e Historia, Dr. Eusebio Dávalos Hurtado. Reproduction authorized by the Instituto Nacional de Antropología e Historia.

the illustrations in red script. The accompanying descriptions of the plants are written in Latin beneath the illustrations. The Latin text describes each plant's healing benefits, then offers a recipe for its use in a medicinal compound and directions for its application. Many of the Nahuatl words occur here for the first time in Spanish and Nahuatl written history and bear no precedent in other sixteenth-century Nahuatl-Latin texts, including the first Nahuatl-to-Spanish dictionary, which was composed by Franciscan friar Alonso de Molina shortly after the creation of the Badianus Herbal (Trueblood 1935, xiii).

Although the Badianus Herbal may have been modeled after a European format, its authors localized the form by including the Indigenous names for plant species and documenting Indigenous remedies and healing practices. In addition, they incorporated distinctly pre-Hispanic pictorial conventions. The artist used small amounts of shading and contouring to indicate dimensionality, but most of the plants are rendered as conventionalized,

two-dimensional objects. All the plants are drawn to the same general scale, regardless of their actual size. The artist chose to depict the plants as if taken from their natural environment and placed flat on a table for study, displaying the plants' surface and root parts. The format of these illustrations differs markedly from the depictions of plant life in Sahagún's chapter, which depicts plants in their natural environments or incorporated into naturalistic settings. In contrast, the images in the Badianus recall the pre-Hispanic pictorial language that used codified forms and colors to represent ideas or objects. The thick outlines, two-dimensional patterning, and conventionalized representations of objects found in nature are hallmark characteristics of the early colonial style (Robertson 1994, 9–10). Similarly, the symbols and pictographic conventions in certain cases also act as carriers of information that recall pre-Hispanic central Mexican pictorial language.

In many cases throughout the herbal, the pictorial conventions are incorporated into the images to convey additional information not communicated in the written descriptions. The artist innovated the kind of information relayed in the herbal about each plant's relationship to its environment, as well as the specificity of its environment, by incorporating pre-Hispanic pictographic symbols. For example, a root system drawn against a blue background indicated that the plant grew in an aquatic environment like a swamp or pond. In other instances, the presence of a boulder behind the root system indicated that the plant grew in the crevices of a hard, rocky surface. Based on a study of ethnographic sources including Sahagún's Florentine Codex, Molina's *Vocabulario* (1571), Rémi Siméon's *Diccionario de la lengua náhuatl o mexicana* (1885), and toponyms found in other legal documents, Barbara Williams (2006, 18–19) argues that the Nahua distinguished between up to four or five different soil classes. With evidence that the Nahua made such distinctions in their botanical knowledge, one can argue that the stylistic variations in each image account for specific soil types, underscoring the importance of pre-Hispanic convention for the kind of information presented in the depiction of the plant. For example, in figure 3.1, the roots of *acamallotetl* are depicted enclosed within a polygonal shape and anchored into the pre-Hispanic representation of water. This image has been interpreted as a rock submerged in water with the roots growing in its crevices, perhaps referring to the crystallization or mineralization of the roots of the plant that resulted from its complete submersion in water over time (Aranda et al. 2003, 15).

Returning to the authors themselves, we know that Cruz was trained as a physician prior to the Spanish invasion; thus, it merits returning to how physicians were trained and perceived in Nahua society. Like the tlacuiloque

and the students of the calmecac, Indigenous physicians held an esteemed position within pre-Hispanic society and, as has been established, were regarded as members of the tlamatinime. Certain districts with abundant herb gardens—including Tenochtitlan, Coyoacan, Texcoco, and Huaxtepec—became great centers of medical learning. The lords of each district acted as patrons for these healers and appointed them to administer remedies to the sick as well as teach apprentices their craft. In the Florentine Codex, the physician is described in Nahuatl as "a curer of people, a restorer . . . a diagnostician, experienced—a knower of herbs, of stones, of trees, of roots" (Sahagún 1959–82, 10:30). Additional reference is made to the types of treatments the physician provides (setting bones, fashioning splints, and creating potions).

The Florentine Codex emphasizes that this knowledge is a result of experience; it is not clear that physicians were ever charged with representing their knowledge graphically (Sahagún 1959–82, 10:30). In fact, that task seems to have been directed to the tlacuilo, who is described in the same chapter as one who "paints, applies color, makes shadows, *draws gardens, paints flowers,* creates work of art" (Sahagún 1959–82, 10:28, emphasis added). It is interesting to note, however, that within book 10, the physician (*ticitl*, pl. *titicih*) is described in the same chapter as both a tlacuilo and a tlamatini. To further complicate matters, the tlamatini is described as a physician no fewer than three times. These confluences and ambiguities suggest that at the very minimum, within Nahua culture these seemingly distinctive professions inhabited the same conceptual category. Cosmographic knowledge, medical knowledge, and artistic knowledge abutted one another closely, and those who attained this knowledge in their profession were widely revered.

That the expectations and requirements of knowledge, education, and skill were likely similar among tlacuiloque, tlamatinime, and titicih likely helps explain these practitioners' fluid transition into the Colegio as a site of creative knowledge production in the early colonial period. Another overlap exists in the cosmological aspect of these three occupations. As Debra Hassig (1989, 41–42) notes, "the practice of medicine was inextricably linked to the deities, who were believed to both cause and cure certain diseases." Hassig cites, for example, the god Xipe Totec, who caused skin problems and, after the conquest, ruled over smallpox.

Indigenous physicians were vital sources of medicinal, healing, and plant knowledge for the Spanish in the sixteenth century, in the face of devastating epidemics among the population of Mexico City. After the creation of the Badianus Herbal, the first materia medica of its kind produced in the Americas, the artists of the Florentine Codex documented native plants and remedies for book 11 ("Earthly Things"), reflecting a concern for Indigenous

plant and medical knowledge throughout the sixteenth century as well as the importance of Indigenous healers to creative production at the Colegio. In fact, of all the informants solicited for the creation of the Florentine Codex, only the seven physicians who helped produce, revise, and expand book 11 (pertaining to natural history) are recorded by name (Hassig 1989, 43). In all the Americas, the Badianus Herbal and book 11 of the Florentine Codex remain the earliest known Indigenous-produced pictorial and textual records of native plants, their properties, and remedies. The fact that both were produced at the Colegio de Santa Cruz suggests the existence of an active group of native healers or physicians that contributed to creative production at the Colegio.

The Badianus Herbal is a document whose form was adapted from European models because of the Crown's interest in Indigenous flora and its healing properties, and stemmed from a particular interest in Indigenous medicine due to public health challenges in sixteenth-century Mexico City. It is unclear whether native physicians participated in pictorial production prior to the Spanish conquest, but the epidemics galvanized colonial authorities to adopt courses in Indigenous healing and medicine into the Colegio curriculum and give Indigenous physicians opportunities to participate in artistic production. Thus, the Badianus crystallizes the inception of Indigenous medicine, healing, and their graphic representation in New Spain's early colonial visual culture as well as the incorporation of Indigenous physicians into the Colegio's creative process.

The Uppsala Map

Housed in the library of Uppsala University in Sweden, the Uppsala Map, also widely known as the Map of Santa Cruz for its initial misattribution to Spanish cosmographer Alonso de Santa Cruz (Mundy 2015, 39–42), measures approximately 75 × 114 centimeters and is a hand-painted map of Mexico-Tenochtitlan and the surrounding basin (an average distance of about fifty kilometers from center in all directions) (figure 3.2). The map was relatively unknown to the rest of the world until its publication in the late nineteenth century, and it is also unknown how the map came to be in Sweden. Scholars generally agree that the map originated from the Colegio de Santa Cruz, due to the enlarged size of the monastery relative to the rest of the sites depicted in the urban plan, in keeping with Indigenous-made maps, in which mapmakers enlarged the site of most importance to them, usually their own community (Mundy 1998, 200). In addition, the pronounced influence of European naturalistic representation echoes that

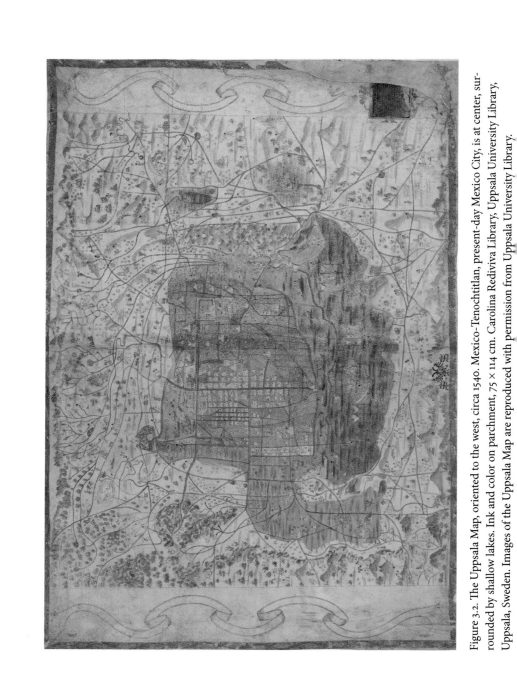

Figure 3.2. The Uppsala Map, oriented to the west, circa 1540. Mexico-Tenochtitlan, present-day Mexico City, is at center, surrounded by shallow lakes. Ink and color on parchment, 75 × 114 cm. Carolina Rediviva Library, Uppsala University Library, Uppsala, Sweden. Images of the Uppsala Map are reproduced with permission from Uppsala University Library.

seen in other visual documents produced at the Colegio, like the Florentine Codex. A cartouche in the lower right-hand corner of the map bears a dedication to Charles V, king of Spain and Holy Roman emperor, from his royal cosmographer, Alonso de Santa Cruz. The cosmographer likely acquired the map from Viceroy Mendoza, an ardent supporter of the Colegio with whom he shared ongoing epistolary communication (León-Portilla and Aguilera Garciá 1986, 34).

The Uppsala Map provides a detailed representation of Mexico-Tenochtitlan's urban plan and central landmarks such as the Plaza Mayor (the main square, known as the Zócalo today), the Casa del Marqués (the residence of Hernán Cortés), and a number of churches and monasteries that are labeled for the viewer. The plan is so accurate that even today, it can be corroborated with an overlay of the city's central historic district and the edifices that are still standing. The map also includes almost two hundred figures of Indigenous people engaged in labor across the landscape, as well as almost two hundred central Mexican-style place glyphs. Additionally, a vast network of roads and waterways stretch weblike across the entirety of the map. The hydrographic detail and transportation networks seem to have been of particular interest to either the map's patron or its makers and, along with the dedicatory cartouche, indicate that the map was likely made with a Spanish audience in mind (López 2014).

The authorship of the Uppsala Map has long been debated. The first attributions pointed to royal cosmographer Santa Cruz, who had the map at one point (as indicated by the dedication) and was responsible for cartographic projects in Spain. The Mexican art historian Manuel Toussaint (1938, 142), however, put an end to that line of thinking when he deduced that since Santa Cruz had never set foot on the soil of New Spain, it was highly unlikely that he would have employed numerous Indigenous pictorial conventions such as the place glyphs and *tecpan* (ruling house) conventions denoting sites of importance. The map's authors, Toussaint argued, must have been Indigenous. Scholars who have followed in his footsteps have unanimously agreed that the mapmakers were Indigenous, and yet no definitive attribution for the map has emerged (Linné 1948, 201).

I concur with previous scholars who have posited that the Uppsala Map must have been produced through an artistic collaboration at the Colegio de Santa Cruz (Linné 1948, 201; Robertson 1994, 162). Like the Florentine Codex and the Badianus Herbal, which both resulted from collaboration among the friars and their Indigenous collaborators, it appears to have been created through a process in which artistic "masters" or skilled experts (in this case a single skilled artist) spearheaded the production and supervised a team of

assistants. Close visual analysis of the Uppsala Map supports this conclusion. The dozens of miniature human figures on the map reveal the work of different artistic hands. For example, in figure 3.3*A*, the artist strove for a naturalistic rendering of the human body. Lines contour pectoral muscles, the pelvic region, shoulders, elbows, and calf muscles. The artist also employed hatch marks to shade and model the figure. This technique was commonly employed by European printmakers of the time, indicating that the artist copied from available prints or books, a common feature of artistic production at the Colegio (Robertson 1994, 41, 45, 156). A second artist rendered figures in a blockier fashion, their bodies devoid of any kind of contrapposto or fluidity (figure 3.3*B*). A third artist consistently represented elongated figures with pointed feet and tapered waists (figure 3.3*C*). The latter two artists' depictions of the human form suggest far less experience working within the European style of representation. This evidence suggests that an artist more accustomed to the naturalistic style of the European tradition likely supervised a team of assistants that collaborated on the project, following the pattern identified by Magaloni Kerpel (2019, 152) for the Florentine Codex.

As we saw with the Florentine Codex and the Badianus Herbal, the friars worked with skilled and knowledgeable Indigenous intellectuals who had extensive experience in their profession (whether tlacuiloque, tlamatinime, or titicih). Thus, this begs the question: what members of colonial Indigenous society might have marshaled such an extensive geographic and hydrographic knowledge of the basin surrounding Mexico-Tenochtitlan and Tlatelolco? To answer this question, it might help to retrace the contours of cartographic production in pre-Hispanic Mexico. Although almost no pre-Hispanic maps exist today, many examples of Indigenous maps made after the conquest have survived. Because these cartographs share pictorial conventions and structural principles unlike those of European maps of the time, scholars generally agree that they exemplify characteristics stemming from a long-established, although widely varied, set of Mesoamerican mapping traditions (Mundy 1998, 183). The format of an Indigenous map was largely dictated by its function; artists selected the cartographic representational strategy that best suited their needs. Indigenous maps generally fall into four main categories: cosmographic maps, cartographic histories (accounts of migration and the founding of settlements inscribed on a representational landscape), celestial maps of the night sky, and terrestrial maps devoid of a historical component (such as maps of cities and cadastral documents like property plans) (Mundy 1998, 187). It is likely that tlacuiloque were charged with creating cosmographic maps or cartographic histories, as these were the sort of documents that would have required profound knowledge of creation

A

B

C

Figure 3.3. Different styles for human figures, the Uppsala Map, circa 1540. *A* shows a relatively naturalistic human body. *B* shows a figure rendered in a blockier fashion. *C* shows a figure elongated with pointed feet and tapered waist. Ink and color on parchment. Carolina Rediviva Library, Uppsala University Library, Uppsala, Sweden. Images of the Uppsala Map are reproduced with permission from Uppsala University Library.

mythology, genealogy, and community history so they could represent these values on paper according to strict iconographic conventions. It seems from the ethnohistorical sources, however, that members of the tlacuiloque were not the exclusive creators of maps.

Although Indigenous scribes were certainly entrusted with the creation of divinatory and religious manuscripts, accounts from the Spanish conquistadors such as Hernán Cortés and Bernal Díaz del Castillo describe wayfinding maps made for them by members of an Indigenous merchant class known as the *pochteca* (see chapter 4) as they set off to further explore Indigenous territory (Díaz del Castillo, García, and Maudslay 1908, 12, 14; Cortés 2001, 94, 340, 344, 349). The Florentine Codex contains passages describing maps made by spies in times of war. In fact, pochteca sometimes assumed wartime responsibilities such as reconnoitering enemy territory. Because of their travel experience through foreign and, sometimes, enemy territories, these merchants made ideal spies. The Florentine Codex even describes pochteca as engaging in battle (Sahagún 1959–82, 9:6). Pochteca played an integral role in collecting, synthesizing, and diffusing geographic knowledge in Indigenous society. Their extensive travel made them valuable to the empire in times of war and prosperity, and these were most likely the individuals Cortés and Díaz de Castillo encountered on their initial forays through Indigenous territory.

Prior to the arrival of the Spanish, pochteca occupied a place in society somewhere between commoners (*macehualtin*) and the nobility (*pipiltin*). Although they were not considered nobles, they were exempt from the tribute and draft labor obligations of the rest of the macehualtin. In addition, their daughters were eligible to marry the *tlatoque* (sing. *tlatoani*), or noble lords (Lockhart 1992, 100). Before the arrival of the Spanish, many pochteca lived in barrios in Tlatelolco, which housed an enormous marketplace where many of the Triple Alliance's long-distance goods and tributes arrived. Sahagún described pochteca as living side by side in adjacent districts of Tlatelolco with other highly regarded craft specialists, like featherworkers, or *amanteca* (Peterson 2003, 238). The Florentine Codex, which we have seen was also produced in Tlatelolco, dedicates an entire volume, book 9, to a description of the unique subculture of the pochteca within Indigenous society. Both Alfredo López Austin (1974, 139–40) and Edward E. Calnek (1974, 189–90) argued that book 9 of the Florentine Codex highlights the perspective of an elite merchant class, and that the testimonies were most likely gathered directly from pochteca who lived in Tlatelolco. Similarly, the mapmakers' enlargement of Tlatelolco, their emphasis on trade networks, and the predominant depiction of burden carriers and merchants in the Uppsala Map

Figure 3.4. *Pochteca*, in the Florentine Codex, Fray Bernardino de Sahagún's *Historia general de las cosas de Nueva España*, fol. 39, vol. 2, bk 9. Mexico, compiled 1545–90. Ink on European paper, 21.2 × 31.0 cm. Ms. Med. Palat. 219 carta 346v, Biblioteca Medicea Laurenziana, Florence. Printed by permission of MiBAC. Any further reproduction by any means is prohibited.

also reflects a Tlatelolco-centric perspective that points toward the likely possibility that the map's artists were affiliated with pochteca.

The visual similarities between the illustrations of pochteca in Sahagún's book 9 and the Uppsala Map also support this assertion. Several illustrations in book 9 depict merchants traveling through the countryside. In one, two pochteca wear simple white knee-length garments knotted over one shoulder (figure 3.4). They are each hunched over with a burden tied to a wooden carrying frame, secured to the forehead with a tumpline. Footprints, the pre-Hispanic convention for roads, mark the path on which the merchants travel. Both merchants carry a large staff in their left hand, while their right grasps their tumpline. It appears that both pochteca (semi-elite merchants) and porters (affiliated with a lower social status) are depicted on the Uppsala Map. The merchants on the Uppsala Map are depicted just like those in the Florentine Codex—with carrying racks, burdens, and, sometimes, staffs—which seems to differentiate them from the common porters. The two human forms in figure 3.5, both from the Uppsala Map, capture this distinction. The porter in figure 3.5A wears a *maxtlatl* (loincloth) and carries a large bundle of what appears to be lumber. The burden is secured to his body by means of a tumpline. In comparison, the pochtecatl in figure 3.5B carries a staff in his or her left hand and leans backward to support a large load using a carrying rack.

A close visual analysis of the Uppsala Map reveals aspects of the working process that resonate with other documents produced at the Colegio. First, the map appears to have been produced by a collaborative team supervised by an experienced draftsperson. Second, as with the Badianus Herbal, the

A B

Figure 3.5. Two merchant figures from the Uppsala Map, circa 1540. *A* shows a figure wearing a *maxtlatl* and carrying a large bundle. The burden is secured to his body by means of the typical Indigenous tumpline carrying method. *B* shows a figure carrying a staff in his or her left hand and leaning backward to support a large load using a carrying rack. Ink and color on parchment. Carolina Rediviva Library, Uppsala University Library, Uppsala, Sweden. Images of the Uppsala Map are reproduced with permission from Uppsala University Library.

map suggests that the friars, Indigenous faculty, and students collaborated with members of Indigenous society whose occupations fell outside the purview of artist, toltecatl, or tlacuilo. In this case, the extensive knowledge of Mexico's hydrography, geography, and roadways suggests collaboration with merchants or traders. Taking into consideration the accounts of Díaz del Castillo and Cortés, we can surmise that native merchants were involved in cartographic production, and so the involvement of pochteca with the map may well have been a carryover from Indigenous tradition.

Conclusion

In this analysis of three significant pictorial documents produced (at least in part) at the Colegio de Santa Cruz, several conclusions emerge. First, it seems that artistic production was a collaborative effort and that the artistic projects were accomplished by teams of individuals supervised by skilled

draftsmen. We see this particularly in the case of the Florentine Codex and the Uppsala Map. Second, it is clear that these pictorial documents drew extensively from Indigenous knowledge and traditions, and that the friars and Indigenous faculty members of the Colegio engaged with many who may have been considered outside of the traditional profession of tlacuilo, or painter-scribe, such as sages, physicians, or merchants. As mentioned at the outset of this essay, however, in the case of the Florentine Codex, we *do* have the rare record of the names of many Indigenous individuals who worked on these projects. In the colonial context of sixteenth-century New Spain, then, what was the social import of working as an "artist"? I conclude by focusing on one specific individual: Antonio Valeriano.

Antonio Valeriano (born c. 1522) was an Indigenous grammarian immortalized in the pages of the Florentine Codex as having served as one of Sahagún's principal assistants. Described by Sahagún (1959–82, intro.:55) as the "principal and wisest one," Valeriano came from Azcapotzalco as a Colegio student, later taught at the Colegio (1566–67), and then became its rector (1568). Valeriano came from an esteemed lineage; he was the great-grandson of the Aztec ruler Axayacatl (Castañeda de la Paz 2013, 167, 275–79, 461). Later, Valeriano became *juez-gobernador* (judge-governor) of Mexico-Tenochtitlan in 1573 and oversaw a major aqueduct-building project to bring fresh water into the city from Chapultepec (Mundy 2019, 129). As we can see, for Valeriano, his entry to the Colegio as a student served as a launchpad for an illustrious career in Mexico City. This might be due in part to his established heritage as a member of Nahua elite, but he was not the only student of the Colegio to go on to an administrative position either at the school or in the viceregal administration. Many of Sahagún's named assistants would also become Colegio faculty members, and two other students would become gobernadores (SilverMoon 2007, 110).

By focusing on the site of the Colegio as a center of artistic and creative production in the sixteenth century, we can see that the collaborations that took place there required the contributions of many people with occupations outside of the traditional scope of artist, craftsperson, or even tlacuilo. Contributing to a project with particular prestige or esteem at the Colegio might have also helped one transcend their status in colonial society. It seems that in the sixteenth century at the Colegio de Santa Cruz, the Indigenous constituents conceived collaboration with the friars as an opportunity for upward social mobility. In the case of Valeriano and others, to contribute to these projects might have meant recognition by viceregal authorities and even the Spanish king, promotion to professor at the Colegio, or even the chance to serve as one of the viceroyalty's Indigenous juez-gobernadores.

To be involved in the highest levels of teaching and creating images in pre-Hispanic Mexico implied being one of the most revered and respected members of the community. A principal site where these activities transpired was the calmecac. In this essay, I have emphasized the syncretic origins of the Colegio as an institution of higher education based on both Indigenous and European models. This also facilitated the continuation of activities traditionally carried out not only by the tlacuilo, or painter-scribe, but also by the tlamatini as a sage and learned member of the community. The Colegio also facilitated a transformation of artistic practice that would include physicians and merchants (there is no evidence yet to support that physicians and merchants collaborated with painter-scribes prior to the Spanish invasion).

As demonstrated earlier in this essay, art-making, particularly manuscript painting, was a highly intellectual pursuit imbued with profound cultural and moral significance that reveals a close alliance between intellectual knowledge, religion, and political power in Nahua society. I posit that this also points toward a more collaborative nature of cultural production (diverse works requiring the input of multiple sages depending on their expertise) as is evident in works like the Florentine Codex, the Badianus Herbal, and the Uppsala Map. Finally, just as for those who gained privileged acceptance to the calmecac, to participate in creative production at the Colegio de Santa Cruz meant a potential chance at recognition or promotion—ultimately, it meant an opportunity.

Notes

1. The Mexica were one of three powerful ethnic groups that led the Aztec Empire, also known as the Triple Alliance. In this essay, I refer to the Indigenous population that lived in central Mexico using the terms Aztec and Nahua. Although the Indigenous population comprised several ethnic groups and spoke multiple languages, the dominant majority spoke Nahuatl, and many descendants of the Indigenous groups that lived in pre-Hispanic Mexico survive and continue to speak Nahuatl today.

2. Scholars have made great strides in reformulating our contemporary understanding of western European–imposed distinctions between art and writing, and to them, I am much indebted (Boone and Mignolo 2004).

3. Indigenous students and alumni not only produced pictorial manuscripts under the supervision of the Franciscans and former Indigenous students who advanced to the role of instructors, but also wrote both Indigenous- and Spanish-language grammars and religious dramas (Mathes 1985, 26–27).

4. As mentioned by Elizabeth Hill Boone (2005, 10), "*tlamatinime* were traditionally old and generally but not exclusively noble and male. Individual female painters and poets are known."

5. The term *alguacil* might refer to a position in the community or in the church (Lockhart 1992, 42–43, 217, 538n58).

6. Translations from the Spanish are my own.

7. See, for example, the epigraph to Elizabeth Hill Boone's *Stories in Red and Black* (2000, n.p.), which reads "*In tlili in tlapalli,* the black, the red, these are the writings, the paintings, the books, knowledge." The epigraph source notes it as a "Nahuatl metaphor, adapted from Sahagún, bk. 10, ch. 29."

8. The students of the calmecac—and, subsequently, those trained as tlacuiloque— could be either boys or girls. The Nahuatl nouns are themselves gender neutral, but often are translated in the Florentine Codex as male (Boone 2000, 26–27).

9. I would like to thank Allison Caplan for pointing out this connection to me (pers. comm., January 2021.)

Reference List

Aranda, A., C. Viesca, G. Sánchez, M. Ramos de Viesca, and J. Sanfilippo. 2003. "La materia médica en el 'Libellus de medicinalibus indorum herbis.'" *Revista de la Facultad de Medicina, Universidad Nacional Autónoma de México* 46 (1): 12–17.

Baudot, Georges. 1995. *Utopia and History in Mexico: The First Chroniclers of Mexican Civilization (1520–1569)*. Niwot: University Press of Colorado.

Boone, Elizabeth Hill. 2000. *Stories in Red and Black: Pictorial Histories of the Aztecs and Mixtecs*. Austin: University of Texas Press.

———. 2005. "In Tlamatinime: The Wise Men and Women of Aztec Mexico." In *Painted Books and Indigenous Knowledge in Mesoamerica*, edited by Elizabeth Hill Boone, 9–25. New Orleans: Middle American Research Institute.

Boone, Elizabeth Hill, and Walter D. Mignolo. 2004. *Writing without Words: Alternative Literacies in Mesoamerica and the Andes*. Durham, NC: Duke University Press.

Calnek, Edward E. 1974. "The Sahagún Texts as a Source of Sociological Information." In Edmonson 1974, 189–204.

Castañeda de la Paz, María. 2013. *Conflictos y alianzas en tiempos de cambio: Azcapotzalco, Tlacopan, Tenochtitlan y Tlatelolco (Siglos XII–XVI)*. Mexico City: Universidad Nacional Autónoma de México, Instituto de Investigaciones Antropológicas.

Cortés, Hernán. 2001. *Hernán Cortés: Letters from Mexico*. Translated by Anthony Pagden. New Haven, CT: Yale University Press.

Cruz, Martín de la, and Juan Badiano. 1964. *Libellus de medicinalibus indorum herbis, manuscrito azteca de 1552: Según traducción latina de Juan Badiano versión española con estudios y comentarios por diversos autores*. Edited by Efrén C. del Pozo. Mexico City: Instituto Mexicano del Seguro Social.

Díaz del Castillo, Bernal, Genaro García, and Alfred Percival Maudslay. 1908. *The True History of the Conquest of New Spain*. 2nd ser., vol. 5. London: Hakluyt Society.

Edmonson, Monro S., ed. 1974. *Sixteenth-Century Mexico: The Work of Sahagún*. Albuquerque: University of New Mexico Press.

Fernández, Justino. 1991. "Las miniaturas que ilustran el códice." In *Libellus de medicinalibus Indorum herbis manuscrito azteca de 1552*, 101–6. Mexico City: Fondo de Cultura Económica.

Garone Gravier, Marina. 2013. "Calígrafos y tipógrafos indígenas en la Nueva España." *Revista General de Información y Documentación* 23 (2): 315–32.

Gimmel, Millie. 2008. "Reading Medicine in the Codex de la Cruz Badiano." *Journal of the History of Ideas* 69 (2): 169–92.

Hassig, Debra. 1989. "Transplanted Medicine: Colonial Mexican Herbals of the Sixteenth Century." *RES: Anthropology and Aesthetics* 17 (1): 30–53.

Karttunen, Frances. 1992. *An Analytical Dictionary of Nahuatl*. Norman: University of Oklahoma Press.

Kobayashi, José Maria. 1974. *La educación como conquista (empresa franciscana en México)*. Mexico City: El Colegio de Mexico.

León-Portilla, Miguel. 1990. *Aztec Thought and Culture: A Study of the Ancient Nahuatl Mind*. Norman: University of Oklahoma Press.

———. 2002. *Bernardino de Sahagún: First Anthropologist*. Norman: University of Oklahoma Press.

———. 2003. *Códices: Los antiguos libros del Nuevo Mundo*. Mexico City: Aguilar, Altea, Taurus, Alfaguara.

León-Portilla, Miguel, and María del Carmen Aguilera García. 1986. *Mapa de México Tenochtitlan y sus contornos hacia 1550*. Mexico City: Celanese Mexicana.

Lepage, Andrea. 2007. "El arte de la conversión: Modelos educativos del Colegio de San Andrés de Quito." *Procesos: Revista Ecuatoriana de Historia* 27 (1): 45–77.

Linné, Sigvald. 1948. *El valle y la ciudad de México en 1550: Relación histórica fundada sobre un mapa geográfico, que se conserva en la biblioteca de la Universidad de Uppsala, Suecia*. Stockholm: Statens Etnografiska Museum.

Lockhart, James. 1992. *The Nahuas after the Conquest: A Social and Cultural History of the Indians of Central Mexico, Sixteenth through Eighteenth Centuries*. Stanford, CA: Stanford University Press.

López, John F. 2014. "Indigenous Commentary on Sixteenth-Century Mexico City." *Ethnohistory* 61 (2): 253–75.

López Austin, Alfredo. 1974. "The Research Method of Fray Bernardino de Sahagún: The Questionnaires." In Edmonson 1974, 111–49.

———. 1988. *The Human Body and Ideology: Concepts of the Ancient Nahuas*. Salt Lake City: University of Utah Press.

Magaloni Kerpel, Diana. 2012. "The Traces of the Creative Process: Pictorial Materials and Techniques in the Beinecke Map." In *Painting a Map of Sixteenth-Century Mexico City: Land, Writing, and Native Rule*, edited by Mary Miller and Barbara Mundy, 75–91. New Haven, CT: Yale University Press.

———. 2014. *The Colors of the New World: Artists, Materials and the Creation of the Florentine Codex*. Los Angeles: Getty Conservation Institute.

———. 2019. "Powerful Words and Eloquent Images." In Peterson and Terraciano 2019, 152–64.

Mathes, Walter. 1985. *The America's First Academic Library: Santa Cruz de Tlatelolco*. Sacramento: California State Library Foundation.

Mignolo, Walter D. 1995. *The Darker Side of the Renaissance*. Ann Arbor: University of Michigan Press.

Motolinía, Toribio. 1951. *Motolinía's History of the Indians of New Spain*. Edited by Francis Borgia Steck. Washington, DC: Academy of American Franciscan History.

Mundy, Barbara E. 1998. "Mesoamerican Cartography." In *Cartography in the Traditional African, American, Arctic, Australian, and Pacific Societies*, edited by David Woodward and G. Malcolm Lewis, 183–256. Chicago: University of Chicago Press.

———. 2015. *The Death of Aztec Tenochtitlan, the Life of Mexico City*. Austin: University of Texas Press.

———. 2019. "Ecology and Leadership: Pantitlan and Other Erratic Phenomena." In Peterson and Terraciano 2019, 124–38.

Mundy, Barbara E., and Aaron M. Hyman. 2015. "Out of the Shadow of Vasari: Towards a New Model of the 'Artist' in Colonial Latin America." *Colonial Latin American Review* 24 (3): 283–317.

Nicolau d'Olwer, Lluís. 1987. *Fray Bernardino de Sahagún, 1499–1599*. Salt Lake City: University of Utah Press.

Peterson, Jeanette Favrot. 2003. "Crafting the Self: Identity and the Mimetic Tradition in the Florentine Codex." In *Sahagún at 500: Essays on the Quincentenary of the Birth of Fr. Bernardino de Sahagún*, edited by John Frederick Schwaller, 223–53. Berkeley, CA: Academy of American Franciscan History.

Peterson, Jeanette Favrot, and Kevin Terraciano, eds. 2019. *The Florentine Codex: An Encyclopedia of the Nahua World in Sixteenth-Century Mexico*. Austin: University of Texas Press.

Rappaport, Joanne, and Tom Cummins. 2012. *Beyond the Lettered City: Indigenous Literacies in the Andes*. Durham, NC: Duke University Press.

Robertson, Donald. 1994. *Mexican Manuscript Painting of the Early Colonial Period: The Metropolitan Schools*. Norman: University of Oklahoma Press.

Roest, Bert. 2000. *History of Franciscan Education*. Leiden: Brill.

Sahagún, Bernardino de. 1959–82. *Florentine Codex: General History of the Things of New Spain*. Introduction and books 6, 9, and 10. Edited by Arthur J. O. Anderson and Charles E. Dibble. Santa Fe, NM: School of American Research.

SilverMoon. 2007. "The Imperial College of Tlatelolco and the Emergence of a New Nahua Intellectual Elite in New Spain (1500–1760)." PhD diss., Duke University.

Terraciano, Kevin. 2019. "Introduction: An Encyclopedia of Nahua Culture: Context and Content." In Peterson and Terraciano 2019, 1–18.

Toussaint, Manuel. 1938. "Plano atribuido a Alonso de Santa Cruz: Estudio histórico y analítico." In *Planos de la ciudad de México, siglos XVI y XVII: Estudio histórico, urbanístico y bibliográfico*, by Manuel Toussaint, Federico Gómez de Orozco, and Justino Fernández, 133–46. Mexico City: Instituto de Investigaciones Estéticas de la Universidad Nacional Autónoma de México.

Trueblood, Emily W. Emmart. 1935. *Concerning the Badianus Manuscript, an Aztec Herbal: "Codex Barberini, Latin 241."* Washington, DC: Smithsonian Institution.

Webster, Susan Verdi. 2017. *Lettered Artists and the Languages of Empire: Painters and the Profession in Early Colonial Quito*. Austin: University of Texas Press.

Williams, Barbara. 2006. "Aztec Soil Knowledge: Classes, Management, and Ecology." In *Footprints in the Soil: People and Ideas in Soil History*, edited by Benno P. Warkentin, 17–42. Oxford: Elsevier.

4

The Pochtecatl Angelina Martina

Supplying Mexico City's Art World in the Sixteenth Century

MARGARITA VARGAS-BETANCOURT

In 1580, a Tlatelolca woman wrote her testament. Her name was Angelina Martina, and she was a *pochtecatl* (merchant, pl. *pochteca*). Among her possessions, she listed numerous luxury and common goods, houses, and land. Her story indicates that Indigenous women played an indispensable role in what we might term the "art world" of early colonial Mexico City, as suppliers of featherwork and textiles. Angelina Martina's will is not a hidden document, but previous scholars have not studied her story in relation to art (AGN, Tierras, vol. 49, exp. 5, fol. 7–8v).[1] Here I will examine her agency as a supplier or merchant of items that had aesthetic and exchange value in the colonial economy.

Mexico City was fertile ground for an art market since both the Mexica and the Spaniards valued the creation of sumptuary goods, which, despite serving a social purpose by bearing religious symbols or social identifiers, had added value due to their aesthetic properties and the exchange value of their materials. Furthermore, in both traditions skilled professionals were in charge of the production of these goods. The Mesoamerican and the Spanish traditions came together in that environment through a process of negotiation, adaptation, conflict, and misunderstanding. It can be seen as a "fractured locus" or a frontier space, as defined by María Lugones (2010) and Gloria Anzaldúa (Silva 2021). Angelina Martina ably negotiated that space by participating at a high level in a distribution system of raw material indispensable for the production of luxury goods.

The relative lack of attention given to Angelina Martina follows a general trend. Despite the availability of and access to numerous colonial documents regarding Indigenous women from the Viceroyalty of New Spain, the role of Nahua women in the commercial and artistic activity of Mexico City is rarely

examined. Colonial accounts, such as the Spanish translation of the Floren-tine Codex, and even modern Mexican museums, such as the museum of the Tlatelolco archaeological site, run by the National Autonomous Univer-sity of Mexico (Museo de Sitio Tlatelolco del Centro Cultural Universitario), describe women's economic activity as limited to the sale of the surplus of their domestic production. This under- and misrepresentation is especially poignant in the case of Tlatelolca women, for sources indicate that they had a preeminent economic role in colonial Mexico City.

The role of Indigenous women in art production and circulation contin-ues to be a research lacuna because of historians' lack of interest and, at times, because of the bias of certain favored sources. The Florentine Codex consti-tutes one example. Even though it is a comprehensive ethnographic study, it presents gendered activities in an idealized form. Moreover, the Spanish ver-sion, which differs significantly from the Nahuatl and has become dominant in Mexico's scholarship on the colonial period, restricts women's activity to European patterns (Sousa 2010, 78–79).

In order to understand Indigenous women's role more clearly, it is neces-sary first to overcome the colonial archive's European gender bias, and sec-ond to identify the hidden voices of Indigenous women in colonial sources. The remarkable story of Angelina Martina can be reconstructed from a bill of sale (1551), her testament (1580), and, after her death, the lengthy lawsuit that her descendants embarked on to defend their inheritance (AGN, Tier-ras, vol. 49, exp. 5). Comparing and contrasting this case with the Florentine Codex's descriptions of the pochteca and the *amanteca* (feather artisans) in its three versions—the Spanish, the Nahuatl, and the pictographic—allows scholars to better understand the role of Indigenous women as merchants of luxury goods in Mexico City. At the same time, Angelina Martina's case illustrates that Indigenous women's participation in the colonial art world allowed them to preserve Indigenous cultural traditions while adapting to Spanish needs. In doing so, they were able to preserve their elite social status and wealth.

Tlatelolco and the Market

During the precontact era, Tlatelolco was dominant in the commercial activ-ity of the basin of central Mexico due to political, social, environmental, and geographic factors. During the viceroyalty, Santiago Tlatelolco was one of two *repúblicas de indios* (Indigenous districts) in Mexico City; the other was San Juan Tenochtitlan. Tlatelolco and Tenochtitlan were situated on the same island in Lake Texcoco, which was part of the basin's lacustrine system. The

five lakes that constituted the system were Xaltocan and Zumpango, to the north; Texcoco, in the center; and Xochimilco and Chalco, to the south. Lake Texcoco was the largest and the shallowest; Lakes Xochimilco and Chalco were freshwater, while the rest were brackish (Mundy 2015, 34–39). As a result, the most fertile land was at the south end of the basin. In the north, agriculture was more difficult. This environmental disadvantage probably spurred the Tlatelolca toward commerce (Vargas-Betancourt 2015, 157–202).

The market in Tlatelolco was the most important in Mesoamerica when the Triple Alliance dominated the basin of central Mexico (1428–1521). In fact, it was the most renowned center of exotic and luxury goods, such as featherwork and textiles, which functioned as social markers and as spiritual objects. Given the significance of these crafts, merchants and artisans involved in them held privileges like being exempt from tribute, both in kind and in labor (Robles Álvarez 2002, 157, 165, 167; Stanfield-Mazzi 2021, 123–25). In general, Indigenous markets did not undergo a drastic transformation during the viceroyalty. Even in the capital, the traditional system of commercial exchange showed great continuity.

The Role of Tlatelolca Women

The role of Indigenous women as merchants and artisans in Tlatelolco remains confusing in modern public history and in modern histories of the colonial era. In the realm of public history, Mexico City's museum of the Tlatelolco archaeological site previously included a diorama that represented women as produce merchants. The label next to it stated the following:

> The trades of women were those related to housekeeping. From a young age, they learned to prepare cacao, grind corn, cook, spin, and weave. They were in charge of the entire textile production, from common clothes to the ceremonial ones priests wore. Some women learned the trade of midwifery. In addition to counseling the future mother during their pregnancy, midwives knew which medicinal plants to use and which procedures to follow during birth. (figure 4.1)

The label and the graphic representation restrict Indigenous women's economic role to domestic and agricultural activities. The diorama consisted of two panels of plexiglass above and behind an exhibit case that contained plastic fruits and vegetables. Such a display reinforces the idea of female trade being restricted to the sale of agricultural household production. Both drawings behind the case were artificial configurations created by extracting separate elements from pictographic compositions of the Florentine Codex and

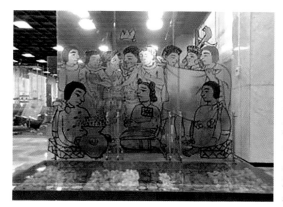

Figure 4.1. *Diorama of Tlatelolco's Market.* Museo de Sitio Tlatelolco del Centro Cultural Universitario, Universidad Nacional Autónoma de México, Mexico City. Photograph by the author, 2018.

superimposing them in a single panel.[2] The foreground drawing, as shown in figure 4.1, depicts three sitting figures, purportedly fruit and vegetable sellers. The Florentine Codex (book 10) contains numerous pictographic depictions of different types of market sellers (Vargas-Betancourt 2020). Yet the curators selected images from book 9, which describes other tradespeople: merchants or pochteca.[3] The first and third figures, located to the left and right of the central female figure, represent high-ranking Indigenous men. Following pictorial conventions, they wear cotton cloaks (*tilmatli*) knotted over their shoulders and covering their bent knees, and they sit on top of woven mats. The style of their capes and seats signals an elite status (Boone 2000, 45–46). The man to the left wears a cape that simulates *ocelotl* or jaguar skin; its source is a representation of four Tlatelolca pochteca who are called by the Mexica *tlatoani* (ruler) to explore faraway regions (Sahagún 1577, bk. 9, fol. 7r; figure 4.2, second figure from the left). In front of him is a pot with a foamy drink. Since the label includes a reference to cacao, the viewer might assume that this is a representation of hot cocoa or chocolate; however, in its original source it represents the traditional Mesoamerican alcoholic drink pulque (Sahagún 1577, bk. 1, fol. 40). The man to the right wears a cape decorated with flowers; its source is a representation of a pochtecatl buying a slave at Azcapotzalco's slave market to be sacrificed at the feast of Panquetzaliztli (Sahagún 1577, bk. 9, fol. 36; figure 4.3, figure at far right). The central figure in the panel is a woman whose source is the representation of a woman selling banquet utensils to a pochtecatl (Sahagún 1577, bk. 9, fol. 17r; figure 4.4, figure at right). In the original scene the male pochtecatl is shown to outrank the woman: he is sitting on a woven mat, and speech scrolls come out from his mouth. Both the mat and the speech scrolls are symbols of power (Boone 2000, 46). Nevertheless, the Nahuatl text that precedes the image indicates

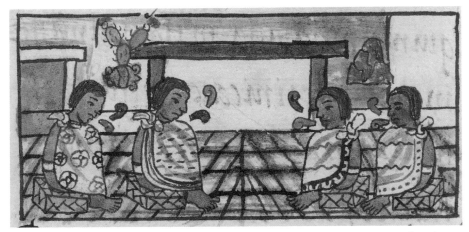

Figure 4.2. *Pochteca Discussing an Expedition*, in the Florentine Codex, Fray Bernardino de Sahagún's *Historia general de las cosas de Nueva España*, fol. 7r, vol. 2, bk. 9. Mexico, compiled 1545–90. Ink on European paper, 21.2 × 31.0 cm. Ms. Med. Palat. 219 carta 315v, Biblioteca Medicea Laurenziana, Florence. Printed by permission of MiBAC. Any further reproduction by any means is prohibited.

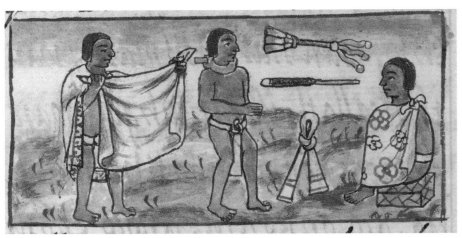

Figure 4.3. *Pochtecatl Buying a Slave*, in the Florentine Codex, Fray Bernardino de Sahagún's *Historia general de las cosas de Nueva España*, fol. 36r, vol. 2, bk. 9. Mexico, compiled 1545–90. Ink on European paper, 21.2 × 31.0 cm. Ms. Med. Palat. 219 carta 344r, Biblioteca Medicea Laurenziana, Florence. Printed by permission of MiBAC. Any further reproduction by any means is prohibited.

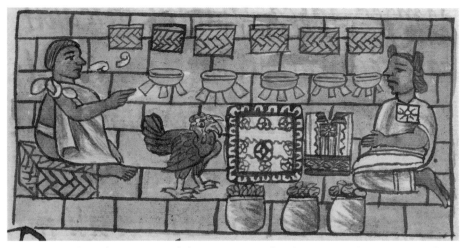

Figure 4.4. *Pochtecatl Buying Utensils for a Banquet*, in the Florentine Codex, Fray Bernardino de Sahagún's *Historia general de las cosas de Nueva España*, fol. 17r, vol. 2, bk. 9. Mexico, compiled 1545–90. Ink on European paper, 21.2 × 31.0 cm. Ms. Med. Palat. 219 carta 335v, Biblioteca Medicea Laurenziana, Florence. Printed by permission of MiBAC. Any further reproduction by any means is prohibited.

that women, like men, could serve as principal merchants.[4] The woman appears as a seller of baskets, three-legged pots (probably *molcajetes*), capes, turkeys, and pots with food.

Principal merchants lived in Tlatelolco. Their main activity was to supervise, administer, and even judge commercial affairs that took place in the markets. They hired dealers, known as *oztomecatl*, who would travel to remote places to acquire merchandise (Sahagún 1959–69, 9:1–2).[5] By extracting images from their pictorial and textual context, the curators at the museum of the Tlatelolco archaeological site privileged design over faithfulness to the original sources. The result obscures the preeminent role of women in commerce, including that of the luxury arts.

At the same time, the Florentine Codex presents contradictory information regarding trades and gender. I analyzed book 9 ("The Merchants") and book 10 ("The People") to determine the extent to which the information in the Nahuatl text is different from the Spanish text and also from the images painted by Indigenous scribes or *tlacuiloque* (Magaloni Kerpel 2019, 152–53). The study led to several conclusions. First, in the Spanish text the economic role of women is described as more restricted than in the Nahuatl text or in the images. Second, both the Spanish and the Nahuatl texts include references to women as merchants, but the Nahuatl version specifically denotes the *pochtecacihuatl* or woman merchant. Finally, in the pictorial images, the

participation of women in the market is presented as extensive and diverse (Vargas-Betancourt 2018, 2020).

Noblewomen also played a fundamental role in the Mexica economy. In the admonition or *huehuetlatolli* that rulers gave to their daughters during their coming-of-age, fathers highlighted their daughters' nobility and the importance of their labor to the production of luxury goods within the *altepetl* (ethnic state).[6] This speech, along with information from other archival sources, suggests that noblewomen became leaders of the altepetl's craft production, especially in featherwork and textiles, for they supervised the work of commoner women they employed (Sousa 2017, 206). This was especially significant in Tenochtitlan, where "women of the royal court were particularly important creators of luxury cloth" (Mundy 2015, 56).

Pochteca and Amanteca

Fray Bernardino de Sahagún (1959–69, 10:42, 10:65–68; 1997, 558) and his Indigenous informants described in detail the trades of artisans and merchants in book 10 of the Florentine Codex. There were two types of dealers: those who produced and sold their own merchandise and those who traveled to the place where the goods were produced to buy them in bulk and to resell them. The latter were known as pochteca, but in fact not all of them traveled. In the Mexica social hierarchy, the pochteca constituted the highest commoners' rank, directly below the nobility (Smith 2008, 154–55). The pochteca were in charge of the trade of the luxury items that the Mexica nobility and warriors used to indicate their rank and status, such as exotic feathers, semiprecious stones, garments woven in cotton, silver and gold ornaments, furs, cacao, and slaves (Vargas-Betancourt 2018). As mentioned above, principal merchants lived in Tlatelolco and oversaw commercial transactions in the markets (Sahagún 1959–69, 9:1–2, 10:59–62). The Spanish and Nahuatl texts of the Florentine Codex indicate that both men and women worked as principal merchants. For this reason, the phrase *puchtlan tenan, teta* (father and mother of all merchants) was used to connote principal merchants in general (Sahagún 1959–69, 10:59).

The connection between pochteca and amanteca was not only historical but economic, religious, and social. They lived in contiguous neighborhoods, their deities were related, they participated in the same ceremonial festivities, and their social position was the same. Given the significance of the crafts that merchants and artisans made and sold, both groups held privileges like being exempt from tribute, both in kind and in labor (see chapter 2). They did not have to undertake communal work, perform personal

service to elites, or provide labor for public works. However, their essential relationship was economic, for the pochteca provided raw material (feathers and cotton) to the amanteca (Robles Álvarez 2002, 157, 165, 167; Stanfield-Mazzi 2021, 124).

Before the rulership of Ahuizotl (r. 1486–1502), the amanteca worked with a limited range of feathers: black and white feathers from turkeys, ducks, and herons. Their tools were also limited and simple: obsidian blades and cutting boards made from *ahuehuete* or bald cypress (*Taxodium mucronatum*). As the Mexica expanded their dominion, they established an extensive network of tribute and commerce that allowed them to have access to an ample spectrum of exotic feathers, such as quetzal, troupial, red spoonbill, blue cotinga, hummingbird, and parrot, as well as to cotton, a lowland crop (Sahagún 1959–69, 9:89–91; 1997, 519, 529). Through their extensive distribution network, the pochteca made these materials available to Mexica artisans (Berdan 1987, 236).

Social Continuity

Although the coming of the Spaniards caused major disruption, there was a level of continuity in Indigenous sociopolitical systems, especially at the local level. The altepetl continued to structure Mesoamerican society, and Mesoamerican noble lineages continued to rule alongside Spanish officials. The Indigenous corporation or altepetl was adapted to Spanish corporations such as the municipal system, the *encomienda* (a grant of Indian tribute and labor to a Spaniard), the parish, and the *cabecera* (head town). Spanish officials relied on Indigenous rulers (organized in town councils or *cabildos*) to collect tribute, organize communal labor, and serve as first-instance judges. The first to occupy these posts were members of local noble lineages. Therefore, there was continuity in both their position and their way of life; at the same time, they developed strategies to adapt to new circumstances. During the viceroyalty, in exchange for their service to Spanish authorities and to their communities, dynastic rulers continued to be empowered and have access to land, tribute, and the labor of *macehualtin* or commoners (Olko 2014, 26–29; Lockhart 2002, 28–40).

The sixteenth-century cabildo system also allowed the participation of lesser members of Nahua nobility; they held the positions of *alcaldes* (judges), *regidores* (councilmen), *escribanos* (notaries), *tenientes* (provincial lieutenants), *alguaciles* (constables), and *mayordomos* (officeholders in religious organizations). Pre-Hispanic elites used these positions to preserve their status. Spanish recognition of their hereditary rights allowed them to

preserve, fight for, and sometimes seize land, tribute, and labor. They also continued the practice of interdynastic marriage. This strategy resulted in the continuity of native titles up to the seventeenth century. At the same time, Indigenous nobility continued to use precontact elite objects to mark their status. For this reason, merchants like Angelina Martina, who provided raw material to the amanteca, continued to be relevant (Olko 2014, 28; Lockhart 2002, 41–44).

In the second half of the sixteenth century, Spanish officials began to appoint people external to the altepetl into cabildo posts. Yet, these newcomers used the same strategies that Indigenous dynastic nobles used to signify and legitimize their status, such as wearing clothing and ornaments made with rare and exotic materials like feathers, cotton, and precious stones and metals (Olko 2014, 26).

Status and Luxury Goods

In the early viceroyalty, dynastic *tlatoque* (rulers, pl. of *tlatoani*) continued to use precontact insignia as one mechanism to defend their positions. At the same time, lower officials and newcomers appropriated Mexica noble insignia to legitimize their new authority. These groups actively sought the right to bear European symbols of power, such as weapons, horses, and Spanish accoutrements like silver garments, to indicate the preservation of authority or the acquisition of a new type of position (Olko 2011, 457–58; Pérez-Rocha and Tena 2000, 14–29).

Colonial documents and chronicles indicate that Indigenous people continued to use Nahuatl terms to refer to traditional elite objects, even up to the seventeenth century. The parallel use of Spanish and Indigenous rank insignia was complex. During the sixteenth century, Spanish objects had the aura of "novelty and foreignness" and became badges "of local pride and self-identity." At the same time, pre-Hispanic elite objects continued to be signifiers of status and authority. By the seventeenth century, people of all status used Spanish objects, which thus ceased to be elite markers, while traditional insignia continued to preserve their connotations of status (Olko 2014, 339–40, 345). Testaments written by Indigenous elites during the sixteenth and seventeenth centuries indicate that Indigenous rulers continued to own and bequeath objects with traditional insignia. In some cases, there is evidence of newly manufactured traditional objects. Ornaments made with turquoise, exotic feathers, and cotton were the most common.[7]

Angelina Martina

On February 15, 1580, Angelina Martina, age eighty-one, resident of the alte-petl of Santiago Tlatelolco and of the *calpulli* (a unit of several households) San Martín Telpochcaltitlan Pochtlan, made her will and bequeathed her possessions to her grandchildren and sisters.[8] In her testament, she made a detailed description of her property, including luxury goods, houses, and land. Most of the luxury goods that Angelina Martina bequeathed were ex-otic feathers, balls of cotton fiber (some dyed), and cotton capes, along with merchandise such as gourds and even construction material. She also owned another exotic product: ocelotl skins. Her affiliation to the calpulli and alte-petl of merchants, the type of goods she owned, and her wealth suggest that she was a pochtecatl.

Among the goods Angelina Martina bequeathed were four mantles and four cotton capes. The testament does not indicate whether these were of personal use or merchandise. The same is true for the balls of yarn, the gourds, and the construction materials in her possession. As mentioned above, weaving and featherwork were both considered to be the ultimate expression of elite female artisans. As a pochtecatl and thus a dealer of both raw materials (feathers, yarn, and cotton) and finished artworks (woven capes), she appears to have had an active and significant role in Tlatelolco's art world.

The case of Angelina Martina indicates that during the viceroyalty the precontact art forms of featherwork and textiles continued to be popular and meaningful, even if adapted to a new reality. Thus, Tlatelolca merchants, which included women, continued to be active in the trade. Angelina Marti-na's testament (1580), along with a bill of sale (1551) of a piece of land that she bought from a Mexica noble, highlights not only the details of her economic activity, but also the wealth that such trade allowed her to accumulate, and even her cosmovision.

Cotton Capes

Not only was weaving a major economic activity, but it also had profound cosmological significance. According to Cecelia F. Klein (1982, 6), the vast majority of Mesoamerican people conceived of the universe as a cloth in which cords and thread were woven to create a symmetrical, stretched web that followed "the geometric principle of the grid, in which vertical elements interweave with horizontal ones." In a complementary manner, they con-ceived of the underworld as "a dense wad or ball of tangled strands, some of

which emanate out and upward in a slow, tortuous fashion" (Klein 1982, 7). This clothlike universe was folded into multiple layers. The folds may have simulated the passage of time, explaining why cloth and cords marked the most important stages of the life of an individual. The sun was conceived of in a similar manner: as a woven shield (Klein 1982, 22, 25).

Like food, cloth was exchanged as gifts that cemented social relations (Sousa 2017, 179). The exchange of clothing was part of rites such as birth, marriage, and diplomatic relations. On behalf of the Mexica tlatoani, the pochteca took precious gifts to faraway rulers in order to establish or strengthen alliances. These precious gifts were often cotton capes (Sahagún 1959–69, 9:1–2, 10:59–62). Clothing was also offered to deities and, during the viceroyalty, to Catholic saints (Sousa 2017, 181). The significance of cloth especially in the form of cotton capes can be seen in the fact that the latter constituted the most important form of currency, even more important than cacao and gold dust (Klein 1982, 25–28; Sousa 2017, 182). This continued to be true in colonial times. Clothes were used "to pay tribute, sponsor local festivals, and raise money for the community." Colonial documents suggest that cloth constituted people's wealth to a greater degree than money (Sousa 2017, 182–83).

From the sixteenth to the seventeenth centuries, Indigenous nobility wore and bequeathed cotton capes decorated with precontact motifs.[9] Codices show that even when Indigenous men wore Spanish shirts, they continued to wear capes over their European clothes.[10] In pre-Hispanic times, commoners wore capes made from maguey fiber, while nobles wore cotton ones. Mesoamerican manuscript paintings show the different styles of cotton capes that Indigenous nobles wore. One type was blue with a gridlike design, with dotted circles or actual turquoise stones placed in each diamond-shaped square. The color blue and the semiprecious stone connoted "legitimate rulership," and thus were attributes restricted to "the huei tlatoque of Tenochtitlan" (Olko 2014, 86–87; see also Anawalt 1990, 291). Angelina Martina owned a good quantity of blue-dyed thread and fabric, which was likely used to make capes that the Indigenous nobility continued to use up to the seventeenth century. In 1625, doña Petronila de Turcio from Amaquemecan bequeathed ornamented blue cotton capes to her heirs. Perhaps these blue capes correspond to the pre-Hispanic antecedent discussed above. Even if doña Petronila was from the lower nobility, these blue capes could have been imitations of the turquoise-mosaic design used as royal insignia, a common colonial practice through which provincial and lower nobility appropriated the "color of royalty" (Olko 2014, 93; and see Rojas Rabiela, Rea López, and Medina Lima 1999–2004, 3:156–71, qtd. in Olko 2011, 463).

Figure 4.5. *Cotton Cape Seller*, in the Florentine Codex, Fray Bernardino de Sahagún's *Historia general de las cosas de Nueva España*, fol. 46r, vol. 3, bk. 10. Mexico, compiled 1545–90. Ink on European paper, 21.2 × 31.0 cm. Ms. Med. Palat. 220 carta 48r. Biblioteca Medicea Laurenziana, Florence. Printed by permission of MiBAC. Any further reproduction by any means is prohibited.

Other types of capes were decorated with eagle and jaguar designs (known as *quauhtilmatli* and *ocelotilmatli*) that evoked rulership. These appear in the 1673 testament of doña María Xacoba from the pueblo of San Bartolomé Actopantonco, where she refers to the capes as *tlatocatilmatli* or capes of the rulers (Rojas Rabiela, Rea López, and Medina Lima 1999–2004, 3:282–87, qtd. in Olko 2011, 463). Capes with eagle designs were used in the ceremonial context of mourning. Capes made of jaguar skin were used as royal attributes in Aztec times, whereas cotton capes imitating jaguar skins were used by lower nobility to signify status (Olko 2014, 93, 95, 99–100). The use of jaguar-skin capes, whether real or imitation, continued into viceregal times to signify royal power or elite social status. Angelina Martina bequeathed a jaguar-skin cape to her descendants.

According to Sahagún (1959–69, 10:63–64, 10:73; 1997, 565, 567–68) and his Indigenous informants, there were two types of cloth dealers: resale merchants and producers. The cotton cape sellers (known as *tilmapan tlacatl* and *quachnamacac*) bought for resale cotton capes decorated with sophisticated designs (figure 4.5). In contrast, the producers of maguey capes sold them directly. Thus, while cotton capes were a luxury product sold by the pochteca, maguey capes constituted a more common product. It is likely that most of Angelina Martina's capes were of cotton, for in her will, she describes some as wool capes and another as *quauhnahuacayotl*, the term used to refer to cotton capes from Quauhnahuac (today Cuernavaca).

Angelina Martina's role was probably restricted to the distribution of cotton capes; such activity follows a common trend among Tlatelolca women. Colonial documents from the Juzgado General de Indios (special court for

Indigenous affairs) suggest that in Mexico City, Tlatelolca women sold textiles in the city's markets and plazas (Sousa 2017, 179–85). In 1589, Gonzalo Gómez de Cervantes, *alcalde ordinario* (cabildo magistrate), inspected the stalls that merchants Mariana, Juana, Cecilia, Martina Juana, other women from San Juan Tenochtitlan and Santiago Tlatelolco, and Andrés de Hernández had in Mexico City's markets. The purpose of the inspection was to ensure that no one dispossessed these people of their stalls. In 1603, Antonio de Santiago and his wife, Francisca María, both Tlatelolca, requested protection from the viceroy, don Rodrigo Pacheco y Osorio, Marqués de Cerralvo. They explained that they had a stall in Mexico City's market where they sold *jubones de holandilla* (cotton doublets) and cotton capes.[11] From their sales, they supported their family and also paid tribute, but they asserted that some Spaniards wanted to take away their stalls. Viceroy Cerralvo sent an alguacil to protect them. In 1640, the Tlatelolca merchants had to request viceregal protection once more (AGN, Indios, vol. 4, exp. 52; vol. 12, exp. 119). These documents suggest that although during the viceroyalty Indigenous women continued to engage in the production and distribution of textiles, they faced competition and harassment from Spanish merchants. But, like the artisans discussed by Maya Stanfield-Mazzi in chapter 2, they demanded and often gained protections for their professions.

Featherwork

In the Mesoamerican worldview, feathers, especially those from tropical birds, had spiritual significance. They represented the *tonalli* (pl. *tonaltin*), or the energy that came from the sun and gave life to living beings. For this reason, rulers used feathers to signify their tonaltin. Feathers also symbolized the *nahual*, or a person's animal alter ego (Russo 2002, 230, 234; Furst 1998, 214; Stanfield-Mazzi 2021, 122). Mexica warriors used feathers in their regalia to represent predatory animals.[12] Since feathers embodied Mesoamerican deities, they were essential elements for rulership and ritual human sacrifice. Tlatoque wore suits decorated with feathers that represented deities to take on the divine identities of the latter (Mundy 2015, 56). Before being sacrificed, slaves or captives were dressed up with feathers. These were fundamental not for representing sacredness but for literally constituting it. In other words, through regalia, victims of sacrifice, like rulers, became the deities that their accoutrements represented. The *ixiptlayotl* or real essence of a deity remained in the suit of the sacrificial victim. Consequently, the accoutrements, including the feathers, became sacred objects. The iridescence of exotic feathers, especially the quality of changing color, connoted the

ambiguity between deity and victim (Russo 2002, 234–36; Magaloni Kerpel 2015, 376; Stanfield-Mazzi 2021, 122).

In addition to its spiritual significance, featherwork also had an important political function: to signify social position. Tlatoque, nobles, priests, and warriors used feathers in their headbands and accessories to signal their rank. The feathers, whether from heron, quetzal, eagle, roseate spoonbill, or blue cotinga, each had specific connotations. For example, heron feathers connoted the war god Tezcatlipoca, making them a favorite among warriors. Blue feathers evoked turquoise and, like the stone, symbolized rulership or *tlatocayotl* among the Mexica and other Nahua communities. The reason was that both elements connoted Toltec and Teotihuacan symbols specifically related to Xiuhtecutli, god of "celestial fire, creation, and war" (Olko 2014, 54; see also 34, 37, 40, 53, 60; Boone 2000, 46; Rojas Rabiela, Rea López, and Medina Lima 1999–2004, 2:88–92, qtd. in Olko 2011, 462). Feather headdresses were worn during ceremonial dances. In headdresses, feathers constituted elements of a symbolic language that transmitted messages about the rank and status of the wearers (Sahagún 1959–69, 9:89; Olko 2014, 57–59, 61, 70).

Military insignia followed a complex system of signs consisting of colors, patterns, and materials that communicated the different ranks of the Mexica military hierarchy. Feathers were essential signifiers in that system. The word *tlahuiztli* denoted the bodysuits, headdresses, and shields used by Mexica warriors and nobles. The lexeme of the word is the verb *tlahuia*, which means "to give light, to shine." Colonial accounts indicate that when tlatoque, nobles, or warriors performed ritual dances or fought in battle, their attire shimmered even from far away (Siméon 1977, 585, 692, 695; Sten 1989, 143; Boone 2000, 46; Olko 2014, 109, 111; Caplan 2019, 65).[13] The feathers of certain birds change color depending on the type of light and the angle of the feathers. Under adequate conditions, this change of color can be astonishing. The biological reason for this is that tropical birds change position to reflect or hide the colors of their feathers as a survival mechanism. They hide the colors for predators; they make them shine during mating. Mexica featherwork artisans used this quality to design war shields whose color only showed when the sun struck them directly (Stanfield-Mazzi 2021, 164–65; McMahon 2017, 15–16). For the Mexica another connotation of exotic feathers in military attire was that of hegemony: feathers symbolized the military might and dominance of the Triple Alliance over an extensive territory (Mundy 2015, 55).

The most popular tlahuiztli were animal costumes and those with divine or cosmological significance. Examples of animal suits were those of coyote, eagle (*cuauhtli*), and jaguar (ocelotl), names that referred not only to the

most prized groups of Mexica warriors but also to their warrior suits and their animal alter egos. Despite the references to nonavian animals, these suits were decorated with different types of feathers. In addition to bodysuits, other military insignia decorated with feathers were headdresses, back gear, standards, banners, and shields. These, too, were rich in cosmological symbolism. Two types of feathers signaled the highest ranks of nobility: quetzal feathers and blue cotinga feathers (which, as stated above, connoted turquoise and the fire god Xiuhtecutli). The renowned headdress purported to be Moteuczoma's is an example of the spectacular quetzal-feather crests worn by the Tenochca emperor (Olko 2014, 112, 115, 117, 119–20, 128–29).

Shields decorated with feathers are another example of featherwork masterpieces (Fane 2015, 104–11). The type of feathers and the design of each shield connoted rank and status. As stated above, amanteca made these shields so that they would shine when seen at certain angles. Mexica warriors used this sparkling as one of their military strategies. The *xiuhchimalli* (turquoise shields) were decorated with turquoise mosaics or blue cotinga feathers and constituted the regalia of Mexica rulers. Royal insignia were not sold in markets; they constituted elite merchandise that pochteca sold directly to the tlatoque (Olko 2014, 132, 136).

Like other precontact insignia, military accoutrements continued to be used in the late sixteenth and early seventeenth centuries. In 1566, don Julián de la Rosa, teuctli or lord of the royal dynasty of San Pedro Tecpan in Ocotelolco, Tlaxcala, bequeathed a shield with two hundred quetzal feathers, a coyote headdress, and a monkey suit with its headdress; both headdresses were decorated with feathers (Anderson, Berdan, and Lockhart 1976, 51, qtd. in Olko 2011, 460). Although the use of these items is not addressed, another testament hints at the significance of military regalia in the viceroyalty. In 1579, don Juan Jiménez, former governor of Cuernavaca, bequeathed three shields and four feather headdresses, specifically to be used in ceremonial dances (Haskett 1985, 669, qtd. in Olko 2011, 465). The continuity of military regalia well into the seventeenth century is attested in the 1650 testament of don Martín Cerón de Alvarado, ruler in the cabecera of Tepenchi in Xochimilco. Among his goods, don Martín bequeathed a warrior bodysuit and shield referred to in his will as *ce chimalli cuextecatl* (Rojas Rabiela, Rea López, and Medina Lima 1999–2004, 3:243; Olko 2011, 462). The term *cuextecatl* referred to the Huaxtec warrior costume that Mexica entry-level warriors wore; warriors earned this suit after capturing a second war prisoner. This costume was the one most represented in Mexica imperial tribute documents. It was also made with feathers and included a "pointed

hat, unspun-cotton ear ornaments, and a widely spaced, overall decoration of short, black parallel lines" (Berdan and Anawalt 1997, 188).

Chronicles and manuscript paintings also indicate that Indigenous nobility used precontact military regalia decorated with feathers for religious and civil ceremonies during the colonial period. Even in religious ceremonies, Indigenous nobles wore warrior suits (see Sten 1989, 149–65). In the 1539 celebration of Corpus Christi, the Tlaxcalteca staged the play *La conquista de Jerusalén* (The conquest of Jerusalem). In a reversal of roles, the actors that attacked Jerusalem wore Spanish soldier costumes, whereas the defenders wore precontact warrior costumes (Harris 2000, 256–60).[14] The Tlatelolco Codex, created around 1562, depicts the ceremony to commemorate Philip II's coronation in 1557 (figure 4.6). In the center of the image, there is a platform occupied by the most significant Spanish authorities: Viceroy Luis de Velasco I and Archbishop Alonso de Montúfar. The Indigenous governors of Santiago Tlatelolco, Tenochtitlan, and Texcoco appear directly below them. Each is depicted wearing traditional pre-Hispanic regalia such as the turquoise diadem, a *quetzaltlalpiloni* (royal hairstyle, tied up with feathers), and a cotton cape (Valle 1994, 65, 76, 79; Nóguez 1998, 29; Boone 2000, 46–47). Below the tlatoque, there are three dancers in warrior attire (two jaguar and one eagle) worn over European clothes. In their hands, they have fans and flowers. The cases discussed above indicate that like in precontact times, feathers continued to be an important part of the insignia that Indigenous elites wore during colonial religious and political ceremonies.

Featherwork was an important signifier for both Spaniards and Nahuas, hence its continuity. For the former, it was a proxy for the textiles used for liturgical rituals in Europe; for the latter, featherwork was connected to political power and the conceptualization of the sacred. Spaniards believed that this Indigenous art could be used to glorify Catholic authorities as well as to communicate basic Christian principles. The result was a spectacular evolution of liturgical featherwork that began in the sixteenth century and continued up to the eighteenth (Stanfield-Mazzi 2021, 115–16).

The most striking quality of religious images made with feathers was their iridescence (Russo, Wolf, and Fane 2015b, 9; Estrada de Gerlero 2015, 299; Magaloni Kerpel 2015, 371–73). Colonial artisans designed bishops' miters that reflected light coming from below. Iridescence was also used to highlight the divine in religious images; one example is the *Mass of Saint Gregory* (figure 2.2; Stanfield-Mazzi 2021, 142, 164–65). Alessandra Russo calls this technique the aesthetics of radiance (Museo Nacional de Arte 2012). According to Russo, Nahua featherworkers used the Mesoamerican technique

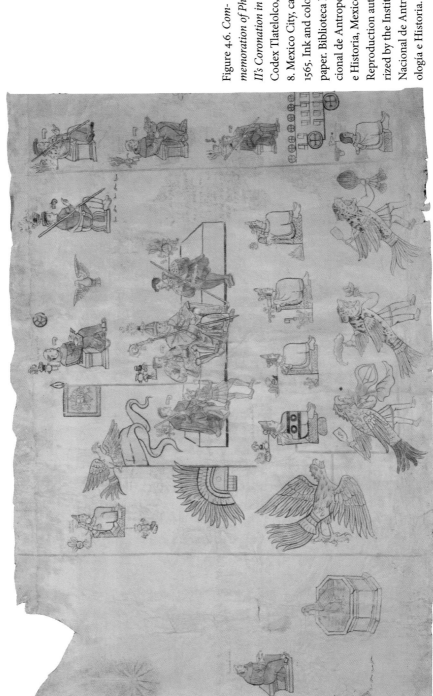

to make religious images shine, replacing the European technique of gilding (Estrada de Gerlero 2015, 302–3).

Indigenous people probably understood the use of feathers by priests and in religious images as an extension of the ixiptlayotl (Stanfield-Mazzi 2021, 122). Among them, feathers also symbolized a concept similar to that of the soul: *yolia* or "the bird of the heart" (Furst 1998, 213). For this reason, feathers were associated with butterflies and birds. In the Catholic religion, the Holy Spirit is represented by a dove, but in New Spain, it was represented by feathers from tropical birds (Russo 2002, 227). The use of featherwork in religious images connected Catholic beliefs to Mesoamerican religions. Although the art of featherwork continued during the viceroyalty, its use in liturgical artifacts began to decline during the second half of the sixteenth century. The trade continued during the seventeenth and eighteenth centuries, but it was used for feather paintings rather than regalia (Alcalá 2015; Stanfield-Mazzi 2021, 165).

An example of a Catholic liturgical artifact decorated with featherwork is a *manifestador* (tabernacle or altarpiece used to exhibit the holy sacrament) decorated with gold and feathers described in the Tlatelolco Codex (figure 4.7). This image is located between the figure of don Martín Quauhtzin Tlacatecatl, Tlatelolco's governor between 1539 and 1545, and that of don Diego Mendoza de Austria Moctezuma, governor of Tlatelolco between 1559 and 1560 (Estrada de Gerlero 2015, 299; Vargas-Betancourt 2015, 268). It is likely that this object was either a gift or tribute from the Tlatelolca to the church; such donation is important because it indicates that the featherwork produced by Tlatelolca artisans had a distinguished role in Mexico City's liturgy during the second half of the sixteenth century.

Diversification

In addition to textiles, yarn, and feathers, Angelina Martina also included other types of goods in her will, such as gourd bowls (*jícaras*), construction material, and even arable land. This suggests that her commercial activities were diversified. In her will, she indicated that she owned twenty-two gourd bowls, which she described as *casi nuevas* (almost new). This could mean either that the gourds were not decorated yet or that they were hardly used. Perhaps Angelina Martina or others in her household would have decorated them, as the Florentine Codex is also vague regarding the distinction between the people who sold gourds and the artisans who made them. Sahagún (1959–69, 10:77–78) and his informants described "the seller of gourd bowls" as a dealer or retailer who brought the gourds from different

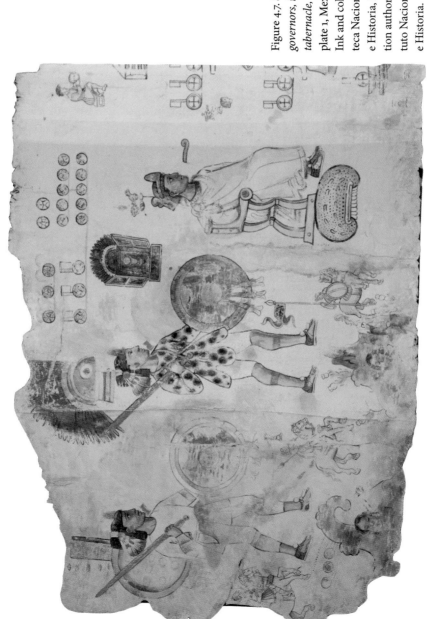

Figure 4.7. *Santiago Tlatelolco governors, including feathered tabernacle*, Codex Tlatelolco, plate 1, Mexico City, ca. 1565. Ink and color on paper. Biblioteca Nacional de Antropologia e Historia, Mexico. Reproduction authorized by the Instituto Nacional de Antropologia e Historia.

regions. However, they also indicated that they were part of the production: "The seller of gourd bowls is an owner of gourd bowls, a dealer in gourd bowls, a retailer. [He is a worker] who removes the [gourd's] bumps, who burnishes, varnishes, paints them. He sells gourds with raised [designs], with stripes, with lines, scraped, rubbed with *axin*, rubbed with [the powdered] fruit pits [of the yellow sapote tree], smoked, treated with oils." Thus, in the colonial account, sellers of gourd bowls not only decorated the bowls but also prepared the fruit for decoration. The most important centers of jícara production were located in Guerrero, Michoacán, and Morelos, next to the Amacuzac and Balsas Rivers. The manufacturing of the gourds was lengthy and complicated. After cultivating and harvesting the gourds, artisans rinsed them in streams for several days. They then scraped the insides and put the fruits out to dry. Then they cut and burnished the gourds. Women assisted men by preparing the substances needed to polish and dye, such as chía oil (Mentz 2020, 57). It is impossible to determine to what degree Angelina Martina and her family were involved in the making and decorating of the jícaras. Maybe they were only the retailers; maybe they decorated the gourds.

In her will, Angelina Martina also bequeathed adobe from a dividing wall and one fathom of stone. The sale of construction material was another economic activity in which women participated. In 1560, the Tlatelolca accused don Baltazar (Azcapotzalco's governor) and his three alguaciles of attacking four Tlatelolca women who were making adobe on the shores of the Santa Cruz marshes (AGN, Tierras, vol. 1, parts 1 and 2). It is likely that they sold the adobe in markets. The Florentine Codex includes depictions of Indigenous women selling lime (Sahagún 1577, bk. 10, fol. 69). Angelina Martina's will suggests that the considerable wealth that women obtained from supplying primary material to both the art world and the construction industry allowed them to engage in other economic activities such as buying and selling real estate, lending money, and hiring out lands for cultivation. In other words, women engaged in multiple diversified activities, primarily from their domestic households.

The Domestic Household

Archaeologists like David Carballo have concluded that the domestic unit was the basic production element of premodern societies. In former theoretical Mesoamerican models, households were conceived of as sites of limited production used for self-consumption, whereas it was believed that full-time artisans undertook specialized production in different settings. More recent archaeological analysis suggests, rather, that intensive, complex, specialized,

and, above all, diversified production took place at the domestic level. Nonetheless, Carballo (2001, 144) points out a distinction between the production of different social classes. Lower classes produced crafts to supplement their income, while elites focused on the intensive production of luxury items that were used to symbolize the power and prestige of the upper class.

Angelina Martina's case fits the revised model. In the description of one of her properties, she indicates that the patio was used as a retailing space. Within households, patios constituted workspaces that included structures for storage and areas to receive people (Alcántara Gallegos 2006, 35–36). She bequeathed most of her land and goods to her grandchildren and great-grandchildren, indicating that households constituted social units. Although kinship was an important bond in these units, the most important connection was a shared economic activity.[15] The list of Angelina Martina's properties is extensive; its description reveals remarkably diversified economic activity. In addition to the patrimonial properties that she had inherited, she had bought thirteen plots of land. Five of them included houses; four included more than one house; and three were located next to causeways, roads, or ditches. The strategic location of this last suggests that the patios of these households were used to produce, finish, or distribute goods that could be sold in the city's markets or to sell those goods in situ. In her will, Angelina Martina noted that she had already sold one of these plots. This fact indicates that she was also involved in the business of real estate. On the other hand, six of her plots were described as *nomilcoal* or land to grow corn. Three of them constituted most of the land that she owned: 13,416 square meters, by modern measures.

In addition to these activities, she also lent money. Angelina Martina stated that she had four debtors who owed her thirty-three pesos in total. She asked that the debts be collected and that the funds be used to pay for masses in two specific sanctuaries: that of Our Lady of Guadalupe and the chapel of San Martín (her namesake and that of her calpulli). Other requests in her will confirm her religiosity. She asked that two hoes be sold and that the money be given to the Brotherhood of the Holy Sacrament; she offered money and two *petates* (reed mats) to the painting of the Holy Trinity on the altar of the pochteca in the Mexico City cathedral; she requested that five plots of land be sold and that the money be used for masses and for several religious institutions. Finally, she requested to be given a Catholic burial and to be dressed with the Franciscans' habit.

Angelina Martina's religiosity was an intrinsic quality of the household system. In the precontact era, pochteca and amanteca shared the same ritual ceremonies. In addition to these public ceremonies, domestic units followed

their own private rituals. These rites constituted one of the most important elements of social cohesion. Each domestic unit was a corporate organization that was essential for economic specialization and for collective landholding. Religious ritual gave a specific identity and affiliation to each household. This bond ensured the participation of all members in the economic activities of the unit. At the same time, domestic rites differentiated households based on their accumulation of land, labor, and wealth, for the rituals connoted each social group's level of access to supernatural knowledge and to divine privilege. Thus, households had altars and religious images in their alleys, patios, and houses (Carballo 2011, 152, 156–57; Alcántara Gallegos 2006, 35–36, 174–76; Lockhart 2002, 67). During her life, Angelina Martina used the veneration of domestic images to strengthen the social cohesion of her family. In her death, she used the same images to corroborate the connection of her household with the colonial religious system, and she did it at all levels: from local *cofradías* (parishioners' associations) to the monastery of her altepetl (Santiago Tlatelolco), to the altar of the pochteca in the city's preeminent church.

Conclusion

The story of Angelina Martina includes different threads that together reveal a distinct picture of how Indigenous women could play important roles related to the arts in colonial Latin America. As a supplier of luxurious raw materials, she enabled the work of "urban women, who were master dyers, spinners, weavers, and embroiders" (Mundy 2015, 56). As a seller of finished products, she ensured their distribution. During the viceroyalty dealers and artisans safeguarded the continuity of precontact art forms that had deep religious, political, social, and military connotations, such as featherwork and textiles. Colonial Indigenous elites continued to use feathers and elaborate cotton capes as social markers during political and religious ceremonies. Feathers continued to reproduce the connection between the earthly and the celestial realms.

The quest to understand the significance of Indigenous women in the art world as well as the broader economy of New Spain has faced obstacles that can now be surpassed due to academic and technological advances. Perhaps the most serious obstacle has been bias. In colonial times, the Spanish patriarchal system was imposed on the description and study of gender roles. Thus, while in Mesoamerica female and male roles were complementary and equivalent, Spanish chronicles described Indigenous women as subordinate. Modern scholarship has followed the same bias. Although Indigenous

women from New Spain do not lack representation in colonial archives (Sousa 2010, 76), these sources need to be revisited and reinterpreted under a different light, such as that provided by interdisciplinary methodologies.

The philological analysis of the Nahuatl terms in the Florentine Codex, the careful analysis of its pictographic content, and the comparison and contrast with the Spanish text reveal contradictory information. Unlike the Spanish text, both the Nahuatl and the pictographic material indicate that Indigenous women played a major commercial role in precontact times, not only as sellers and dealers, but also as leaders. In other words, women could be principal merchants or pochteca. With their male counterparts, they hired and coordinated trips to faraway lands; they planned and performed major ritual ceremonies; they participated in other economic activities; and they accumulated great wealth. The story of Angelina Martina reveals that at least in the early colonial period, merchant Tlatelolca women continued to be fundamental for the world of the arts in the viceroyalty.

Notes

1. Susan Kellogg (1979; 1998, 52–53) analyzed Angelina Martina's will for her dissertation, and discussed it in a later publication. It was published by Luis Reyes García, Eustaquio Celestino Solís, and Armando Valencia Ríos (1996, 190–200) and, in 2004, included by the editors of the renowned series *Vidas y bienes olvidados: Testamentos indígenas novohispanos* in their index to Indigenous testaments at the Archivo General de la Nación (AGN) (Rojas Rabiela, Rea López, and Medina Lima 1999–2004, 5:26).

2. The background panel is an artificial composition that purportedly represents a slave market. Its sources are from the Florentine Codex (Sahagún 1577, bk. 7, fol. 16v; bk. 9, fol. 36 and 58).

3. This section of book 9 was written by Tlatelolca artists who were clearly familiar with this occupation (see chapter 3).

4. The main guests for this banquet were "our mothers, our fathers, the old merchants, the principal merchants" (Sahagún 1959–69, 9:33).

5. Lisa Sousa (2017, 206) indicates that among Tlatelolco principal merchants, there were women who served as judges.

6. "If perhaps already the misery of the nobility dominateth, look well, apply thyself well to the really womanly task, the spindle whorl, the weaving stick. Open thine eyes well as to how to be an artisan, how to be a feather worker; the manner of making designs by embroidering; how to judge colors; how to apply colors [to please] thy sisters, thy ladies, our honored ones, the noblewomen. Look with diligence; apply thyself well as to how heddles are provided; how leashes are provided, how the template is placed. Take care not to fail to know, not to lose through neglect, not to lose through carelessness" (Sahagún 1959–69, 6:96).

7. For the Mexica and other groups located south of the basin of central Mexico, turquoise was a royal stone used to signal *tlatocayotl*, or the power of rulership. See the testaments of Juana Francisca from Tzaqualco in Mexico City (1576); don Miguel Alexandrino,

governor of Tullantzinco (1577); doña Ana de Guzmán, *principal* or noble from Xochimilco (1577); Juan Rafael Tlacochcalcatl from Culhuacan (1581); Mariana, widow of the former (1581); Simón Moxixicoa from Culhuacan (1581); and doña Ana de Santa Bárbara, *cacica principal* (native female lord) of Santo Domingo Tepexi de la Seda (1621) (Olko 2011, 459, 462; 2014, 39–40, 44, 342; Boone 2000, 46).

8. According to Sahagún's informants, principal merchants came from the following Tlatelolco calpulli: Pochtlan, Auachtlan, Atlauhco, Acxotla, Tepetitlan, Itztocolco, and Tzonmolco. Angelina's calpulli, Pochtlan, was the most important; it was the commercial center, and thus its name became the root of the word *pochtecatl*. (Sahagún 1959–69, 9:12; 1997, 495).

9. Such mantles are mentioned in the testaments of Martín Lázaro Pantecatl, from the barrio of Moyotlán in Mexico City (1551); don Julián de la Rosa, *teuctli* (lord) of the royal dynasty of San Pedro Tecpan in Tlaxcala (1566); María Xocoyotl, from Xochimilco (1569); Francisco Xochpanecatl, from Santa María Asunción in Mexico City (1576); doña Petronila de Turcio, from Amequamecan (1625); and doña María Xacoba, from the pueblo of San Bartolomé Actopantonco (1673) (Olko 2011, 460, 462–63).

10. Such attire appears in the Codex Cuetlaxcohuapan (1531–32) and the Mapa de Coacoatzintla (sixteenth century) (Olko 2014, 337–38).

11. The documents do not specify whether these accoutrements were Indigenous or European. It is likely that they were Indigenous despite the European terms because in the colonial period, cotton capes and clothes, formerly restricted to the elites, became common use among Indigenous people (Urquiola Permisán 2004, 209).

12. The Codex Mendoza includes several examples. For the Mexica, such attire was an important part of the cult of war. In fact, suits decorated with feathers to represent predatory animals were given to warriors who had captured a specific number of enemies. The regalia of each suit indicated military rank. For instance, in the Petlacalco altepetl, the ocelotl attire indicated that the warrior had captured four enemies during battle. Thus, these outfits constituted an important incentive in an ideology where war was used to legitimate the power of the elites (Stanfield-Mazzi 2021, 119–22).

13. Rémi Siméon (1977, 585, 692, 695) defines *tlahuiztli* as the weapons and insignia of warriors, and *tlahuia*, which he spells as *tlauia*, as to give light.

14. "As soon as the former passed and settled in their camp, then from the other side the New Spain army entered. They were divided into ten companies, each one dressed with the attire they used in war. . . . All of them wore the best they had in sumptuous feathers, insignia, and shields, for all of the participants in the play were lords and rulers" (Motolinía 1995, 67–68, my translation).

15. In fact, according to James Lockhart (2002, 59), in Nahuatl there was no word for family. Instead, Nahuas connoted the concept with the words for house and patio: *calli* and *ithualli*. These terms referred to the individuals who lived in the same domestic unit, that is, in the houses or rooms that surrounded the same patio.

Reference List

AGN (Archivo General de la Nación), Mexico City. Indios, vol. 4, exp. 52; vol. 12, exp. 119.
———. Tierras, vol. 1, parts 1 and 2; vol. 49, exp. 5.
Alcalá, Luisa Elena. 2015. "Reinventing the Devotional Image: Seventeenth-Century Feather Paintings." In Russo, Wolf, and Fane 2015a, 386–405.
Alcántara Gallegos, Alejandro. 2006. "Las zonas residenciales de Tenochtitlan según las fuentes coloniales." Thesis, Universidad Nacional Autónoma de México.
Anawalt, Patricia Rieff. 1990. "The Emperors' Cloak: Aztec Pomp, Toltec Circumstances." *American Antiquity* 55 (2): 291–307.
Anderson, Arthur J. O., Frances F. Berdan, and James Lockhart. 1976. *Beyond the Codices: The Nahua View of Colonial Mexico.* Berkeley: University of California Press.
Berdan, Frances F. 1987. "Cotton in Aztec Mexico: Production, Distribution and Uses." *Mexican Studies* 3 (2): 235–62.
Berdan, Frances F., and Patricia Rieff Anawalt. 1997. *The Essential Codex Mendoza.* Berkeley: University of California Press.
Boone, Elizabeth Hill. 2000. *Stories in Red and Black: Pictorial Histories of the Aztecs and Mixtecs.* Austin: University of Texas Press.
Caplan, Allison. 2019. "Their Flickering Creations: Value, Appearance, Animacy, and Surface in Nahua Precious Art." PhD diss., Tulane University.
Carballo, David. 2011. "Advances in the Household Archaeology of Highland Mesoamerica." *Journal of Archaeology of Highland Mesoamerica* 19:133–89.
Castro, Felipe, and Isabel Povea, eds. 2020. *Los oficios en las sociedades indianas.* Mexico City: Universidad Nacional Autónoma de México, Instituto de Investigaciones Históricas.
Estrada de Gerlero, Elena Isabel. 2015. "The *Amantecayotl,* Transfigured Light." In Russo, Wolf, and Fane 2015a, 298–309.
Fane, Diana. 2015. "Feathers, Jade, Turquoise, and Gold." In Russo, Wolf, and Fane 2015a, 100–117.
Furst, Jill Leslie McKeever. 1998. "The *Nahualli* of Christ: The Trinity and the Nature of the Soul in Ancient Mexico." *Anthropology and Aesthetics* 33 (Spring): 208–24.
Harris, Max. 2000. "Reconciliaciones disfrazadas: Voces indígenas en los comienzos del drama misionero franciscano en México." In *El teatro franciscano en la Nueva España: Fuentes y ensayos para el estudio del teatro de evangelización en el siglo XVI*, edited by María Sten, Óscar Armando García, and Alejandro Ortiz Bullé-Goyri, 253–64. Mexico City: Universidad Nacional Autónoma de México.
Haskett, Robert. 1985. "A Social History of Indian Town Government in Colonial Cuernavaca Jurisdiction, Mexico." PhD diss., University of California, Los Angeles.
Kellogg, Susan. 1979. "Social Organization in Early Colonial Tenochtitlan-Tlatelolco: An Ethnohistorical Study." PhD diss., University of Rochester.
———. 1998. "Testaments and Trade: Interethnic Ties among Petty Traders in Central Mexico." In *Dead Giveaways: Indigenous Testaments of Colonial Mesoamerica and the Andes*, edited by Susan Kellogg and Matthew Restall, 59–84. Salt Lake City: University of Utah Press.

Klein, Cecelia F. 1982. "Woven Heaven, Tangled Earth: A Weaver's Paradigm of the Meso-american Cosmos." *Annals of the New York Academy of Sciences* 385 (1): 1–35.

Lockhart, James. 2002. *The Nahuas after the Conquest: A Social and Cultural History of the Indians of Central Mexico, Sixteenth through Eighteenth Centuries.* Stanford, CA: Stanford University Press.

Lugones, María. 2010. "Toward a Decolonial Feminism." *Hypatia* 25 (4): 742–59.

Magaloni Kerpel, Diana. 2015. "Real and Illusory Feathers: Pigments, Painting Techniques, and the Use of Color in Ancient Mesoamerica." In Russo, Wolf, and Fane 2015a, 364–77.

———. 2019. "Powerful Words and Eloquent Images." In *The Florentine Codex: An Encyclopedia of the Nahua World in Sixteenth-Century Mexico*, edited by Jeanette Favrot Peterson and Kevin Terraciano, 152–64. Austin: University of Texas Press.

McMahon, Brendan Cory. 2017. "Iridescence, Vision, and Belief in the Early Modern Hispanic World." PhD diss., University of Southern California, Los Angeles.

Mentz, Brígida von. 2020. "Oficios en el medio rural: Una aproximación." In Castro and Povea 2020, 41–70.

Motolinía, Toribio. 1995. *Historia de los indios de la Nueva España: Relación de los ritos antiguos, idolatrías y sacrificios de los indios de la Nueva España, y de la maravillosa conversion que dios en ellos ha obrado.* Mexico City: Editorial Porrúa.

Mundy, Barbara E. 2015. *The Death of Aztec Tenochtitlan, the Life of Mexico City.* Austin: University of Texas Press.

Museo Nacional de Arte. 2012. "'El vuelo de las imágenes': Arte plumario de México y Europa. Marzo 2011." Youtube video, 5:36. Uploaded August 9, 2012. https://www.youtube.com/watch?v=TPZxD9D84ZI.

Nóguez, Xavier. 1998. "El Códice de Tlatelolco: Una nueva cronología." In *De tlacuilos y escribanos: Estudios sobre documentos indígenas coloniales del centro de México*, edited by Xavier Nóguez and Stephanie Wood, 15–32. Zamora, Mexico: El Colegio de Michoacán.

Olko, Justyna. 2011. "Supervivencia de los objetos de rango prehispánicos entre la nobleza colonial nahua." *Revista Española de Antropología Americana* 41 (2): 455–69.

———. 2014. *Insignia of Rank in the Nahua World: From the Fifteenth to the Seventeenth Century.* Boulder: University Press of Colorado.

Pérez-Rocha, Emma, and Rafael Tena. 2000. *La nobleza indígena del centro de México después de la conquista.* Mexico City: Instituto Nacional de Antropología e Historia.

Reyes García, Luis, Eustaquio Celestino Solís, and Armando Valencia Ríos, eds. 1996. *Documentos nauas de la Ciudad de México del siglo XVI.* Mexico City: Centro de Investigaciones y Estudios Superiores.

Robles Álvarez, Irizelma. 2002. "Las ocupaciones de la mujer en el contexto social mexica." PhD diss., Universidad Nacional Autónoma de México.

Rojas Rabiela, Teresa, Elsa Leticia Rea López, and Constantino Medina Lima. 1999–2004. *Vidas y bienes olvidados: Testamentos indígenas novohispanos.* Vols. 2, 3, and 5. Mexico City: Centro de Investigaciones y Estudios Superiores en Antropología Social.

Russo, Alessandra. 2002. "Plumes of Sacrifice: Transformations in Sixteenth-Century Mexican Feather Art." *Anthropology and Aesthetics* 42 (Autumn): 226–50.

Russo, Alessandra, Gerhard Wolf, and Diana Fane, eds. 2015a. *Images Take Flight: Feather Art in Mexico and Europe, 1400–1700.* Munich: Hirmer.

————. 2015b. Preface to Russo, Wolf, and Fane 2015a, 8–19.

Sahagún, Bernardino de. 1577. "Historia general de las cosas de Nueva España." Manuscript, Biblioteca Medicea Laurenziana, Florence. Library of Congress, 2021.

————. 1959–69. *Florentine Codex: General History of the Things of New Spain.* Books 6, 9, and 10. Edited by Charles E. Dibble and Arthur J. O. Anderson. Santa Fe, NM: School of American Research.

————. 1997. *Historia general de las cosas de Nueva España.* Edited by Ángel María Garibay K. Mexico City: Editorial Porrúa.

Silva, Vivian da Veiga. 2021. "Dialogando com as línguas selvagens: Contribuições de Gloria Anzaldúa para pensar o feminismo decolonial." *Revista Ártemis* 31 (1): 336–53.

Siméon, Rémi. 1977. *Diccionario de la lengua nahuatl o mexicana redactado según los documentos impresos y manuscritos más auténticos y precedido de una introducción.* Mexico City: Siglo Veintiuno.

Smith, Michael. 2008. *Aztec City-State Capitals.* Gainesville: University Press of Florida.

Sousa, Lisa. 2010. "Spinning and Weaving the Threads of Native Women's Lives in Colonial Mexico." In *Contesting Archives: Finding Women in the Sources*, edited by Nupur Chaudhuri, Sherry J. Katz, and Mary Elizabeth Perry, 75–88. Urbana: University of Illinois Press.

————. 2017. *The Woman Who Turned into a Jaguar and Other Narratives of Native Women in Archives of Colonial Mexico.* Stanford, CA: Stanford University Press.

Stanfield-Mazzi, Maya. 2021. *Clothing the New World Church: Liturgical Textiles of Spanish America, 1520–1820.* Notre Dame, IN: University of Notre Dame Press.

Sten, María. 1989. *Ponte a bailar, tú que reinas: Antropología de la danza prehispánica.* Mexico City: Editorial Joaquín Mortiz.

Urquiola Permisán, José Ignacio. 2004. "Los textiles bajo el mestizaje tecnológico." In *Mestizajes tecnológicos y cambios culturales en México*, edited by Enrique Florescano, Virginia García Acosta, and Magdalena A. Garcia Sánchez, 203–59. Mexico City: Centro de Investigaciones y Estudios Superiores en Antropología Social.

Valle, Perla, ed. 1994. *Códice de Tlatelolco.* Mexico City: Instituto Nacional de Antropología e Historia.

Vargas-Betancourt, Margarita. 2015. "Land, Water, and Government Conflicts in Santiago Tlatelolco in the Sixteenth and Early Seventeenth Centuries." PhD diss., Tulane University.

————. 2018. "Pochtecas, productoras y vendedoras: Mujeres tlatelolcas en la Ciudad de México durante el siglo XVI." Paper presented at the Coloquio: Los oficios en las sociedades indianas, Universidad Nacional Autónoma de México, Mexico City, October 24 and 25, 2018. https://ufdc.ufl.edu/IR00010635/00001.

————. 2020. "Pochtecas, productoras y vendedoras: Mujeres tlatelolcas en la Ciudad de México durante el siglo XVI." In Castro and Povea 2020, 71–100.

5

The Power of Expertise

Artists as Arbiters of the Miraculous in New Spain

DEREK S. BURDETTE

Artworks believed to be miraculous were central to the visual landscape of New Spain. However, they are rarely the subject of art historical studies that aim to shed light on questions of artistic agency. This makes sense, given that many of the best-known miraculous paintings and sculptures from across colonial Latin America obstinately deny any connection to the artists responsible for their production (Alcalá 2009). While some miraculous artworks began as anonymous devotional images, others shed their connection to known artists gradually. This occurred as their biographies as objects, forged through oral histories and eventually recorded in print, coalesced around a "myth of production" that replaced ordinary acts of artistry with tales of divine apparition, delivery, or repair (Peterson 2005b, 57). Over time, the traces of artistry and authorship that might once have tethered miraculous images to individual painters or sculptors were confined to the archives or lost to the passage of time. As a consequence, art historians have been able to document only sporadic intersections between miraculous artworks and individual artists or artisans active within New Spain. Most often, these occurred when painters were commissioned to create copies, known as *verdaderos retratos* (true portraits), of original images (see chapter 6). However, careful consideration of the archival records reveals another, often overlooked, intersection between miraculous imagery and master artists from the period. On several occasions, starting in the seventeenth century, artists offered their expert testimony as part of the investigative process that confirmed and factualized the miraculous nature of many of the region's most powerful wonder-working images. In such cases, artists were momentarily drawn out of the shadow cast by the miraculous image itself, and placed within the social spotlight of the church's administrative process.

This essay examines three examples of the artistic evaluation of miraculous images from the seventeenth and eighteenth centuries in New Spain, each of which reveals the social dimensions of this practice and helps refine our understanding of how artistic identities were interwoven with the execution of church power during the period. In the wake of the Council of Trent (1545–63), the Catholic Church closely controlled the use of the term *miraculous*, prohibiting the promotion or publication of any accounts of miraculous activity that had not been verified through an exhaustive investigative process. While priests and clergy could investigate many purported miracles on their own, interviewing people about their experiences and compiling dossiers of testimony, they required outside help when it came to physically examining paintings, prints, and sculptures that had reportedly defied the laws of the natural world and thus garnered the attention of the faithful. In those cases, church officials lacked the sufficient experience and expertise to verify whether a sculpture had been repainted or miraculously restored, or whether the sweat found on a printed image was indeed a miraculous humor or instead a resin carefully applied to trick devotees and generate profits. To know such things, they needed the expertise of master artists whose training and experience provided a foundation for judgment and whose membership within artistic guilds and metropolitan workshops attested to their skill and standing in the field. Their expert testimony, like that of eyewitnesses or theologians, was integral to what historian Fernando Vidal (2007) has called the "factualization" of miracles from the period.

Looking closely at several of the best-documented examples of artistic examinations of miraculous imagery in New Spain reveals not only the practical dimensions of this investigative process, that is, how such examinations were carried out, but also the social implications it might have held for all involved. The archival accounts suggest that the expert witnesses scrutinized the artworks in the presence of important church figures before couching their findings within the language of both aesthetics and technical expertise, which together constituted the bedrock of their artistic authority. Those connoisseurial proclamations were further fortified by the performative nature of the artists' examination, through which they showcased their knowledge and skill by physically engaging with the artworks in ways that were legible to witnesses and other onlookers. By touching, scrutinizing, and testing the materials in question, the artists enacted their expertise in ways that are rarely captured within the art historical record. Their actions had direct bearing on both their individual identities and the broader claims that painters and sculptors made to elevate their professions during the period.

The desire to search for traces of artistic subjectivity in the realm of miraculous imagery responds, at least in part, to the call issued by Barbara E. Mundy and Aaron Hyman (2015), appealing to art historians to consider the specific social circumstances that determined the contours of artistic practice across the Spanish Americas. The archival and published accounts of artists' testimonies from New Spain related to miraculous images offer a means for setting aside the traditional approach to evaluating artists and artistic achievement, an approach that centers on the relationship between an artist and his masterpieces. In fact, these cases help bring into focus an aspect of artistic agency in New Spain that had little to do with the act of making art. They allow us to set aside the idea of artists as *makers*, and instead present us with a view of artists as *expert witnesses*. By shifting the lens through which we study their actions, focusing if only momentarily on the cases in which artists served as interpreters of divine intervention, we can expand and extend our understanding of how their authority was generated and how they fashioned their own artistic identities without a brush or chisel in hand.

The *Información Jurídica* and the Factualization of Miracles

Investigations into the veracity of miracles performed by sacred images in New Spain emerged from a complex matrix of faith and skepticism, with origins in the medieval antecedents of early modern Catholicism. Such investigations took as a foundation the belief in miracles, which the historian William Taylor (2016, 309) succinctly describes as "acts of God that defy natural laws." Early modern theologians universally recognized the role that miracles played in rewarding the pious, affirming individual faith, and converting the unfaithful. Trust in the value of miracles was unwavering. Yet those same theologians also knew that people mimicked divine action using mundane trickery, and believed that the devil ensnared the naive and unwitting using his own supernatural powers. Consequently, they espoused a deep skepticism toward many reported miracles, believing they could potentially have been perpetrated by deceitful human actors or the devil himself (Daston 1991, 106–8). The urgency of distinguishing between legitimate miracles and fraudulent acts only increased in the sixteenth century, as Protestant reformers adopted a skeptical disposition toward contemporary miracles, affirming those recorded in the Old and New Testaments while rejecting outright most modern accounts of miraculous activity (Daston 1991, 114). The Catholic response to this challenge was to both affirm the presence of miracles in contemporary society and tighten institutional control over the

oral histories and local cults that surrounded unverified miracles. The Council of Trent explicitly addressed the concern regarding popular, unconfirmed miracles, noting:

> The holy council decrees that no one is permitted to erect or cause to be erected in any place or church, howsoever exempt, any unusual image unless it has been approved by the bishop; also that no new miracles be accepted and no relics recognized unless they have been investigated and approved by the same bishop, who, as soon as he has obtained any knowledge of such matters, shall, after consulting theologians and other pious men, act thereon as he shall judge to be consonant with truth and piety. (Schroeder 1941, 217)

While this passage falls short of an explicit prohibition on enshrining and venerating miraculous imagery without the bishop's approval, it directly juxtaposes restrictions on "unusual image[ry]" and restrictions on new miracles and relics. Together, these restrictions form a clear condemnation of the display and veneration of unverified miraculous imagery, and a call to action for bishops across the Catholic world.

In the wake of the Council of Trent, the church in Spain quickly took up the charge, and during the early seventeenth century diocesan synods in both Toledo and Cuenca reaffirmed the need to police the promotion of unverified miracles. They demanded the removal of all "ex-votos, shrouds, signs [*letreros*] and insignia of miracles worked by such images without notarized testimony [*informaciones*] and approval" (qtd. in Rodríguez G. de Ceballos 2009, 24). In these official decrees we can see the efforts undertaken to distinguish between the behavior surrounding purportedly miraculous imagery and the underlying belief in the capacity of images to act as agents of divine will. Rather than suppressing the cult of miraculous imagery altogether, the decrees were aimed at raising the evidentiary threshold for recognizing miraculous images and making sure that true miracles could be sorted from diabolical and fraudulent inventions. The most important instrument in this process was a large-scale investigation, known in the Hispanic world as an *información jurídica*. The judge of the diocesan court, who held the title of *vicario general y juez provisor*, oversaw these investigations in accordance with Tridentine guidelines. A diocesan attorney, the *promotor fiscal*, collected notarized testimony by witnesses, experts in theology, and, when applicable, master artists.

In New Spain, post-Tridentine concerns regarding the verification of miracles were folded together with specific concerns espoused by colonial authorities regarding the nature and trajectory of religious devotion among

the Indigenous population. The first New Spanish *informaciones jurídicas* date to the 1580s, just decades after the Tridentine decree was issued. In 1582, authorities in Puebla, Mexico, documented the miraculous activity of the diminutive Marian image known as *La Conquistadora* (The Conqueror), which was believed to have acted on behalf of Spanish soldiers during the wars of conquest (Taylor 2016, 48, 83nn55–59). The following year, in 1583, the archdiocese in Mexico City launched an inquiry into the promotion and veneration of the Señor de Totolapan (The Lord of Totolapan), a miraculous crucifix that allegedly perspired during its procession to the Augustinian church in downtown Mexico City (Hughes 2010, 94–97; AGN, Inquisición, vol. 133, exp. 23, fol. 244–94). Nonetheless, these early investigations, which were both intertwined with Franciscan political maneuvering, proved to be outliers within the broader historical trajectory of investigations in New Spain. Decades passed before the next documented investigation occurred. The notable lack of scrutiny around miraculous imagery in the sixteenth century can be explained by a broader aversion to the miraculous in this period. The first waves of mendicant friars, led by the Franciscans, generally "mistrusted the miraculous" and were rarely inclined to verify and promote accounts of images that transcended the laws of nature (Gruzinski 2001, 107; Taylor 2016, 348n23). Mendicant reluctance to embrace the veneration of miraculous images stemmed from the concern that such a practice might be misunderstood by recently converted Indians. To many mendicants, miraculous imagery presented too many resemblances to what they deemed pre-Hispanic idolatry and thus offered the devil an ideal venue for creating false miracles that could lead the innocent astray. It was not until the early seventeenth century, when the initial age of evangelization had concluded and mendicant authority had waned, that cults around miraculous imagery fully blossomed across New Spain.

The historian William Taylor (2016, 65–66, 312–13, 346n16), who has carried out the most comprehensive archival research to date into the veneration of sacred images in New Spain, located archival traces of only twenty-two informaciones jurídicas related to miraculous artworks in the viceroyalty, with nearly three-quarters of those dating to the years between 1639 and 1670. While the number of documented cases is much lower than one might expect given the hundreds of shrines dedicated to miraculous images that flourished in the region, the timing of the investigations makes perfect sense. In the first decades of the seventeenth century, popular devotion to miraculous artworks across central Mexico proliferated and intensified, bolstered by the official recognition of the miraculous power of many images and their promotion in printed histories and hagiographies. As the many miraculous

images in the region experienced a surge in popularity, investigations into the various miracles surged as well. In most cases, the investigations were relatively simple processes that never grew into full-scale informaciones jurídicas. But for a select number of artworks whose popularity and public stature demanded it, church officials effectively held "confirmation hearings" that marshaled the power of the investigative process to legitimize and promote devotions that had organically emerged from a groundswell of miraculous fervor across the region (Taylor 2016, 313). The episcopal judge overseeing such a case searched for textual accounts contemporaneous to the purported miracles, scoured the community to find individuals who could offer testimony, and drew on experts whose skills could be applied to examine and analyze any physical evidence pertaining to the cases. The judge then considered all the evidence and, along with the local bishop and other members of the church administration, issued a ruling regarding the miraculous nature of the artwork in question.

The importance given to the sworn testimony of eyewitnesses and experts, whether they be artists, theologians, or medical doctors, reflects the broader currents of the intellectual and scientific culture of the period. As Vidal (2007, 481) has argued, such testimony was required for "the establishment of 'matters of fact' and for the production of legitimate knowledge" in both the confirmation of post-Tridentine miracles and nascent forms of scientific discourse during the seventeenth century. He also notes that "within the medico-legal economy of miracles, testimony constituted the factualization process par excellence, the ultimate foundation of the empirical existence and epistemic legitimacy of miracles" (Vidal 2007, 495). The testimony of trained artists was a bedrock of the factualization of miracles associated with sacred artworks. Artists were uniquely positioned to decipher the physical clues found in images (in the form of brushstrokes, beads of sweat, and mysterious substances) and offer definitive testimony that could establish the purported miracles as matters of fact. Consequently, these inquiries stand apart from secular investigations into the personal or professional behavior of colonial artists. Such secular investigations help us reconstruct traces of the social lives of those involved and the nature of their profession (see chapter 8), but do not reveal how artistic expertise was integral to the colonial understanding of sacred materiality and divinity.

It is remarkable that artists were drawn so closely and concretely into the center of ecclesiastical authority during these inquiries, given the fact that painters and sculptors historically struggled to establish their professions as intellectual pursuits whose practice would be afforded the prestige that their participation in such inquiries implied. While the first generations

of Indigenous painters trained after the Spanish conquest were often noble members of Nahua society (see chapter 3), the imposition of Spanish ideologies regarding labor and class meant that European conceptions of the status of artists soon took root in the Americas. Indigenous painters and sculptors, starting in the sixteenth century, struggled to differentiate themselves from common laborers, who were subject to greater taxation and financial burdens (see chapter 2). In New Spain, the efforts to distinguish painting as a liberal art rather than an inferior mechanical one intersected with the racialized politics of the viceroyalty, in which Spaniards and *criollos* (American-born descendants of Spaniards) sought to assert their superiority over their Indigenous counterparts and thus to secure the more lucrative commissions. The guild system was a central tool within this campaign. The guild of painters and gilders, which was first established in 1557 and which eventually fell dormant before a brief revival in the 1680s, both elevated the art of painting and effectively limited the participation of Indigenous painters within the elite, metropolitan marketplace in Mexico City (Katzew 2014, 151–56). Similar efforts can be found within the social milieu of New Spain's sculptors, whose labor was initially governed by the carpenters' guild, which was formed in 1568 to regulate professionals in four related fields of woodworking: *carpinteros, entalladores, ensambladores,* and *violeros* (carpenters, sculptors, joiners and altarpiece makers, and luthiers) (Tovar de Teresa 1984; Ruiz Gomar 1990, 35–37). Over time, however, the divisions between these art forms and the discrepancies in status and profitability grew untenable. The guild ordinances were modified in 1589 to meet the needs of the entalladores and ensambladores, whose role in furnishing the devotional sculptures and altarpieces in the region's churches bolstered their social status. Over the next century, these differences continued to grow, as the artists responsible for the creation of the region's altarpieces, by that point referred to as ensambladores and *escultores* (sculptors), depending on the context, accrued greater social influence and earned much more money than other woodworkers (Tovar de Teresa 1984, 7–8; Katzew 2014, 152). It is against the backdrop of this broader campaign by Spanish painters and sculptors to elevate their art forms and to publicly lay claim to the status of intellectual elites that we can return to the expert testimony offered by artists in relation to the region's miraculous imagery in the seventeenth century. The examinations offered unparalleled platforms on which master painters and ensambladores could display the intellectual (rather than manual) aspects of their profession in the presence of many of the most powerful members of colonial society.

Miguel Cabrera and the Influence of the Artist-as-Maker Paradigm

No one capitalized on this opportunity better than the painter Miguel Cabrera, whose eighteenth-century examination of Our Lady of Guadalupe has been the most celebrated encounter between an artist and a miraculous image in New Spain. Cabrera's investigation, which took place in 1751 and involved the formal study of the miraculous icon by the painter and six of his colleagues, was designed to provide indisputable proof of the artwork's miraculous origins by elaborating on the artwork's form and facture from the perspective of the field of painting. According to the apparition narrative that emerged around the image in the seventeenth century, the Virgin Mary appeared to an Indigenous man named Juan Diego just outside of Mexico City in 1531 and filled his *tilma*, or cloak, with flowers to serve as proof of her presence. When he spilled those flowers at the feet of Mexico's first bishop, Fray Juan de Zumárraga, the image of Mary appeared miraculously imprinted on the garment (figure 2.4; Poole 1995, 26–33). This apparition story provided a powerful foundation for the cult and established the image of Our Lady of Guadalupe as having been made without intervention of human hands, outside the realm of human creativity and artistry. During the course of the colonial period the icon evolved into the patroness of New Spain and a symbol of *criollo* pride. No fewer than four formal examinations into the painting's form were undertaken to confirm the veracity of the apparition and to augment the evidence compiled in its favor (Poole 1995, 128–43, 174–78, 204–5; Brading 2001, 169–79, 188–95). Cabrera's 1751 examination of the artwork, though neither the first nor the last such examination, has been the most widely remarked on. This fact can be attributed, at least in part, to the appeal of its artistic protagonist, whose skills for self-promotion and prodigious intellectual and artistic endeavors have made him a darling of New Spanish art history.

Cabrera was an ardent advocate of the profession of painting as well as one the finest practitioners of the art form in eighteenth-century New Spain. As the leading voice in the eighteenth-century campaign to ensure that artists, and in particular painters, were understood as intellectual practitioners of the liberal arts, he lobbied for the creation of an arts academy, picking up where others had failed and eventually laying the groundwork for the foundation of the Academy of San Carlos in Mexico City. He also operated a large workshop that produced a variety of magnificent, and marketable, paintings, ranging from the finest extant set of casta paintings to compelling devotional images and captivating portraits. His prominence and accomplishments, in addition to his social ties and intimate relationship with powerful figures in

the church, surely suggested him in 1751 for the role of examiner of the tilma, which was intended to yield findings that could be, along with a true portrait of the miraculous image, passed along to Pope Benedict XIV in hopes that it would sway His Excellency in favor of recognizing Our Lady of Guadalupe.

Somewhat surprisingly, the most remarkable part of Cabrera's examination of the image is what happened after the actual examination concluded. Five years later, in 1756, Cabrera published an elaborate account of his findings entitled *Maravilla americana, y conjunto de raras maravillas, observadas con la dirección de las Reglas de el Arte de la Pintura en la prodigiosa imagen de Nuestra Sra. de Guadalupe de México* (figure 5.1). In *Maravilla americana* Cabrera presented evidence supporting the tilma's acheiropoietic (i.e., miraculous) nature, while also arguing the merits of painting as a liberal art (Cuadriello 2001b, 189–98; Mues Orts 2001b, 52–59; 2008). At the same time, Cabrera's workshop created numerous paintings that promoted his connection to Our Lady of Guadalupe, including many true portraits of the original tilma and others that celebrated her patronage of the viceroyalty (figure 5.2; Peterson 2005b). Cabrera's creative output and his social connections earned him the chance to examine the image, and he leveraged that chance to burnish his own reputation and advocate on behalf of his fellow painters.

Cabrera's examination of the tilma has offered scholars an unparalleled opportunity to consider the intersection of artistic expertise and miraculous imagery, bolstered by a famous artist, a published text, and a panoply of paintings. But rather than providing a model for thinking about other formal examinations of miraculous imagery in the region, Cabrera's examination and subsequent promotion should be understood as outliers that distort rather than refine our understanding of the broader genre of expert examinations by emboldening deeply rooted, disciplinary desires to structure New Spanish art history around master painters and their masterpieces. This tendency, which has been defined and critiqued in recent years, favors artists whose biographies are knowable and whose intellectual pursuits and creative output support the construction of a heroic biography (Mundy and Hyman 2015, 285). Cabrera's reputation has undoubtedly benefited from this approach, and he has, in some ways, become the best example of an artist whose history can profitably be built around the scaffold of the life-work model. He has been hailed as the "Michelangelo of Mexico," and the life-work model, which provides the logic for several monographic studies of his career, is well suited to the contours of his biography (Palermo 2016; Carrillo y Gariel 1966; Tovar de Teresa 1995). Given Cabrera's stature and visibility, it is tempting to imagine his 1751 examination as a crowning achievement of his biography and an exemplar of the others that came before it. To do

MARAVILLA AMERICANA,

Y CONJUNTO

DE RARAS MARAVILLAS,

OBSERVADAS

Con la direccion de las Reglas de el Arte
de la Pintura

EN LA PRODIGIOSA IMAGEN

DE NUESTRA S^{RA}. DE GUADALUPE
DE MEXICO

POR DON MIGUEL CABRERA,
PINTOR

DE EL ILL^{MO}. S^R. D. D. MANUEL
JOSEPH RUBIO, Y SALINAS,

Dignifsimo Arzobifpo de Mexico, y de el Confejo
de fu Mageftad, &c.

A QUIEN SE LA CONSAGRA.

❈❈❈❈❈❈❈❈❈❈❈❈❈❈❈❈❈❈❈❈❈❈❈❈❈❈

CON LICENCIA:

En Mexico en la Imprenta del Real, y mas Antiguo Co-
legio de San Ildefonfo.
Año de 1756.

Figure 5.1. Miguel Cabrera, *Maravilla americana, y conjunto de raras maravillas, observadas con la dirección de las Reglas de el Arte de la Pintura en la prodigiosa imagen de Nuestra Sra. de Guadalupe de México* (Mexico City: En la Imprenta del Real, y mas Antiguo Colegio de San Ildefonso, 1756), title page. Getty Research Institute, Los Angeles, accession no. 1405-332.

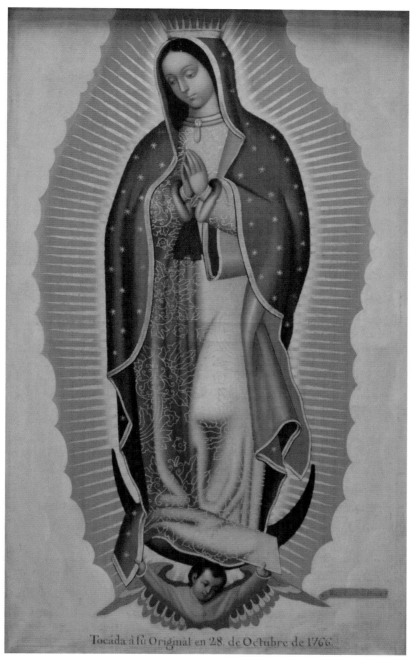

Figure 5.2. Miguel Cabrera, *The Virgin of Guadalupe*, Mexico City, 1766. Oil on canvas, 192 × 107.5 cm. Museo de la Basílica de Guadalupe. Reproduction authorized by the Instituto Nacional de Antropología e Historia.

so would be to fall into the very trap that Mundy and Hyman warn against. When it comes to artists who offered their expert testimony regarding miraculous imagery, Cabrera is an exception; he is the only artist to have published his own account of an examination of a miraculous work, and, even more remarkably, he appears to be the only artist who painted the image he examined. In other words, Cabrera was the only artist whose role of artistic examiner acted as a launchpad for subsequent creative pursuits with a pen and paintbrush. The fact that Cabrera leveraged his examination of the image into subsequent creative acts (writing and painting) has, in my opinion, attracted scholars to it. By triangulating his expert testimony with his painterly output and published account, scholars have been able to nestle him safely into the Eurocentric role of the maker of art, whose biography and oeuvre can be coupled together into a complete narrative. But what about the other artists who examined miraculous artworks, who did not immediately use their acts of expertise as platforms for authorial or painterly production? Those other cases, many of which occurred more than a century before Cabrera's campaign to validate painting as a liberal art, demand a different approach to artistic subjectivity, one that does not adhere so closely to the life-work model and the Vasarian template of art history. In fact, the other cases require a new approach to thinking about how artists performed their expertise in ways that were entirely removed from the act of making art, and yet were part of what it meant to be a practicing artist in colonial Mexico.

Earlier Cases of Expert Testimony and Performative Connoisseurship

Earlier examples of the artistic examination of miraculous imagery reflect a historical context distinct from that underpinning Cabrera's experience, and the very first examination of the tilma, which took place roughly a century earlier, in 1666, offers a perfect site for reconsidering the role of artists as expert witnesses and the ways that they performed their expertise and operated within ecclesiastical structures of power. The examination emerged as a part of the broader effort to secure papal recognition of the miraculous apparition and the dedication of a feast day and mass in honor of the Virgin. To that end, local church leaders began compiling evidence and testimony that could fulfill the Tridentine demand for rigorous factualization of new miracles (Vera 1889, 7). To strengthen their case, doctor don Francisco de Siles, a canon of the *cabildo eclesiástico* (chapter of canons), requested the formation of a panel of "masters expert in the art of painting" who could examine the image and confirm its material composition, the artistic techniques employed in its production, and its authorship, whether mundane or

miraculous (Vera 1889, 132–38). A written account composed by the *notario apostólico y público* (public notary of the archdiocese), Luis de Perea, who recorded and organized the investigative materials for the case, offers us a window into the role that artists played in the process.

On March 13, 1666, a team of seven painters gathered at the Basílica of Our Lady of Guadalupe to scrutinize the image. The group included one painter who was also a practicing priest (Juan Salguero) and six full-time practitioners of the art of painting (Thomás Conrado, Sebastián López de Ávalos, Nicolás de Fuenlabrada, Nicolás de Angulo, Juan Sánchez Salmerón, and Alonso de Zárate). The event drew a large audience, including many of the region's most powerful people, among them the viceroy, the Marqués de Mancera. The dean of Mexico City's cathedral, don Juan de la Poblete, presided over the event, along with two other canons of the cathedral (Vera 1889, 135–36). After the dean celebrated mass, the tilma was lowered from the main altarpiece of the shrine to facilitate its examination. Unfortunately, the notarial account of the inspection provides few insights into the precise methods the seven artists employed in their inspection, simply describing their examination as an "eyewitness examination" (*reconocimiento por vista de ojos*). The verb *reconocer*, from which the event's description was derived, meant "to examine something with care, to find out about something that lacks clarity, or to find out information that is needed" (*Diccionario de Autoridades* 1737, s.v. "reconocer"). Similarly, the idea of a *vista de ojos* was routinely employed within juridical proceedings to describe events wherein official information was acquired on the basis of visual examination, including the surveying of land to delineate ownership or to evaluate its development. Thus, the description of the event as a vista de ojos further cements the act within an official, juridical context of knowledge production. The artists' careful and clarifying examination surely included both visual analysis and physical manipulation of the image to further understand its composition and materiality. The fact that the artists physically engaged with the artwork was made clear near the conclusion of the notarial account, when the notary emphasized that the artists "have touched with their own hands said Painting of the Most Holy Image" in front of the viceroy, the dean, and the cabildo of the cathedral of Mexico City (Vera 1889, 137). Both their physical contact with the artwork and the fact that such powerful people witnessed the event were surely meant to further legitimize their findings.

Based on their expert examination, the artists unanimously confirmed that Our Lady of Guadalupe had been miraculously imprinted on the tilma. To support their conclusion, they articulated four distinct arguments. The first two were rooted in an aesthetic evaluation of the artwork. They argued

that an ordinary artist would have been incapable of creating such a fine and beautiful painting on such a rough canvas, and that the draftsmanship required to have drawn the figure of the Virgin, in particular her hands and face, exceeded the capacity of ordinary artists. The last two rationales turn to material concerns. The artists noted that the precise nature of the pigment visible in the painting defied identification, conforming to their expectations of neither tempera nor oil paint, and that the venerable image did not appear to have aged in the century since it was made. The notary summarized the artists' conclusions: "They have been able neither to find nor discover in it anything that is not mysterious and miraculous" (Vera 1889, 137). In other words, the image was miraculously made using mysterious media.

It is worth considering the social dynamics of the artists' testimony in light of both how the artists acquired their authority and what they gained from their service. Unlike Miguel Cabrera, the experts called on to authenticate and attribute the tilma in 1666 are relatively unheralded by art historians. In fact, Manuel Toussaint (1965, 109–15), who could aptly be called the father of New Spanish art history, noted that all the painters lacked celebrated commissions and extant masterpieces that could elevate them within the field. As a result, he included them all within the second and third ranks of painters from the period, beneath the great masters. Toussaint, like many scholars who have followed in his footsteps, searched for status only within the painterly output of the artists. Yet, their service as expert witnesses regarding the most important artwork in New Spain speaks volumes about their status and authority in the eyes of their fellow artists and those of church officials.

Despite the fact that little is said about the artists within the notarial account of the inquiry beyond their names and their training, some basic facts can be established about their place within New Spanish society. The notary who recorded their testimony referred to the artists as masters of the art of painting (*maestros del arte de la pintura*), while also making careful note of the age and level of experience each artist had gained (Vera 1889, 136).[1] Taken together, the artists leveraged over 137 years of artistic experience. Such an approach to documenting the status of the participants, which carefully counted the years of labor attributable to each individual while making no mention of their masterpieces or their broader biographies, makes clear the locus of their collective authority: practical experience.

Reading into the silences of the archival account we can perceive another, unstated aspect of the artists' identities that suggested them for this particular service: their belonging to the elite community of Spanish and *criollo* painters, whose ethnic identities garnered them an elevated position within the viceroyalty and set them apart from, and above, their Indigenous

counterparts. In contrast to other instances across the Spanish viceroyalties, wherein the ethnic identity of painters or sculptors was central to the way they were discussed and written about within colonial documents (see chapter 6), the notarial account of the painters who examined the tilma leaves this dimension of their identity unmarked. They are called only maestros del arte de la pintura. Previous scholarship has shown that ethnic identity was usually recorded only for non-Spanish artists, and all master artists were presumed to be Spanish or *criollo* unless explicitly designated otherwise (Cohen-Aponte 2017, 79–81). Status as a master artist was, by default, enveloped within the racialized politics of the period. The fact that the painters in the tilma inquiry were either Spanish or *criollo* should not be surprising, given the divisive role played by the guild system, which would be reactivated in the 1680s to help reinforce the boundary between Spanish and native artists. While, as discussed in chapter 2, the tilma is now widely believed to have been painted during the sixteenth century by the Indigenous artist Marcos Cipac de Aquino, the prestigious act of evaluating its artistic origins was not entrusted to Indigenous painters (Peterson 2005a, 585–90; 2014, 114–18). That task, and the social capital it generated for its participants, was granted to members of the Spanish elite. The politics of the viceroyalty and the practices of both faith and artistry were thus wound together and made inseparable.

A second, related case study helps reveal the ubiquity of many of the underlying beliefs and practices that shaped the tilma's investigation. Roughly a decade later, in 1677, church officials undertook another investigation in Mexico City, this time into the sculpted crucifix known as the Señor de Ixmiquilpan (the Lord of Ixmiquilpan) (figure 5.3). The statue was believed to have miraculously renovated itself more than fifty years earlier, in 1621, going from decayed to beautiful without the aid of any human intervention (Taylor 2005; Burdette 2016). The two chaplains who oversaw the Carmelite Convent of Santa Teresa la Antigua, where the statue was housed, requested the formal inquiry into its miraculous nature in order to secure the rights required to promote its veneration. In response to their request, the *juez provisor* (ecclesiastical judge) of the archdiocese, don Juan Díez de la Barrera, began a broad investigation that secured notarized testimony from witnesses, collected written and printed materials related to the statue's renovation, and eventually, in 1679, arranged for an examination of the artwork by a panel of experts (AGN, Indiferentes Virreinales, vol. 862, exp. 5, fol. 1–201).

The collection of artists assembled to examine the Señor de Ixmiquilpan reflects the complex nature of the statue's construction, which combined a lightweight wooden and paper armature with a painted surface. To ensure that the experts could appropriately decipher the material evidence, the juez

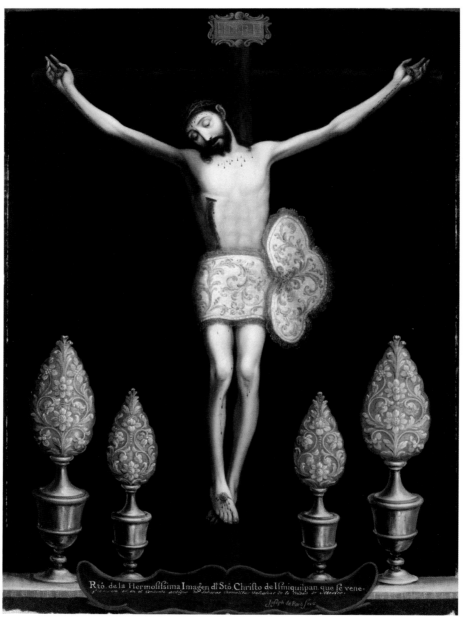

Figure 5.3. José de Páez, *Christ of Ixmiquilpan* (*El Señor de "Santa Teresa"*), Mexico City, circa 1750–60. Oil on canvas, 85.73 × 62.23 cm. Los Angeles County Museum of Art.

provisor called on six artists, including two master joiners and sculptors (*ensambladores y escultores*), two painters of the polychrome surfaces of wooden statues (*encarnadores*), and two easel painters who offered connections to the church and the investigative process. As was the case in the investigation of the tilma, the artists are all referred to exclusively as masters of their various professions, leaving their ethnic identity unmarked and suggesting by inference their membership within Spanish or *criollo* society. Bartolomé de Arenas, the first of the trained painters, was listed as both a master artist (maestro del arte) and member of the clergy. His leadership role within the group was never made explicit, but the fact that he was the only artist to file an individual report suggests a level of autonomy and independence that would align with higher status or privileged rank. Like the priest Juan Salguero, who fulfilled a similar role in the 1666 examination of the tilma, Arenas was likely selected not because of his painterly production but rather because of his dual identity as both a master painter and a priest. Such a background made both Arenas and Salguero ideal intermediaries between the *provisores* and the rest of the artists on their respective panels, ensuring the orderly administration of the events. Their participation in the inquiries also demonstrates how certain artists were able to advance professionally by establishing a firm connection to the divine.

The second painter on the 1679 panel, Juan Sánchez Salmerón, had actually participated in the earlier investigation of the tilma and thus boasted firsthand experience with the investigative process. Interestingly, his performance as both a painter and an expert witness subsequently earned him a more permanent position of power. In 1686, after more than twenty years of practicing his craft within the viceregal capital, he was appointed *veedor*, or inspector of the newly reformed guild of painters (Sigaut 1986, 50–51). In the cases of both Arenas and Sánchez Salmerón, we find painters whose authority originated not in their skill with a brush or their popular commissions, but rather with their social standing as artists with connections to both the church and previous investigations into miraculous artworks. It was social capital, not prolific painterly output, that earned them their places in the investigatory groups.

The four other artists who examined the statue were, by contrast, experts whose training made them uniquely suited to scrutinizing wooden sculptures. That group included Andrés de Fuentes and Joseph Juárez, who were described within the notarial account as *encarnadores*, or painters trained in the polychromy of wooden sculpture. Given that the statue's painted surface was at the center of its miraculous transformation, their inclusion would appear to have been vital. The group also included two sculptors, Antonio

Maldonado and Laureano Ramírez de Contreras, who were described as ensambladores y escultores, referring to their mastery of the art of joinery required to construct elaborate altarpieces as well as their proficiency in sculpting statues in the round. Ramírez de Contreras's biography offers an instructive case study on the value of such expertise. A member of New Spain's *criollo* community, Ramírez de Contreras was born in Mexico City in 1640, and he followed in the footsteps of his father and grandfather, who were both master ensambladores. He trained in his father's workshop in Mexico City, and archival accounts suggest that he was active until his death in 1686, at the age of forty-six. In 1679, the same year that he inspected the Señor de Ixmiquilpan, Ramírez de Contreras accepted a commission for the renovation of the altarpiece of the Convent of Jesús María in Mexico City (Ruiz Gomar 2000, 110). In such a context, Ramírez de Contreras would have worked to undo and repair deterioration within wooden sculptures, granting him firsthand experience in identifying and explaining the very same types of repairs that the panel of experts was looking for in its examination of the Señor de Ixmiquilpan, which had purportedly been repaired miraculously by an act of divine artistry after suffering deterioration and decay. His inclusion in the committee, alongside the other artists trained in the creation and care of wooden polychrome imagery, makes perfect sense. After all, who better to scrutinize the miraculous renovation of a wooden sculpture than the very artists charged with renovating and restoring the aging altarpieces in churches across Mexico City?

The actual spectacle of the artistic examination of the image closely resembled the examination of Our Lady of Guadalupe carried out only a decade earlier, although on a smaller scale. The experts gathered within the statue's chapel along with a number of church officials, including the prioress and other cloistered nuns from the convent, who witnessed the events from the lower choir. The vicario general y juez provisor of the archdiocese, doctor don Juan Cano Sandoval, presided over the event. He, along with other senior clergy, closed the church doors and extracted the statue from its altarpiece, which included a pane of glass designed to make the statue inaccessible to the public. They placed the statue atop a well-lit table that had been erected near the church's main altar to facilitate the examination, and, according to the notarial record, the provisor addressed the artists with an eye toward clarifying their moral obligation and purpose. The account states that "they were made to understand . . . the gravity and importance of the undertaking and that they should proceed devoid of love, affection, and devotion, with only the purpose of fulfilling their mission and explaining their reasoning and motives according to their respective Professions." The artists

swore to faithfully comply with these orders, and then began their "inspección y vista de ojos" (Velasco 1688, 48v–49r). They carefully separated the statue from its cross and set aside the wig and crown of thorns that obscured its head, inspecting the entirety of the figure in search of unassailable proof that would either confirm or disprove its miraculous origins. They turned the statue over, prodded and pressed on areas of interest, and peered into the cavity within the statue's hollow form. After the examination, they testified that the Señor de Ixmiquilpan had been miraculously renovated. The findings were published in the first version of the official history of the image, composed by Alonso Alberto de Velasco (1688, 48–55), which cemented the statue's fame and facilitated centuries of popular devotion to the image.

In their report, the artists testified that they had identified two sets of materials and marks of facture that corresponded to two discrete moments of artistry. The first they attributed to the original creation of the artwork in the sixteenth century, and the second they attributed to an act of divine intervention in 1621. Their testimony regarding the more recent divine act of artistry includes many rhetorical conventions that can be found in relationship to other acheiropoietic artworks. They testified, for example, that not only did their examination uncover irregular materiality that defied the natural laws of age and decay, but it also, more importantly, showed that the miraculous crucifix boasted otherworldly beauty that could only have been achieved by supernatural means. Their testimony reads as follows: "that which pertains to the anatomy is found to be very natural and perfect in all of its measurements and proportions and the body to be of the natural stature of a man, without being able to add a single thing nor find on it an imperfection in any part of the body, from head to toe, and it is recognized to be of great and singular beauty"(AGN, Indiferentes Virreinales, vol. 862, exp. 5, fol. 146r). In Arenas's individual report, he ascribes divine origins to the statue's beauty when he writes, "permit me to piously state that given the great beauty that it has, it appears that his Divine Majesty, for our consolation, created a portrait of himself" (AGN, Indiferentes Virreinales, vol. 862, exp. 5, fol. 143v). Human artists, Arenas reasoned, would have been incapable of crafting such an image.

The accounts of the artistic examination of the tilma and the Señor de Ixmiquilpan both reveal a great deal about the role that artists played as expert witnesses within the broader campaign to determine the limits between divine and human acts of artistry. In both cases, it appears that the outcome was never truly in question, given the widespread public faith in the miraculous origins of the artworks that had precipitated the investigations in the first place. That is not to say, however, that the artists' testimonies did not

matter. On the contrary, their voice was necessary to convert matters of faith, which were already well established among the devotional public, into matters of fact that would be officially recognized by the church. To ensure that their testimonies carried authority and weight, the artists needed to examine the images in ritualized settings that made visible the otherwise invisible (and thus, less credible) acts of aesthetic evaluation underpinning their findings. The artists' public performance of expertise was a key foundation on which the social standing of their testimony was constructed. The archival accounts make clear that the examination of both Our Lady of Guadalupe and the Señor de Ixmiquilpan were carefully staged events that culminated with the public inspection of the miraculous images by the team of artists. Both images were extracted from their altarpieces and made available to the experts in ways that were exceedingly rare. While the laity was almost never allowed to approach or touch miraculous imagery during the early modern period, the artists were granted unfettered access. From a practical perspective, their remarkable access to the images was a precondition for their ability to learn about the images' forms. The artists needed to scrutinize the surfaces of the images, touch them, and visually consider them from various angles. Physically engaging with the artworks was instrumental to their findings.

It was also central to the ritual grammar of the performance of expertise, which ensured that the onlookers believed their findings and invested their testimony with the authority required to determine the outcome of the investigation. To be clear, I do not mean to conflate performativity with duplicity, or to suggest that the artists believed one thing and did or said another; instead, I appeal to the established literature on early modern ritual practices, which affirms that behavior could be simultaneously scripted and sincerely felt and that public performance was integral to notions of faith and piety (Burke 1987; Christian 1982; Webster 1998). Physically connecting with the artwork was the only way that the experts could perform their knowledge before eyewitnesses. Had the artists studied the images alone in a private room and without the rituals of swearing a public oath, celebrating mass, or collectively removing the artwork from its altarpiece, their results would not have been as powerful or persuasive. Had they simply appraised the artworks visually, drawing aesthetic conclusions based on intellectual labor that was not visible to onlookers, their results would not have been as powerful or persuasive. As the artists touched, prodded, or turned over the artworks they *visibly* performed the *invisible* thinking that allowed them to make such audacious declarations. The ritualized and performed aspects of the event ensured a credible context for the production of knowledge that legitimized their findings and elevated their social status.

In both cases the artists' service must have publicly reinforced their social status. Not only did the witnesses appear as preeminent voices representative of their entire professions, but they also showcased their devotion and service to God in front of many of the region's most important people and potential patrons of the arts. Beyond the individual, we can also see that these processes would have had implications for the broader fields of painting and sculpture, for as the painters approached and examined the painted images of the Virgin or the life-size statue of Christ on the cross their participation in the event would have reinforced, if only subconsciously, the notion that painting and sculpture were appropriate media for divine action. The fact that painters and sculptors worked in the same media and with the same techniques as divine actors would have elevated their professions overall.

Artistic Expertise and Empirical Evidence

Artists' expertise was not limited to investigating acts of divine authorship. In fact, experts were more often called on to help determine the validity of the "activation" of ordinary images. In such cases, they focused on the material indices of an artwork's miraculous behavior rather than the question of its divine creation. Artworks that bled, sweat, or changed their form were powerful generators of spiritual, social, and financial capital, and church officials were quick to intervene and investigate reports of local cults emerging around such artworks across New Spain. An artistic inquiry from Mexico City that has received less scholarly attention than the two discussed in the previous section reveals exactly how artists leveraged their experience with relevant artistic media, whether wood, paint, or resins, to authoritatively distinguish between such media and miraculous substances that could be neither identified nor explained. This case reveals how artists engaged with Enlightenment ideas about the importance of empirical evidence that placed them squarely within the intellectual center of the viceroyalty during the late seventeenth and eighteenth centuries.

In 1731, a life-size wooden crucifix known as the Señor de los Desagravios (Lord of the Reparations), belonging to the Count and Countess of Orizaba, experienced a miraculous activation in the immediate aftermath of an earthquake that struck the city (AGN, Bienes Nacionales, vol. 1157, exp. 1; Romero de Terreros 1999; Burdette 2018). While the statue normally hung within the nearby Franciscan convent, it was being temporarily housed at the home of its powerful patrons when the earthquake struck. In the moments after the event, its appearance temporarily changed, taking on a grave pallor, and it perspired both sweat and blood that lingered on the statue's surface.

Perhaps because of the social and political influence of its owners, the provisor launched a full-scale investigation into the artwork's miraculous activation, taking care to adhere to the guidelines set out by the Council of Trent. He quickly collected testimony of witnesses and engaged experts and "pious men" to guide the process. He selected four master artists to physically examine the image. The painters chosen were among the most prominent practitioners of the craft in Mexico City. Francisco Martínez was respected as both a painter and a gilder who had completed numerous large commissions for religious orders in the city. Five years after this investigation, in 1736–37, he would earn further renown for his work gilding the main altarpiece of the Metropolitan Cathedral, and he also designed ephemeral architecture for political rituals in New Spain, including the oath ceremony of Spanish king Fernando VI in 1747 (Alcalá 1999; Katzew 2014, 169–76). In addition to these creative activities, or perhaps because of their successful completion, Martínez would also occupy an important role as an inspector of the Holy Inquisition, starting in 1737. The second painter chosen was José de Ibarra, who in the 1730s was perhaps the only painter in Mexico City of greater renown than Martínez (Mues Orts 2001a). Ibarra, described by the art historian Ilona Katzew (2014, 171) as the "foremost painter of his generation," was a central figure within the history of eighteenth-century painting. He connected those painters who came before him, including Juan Correa and the Rodríguez Juárez brothers, in whose workshops he trained, with subsequent standouts such as Miguel Cabrera, who studied within Ibarra's workshop. Throughout Ibarra's career, he played a central role in the campaign to have painting recognized as a noble art, fashioning his own identity not around the traditional title of master, but instead around the status of "professor of the noble art of painting," which emerged in conjunction with nascent efforts to establish an arts academy in Mexico City (Mues Orts 2001a, 24). Ibarra's rise to prominence also exemplifies the complex calculus surrounding racialized identities in New Spain. For while we now know that he was of African ancestry, Ibarra identified and was understood by his peers as a Spaniard (Katzew 2014, 169). Ibarra's successful racial passing at the same time as he ascended the social ranks of the city's painters is a reminder not only of the fluidity of racialized identities, but also of the de facto connections between artistic authority, race, and colonial perceptions of *calidad*, or quality, which, according to Magali M. Carrera (2003, 6), "included references to skin color but also often encompassed, more importantly, occupation, wealth, purity of blood, honor, integrity, and place of origin" (see also Rappaport 2009). Unlike in other New Spanish contexts, including Cuba and the parts of the Caribbean where free people of color dominated the painterly trade (see

chapter 8), in Mexico City it would appear that to enter the artistic and intellectual elite Ibarra had to leave behind his African ancestry in favor of a Spanish identity that afforded him greater authority.

Alongside these prominent painters, two *maestros de ensambladuría*, or masters of joinery, Juan de Roxas and Salvador de Ocampo, were called to testify to the statue's materiality (AGN, Bienes Nacionales, vol. 1157, exp. 1, fol. 27r–31v). While the art historical scholarship on these altarpiece makers is comparatively thin—reflecting the disciplinary biases that continue to privilege painting over other cognate arts as well as the challenges of reconstructing the authorship of large-scale construction projects such as altarpieces—we can affirm that these artists' profession was widely esteemed at the time (Berlin 1948). Maestros de ensambladuría were powerful actors who oversaw large teams of artists to create architectural sculptures that dominated the churches in which they were housed. Together, the team of painters and altarpiece makers would have been an influential group of artists, whose collective experience offered a powerful foundation on which the process of factualization could rest.

Unlike the inquiries into the Señor de Ixmiquilpan and Our Lady of Guadalupe, which confirmed the nature of events that had happened decades prior and that had long since been codified within popular culture, the artists' examination of the Señor de los Desagravios took place almost immediately after the activation of the statue. Consequently, their testimony played a decisive role in the provisor's declaration that the crucifix had, in fact, behaved in ways that defied the laws of nature and was thus miraculous.

The specter of human deceit lingered throughout the investigation into the Señor de los Desagravios. The artists searched for signs that the purported miracle had been an attempt to pass off paint and resin as blood and sweat. They were looking for fraud, and with good reason. Cases of fraudulent miracles were common during the early modern period, and they cast a shadow of doubt on all reports of activated images across the region. In 1739, a few years after the inquiry into the Señor de los Desagravios, for example, a mestizo *español* named Joseph Somonte, whose family had roots in Mexico but who lived in Manila, Philippines, claimed to be in possession of an image of the Virgin Mary that miraculously perspired. An inspection, the details of which are not elaborated on in the surviving documents, determined that the perspiration was not miraculous after all, but rather the result of Somonte's duplicity. Consequently, Somonte was convicted of being a *milagrero fingido*, or a faker of miracles (AGN, Inquisición, vol. 876, exp. 45, fol. 312–14). He was jailed, subjected to three days of public shaming in front of local churches, and exiled from Manila for two years. Suspicions of

fraud and dishonesty thus haunted every investigation into the miraculous activation of devotional imagery in the Spanish world. The careful study of purportedly miraculous artworks by master artists offered the best way to vanquish those doubts and to rule out the possibility that human actors or artists had manipulated them.

The archival account of the artists' examination of the Señor de los Desagravios reveals that the artists employed a series of physical tests to determine the nature of the materials found on the artwork and used in the artwork's initial execution, effectively generating empirical evidence and formulating knowledge in keeping with Enlightenment ideals. Instead of individual testimonies, the painters and ensambladores crafted collective statements based on their professions. The ensambladores, not surprisingly, focused their attention on the wood from which the statue was crafted, searching for anything that could explain where the moisture might have come from. From their testimony, it is clear that they were searching for evidence that might have suggested fraud. They tapped the statue's surface and examined it for signs of irregularities, holes, or depressions where fluids could have been stored (AGN, Bienes Nacionales, vol. 1157, exp. 1, fol. 28v–29r). They also considered natural causes for the humors, entertaining the idea that the wood from which the statue was carved might have been the source of the moisture. After searching for knots in the wood and other irregularities from which fluid might have seeped, they explicitly ruled out that possibility. Not only would the age of the wood have made it impossible for any moisture to remain, but, as they noted, the varnish applied to its surface would have proved impenetrable and trapped any moisture inside.

The painters, Ibarra and Martínez, offered a similarly thorough examination, searching for evidence that the crystalline and red fluids found on the surface of the statue and the associated textiles were the result of human intervention. They rubbed the wounds of the statue with clean, moist cloth to see whether anything would transfer from the artwork that might show how the previous stains on the cloths had been produced. They did, in fact, note that some residue from the cochineal-based red pigment (*carmín*) used to paint the wounds on the statue transferred, as did some dust that would naturally have accumulated on the statue. Similarly, the two artists sprinkled water on the altar cloths to see how the moisture would discolor the fabric and to compare the marks that water made to the stains from the humors that were wiped from the statue. Despite their expert knowledge of pigments and varnishes, they testified that they could not identify the "liquor, resin, or balm" with which the stains were produced (AGN, Bienes Nacionales, vol. 1157, exp. 1, fol. 30r–30v). All four artists agreed that the humors found on

the artwork were not placed there by an artist or through the use of artistic media.

The case of the Señor de los Desagravios highlights how the artistic experts, who positioned themselves as skeptics in search of malfeasance, carried out a series of tests on the artwork and collected empirical evidence that could prove, without appealing to subjective aesthetic arguments, that the material traces found on the artwork were not indices of ordinary artistic interventions. Their actions reflect the rising tide of Enlightenment thinking, which positioned empirical evidence as the gold standard for knowledge production. Much has been written recently about the intersection of art and the Enlightenment in the Spanish world, and we have come to appreciate how artists created knowledge through still-life paintings, portraits, and botanical illustrations (Katzew 2004; Bleichmar 2012). What we see here is different; in the artistic examination, the artists' connection to science is found not in their creative practice (in their illustrations or paintings) but rather in their social performance of experience and intellect. The distinction is subtle and yet important because it is so easy to overlook dimensions of artistic identities that are not manifested within the artistic record. If we focus only on the paintings by José de Ibarra, for example, however stunning they might be, we miss the nuanced ways in which Ibarra practiced his craft and performed his expertise without a brush in hand, as he poured water onto a cloth or carefully polished a statue to examine the behavior of painted pigments. In this snapshot of Ibarra as an expert, we see how he and the other artists were able to insert themselves into the broader process of delineating the boundaries between the man-made and the miraculous. Through physical engagement with the miraculous image the artists were able to step outside of the arena of aesthetic evaluation and provide powerful testimony rooted in their evaluation of the statue's basic composition. In so doing, they not only drew themselves closer to an artwork that had been imbued with divine immanence, but also demonstrated a powerful proficiency in the broader language of juridical and scientific processes required to establish matters of fact within New Spain.

Conclusion

Painted and sculpted images of the Virgin, Christ, and saints provided the most concentrated and approachable sites of God's presence found anywhere in New Spain. These artworks were central to the experience of divinity for people within the colonial world and, consequently, became incredibly popular and powerful. As their fame increased, the ties that had once bound the

artworks to artists and artistic practices were often severed by stories of miraculous production or activation. Ironically, it was only through the expert testimony of artists trained in painting and woodworking that the artworks could, once and for all, be established as having transcended the laws of nature and entered the realm of the supernatural.

In each of the cases we have examined, the provisor of the archdiocese assembled a panel of master artists to offer testimony that could inform the larger process of factualizing the miracles associated with the artwork in question, selecting painters to interrogate paintings as well as ensambladores and encarnadores for wooden statues. In several cases, clerics who were also trained as artists appear to have been appointed to lead the panel of experts, perhaps to ensure the inquiries' reliability and adherence to Tridentine processes, or perhaps to reinforce the spiritual authority of their findings. The written records of these examinations, however fragmentary, suggest that the artists employed two basic rhetorical approaches to assess miraculous imagery: first, the elevated language of connoisseurship and beauty, and second, the grounded and technical language of artistic media and materiality. In both approaches, the critical element lay in the artists' capacity to authoritatively leverage their experience and expertise into objective facts on which juridical findings could be based. The artists positioned themselves as experts who boasted absolute knowledge regarding their fields of artistic practice and thus the ability to definitively delineate the boundary between human artistry and divine action. They offered collective, rather than individual, testimony that bolstered the legitimacy of their findings. Collective testimony, however, was not the only tack that the artists took to authorize and bolster their conclusions. As we saw in all three cases, the artists performed their expertise by physically engaging the artworks. They touched, turned over, tapped, and rubbed the images in question, effectively demonstrating to witnesses *how* they generated their conclusions and making their intellectual labor more credible. The artists also, as the case of the Señor de los Desagravios makes clear, physically tested the artwork and its materials, attempting to re-create the effects observed on the artworks using known artistic media to generate empirical evidence that met the standards and expectations of the intellectual elite of New Spain. Through these measures, the artists were able to speak authoritatively on behalf of their respective professions, in ways that established their professional opinions as a matter of fact.

These examinations, and others like them, surely generated social capital for the artists, publicly positioning them as experts capable of speaking on behalf of the entire artistic community. To be chosen to consider the nature

of a miraculous image was to be singled out as a voice worth listening to. It was recognized that an artist could distinguish between ordinary and extraordinary beauty, and that he knew his craft so deeply that he could identify when it had been cheated. Such public recognition must have been a rather powerful feather in the cap of any practicing artist. In the end, however, we should resist the urge to use these cases as additional fodder for biographically oriented studies of the individual artists involved. Instead, we should leverage them to think about the unexpected ways that artists might have negotiated their authority. These cases, for example, offer a glimpse into the way that various professionals—including painters, joiners, and altarpiece makers—were called on to offer overlapping and abutting testimony regarding the aesthetics and materiality of wooden sculptures. Instead of a familiar scene of artists enacting established debates about the relative superiority of painting and sculpture or fighting for autonomous governance within different professional guilds, we see in these cases the voices of disparate artists framed within a single category by ecclesiastical authorities. Their collective participation seems to collapse internal difference between artists in favor of a collective notion of expert artists whose commonalities, when compared with medical doctors and theologians, brought them together.

We might also use these cases as a site for thinking more about the intersection of racialized politics, the professional aspirations of painters and sculptors, and the social scaffolding afforded by ecclesiastical bureaucracy. Painters, for example, had long advocated that the safeguarding of devotional and religious artworks was the key rationale underpinning the need to regulate the art of painting. Spanish and *criollo* painters cited the fear of improper or indecent religious imagery painted by Indigenous artists as a principal rationale for the foundation of their guild in the sixteenth century, and invoked it once again in the seventeenth century as they sought to reaffirm the power of the guild (Katzew 2014, 151–52). What we see in these cases is something adjacent to this tactic, as artists adjudicated a line not between ordinary and troubling artworks, but between ordinary and extraordinary ones. While these extraordinary moments surely added to the efforts of painters and sculptors to distinguish their crafts from other, lesser arts, the gains earned by such participation would not have been shared equally among the artists of the region; the artists chosen to serve in the capacity were overwhelmingly Spanish and often already at the top of their profession. Service as arbiter of the miraculous was a type of social confirmation hearing, nestled within the informaciones jurídicas that guaranteed the religious value of a select group of miraculous artworks.

Note

1. The artists' names and experience are listed as follows: Juan Salguero, fifty-eight years old with more than thirty years of experience; Thomás Conrado, fifty-eight years old with eight years of experience; Sebastián López de Ávalos, fifty years old and more than thirty years of experience; Nicolás de Fuenlabrada, over fifty years old with more than twenty years of experience; Nicolás de Angulo, more than thirty years old with twenty years of experience; Juan Sánchez Salmerón, more than thirty years old with fifteen years of experience; and Alonso de Zárate, more than thirty years old with fourteen years of experience. López de Ávalos is the only artist *not* listed as maestro del arte de la pintura, or some variation thereof.

Reference List

AGN (Archivo General de la Nación), Mexico City. Bienes Nacionales, vol. 1157, exp. 1.
———. Indiferentes Virreinales, vol. 862, exp. 5.
———. Inquisición, vol. 133, exp. 23; vol. 876, exp. 45.
Alcalá, Luisa Elena. 1999. "La obra del pintor novohispano Francisco Martínez." *Anales del Museo de* América 7:175–87.
———. 2009. "The Image and Its Maker: The Problem of Authorship in Relation to Miraculous Images in Spanish America." In Kasl 2009, 55–74.
Berlin, Heinrich. 1948. "Salvador de Ocampo, a Mexican Sculptor." *Americas* 4 (4): 415–28.
Bleichmar, Daniela. 2012. *Visible Empire: Botanical Expeditions and Visual Culture in the Hispanic Enlightenment.* Chicago: University of Chicago Press.
Brading, David. 2001. *Mexican Phoenix: Our Lady of Guadalupe: Image and Tradition across Five Centuries.* Cambridge: Cambridge University Press.
Burdette, Derek S. 2016. "Divinity and Decay: The Narrative of Miraculous Renovation and the Repair of Sacred Images in Colonial Mexico." *Colonial Latin American Review* 25 (3): 351–70.
———. 2018. "Reparations for Christ Our Lord: Devotional Literature, Penitential Rituals, and Sacred Imagery in Colonial Mexico City." In *Visualizing Sensuous Suffering and Affective Pain in Early Modern Europe and the Spanish Americas*, edited by Heather Graham and Lauren G. Kilroy-Ewbank, 358–82. Boston: Brill.
Burke, Peter. 1987. *The Historical Anthropology of Early Modern Italy.* Cambridge: Cambridge University Press.
Cabrera, Miguel. 1756. *Maravilla americana, y conjunto de raras maravillas, observadas con la dirección de las Reglas de el Arte de la Pintura en la prodigiosa imagen de Nuestra Sra. de Guadalupe de México.* Mexico City: En la Imprenta del Real, y mas Antiguo Colegio de San Ildefonso.
Carrera, Magali M. 2003. *Imagining Identity in New Spain: Race, Lineage, and the Colonial Body in Portraiture and Casta Paintings.* Austin: University of Texas Press.
Carrillo y Gariel, Abelardo. 1966. *El pintor Miguel Cabrera.* Mexico City: Instituto Nacional de Antropología e Historia.
Christian, William A. 1982. "Provoked Religious Weeping in Early Modern Spain." In *Re-

ligious Organization and Religious Experience, edited by John Davis, 97–114. London: Academic Press.

Cohen-Aponte, Ananda. 2017. "Decolonizing the Global Renaissance: A View from the Andes." In *The Globalization of Renaissance Art: A Critical Review*, edited by Daniel Savoy, 67–94. Boston: Brill.

Cuadriello, Jaime, ed. 2001a. *El divino pintor: La creación de María de Guadalupe en el taller celestial.* Mexico City: Museo de la Basílica de Guadalupe.

———. 2001b. "El Obrador Trinitario: María de Guadalupe creada en idea, imagen y materia." In Cuadriello 2001a, 61–205.

Daston, Lorraine. 1991. "Marvelous Facts and Miraculous Evidence in Early Modern Europe." *Critical Inquiry* 18 (1): 93–124.

Diccionario de Autoridades. 1737. Vol. 5. Real Academia Española. https://apps2.rae.es/DA.html.

Gruzinski, Serge. 2001. *Images at War: Mexico from Columbus to Blade Runner (1492–2019).* Translated by Heather MacLean. Durham, NC: Duke University Press.

Hughes, Jennifer Scheper. 2010. *Biography of a Mexican Crucifix: Lived Religion and Local Faith from the Conquest to the Present.* Oxford: Oxford University Press.

Kasl, Ronda, ed. 2009. *Sacred Spain: Art and Belief in the Spanish World.* Indianapolis, IN: Indianapolis Museum of Art.

Katzew, Ilona. 2004. *Casta Painting: Images of Race in Eighteenth-Century Mexico.* New Haven, CT: Yale University Press.

———. 2014. "Valiant Styles: New Spanish Painting, 1700–1785." In *Painting in Latin America, 1550–1820*, edited by Luisa Elena Alcalá and Jonathan Brown, 149–203. New Haven, CT: Yale University Press.

Mues Orts, Paula. 2001a. *José de Ibarra: Profesor de la nobilísima arte de la pintura.* Mexico City: Consejo Nacional Para la Cultura y las Artes.

———. 2001b. "Merezca ser hidalgo y libre el que pintó lo santo y respetado: La defensa Novohispana del arte de la pintura." In Cuadriello 2001a, 29–59.

———. 2008. *La libertad del pincel: Los discursos sobre la nobleza de la pintura en la Nueva España.* Mexico City: Universidad Iberoamericana.

Mundy, Barbara E., and Aaron Hyman. 2015. "Out of the Shadow of Vasari: Towards a New Model of the 'Artist' in Colonial Latin America." *Colonial Latin American Review* 24 (3): 283–317.

Palermo, Melisa. 2016. "Miguel Cabrera, *Virgin of the Apocalypse.*" Smarthistory, August 27, 2016. https://smarthistory.org/cabrera-apocalypse/.

Peterson, Jeanette Favrot. 2005a. "Creating the Virgin of Guadalupe: The Cloth, the Artist, and Sources in Sixteenth-Century New Spain." *Americas* 61 (4): 571–610.

———. 2005b. "The Reproducibility of the Sacred: Simulacra of the Virgin of Guadalupe." In *Exploring New World Imagery*, edited by Donna Pierce, 43–79. Denver, CO: Denver Art Museum.

———. 2014. *Visualizing Guadalupe: From Black Madonna to Queen of the Americas.* Austin: University of Texas Press.

Poole, Stafford. 1995. *Our Lady of Guadalupe: The Origins and Sources of a Mexican National Symbol, 1531–1797.* Tucson: University of Arizona Press.

Rappaport, Joanne. 2009. "Mischievous Lovers, Hidden Moors, and Cross-Dressers: Passing in Colonial Bogotá." *Journal of Spanish Cultural Studies* 10 (1): 7–25.

Rodríguez G. de Ceballos, Alfonso. 2009. "Image and Counter-Reformation in Spain and Spanish America." In Kasl 2009, 15–35.

Romero de Terreros, Manuel. 1999. "El Milagro del Cristo de los Desagravios." In *La Casa de los Azulejos*, edited by Carla Zarebska, 41–45. Mexico City: Sanborn Hermanos.

Ruiz Gomar, Rogelio. 1990. "El gremio de escultores y entalladores en la Nueva España." In *Imaginería virreinal: Memorias de un seminario*, edited by Gustavo Curiel, 27–46. Mexico City: Universidad Nacional Autónoma de México.

———. 2000. "Nuevas noticias sobre los Ramírez, artistas novohispanos del siglo XVII." *Anales del Instituto de Investigaciones Estéticas* 22 (77): 67–121.

Schroeder, Henry Joseph, ed. 1941. *Canons and Decrees of the Council of Trent*. Saint Louis, MO: B. Herder.

Sigaut, Nelly. 1986. "Altar de la Divina Providencia." In *Catedral de México: Patrimonio artístico y cultural*, 44–57. Mexico City: Secretaría de Desarrollo Urbano y Ecología y Fomento Cultural Banamex.

Taylor, William. 2005. "Two Shrines of the Cristo Renovado: Religion and Peasant Politics." *American Historical Review* 110 (4): 945–74.

———. 2016. *Theater of a Thousand Wonders: A History of Miraculous Images and Shrines in New Spain*. New York: Cambridge University Press.

Toussaint, Manuel. 1965. *Pintura colonial en México*. Mexico City: Imprenta Universitaria.

Tovar de Teresa, Guillermo. 1984. "Consideraciones sobre retablos, gremios, y artífices de la Nueva España en los siglos XVII y XVIII." *Historia mexicana* 34 (133): 5–41.

———. 1995. *Miguel Cabrera: Pintor de cámara de la reina celestial*. Mexico City: InverMéxico.

Velasco, Alonso Alberto de. 1688. *Renovación por si misma de la soberana imágen de Christo Señor Nuestro Crucificado, que llaman de Ytzmiquilpan*. Mexico City: Viuda de Francisco Rodríguez Lupercio.

Vera, Fortino Hipólito. 1889. *Informaciones sobre la milagrosa aparición de la santísima Virgen de Guadalupe, recibidas en 1666 y 1723*. Amecameca, Mexico: Imprenta Católica.

Vidal, Fernando. 2007. "Miracles, Science, and Testimony in Post-Tridentine Saint-Making." *Science in Context* 20 (3): 481–508.

Webster, Susan Verdi. 1998. *Art and Ritual in Golden Age Spain*. Princeton, NJ: Princeton University Press, 1998.

6

The Brush and the Burin

Copies, Originals, and True Portraits in Juan María de
Guevara y Cantos's *Corona de la divinissima María* (Lima, 1644)

EMILY C. FLOYD

In colonial Latin America the question of the identity and agency of the artist is bound to the question of the copy. It is not unusual to know more about the European print sources that informed the iconography of a work than about the artist who created it.[1] When the printed source becomes the interpretative key for understanding a work of art, the artist risks being reduced to a producer of reproductions, a mechanical hand without individual agency. Indigenous artists in particular are frequently difficult for modern scholars to identify, in some cases because they left their works unsigned and no surviving contracts attest to their authorship, but in others because colonial chroniclers writing about miracle-working images chose not to name the artists who made the statues or paintings at the center of their narratives. Some of these works, understood as "true portraits," purport to faithfully reproduce the appearance of their original, be it a saint, Christ, the Virgin Mary, or an existing painting or sculpture; the diminishment of the artist helps facilitate this claim of reliability as the human hand could add ingenuity or error into the equation, raising doubts about the ultimate reliability of the copy (Alcalá 2009, 56).

Juan María de Guevara y Cantos's 1644 devotional text *Corona de la divinissima María* includes an example of the production of a true portrait, even as it contains suggestive details hinting at the unreliability of its own narrative. Guevara y Cantos, a Spaniard sent to South America by the Spanish Crown to serve as an administrator in the towns of Mariquita, Cuenca, and later Guayaquil, describes his research into mystical sources and the writings of the church fathers to access the Virgin's lived appearance, as well as his efforts to produce a painting reproducing that appearance. He tells how, while

he was in the northern Andean city of Cuenca, the Virgin sent him an *indio pintor* (Indian painter) to produce the painting, and how he ultimately found a goldsmith in Lima who cut plates for engravings to illustrate his *Corona*, including a large, fold-out print reproducing his true portrait of the Virgin. In the *Corona*, Guevara y Cantos leaves both artists unnamed, but the chance survival of a single impression of the engraved version of the true portrait, which I discovered in the collection of the George A. Smathers Libraries at the University of Florida in 2015 (figure 6.1), permits us to problematize the conventional colonial narrative of anonymous production. The engraver, Diego de Figueroa, preserved his own name for posterity in his signature on the print. I identify the painter based on stylistic grounds and archival evidence as the *quiteño* (from Quito) painter Mateo Mexía.

Figueroa's engravings for the *Corona*, which include charts, emblems, and diagrams in addition to the true portrait, are perhaps the only prints made in colonial Lima for which we can trace a patron (Guevara y Cantos), a likely inventor or designer (Mexía), and a plate cutter (Figueroa). Figueroa's true portrait print is also one of the only known prints made in the colonial Andes replicating the iconography of a painting that was not already an established cult object. Colonial Andean painters often used engravings as models, but we have few examples of reproductive engravings after iconographies invented in the New World, comparable, for example, to reproductive engravings of iconographies by Flemish painters Peter Paul Rubens and Maerten de Vos (Hyman 2021; Porras 2016). When considered together, the *Corona*'s text and images, the archival evidence, and the testimony of surviving paintings by Mexía offer a clear-cut example of the colonial origins of the copy/original narrative of colonial artistic production while simultaneously manifesting the cracks within that same narrative. The *Corona* and its affiliated materials challenge characterizations of the Andes as a place in which artistic originality was largely absent by presenting an alternative understanding of the concept. In contrast to common art historical characterizations of originality as the unique invention of a single artist, this is an originality steeped in and reliant on tradition. The innovative nature of the true portrait is based on Guevara y Cantos's combination of theological inquiry and artistic patronage. He employs careful analysis of textual sources alongside direct and indirect forms of divine revelation to draft a written description of the Virgin's physical appearance, which he then commissions a painter to use as a model to create a previously nonexistent iconography. In contradiction to Guevara y Cantos's description of how his true portrait came to be, which diminishes the agency of the artists in shaping the appearance of the final works, it is in fact an originality conveyed not by mute, mechanical hands, but by artists

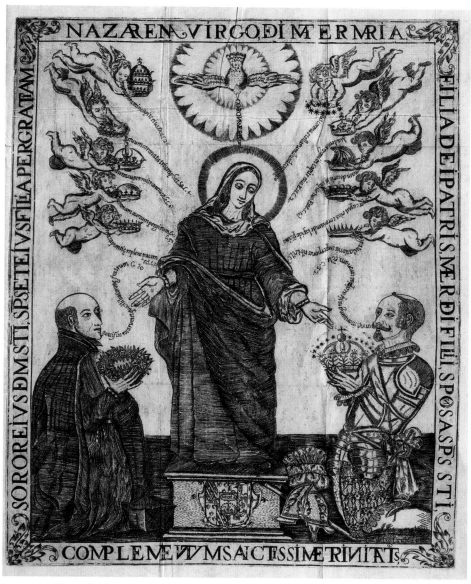

Figure 6.1. Diego de Figueroa after Mateo Mexía, *True Portrait of the Virgin Mary*, Lima, 1644. Engraving, 27.4 × 21.5 cm. The Harold and Mary Jean Hanson Rare Book Collection, Special and Area Studies Collections, George A. Smathers Libraries, University of Florida, Gainesville.

who contributed their own knowledge, technical experience, and stylistic preferences to the final product.

The Perspective of the Patron

One of the most remarkable aspects of the *Corona* is Guevara y Cantos's evocative account of the production of the initial painting. Guevara y Cantos (1644, "Retrato," fol. 12r–13r) describes how, in 1642 in Cuenca, a painter stood poised before a canvas, his brush hovering above the surface, as he awaited the author's signal to begin work on the face of the Virgin Mary.[2] This account allows us to imagine the physical, embodied relationship between artist and patron in a specific space (Guevara y Cantos's home in Cuenca) at the time of the completion of the face of the Virgin (one o'clock in the afternoon on August 2, 1642), and their interaction with the materials before them (the paintbrush and the canvas, already prepared with a sketch of the face of the Virgin). According to Guevara y Cantos's (1644, "Retrato," fol. 9v) description, the large canvas (3 × 2.5 *varas*, or approximately 2.5 × 2.1 meters) at which the *indio pintor* stood in that crucial moment of tension would have allowed for a life-size representation of the Virgin standing on a pedestal with the dove of the Holy Spirit hovering overhead, as well as two life-size kneeling donor figures (the author and his Jesuit brother) before her and a flock of putti encircling her head. The Virgin's face, once completed and not including her hair or veil, was about eighteen centimeters long (Guevara y Cantos 1644, "Retrato," fol. 12v). Given the scale of the canvas, the painter must have stood on a stool to reach the location of the Virgin's face.

Guevara y Cantos lingers on the moment when the tip of the paintbrush was about to touch the surface of the canvas. In his description, the scene is heavily ritualized. He prepared himself that morning by (paying for and) attending several masses dedicated to the Virgin, and then knelt next to the painter and prayed fervently from the Song of Songs, mirroring in his physical position the way donor figures are traditionally presented in paintings, and indeed the way he himself was to be represented in the finished work. He instructed the painter to wait to touch the brush to the canvas until he heard the crucial phrase, "Tota pulchra es amica mea, & macula non est in te. Veni de Libano sponsa mea, veni de Libano, veni CORONABERIS" (You are all pure my friend, and have no stain in you. Come to Lebanon, my bride, come to Lebanon and be crowned) (Guevara y Cantos 1644, "Retrato," fol. 12v). At "coronaberis," on cue, the painter's brush broke the tension, crossed the short distance to the canvas, and began to shape the outlines of the Virgin's face. Guevara y Cantos's (1644, "Retrato," fol. 8v–9v, 13r) account evokes a precise

space and time. He includes in the extended passage details that further allow the reader to envision the setting and sequence of events. He describes how, prior to the production of the painting, he prayed to the Virgin to reveal to him her exact measurements; how he bought an existing painting of Santa Inés (Saint Agnes) to be painted over and to serve as the support for his new work; how, after the completion of the work, he added a title board to the painting with the text "Virgen de Nazareth MARÍA Madre de Dios"; and how he ordered a mass to be sung in honor of the true portrait and afterward had the portrait placed on an altar with a sumptuous curtain to cover it.

All of this, as well as the naming of dates and times at which things happened and the specification of precise measurements, seems calculated to convince us of the immediacy, reliability, and authenticity of Guevara y Cantos's account. The "Retrato" (Portrait) section, which includes this narrative, is a patchwork of genres—including elements of a theological treatise, a devotional guide, a personal narrative, a letter, and an image chronicle. The image chronicle, Guevara y Cantos's story of the creation of the painting, mirrors other colonial chroniclers' hagiographic stories of the production of miracle-working paintings and sculptures, many of which were being written in this same mid-seventeenth-century moment (Alcalá 2009, 56). Guevara y Cantos attributes the successful realization of the image, for instance, not to the artist, but rather to his own ritualized actions of prayer and to the subsequent intervention of the Virgin Mary. In Guevara y Cantos's account, the artist is a minor figure, unnamed and underdeveloped. Although Guevara y Cantos does not tell us of any miracles performed by the painting he commissioned, his narrative nonetheless seems intended to allow for the possibility that his *Corona* might facilitate devotion to the painting. In order for it to do so, he needed to create a story in which there would be no competition between object and artist, in which the artist's contribution was of minimal significance to the final appearance of the work. Guevara y Cantos's description of the painter's reaction upon viewing the finished sketch of the Virgin's face confirms this understanding. He writes, "The painter was left with so much admiration, and tenderness, and he said that *he did not know how he had painted that holy portrait*: truly the Most Divine Mary had deigned to favor our desires" (Guevara y Cantos 1644, "Retrato," fol. 13r, emphasis added).

The disconnect Guevara y Cantos (1644, "Retrato," fol. 8r) expresses between prior depictions of the Virgin and his own rests in his definition of portrait. As he writes, "a Portrait is that in which is seen the physiognomy, actions, habits, practices, condition, face, and size of this Divine Lady; [a] Portrait that appears to be such a living image, that in some manner it can

make up for the absences, of its original." This definition is aligned with the moment in which he was writing—beginning in the fourteenth century, people increasingly expected portraits to represent people as they appeared in life, that is, mimetically. As Jessica Winston (1997, 60–61) has discussed, this development had important implications for how authors started to think about the appearance of the Virgin. Guevara y Cantos (1644, "Retrato," fol. 12v–13r) offers a detailed description of the Virgin's physiognomy, writing how, in the completed painting, her "somewhat elongated face" miraculously appeared exactly as it had been described by the saints and the Greek and Latin fathers: "her face, aquiline, olive-skinned, beautiful, grave, calm, and honest, her eyes large, the eyebrows black and arched, the nose long in its correct proportion, the mouth small, and beautiful, the lips like carnations, and the hair a light chestnut color." He additionally tells us of her long fingers, of her body, neither thin nor fat, and of her height, a little under two varas (approximately 1.7 meters) (Guevara y Cantos 1644, "Retrato," fol. 1v). Guevara y Cantos's description has its idiosyncrasies, but it is inspired by the ninth-century monk Epiphanius's description of the Virgin's appearance in his *Life of the Virgin*, a text that served as the primary reference point for most accounts from the fourteenth century onward (Winston 1997, 92). He also pays close attention to her proportions, specifying that the painted Virgin be divided into nine heads, resulting in a long, elegant body. This attention to the Virgin's corporeal appearance is important to the development of a true portrait, but for Guevara y Cantos (1644, "Retrato," fol. 1r, 8r), if the image were to be "faithfully copied from its original," it also needed to represent her daily "habits, practices, [and] condition." Such elements are rarely evoked in depictions of the Virgin, which tend to show her as she might have appeared on special occasions or manifested in radiant splendor as Queen of Heaven. It is for this reason that his painting was to show the Virgin in a rough, undyed wool robe with a white linen veil and shift (Guevara y Cantos 1644, "Retrato," fol. 2r, 11v). While other paintings display temporary flashes of sartorial magnificence and divine beauty, Guevara y Cantos intended his painting to represent the consolidation of many average moments of ordinary life. In merging theological reflection on the likeness of the Virgin with artistic patronage, Guevara y Cantos took an approach that was unusual if not unprecedented in the period. Although Guevara y Cantos's description of the Virgin bears much in common with theological reflections on the appearance of the Virgin penned by contemporary authors, primarily members of the religious orders, previous writers did not translate their writings into paint and canvas. Theological descriptions of the Virgin seem to have had minimal impact on how she was represented, perhaps in part because a

separate professional genre of writing on art also emerged at this time and was perceived as more useful to artists and patrons than were prescriptive theological texts (Winston 1997, 161–64).[3]

In his discussion of the production of the engraving, Guevara y Cantos continues to struggle with the challenge of creating a faithful "copy" of the Virgin's divine "original." In his references to the engraving, Guevara y Cantos again provides us with precise details that grant his account specificity and suggest its particularity in addition to its universal qualities. Although he does not name Figueroa, he does tell us the engraver's profession (a goldsmith), and offers a somewhat negative assessment of the quality of his work. Immediately following his account of how he had the finished painting placed on an altarpiece with a curtain to protect it, Guevara y Cantos (1644, "Retrato," fol. 13v) writes:

> I had a plate cut reducing the nine parts [referring to the aforementioned division of the Virgin proportionally into nine heads] to seven, because some authors say seven, others eight, and others nine. . . . It has been like a miracle, that a goldsmith, because here there are no masters as in Madrid, or other cities, who have [engraving] as a profession, has put [the engraving] in its final state: I wish that it had come out so perfect as to supply some of the divine beauty of its original.

In Guevara y Cantos's assessment, Figueroa's engraving is merely adequate, and here, as with the painting, it is "like a miracle" that a goldsmith is able to produce the plates.

The adjustment of the proportions of the Virgin from nine heads to seven calls into question the relationship between engraving and painting, and between the two images and the Virgin Mary herself. Despite his meticulous attention to detail—the Virgin's exact height, and the precise qualities of her hair, skin, eye color, and attire—Guevara y Cantos here seems to concede the futility of his endeavor. This recognition reflects a tension inherent in many accounts of true portraits. Often a single narrative praises the perfection and supreme beauty of an image and simultaneously expresses profound doubts about the viability of producing a true reproduction or portrait (Bargellini 2004, 88–89). Colonial chronicles are rife with expressions of the impossibility of copying the divine face of a deceased holy figure, or of perfectly reproducing an already existing painting or sculpture (see, e.g., Buendía 1676; Floyd 2019, 374).

Guevara y Cantos's struggle to produce his true portrait of the Virgin reflects the centrality of the copy in colonial chronicles of miracle-working images. Guevara y Cantos's preoccupation is to reproduce exactly the lived

appearance of the Virgin, to copy the absent and ultimately unknowable and inaccessible original to which all of these images referred. Within this context, removing or downgrading as much as possible the element of human caprice becomes that much more crucial. This approach would be taken to its logical conclusion in mid-seventeenth-century accounts of the apparition of the Mexican Virgin of Guadalupe (see chapter 5). Already in the first printed account, published in 1648, just a few years after the *Corona*, Miguel Sánchez ascribed the reliability of the *tilma* (cloak) image to its having been being made without human hands (Cuadriello 2001, 127, 157). Later, in 1666, Luis Becerra Tanco would characterize the production process as one of "impression"—the rays of the sun "stamping" the Virgin's image onto the cloth (Cuadriello 2001, 179–80). Given his own proximity to and involvement in the production of his true portrait, Guevara y Cantos was unable to assert its nonhuman facture. Instead he sought to supersede all existing images of the Virgin Mary by combining careful research into patristic sources with recourse to the Virgin's guidance and intervention. His detailed and highly specific descriptions of the different moments of production of the painting and of the final appearance of the work bolster his account's claim to reliability and accuracy. Yet, Guevara y Cantos's account is a narrative in which the author is the only human agent of note, and where much of the credit goes to supernatural intervention. Guevara y Cantos offers a new perspective on the true portrait genre, but he couches it within the established conventions of the miracle-working image chronicle (Alcalá 2009, 56). These familiar accounts, of divine agency taking primacy over human, diminishing in particular the role of the artist, scaffold what is unusual in Guevara y Cantos's narrative within accepted frameworks. Guevara y Cantos's account and its supporting narrative are not, however, the only stories of production regarding the *Corona* true portrait. Indeed, the visual and archival evidence attesting to Mexía and Figueroa's contributions largely contradicts Guevara y Cantos's production narrative.

The Engraving and the Painting

The original *Corona* painting does not survive, so we cannot analyze its brushstrokes or consider a potential artist's signature as evidence of the hand of the maker. Nor can we assess pentimenti—modifications to the preparatory drawing or last-minute decisions to change the placement of the hands or the shape of eyes—either via modern scanning techniques or from the visible evidence on the canvas. Instead, our best sources for understanding the

appearance of the painting are Guevara y Cantos's description and Figueroa's engraving.

Figueroa's engraving has a complex composition of multiple figures and iconographic elements, all organized symmetrically along a central vertical axis (figure 6.1). The three main subjects—the Virgin at the center, standing on a plinth adorned with Guevara y Cantos's coat of arms, and the two donors, Guevara y Cantos and his Jesuit brother, kneeling to either side of her—appear in static, stiff poses. The artist has individualized the donors' appearance by careful attention to their coiffures and facial hair: the Jesuit's stubble and his brother's curling mustache, abundant sideburns, and bald patch. The sash across Guevara y Cantos's breastplate declares his elite status as Cuenca's governor (Tobias Campbell, pers. comm., 2019). The exuberant presence of text threatens to overwhelm the donors, Virgin, and putti. Words in lowercase script within the body of the work pulse agitatedly through the air, as if pulling the surrounding figures toward the Virgin at the center of the piece. By contrast, the text in bold capitals embedded within the border monumentally frames and constrains the frenetic energy of the internal composition. Figueroa seems to have delighted in engraving the ornate details of the kneeling Guevara y Cantos's armor, the elaborate patterning of his breeches with their lacey edges, the curling foliate ornament at the corners of the frame, and the intricate curlicues, diamonds, and flowers of the twelve crowns born aloft by the donors and putti.

Figueroa's composition and handling of the figures distinguish this work from most contemporaneous colonial *limeño* (from Lima) engravings. His engraved lines are weighty, unmodulated in thickness. He constructs volume and form through dense parallel lines, alternating their direction to suggest curving, rounded shapes or the undulations of fabric. He only occasionally employs crosshatching, and when he does so it is primarily at edges or across flat planes. His emphasis seems to be more on creating richly patterned surfaces and less on capturing the appearance of real bodies within space. By contrast, the only other engraver in Lima working with any kind of consistency at this moment, the Augustinian friar Francisco Bejarano, had a delicate touch with the burin, cutting fine, hair-thin lines and depicting figures with sweet, gentle expressions (figure 6.2; Floyd 2018a, 87; 2019, 365–68, 375).

Although the *Corona* engraving is unusual, it is not unique; many of its distinctive features also appear in the work of the seventeenth-century quiteño painter Mateo Mexía, the artist whose work likely served as the model for the engraving. Although Guevara y Cantos describes his painter as an *indio pintor*, Mexía's ethnic identity, as I explore later in this essay, is

Figure 6.2. Francisco Bejarano, frontispiece to *Santuario de N. Señora de Copacabana en el Peru: Poema sacro*, by Fernando de Valverde, Lima, 1641. Engraving, 18.65 × 12.3 cm. John Carter Brown Library at Brown University.

uncertain in the archival record (Webster 2017, 186–88). Mexía signed two surviving canvases, and two additional works have been attributed to him on the basis of style. He was active from 1612 to 1662 and had traveled beyond Quito on a commission at least once prior to his potential journey to Cuenca in 1642. From 1628 to 1632 he was in Riobamba, about halfway between Quito and Cuenca, on commission to produce twelve large paintings for the main altarpiece of an Augustinian monastery (Webster 2017, 186, 189–90). It would not, then, have been unprecedented for him to travel to Cuenca to fulfill Guevara y Cantos's commission. Indeed, he completely disappears from the archival register in Quito between 1640 and 1651, just when he might have been in Cuenca. He returned to Quito from an unspecified location in 1652 (Susan Webster, pers. comm., 2020). Like the painting described in the *Corona*, Mexía's extant and documented works are canvases of unusually large dimensions, featuring complicated multifigural compositions (figures 6.3, 6.4, and 6.5). These works are characterized by "complex composition, axial organization, frozen iconic poses, hierarchies of scale, stylized anonymous faces, and above all the liberal application of illusion-shattering gold leaf and lettered texts to the painted surface" (Webster 2017, 195).

Aside from the gold leaf, all these elements could likewise be used to describe Figueroa's engraving. It is organized around the Virgin as its central axis and possesses an elaborate composition. The figures are positioned stiffly and conventionally; the faces, aside from the donors' facial hair, are stylized and generic, and the texts, abundant. A comparison of Figueroa's work to Mexía's known paintings reveals further shared elements. The Virgin and donor figures in the Figueroa engraving have the same elongated faces and long noses as the generic figures that populate Mexía's canvases. Both in Figueroa's engraving and in Mexía's paintings, the figures have heavy-lidded eyes, and the eyes of figures seen in three-quarters are rendered unrealistically, with the far eye overly visible within the face and located slightly too high in the skull. Figueroa and Mexía handle hands in the same manner, with long, square-tipped fingers and carefully marked shadows produced by the metacarpal bones beneath the skin. There are similar, if not identical, decorative floral motifs in Mexía's extant paintings and in the true portrait and other Figueroa engravings for the *Corona* (figures 6.1, 6.5, 6.6, 6.7). The abundance of text in both the engraving and Mexía's known works is suggestive, but the text furthermore follows similar patterns in the engraving and in Mexía's paintings, as if the two men consulted the same calligraphic manuals (Webster 2017, 138, 140).

Mexía was remarkable for the period in which he was active; twentieth-century scholars characterized his work as *retardataire*, out of step with

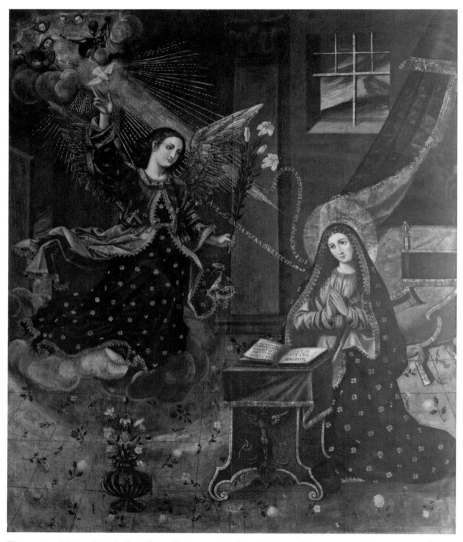

Figure 6.3. Mateo Mexía (attributed), *Annunciation*, Quito, early seventeenth century. Oil and tempera with gold on canvas, 248 × 203 cm. Monastery of San Francisco, Quito. Photo courtesy of Hernán L. Navarrete.

Figure 6.4. Mateo Mexía (attributed), *Triumph of the Risen Christ*, Quito, circa 1615. Oil and tempera with gold on canvas, 249 × 163 cm. Museo Jijón y Caamaño, Pontificia Universidad Católica del Ecuador, Quito. Photo courtesy of Judith Bustamante.

Figure 6.5. Mateo Mexía, *Saint Michael Archangel*, Quito, signed and dated 1615. Oil and tempera with gold on canvas, 252 × 203 cm. Monastery of San Francisco, Quito. Photo courtesy of Hernán L. Navarrete.

Figure 6.6. Mateo Mexía, *Saint Francis and the Tertiaries*, Quito, signed and dated 1615. Oil on canvas, 255 × 203 cm. Museo Fray Pedro Gocial, Monastery of San Francisco, Quito. Photo courtesy of Hernán L. Navarrete.

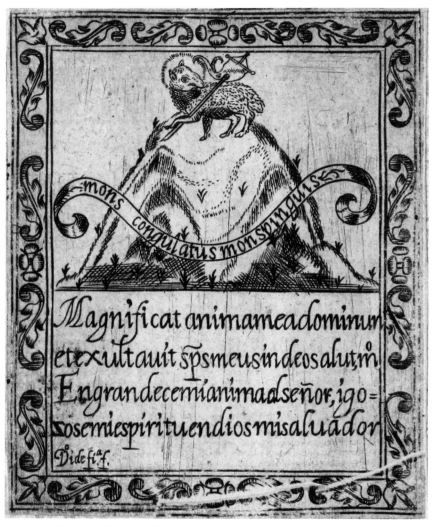

Figure 6.7. Diego de Figueroa, *Magnificat anima mea dominum*, Lima, 1644. Engraving, 7.1 × 5.7 cm. The Harold and Mary Jean Hanson Rare Book Collection, Special and Area Studies Collections, George A. Smathers Libraries, University of Florida, Gainesville.

mid-seventeenth-century trends (Webster 2017, 185). The unique qualities of Mexía's oeuvre are reflected so perfectly back to us in Figueroa's engraving as to leave little room for doubt as to the author of the *Corona* true portrait painting. This has important implications for the relationship between Mexía and Figueroa and offers a potential explanation for the unusual quality of Figueroa's line work in the engraving. The close relationship between the engraving and Mexía's known oeuvre strongly implies the faithfulness of the engraving to the painting (adjusted proportions aside) but begs the question of how the iconography was transmitted from painted original to engraved copy. It allows us to think carefully about the relationship between the two artists as well as between artist and patron.

There is convincing evidence that Mexía's true portrait painting did not travel to Lima with Guevara y Cantos when he brought his manuscript to the press for publication; thus, Figueroa would not have had access to the painted original. As demonstrated both by archival evidence and by Guevara y Cantos's (1644, fol. 57r) own accounting, in 1642, shortly after the completion of the painting, he prematurely and abruptly abandoned Cuenca, where he was the Crown-appointed governor of the region, to journey first to Quito and then to Lima to pursue unspecified complaints before the viceroy. He left behind his wife, his children, and all his worldly possessions; in response to this dereliction of duty the authorities quickly embargoed his belongings (ANH/C, Notaría Tercera, vol. 510, fol. 504r). His wife, doña Leonor María de Vargas, apparently had little interest in trying to join her husband in the viceregal capital and professed no knowledge of when he might return. Instead, she declared her plan to decamp for Guayaquil, her birthplace and the home of her parents, and as such requested that the authorities in Cuenca grant her permission to bring the embargoed goods with her, paying a guarantee, so as to ensure her comfort in her parents' home (ANH/C, Notaría Tercera, vol. 510, fol. 504r). Among these goods were thirty-one paintings, the first thirty listed in the inventory as a lot worth fifty *patacones*, and the last one described as "a large painting" valued at the remarkably high amount of one hundred patacones for the single work (ANH/C, Notaría Tercera, vol. 510, fol. 507r). The inventory does not record the iconographies of the works, but the painting of the Virgin was unusually large in scale and could easily have been the one valued at one hundred patacones, particularly if it, like Mexía's other known works, featured abundant gold leaf. If nothing else, a painting with space for three life-size human figures and a flock of putti would have been far too large for Guevara y Cantos to bring it along on an apparently precipitous journey to the regional capitals (first Quito, then Lima), especially considering he had abandoned all his other belongings

and his wife and children in Cuenca. The painting of the Virgin likely jour-
neyed directly to Guayaquil with doña Leonor and was thus unavailable to
Figueroa to copy.

Even if Figueroa had been afforded the opportunity to view the original
work, Guevara y Cantos's (1644, "Retrato," fol. 13v) instruction that he change
the Virgin's proportions meant that he could not have directly reproduced
the painting exactly as it appeared. Figueroa would have needed either to re-
duce the proportions of the Virgin himself, shifting the composition to fit, or
to copy a drawing incorporating these revised proportions. There is evidence
to suggest that Mexía may have made this revised drawing of the composi-
tion to Guevara y Cantos's specifications. Guevara y Cantos (1644, "Retrato,"
fol. 9v) describes the planning stage for the portrait painting in this manner:
"We made a drawing according to the measure of the size of the most Holy
Virgin in appropriate proportion." He alludes here to a dimension of artistic
practice often assumed to have taken place in colonial Latin America but
rarely registered in the historical record. Only one known workshop drawing
exists from colonial Latin America, in the form of a fragment that survives
because it was reused as the backing to a print preserved in a Mexican print
album (Hyman 2017, 397).[4] The Mexican drawing shows physical evidence
of the workshop process: "Closely spaced pinholes along the contours sug-
gest that the drawing is a tracing from a finalized composition, which was
then pricked, pounced and replicated on another surface" (Hyman 2017,
399). Might Mexía have similarly punched pinholes along the contours of
his drawing, to then transfer it to the final canvas using colored powder? If
Mexía made one drawing for Guevara y Cantos, it seems likely he could have
produced another. In addition to adjusting the proportions, he would also
have scaled down the original drawing so that it would be an appropriate
size to serve as a model for Figueroa's engraving. Did Mexía, knowing that
the engraving technique would produce a mirror image, flip his composition
for transfer to the plate? In his description of the painting, Guevara y Cantos
specifies that the Virgin extends her right hand to his Jesuit brother; the same
is true in the engraving, so at some point either Figueroa or Mexía accurately
reversed the composition to produce the print.

The recognition of Mexía's identity as the author of the painted true por-
trait and a consideration of his surviving oeuvre complicate and add nuance
to Guevara y Cantos's accounting of the production of both true portraits.
Although Guevara y Cantos's narrative omits any attribution of agency to
Mexía in the design of the painting, the evidence of Mexía's earlier work
suggests that he may have had a defining impact on its final appearance.
The engraving was likely a close copy of Mexía's preparatory drawing, and

Mexía's established approach to the handling of faces and hands would have likely been evident in the drawing Figueroa used as a model, as would his interest in ornate and abundant lettering. One of Mexía's surviving paintings is of particular relevance to the *Corona* true portrait. His unsigned, early seventeenth-century *Annunciation* (figure 6.3) challenges Guevara y Cantos's framing of the painter's success in depicting the Virgin's face as made possible only through divine intervention. In the *Annunciation*, the Virgin kneels before a prie-dieu that supports an open book, her hands brought together in prayer, the tips of her fingers just touching. She gazes upward but seemingly out of the painting, as if looking inward rather than toward the angel who descends at her right in a profusion of gold-edged fabric blown back by the force of his movement. The angel's gesture, though pointing up to heaven, is almost identical to that of the Virgin in Figueroa's engraving, as she gestures downward toward the kneeling Guevara y Cantos. Scrolling texts emerge from the two figures' mouths in the *Annunciation*, reaching out to each other as active agents, much like the text in Figueroa's engraving. Yet the most striking similarity between painting and engraving is in the depiction of the Virgin's face. In both images, the woman has a long, grave, calm face with long nose, small mouth, and large eyes with arching dark brows. Mexía's Virgin even generally matches the coloring Guevara y Cantos (1644, "Retrato," fol. 1r) attributes to the Virgin—perhaps not "olive" skin, but light chestnut wavy hair, pink "carnation" lips, and dark eyes. The *Annunciation* is unsigned and not dated, but Webster (2017, 206) associates it with Mexía's three known works, two of which are signed and dated 1615. Furthermore, José Gabriel Navarro (1991, 59) published the *Annunciation* as signed and dated 1615, and his viewing of the work predated the late twentieth-century cleaning of the painting (Susan Webster, pers. comm., 2020). Far from not knowing how he had managed to represent the Virgin's holy portrait, Mexía arguably knew exactly how he had done so—she is, it seems, the same woman who appears in his *Annunciation* from three decades prior, albeit more simply dressed.

Indeed, Mexía seems to have assembled the *Corona* true portrait from elements he had already explored in prior works. Perhaps he drew on a storehouse of preparatory drawings, or perhaps by 1642, having advanced in his career and painted many now-lost works, he had become accustomed to representing the sacred in certain established ways. The Virgin is borrowed from his *Annunciation*, and the gestures of figures in many of his surviving paintings are mimicked in the true portrait. His unsigned *Triumph of the Risen Christ* (figure 6.4) similarly features soaring putti and includes kneeling donor figures to either side of a central figure, one of these donors with a serpentine curl of text emerging from his mouth, reminiscent of the scrolling

texts rising from the mouths of the donor figures in Figueroa's engraving. The numerous royal Franciscan tertiaries in *Saint Francis and the Tertiaries* (figure 6.6) kneel in adoration around the saint, their delicate, many-varied crowns evoking those held aloft by the true portrait's putti, encouraging us to imagine the putti's engraved crowns gleaming with gold leaf. The crown proffered by the kneeling Guevara y Cantos, however, comes from a source outside Mexía's own oeuvre, and is the one element that Mexía clearly borrowed from an existing printed source: an engraving included within the *Corona* itself. This engraving was the work of the French, Madrid-based engraver Juan de Courbes, who contributed eighteen plates to the *Corona* (figure 6.8). Like Figueroa, Courbes signed his name to many of his plates ("I de Courbes F."), but he also left three of them unsigned, two of which organize the verses of the corona prayer (a prayer sequence similar to the rosary), to which Guevara y Cantos dedicated much of the volume, into the shape of a crown (*corona* meaning crown) (figure 6.9; Guevara y Cantos 1644, fol. 1r–1v, 42r; Floyd 2021).[5] The unsigned plates by Courbes can be distinguished from those by Figueroa by their line quality and handling of text. Courbes, like the aforementioned limeño Augustinian engraver Francisco Bejarano, seems to have used a finer burin or engraving tool than did Figueroa, and his lines are as a result thinner and more delicate than Figueroa's comparatively thick, heavy marks. The two men also use different calligraphic hands for the substantial text that characterizes both Figueroa's works and Courbes's three unsigned plates.

Guevara y Cantos (1644, fol. 56v) provides a time line of the production of the different parts of the *Corona*, noting, "in Madrid the year sixteen twenty-six I made the CROWN that you [the corona prayer] form." This apparent reference to the engraving of the crown seems to affirm that Guevara y Cantos commissioned the Courbes plates at this time and then brought them with him to South America.[6] He tells the reader that he originally intended to return to Madrid and publish the *Corona* there, where he probably would have had Courbes or another Madrid-based engraver produce the plates Figueroa ultimately designed (Guevara y Cantos 1644, n.fol.). Crucially, this means that Guevara y Cantos had the Courbes plates, if not impressions thereof, in his possession in Cuenca at the time he commissioned Mexía's true portrait. Courbes's visualization of Guevara y Cantos's corona prayer as a crown appears not only in the two plates he cut for the *Corona* but also in Figueroa's interpretation of Mexía's drawing: the kneeling Guevara y Cantos holds this same crown (in simplified form) aloft toward the Virgin (see Floyd 2021). Courbes influenced Mexía in other ways as well—Mexía's *Triumph of the Risen Christ* (figure 6.4) is based on an engraving by Courbes on the same

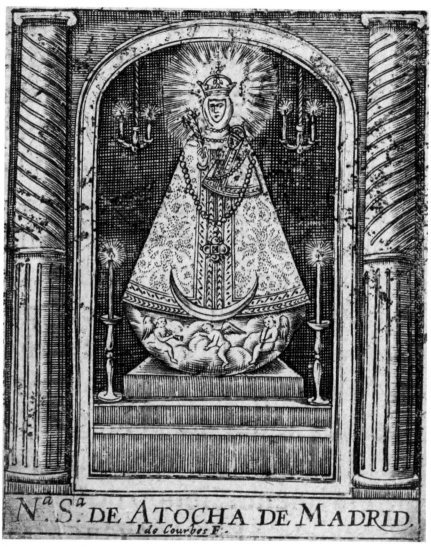

Figure 6.8. Juan de Courbes, *N.ª S.ª de Atocha de Madrid*, plate cut in Madrid, circa 1626, printed in Lima, 1644. Engraving, 9.4 × 8.85 cm. The Harold and Mary Jean Hanson Rare Book Collection, Special and Area Studies Collections, George A. Smathers Libraries, University of Florida, Gainesville.

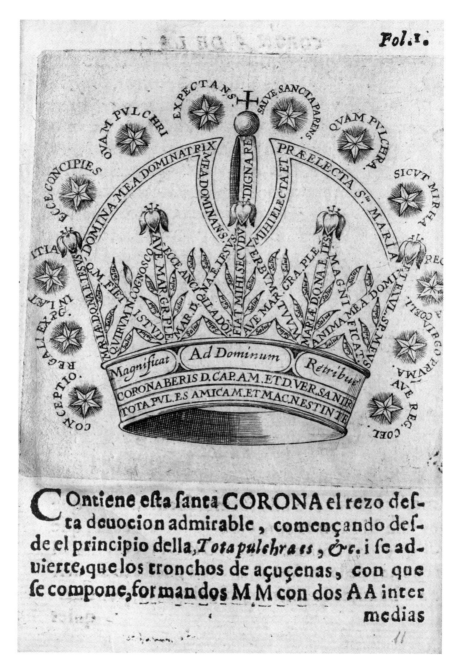

Figure 6.9. Juan de Courbes (attributed), *Crown of the Virgin*, plate cut in Madrid, circa 1626, printed in Lima, 1644. Engraving, 9.5 × 9.1 cm. The Harold and Mary Jean Hanson Rare Book Collection, Special and Area Studies Collections, George A. Smathers Libraries, University of Florida, Gainesville.

subject, although with numerous modifications to the composition, most notably in the donor figures and the putti (Webster 2017, 197–99; Schenone 1998, 32). In the final true portrait iconography, we see Mexía reworking and reimagining his own prior imagery while drawing on the existing visual and textual content of the *Corona*. His painting combined Guevara y Cantos's ideas with Courbes's prior interpretation thereof, and with his own existing understanding of how to represent the divine.

The correspondence between Guevara y Cantos's description of the Virgin's lived appearance and Mexía's work undermines Guevara y Cantos's own presentation of his research process. Rather than being the result solely of Guevara y Cantos's reading of textual sources and the Virgin's divine intercession, the Virgin's appearance in the final work mirrors that of an earlier work by Mexía. Not only does this demonstrate that Mexía drew on his own artistic conventions in order to depict the Virgin, but it also hints that Guevara y Cantos's imagining of the Virgin may have been influenced by prior paintings he had seen. The author was likely in Quito for at least a year between his appointments in Mariquita and Cuenca, and probably had many opportunities to see Mexía's work during that time.[7] If nothing else, Mexía and Guevara y Cantos held a shared understanding of the Virgin's appearance and held a mutual passion for text and symbolism, qualities that are manifest both in Mexía's paintings and in Guevara y Cantos's *Corona*. In deciding how to interpret Guevara y Cantos's vision, Mexía brought together elements from prior works he had painted and influences from Courbes's crown engravings, to produce a new iconography from existing parts.

The Painter and the Goldsmith

Central to Guevara y Cantos's presentation of the *Corona* true portrait is the idea that the original painting, the work of an anonymous *indio pintor*, reproduced exactly, and providentially, the lived appearance of the Virgin Mary. This idea rests on colonial tropes that were developing at the time Guevara y Cantos was working on the *Corona*. In hagiographic narratives dating to the beginning of the seventeenth century, *criollos* (persons born in the Spanish colonies but of Spanish descent) increasingly exalted miraculous images that had appeared to Indigenous witnesses or been made by Indigenous artisans (Alcalá 2009, 68–69). As described in these narratives, Indigenous witnesses and creators legitimized colonial efforts by declaring Indigenous people's capacity for conversion, one of the justifications for the conquest and ongoing Spanish presence in the Americas. Furthermore,

Indigenous individuals' connection to regional miracle-working images suggested the blessed nature of the Spanish American viceroyalties.

The constructed idea of the "Indian artist" affected actual Indigenous people, however, and they were not passive in their response to and engagement with it (Alcalá 2009, 70). The evidence of the *Corona*, of Mexía's extant oeuvre, and of Figueroa's engraving complicates our understanding of the relationship between the *Corona* true portrait painting and engraving, and challenges Guevara y Cantos's characterization of the circumstances around the production of the two works. A consideration of this evidence alongside additional archival information adds further nuance to the *Corona*'s presentation of the two artists. As recorded in the colonial archive, Figueroa was a Granada-born Spaniard active in Lima, whereas Mexía's ethnic identity as manifested in the archive is uncertain and variable, at times seemingly European, at times seemingly Indigenous. The divergence between how Guevara y Cantos framed the two men's ethnic identities, and how they themselves may have understood them, provides another opportunity for rethinking established discourses around copies and their referents. Not only are Indigenous artists more often construed as copyists than are artists of European heritage, but, in the colonial Latin American context, prints are typically understood as sources for paintings, rather than as reproductions of them. Art historians of colonial Latin America rarely consider printmakers directly when thinking about the transmission of iconographies; they generally imagine printmakers as distant from the context of study, located in Europe and not within the same space as Indigenous American artists. Mexía clearly took inspiration from aspects of Courbes's work, but it would be a stretch to understand his painting as a "copy" of an existing printed original. Furthermore, the possibility that the *Corona*'s true portrait might function as a source for future images was always present; Figueroa's reproductive engraving grants access to a newly established iconography rather than serving as its model.

Guevara y Cantos leaves Figueroa ethnically unmarked, describing him only as a goldsmith. Scholars of colonial Latin America have tended to register unmarked individuals—that is, individuals present in the historical record without an ethnic label—as being of European heritage (Rappaport 2014, 10). In Figueroa's case, this seems to be an accurate assumption. Emilio Harth-Terré (1948, 508) mentions Figueroa in a description of the workshop of limeño silversmith Diego de Atiencia. Like Atiencia, Figueroa owned a shop on the appropriately named *calle de la Platería* (Silversmiths' Street), near the Augustinian church that housed the silversmiths' chapel dedicated to San Eloy (Saint Eligius). According to Harth-Terré, Figueroa

was a peninsular Spaniard, born in Granada. Harth-Terré's information is supported by a December 11, 1650, marriage record in which Diego de Figueroa, born in Granada, married *criolla* María de Medrano, born in Lima (AAL, Matrimonios de Españoles y Mestizos, vol. 4, 1641–57, fol. 185r). As a Spaniard, Figueroa had an ethnic identity similar to that of the other seventeenth-century limeño engravers for whom biographical information has been located. Of the seven other known seventeenth-century engravers, at least two were *criollos*, one was French, and four are of unknown background but were likely of European heritage (two of these were members of religious orders, and one was a priest).

Even as scholars have tended to identify unmarked individuals as *criollos* or Spaniards, they have generally accepted that someone like Mexía, designated as *indio* by Guevara y Cantos, should be understood as Indigenous. But Mexía's ethnic identity is less straightforward than Figueroa's. The historical reality of ethnic labels and identity in Spanish colonial South America was complicated, with labels shifting depending on context. Often, a certain label might be applied (or not applied) based on an individual's dress, profession, and place of residence as much as their actual ancestry (Rappaport 2014, 7; Webster 2017, 186). An individual might self-identify differently depending on context as well. Mexía appears numerous times in the quiteño archival record, but he is not always ascribed the same ethnic identity. Although early art historians described Mexía as Spanish based on the appearance of his work, his actual identity is hard to pin down. He lived in the elite Inca neighborhood of San Roque in Quito, home of the descendants of Atahualpa, the last Inca ruler, and was married to María Pasña, who came from a distinguished Indigenous Andean family of artisans (Webster 2017, 85, 187). Yet Mexía's place of residence and marriage did not necessarily mean he shared his wife's ethnic ancestry. Scholars have tended to focus on Indigenous adoption of Spanish dress, language, and culture, but Europeans in the Andes also at times adopted Indigenous ways of life (Nair 2007, 227). The archival evidence of Mexía's heritage is inconclusive. In one instance in the archive, Mexía is listed as *yndio* (i.e., *indio*), whereas in all others he appears unmarked (Webster 2017, 186). This variation in labeling may reflect any number of factors: his dress, his appearance, or his fluency or lack thereof in Spanish or Quechua. The later absence of the *indio* label could even reflect Mexía's increased fame as his career progressed. The *cusqueño* (from Cusco) master sculptor Juan Tomás Tuyru Túpac, himself of elite Inca heritage, "appears to transcend a marked status" in the archives. His renown was such that he is listed only as a master sculptor, not as an "Indian" master sculptor (Cohen-Aponte 2017, 79–80). Furthermore, Guevara y Cantos's

description of Mexía as *indio* may have had as much to do with Guevara y Cantos's desire to downplay Mexía's agency—to make him a better tool for the Virgin—as it did with his actual ancestry.

At first glance, the three men's respective ability to preserve their own names for posterity within the *Corona* seems to reflect their respective positions of power within the colonial Andes, with Mexía having comparatively diminished ability to assert his own agency. Mexía may have signed the painting and thus assumed his memory would survive in his brushstrokes, but the multiple nature of the printed image and typeset text gave the *Corona* and Figueroa's engraving increased chance of survival. At the lower right corner of the engraving, almost hidden among the parallel lines marking the ground on which the donors kneel, Figueroa cut the words "Did. de Fig.ᵃ facieb.ᵗ Limæ" (Diego de Figueroa, was making [this] Lima) (figure 6.10). This inscription acknowledges only one contributor to the artistic labor of producing the engraving—Figueroa himself. Readers of the *Corona* who encountered the print tipped in at the end of the "Retrato" section, as it is in the University of Florida's copy, would have contextualized the work within Guevara y Cantos's narrative of production and known of the author's role in its development and of the Virgin's intercession. They would have known that Figueroa was the limeño goldsmith left unnamed by Guevara y Cantos. Yet the print could also have circulated as a single sheet independent of the *Corona*. Print consumers who saw it within this context would have known only of Figueroa's authorship. Neither the *Corona* nor the engraving itself informs the viewer of Mexía's crucial role in shaping the final image. Mexía is hypervisible (if only as a generic *indio pintor*) in Guevara y Cantos's narrative description, yet invisible in the print, the only surviving record of the visual appearance of his work.

Figueroa's signature on the *Corona* true portrait engraving and on many of the other plates he cut for the *Corona* was not, however, necessarily an intentional exclusion of Mexía or a sign that he even knew the man he was potentially erasing from history. His signature could equally reflect a lack of knowledge of printing conventions, and may be an inexpert attempt to replicate these conventions by a man who was first and foremost a goldsmith, only moonlighting as an engraver. In mid-seventeenth-century Lima, Guevara y Cantos's (1644, "Retrato," fol. 3v) statement that "here there are no masters as in Madrid, or other cities, who have [engraving] as a profession" was accurate. Lima was the only place in colonial South America where engravers regularly cut plates to be editioned, but none of the known engravers active in this period were artists dedicated specifically to the craft (Floyd 2018b). Figueroa had two immediately available models for his choice of a

Figure 6.10. Detail, signature of Diego de Figueroa from *True Portrait of the Virgin Mary*, Lima, 1644 (figure 6.1).

signature. Figueroa's other signatures for the *Corona* are disparate and vary in the spelling of his name (Dide Fᵃ, Diego de Fiᵃ, Dydefiᵃ, Didef.ᵃ), but they consistently use either *f.* or *ft.* to describe his actions. These abbreviations could be read as either *fecit* (made) or *faciebat* (was making), as he signs the true portrait. Courbes, as noted, signed similarly: "I de Courbes F." Figueroa could have looked to Courbes as a model, although his use of *ft.* and *faciebat* as well as *f.* suggests a broader understanding of these conventions. Figueroa could also potentially have used Mexía himself as a model, assuming the painter signed the drawing Figueroa used for the engraving. As is suggested by Mexía's abundant use of text in his paintings, his ability to shift between calligraphic hands, and his use of superscript letters and of ligatures to abbreviate words, Mexía was literate and indeed possessed a high level of practiced literacy. This was broadly true of early colonial painters in Quito. The majority did not sign their paintings, but they did sign notarial documents with "a manifestly practiced hand" (Webster 2017, 5). One of Mexía's two signed works, *Saint Francis and the Tertiaries*, is signed "Mateo Mexia fecit 1615," while the other, *Saint Michael Archangel*, is signed "Matheo Mexia fac[ie]b[at] 1615." Perhaps Mexía similarly signed the drawing using *faciebat*, and Figueroa simply substituted his own name for that of the painter.

Figueroa himself uses superscript letters and abbreviations in his signatures, suggesting some awareness of scribal practices, so the relationship between his signatures and those of Courbes and Mexía must be speculative. Prints by their very nature, however, preserve names and iconographies, and propagate them in a way that individual paintings, subject to loss and damage, do not. Although not all engravers uniformly signed their work (indeed, six of the thirty-one *Corona* plates are unsigned), when they did sign their plates the printing of multiple copies allowed their names to spread widely.

Guevara y Cantos omitted Mexía's name from the *Corona*, but Figueroa and Courbes preserved their names by cutting them into their engraved matrices. Although Mexía likely had the greatest impact of any of the men involved in the production of both painted and engraved versions of the true portrait on their final appearance, the nature of the medium in which he worked, and the colonial art market of which he was a part, meant that he, of the three artists (Courbes, Figueroa, Mexía), was also the most easily transformed, at least in the *Corona* narrative, into a tool of the Virgin and of Guevara y Cantos.

The archival evidence attesting to the respective ethnic identities of Mexía and Figueroa both affirms and complicates Guevara y Cantos's assertions about the two men, and underscores the constructed nature of Guevara y Cantos's presentation of the *indio pintor*. It also reveals once again the default nature of whiteness for colonial writers: Guevara y Cantos tells us Figueroa is Spanish by not telling us that he *isn't* Spanish. Similarly, for Guevara y Cantos, all we need to know about Mexía is that he is an *indio pintor* (Indian painter), and yet Mexía's ethnic status in the colonial archive is opaque and shifting. Mexía, Webster (2017, 186) suggests, benefited from his ability to "pass" as a Spaniard in order to take advantage of the ways that identity at times shifted colonial bureaucracy in his favor. It is worth asking whether he may have also performed Indigeneity in circumstances where that identity benefited him.[8] For Guevara y Cantos, the notion of Mexía as *indio pintor* allowed the artist to better act as a tool of the Virgin, a vehicle through which her power could flow in order to perfectly capture her likeness. Mexía may have embraced this same identity for the commission it brought him from the governor of Cuenca. If the true portrait is in fact the painting valued at one hundred patacones in doña Leonor's inventory, and Mexía was paid this full amount, the monetary rewards for Mexía's embrace of Guevara y Cantos's understanding of his identity would have been substantial. Mexía's example suggests the way in which ethnic labels like *indio*, rather than being fixed and clearly defined, might be leveraged differently over the course of an individual's lifetime, depending both on how they wished to be seen and on who was doing the seeing.

Conclusion

In the *Corona*'s portrait section, Guevara y Cantos lays out his goal of producing a new likeness of the Virgin Mary, one that will adhere more closely to his definition of portraiture than had any prior image of her. It would reflect the Virgin's daily life and habits and accurately convey her physical

appearance. His narrative insists on the specificity of precise moments and locations. He details a ritualized production process, relying on the repetition of passages from the Bible, attendance at mass, and physical postures of rogation, as when he kneels by the painter in preparation for beginning the work. The meticulousness of Guevara y Cantos's account is calculated to convince the reader of the veracity of his words, but its areas of opacity also serve his purpose. In obscuring Mexía's name and diminishing Figueroa's contribution, Guevara y Cantos couches his narrative within already established tropes of miracle-working images. Even as these familiar chronicles consistently stressed divine intercession over human agency, in the colonial Spanish Americas they privileged the Indigenous artist as the most faithful and reliable sacred copyist. These tropes, relying on infantilizing understandings of the Indigenous artist as less capable of individual expression and agency, served as tools for Spanish and *criollo* writers in their stories of divine activity in the Americas.

The reality behind the *Corona* was more complex, directly contradicting conventional religious narratives of image-making and demonstrating the dangers and fallacies of established copy/original models. The *Corona*, with its rich visual components and array of contributors, is an exceptional case study. The attribution of Guevara y Cantos's painting to Mexía, made possible by a combination of archival research, collaborative conversations with other scholars, and visual analysis, challenges and nuances what might initially seem like the reliable account of a first-person narrator. While in Guevara y Cantos's account, Mexía is an unnamed instrument of the Virgin and the author, the archival and visual evidence attests to his definitive role in designing the true portrait's iconography and formal appearance. The evidence presented in this chapter encourages us not only to rethink the relationship between print and painting, and between artist and patron, but to question our understanding of authorship with respect to works of art and text. The reproducible nature of the print medium—as conveyed by both engraved copperplates and typography—facilitated the preservation of Guevara y Cantos's Courbes's, and Figueroa's names, while allowing for the occultation of Mexía's. Nonetheless, we should not read modern survival as indicative of the historical agency of colonial actors. Mexía's name, potentially signed on the original, large-scale painting using elaborate scribal conventions, would have declared his authorship of the work in contradiction to Guevara y Cantos's narrative, but so too would his easily recognizable painterly style. The cracks in Guevara y Cantos's triumphant account remind us to critically engage with and question written sources, particularly when writing about artistic production and material culture. The case of the

Corona offers a model for drawing on visual and archival evidence to trouble and reframe the unreliable voice of the colonial narrator and, in so doing, to recenter the voices of seemingly unknown, marginalized artists.

Acknowledgments

My thanks to Ananda Cohen-Aponte, Susan Webster, Margarita Vargas-Betancourt, and Maya Stanfield-Mazzi for feedback on this essay. Particular thanks to Webster, who suggested the attribution to Mexía. My thanks as well to Terrence Phillips, Ricardo Kusunoki, Laura María Vetter Parodi, and Stephanie Aude, all of whom supported the research for this project in various ways. An anonymous reader offered valuable suggestions. Funding from the Center for the Study of Material and Visual Cultures of Religion at Yale University, the American Catholic Historical Society, and Tulane University helped support research for this essay.

Notes

1. The literature on prints as sources for colonial Latin American art is abundant; see, e.g., Michaud 2009; Ojeda, n.d.

2. References are to the foliation of the copy of the *Corona* in the collection of the George A. Smathers Libraries at the University of Florida, Gainesville. The "Retrato" section of the Gainesville *Corona* has foliation that differs from that of the second known copy, in the Biblioteca Nacional de España. For more on this topic, see Floyd 2021.

3. That being said, Jaime Cuadriello (2001, 116, 130–31) describes two (eighteenth-century) New Spanish Marian images that similarly claim to show the true dimensions of the Virgin and to dress her as described in the patristic tradition. Cuadriello also points out that Vicente Carducho, in his *Diálogos de la pintura* (1633), describes Saint Teresa commissioning paintings of Christ based on his appearance in her visions. The eighteenth-century Jesuit Our Lady of Light iconography was similarly understood to be based on the appearance of the Virgin in a vision. What distinguishes Guevara y Cantos from these examples is the combination of research into the Virgin's appearance *and* the claim of virginal intercession.

4. A group of drawings supposedly by the colonial Colombian painter Gregorio Vásquez de Arce y Ceballos has been described as a remarkable exception to the general loss of colonial workshop drawings. Aaron Hyman (2017, 397n16), however, has argued that these drawings are of questionable authenticity.

5. I previously attributed the crown plates to Figueroa, but I have revised this attribution based on more careful consideration of the visual and textual evidence (Floyd 2018a, 88).

6. To my knowledge, the *Corona* Courbes plates are not known from other contexts (Páez Ríos 1981, 257–58). On Juan de Courbes, see Matilla 1991. On Courbes and other foreign engravers active in Madrid at this time, see Blas, Carlos Varona, and Matilla 2011.

7. Guevara y Cantos was *corregidor* (colonial magistrate) in Mariquita from 1628 to 1633. He was then appointed as corregidor of Cuenca, but a *real cédula* (royal certificate) dated January 26, 1636, suggests that the Audiencia of Quito impeded Guevara y Cantos's immediately taking up the position. Guevara y Cantos may have been resident in Quito during this period. Regardless, by March 24, 1636, he was in Cuenca serving as its corregidor, a post he would fill until 1642. By 1650 at the latest, Guevara y Cantos was governor of Guayaquil. See AGI, Escribanía, 118, n.p.; AGI, Quito, 212, L.6, fol. 88v; AGI, Santa Fe, 56B, N.77, n.p. (this document lists Guevara y Cantos as "don Juan María Velez de Guevara y Cantos Corregidor y Justicia Mayor de las ciudades de Tocaima, Bague, y Mariquita, y de los demás pueblos de partido de tierra caliente"); ANH/C, C.111.889, fol. 1r; Bryant 2014, 35.

8. Webster (2016, 411) suggests this in relation to the one archival reference to Mexía as an *yndio pintor*—a lawsuit against two Indigenous brothers—noting, "it is possible that his identification as 'yndio' . . . may well have been to his legal advantage."

Reference List

AAL (Archivo Arzobispal de Lima). Parroquia el Sagrario, Matrimonios de Españoles y Mestizos, vol. 4, 1641–57.

AGI (Archivo General de Indias), Seville. Escribanía, 118.

———. Quito, 212, L.6.

———. Santa Fe, 56B, N.77.

Alcalá, Luisa Elena. 2009. "The Image and Its Maker: The Problem of Authorship in Relation to Miraculous Images in Spanish America." In *Sacred Spain: Art and Belief in the Spanish World*, edited by Ronda Kasl, 55–73. Indianapolis, IN: Indianapolis Museum of Art.

ANH/C (Archivo Nacional de Historia de Cuenca). C.111.889.

———. Notaría Tercera, vol. 510.

Bargellini, Clara. 2004. "Originality and Invention in the Painting of New Spain." In *Painting a New World: Mexican Art and Life, 1521–1821*, edited by Clara Bargellini, Donna Pierce, and Rogelio Ruiz Gomar, 78–91. Denver, CO: Denver Art Museum.

Blas, Javier, María Cruz de Carlos Varona, and José Manuel Matilla. 2011. *Grabadores extranjeros en la Corte española del Barroco*. Madrid: Centro de Estudios Europa Hispánica.

Bryant, Sherwin K. 2014. *Rivers of Gold, Lives of Bondage: Governing through Slavery in Colonial Quito*. Chapel Hill: University of North Carolina Press.

Buendía, José de. 1676. *Sudor, y lagrimas de Maria Santissima en su santa imagen de la Misericordia*. Lima: En Casa de Juan de Quevedo.

Cohen-Aponte, Ananda. 2017. "Decolonizing the Global Renaissance: A View from the Andes." In *The Globalization of Renaissance Art: A Critical Review*, edited by Daniel Savoy, 67–94. Leiden: Brill.

Cuadriello, Jaime. 2001. "El Obrador Trinitario: María de Guadalupe creada en idea, imagen y materia." In *El divino pintor: La creación de María de Guadalupe en el taller celestial*, edited by Jaime Cuadriello, 61–205. Mexico City: Museo de la Basílica de Guadalupe.

Floyd, Emily C. 2018a. "Grabadores-plateros en el virreinato peruano." In *Plata de los Andes*, edited by Ricardo Kusunoki and Luis Eduardo Wuffarden, 84–97. Lima: Museo de Arte de Lima.

———. 2018b. "The Mobile Image: Prints and Devotional Networks in Seventeenth- and Eighteenth-Century South America." PhD diss., Tulane University.

———. 2019. "Privileging the Local: Prints and the New World in Early Modern Lima." In *A Companion to Early Modern Lima*, edited by Emily Engel, 360–84. Leiden: Brill.

———. 2021. "The Word as Object in Colonial Spanish South America: Juan María de Guevara y Cantos's *Corona de la divinissima María* (Lima, 1644)." *Material Religion* 17 (2): 202–27.

Guevara y Cantos, Juan María de. 1644. *Corona de la divinissima María Purissima Virgen, Madre de Dios.* With "Retrato" section. Lima: Joseph de Contreras. Digitized, George A. Smathers Libraries at the University of Florida, Gainesville, http://ufdc.ufl.edu/AA00037234/00001.

Harth-Terré, Emilio. 1948. "Un taller de platería en 1650." *Mercurio Peruano* 29 (260): 502–11.

Hyman, Aaron M. 2017. "Patterns of Colonial Transfer: An Album of Prints in Mexico City." *Print Quarterly* 34 (7): 393–99.

———. 2021. *Rubens in Repeat: The Logic of the Copy in Colonial Latin America.* Los Angeles: Getty Research Institute.

Matilla, José Manuel. 1991. *La estampa en el libro barroco: Juan de Courbes.* Madrid: Ephialte.

Michaud, Cécile, ed. 2009. *De Amberes al Cusco: El grabado europeo como fuente del arte virreinal.* Lima: Impulso Empresa de Servicios.

Nair, Stella. 2007. "Localizing Sacredness, Difference, and *Yachacuscamcani* in a Colonial Andean Painting." *Art Bulletin* 89 (2): 211–38.

Navarro, José Gabriel. 1991. *La pintura en el Ecuador del XVI al XIX.* Quito, Ecuador: Dinediciones.

Ojeda, Almerindo. n.d. PESSCA: Project on the Engraved Sources of Spanish Colonial Art. Accessed June 16, 2022. https://colonialart.org.

Páez Ríos, Elena. 1981. *Repertorio de grabados españoles en la Biblioteca Nacional.* Vol. 1. Madrid: Imprenta del Ministerio de Cultura.

Porras, Stephanie. 2016. "Going Viral? Maerten de Vos's St. Michael the Archangel." In *Netherlandish Art in Its Global Context*, edited by Thijs Weststeijn, Eric Jorink, and Frits Scholten, 54–79. Leiden: Brill.

Rappaport, Joanne. 2014. *The Disappearing Mestizo: Configuring Difference in the Colonial New Kingdom of Granada.* Durham, NC: Duke University Press.

Schenone, Héctor. 1998. *Iconografía del arte colonial: Jesucristo.* Buenos Aires: Fundación Tarea.

Webster, Susan V. 2016. "Mateo Mexía and the Languages of Painting in Early Colonial Quito." *Hispanic Research Journal* 17 (5): 409–32.

———. 2017. *Lettered Artists and the Languages of Empire: Painters and the Profession in Early Colonial Quito, 1550–1650.* Austin: University of Texas Press.

Winston, Jessica. 1997. "The Face of the Virgin: Problems in the History of Representation and Devotion." PhD diss., Columbia University.

7

Art-Making and Art-Breaking in the Era of Andean Insurgencies

ANANDA COHEN-APONTE

This essay explores artistic patronage, production, and iconoclasm in the eighteenth-century Andes, positing the modification of material culture as a form of world-making by considering case studies from the Tupac Amaru and Katari rebellions of the 1780s, which sought the overthrow of Spanish colonial rule.[1] Visual and material culture played a critical role in these rebellions; rebels and royalists alike commissioned portraits, medallions, religious images, and banners depicting key events, leaders, and patron saints associated with their cause. Equally important to the projects of rebellion and counterinsurgency were targeted interventions into the materiality of objects both during the events of the uprisings and in their repressive aftermaths. Traditional art historical studies that focus exclusively on fully intact or "museum-quality" artworks distort our understanding of fraught periods of history, and particularly rebellions and uprisings, because they overlook the way that alterations to and censorship of artworks provide a venue for contesting and negotiating issues of power.[2] Periods of social upheaval can provide evidence of alternative visualities that would otherwise not make it into the historical record. Some of the most potent objects of insurgent resistance created by Black, Indigenous, and mixed-race artists in colonial Latin America and the broader Atlantic world only survive, if at all, in the form of written descriptions. These object descriptions, embedded within confessions and legal testimony, were often extracted under extreme duress and the threat of torture or death. Yet despite the highly charged and likely distorted nature of these accounts, their importance cannot be underestimated since they are often the only form in which these artworks survive.[3] In other instances, we find images buried under layers of paint, some apparent to the naked eye and others only discoverable through modern

scientific interventions such as X-ray analysis and infrared reflectography. The asymmetrical preservation of the visual record of anticolonial insurgencies poses significant challenges for art historical investigation, given that the fragmentary visual record of counterhegemonic objects is overshadowed by the plethora of surviving royalist imagery produced in their aftermath to reassert colonial control.

The documentary record associated with Andean rebellions is rife with material of art historical significance, from descriptions of portraits of rebel leaders to eyewitness accounts of pointed iconoclastic acts such as rebels skewering a sculpture of the Virgin Mary with *tupus* (garment pins) (Hidalgo Lehuedé 1983, 127). The stories that archives and objects tell us about art-making and art-breaking in the era of Andean insurgencies contain critical omissions, discrepancies, and gaps that render impossible full reconstruction of the artworks and the stories that surround them. The task of restoring paintings to their prerevolutionary appearance or tracing interventions to known artists almost always falls short, evolving into an act of historical projection. Instead of attempting to overcome these limitations, perhaps we should reconsider the very paradigm on which they are constructed and the political implications of the act of reconstruction itself. How might a consideration of anticolonial insurgencies interrupt and dislodge our concepts of the artist and the artwork in colonial Latin America? In this essay, I explore informal networks of vernacular artists and their publics. These networks operated outside of traditional channels of patronage, and their contributions have been largely overlooked due to the altered state in which they survive.

In order to do this work, it is necessary to test the limits of the sources under consideration, from summarized testimony to extant works of art and the unpredictable ways that they survived the test of time. I am inspired by literary theorist Saidiya Hartman's (2008, 11) notion of "critical fabulation," which creatively resituates Black historical narratives extracted from the archives of the transatlantic slave trade to "jeopardize the status of the event, to displace the received or authorized account, and to imagine what might have happened or might have been said or might have been done." In my provisional efforts to adopt Hartman's framework for anticolonial rebellions that were brutally suppressed by the Spanish colonial administration, I recognize the confabulations present in the official archive of the rebellions themselves, and thus reject the impulse to create an unbroken genealogy of truth value from the eighteenth-century courtroom to the twenty-first-century reader. Through a nuanced approach to the historical and visual record, I hope to

create new possibilities to tell an otherwise "impossible story" and, in the words of Hartman (2008, 11), "to amplify the impossibility of its telling."

A Hero without a Face

The Peruvian historian Pablo Macera (1975, n.p.) has aptly described the eponymous rebel leader José Gabriel Condorcanqui Tupac Amaru as a "hero without a face." Drawing on long-standing tropes for describing the prophet Muhammad, Macera points out that unlike the celebrated liberators of the wars for independence, who were memorialized in oil paintings, Tupac Amaru remains an empty signifier. While no known large-scale portraits of Tupac Amaru survive from the eighteenth century, descriptions of two specific portraits appear in the archival record at least nineteen times, within confessions, letters, and reports by military personnel (Gisbert [1980] 2018, 311–15; Estenssoro 1991, 421–24). We also find several general references to medallions and banners bearing the likeness of Tupac Amaru and his wife, Micaela Bastidas, pointing to the important role of portraiture in galvanizing support for the cause (Lewin 1967, 345). These descriptions not only hold value for historians and art historians in search of information about destroyed visual testimonies to the events of the 1780s; they have also informed artists of the twentieth century in their attempts to visually represent the rebel leader, most notably during the 1960s, when Tupac Amaru rose to prominence as a Peruvian national hero under General Juan Velasco Alvarado's government (figure 7.1; Valcárcel 1970; Lituma Agüero 2011; Cant 2012; Asensio 2017).

In the case of Tupac Amaru's portrait we are presented with the inverse of the conundrum most often faced by historians of colonial Latin American art: instead of artworks with no names (Mundy and Hyman 2015, 300), here we have names with no artworks. According to the archival sources, both Simón Ninacancha, an Indigenous artist, and Antonio Oblitas, an Afro-Indigenous assistant to Tupac Amaru, were tasked with painting his portrait. It appears that neither was formally trained, given their absence from known artists' contracts and related documentation from the period. Yet it is evident from the descriptions of the portraits that both artists were well versed in both Andean and Iberian iconographies of power.

The portrait by Simón Ninacancha (hereafter referred to as the Equestrian Portrait) consisted of a full-length portrait of Tupac Amaru seated on a white horse and wearing an *uncu* (Andean tunic), with various Inca insignia on his head (likely a *llautu*, a braided headdress, or *mascapaycha*, a red fringe

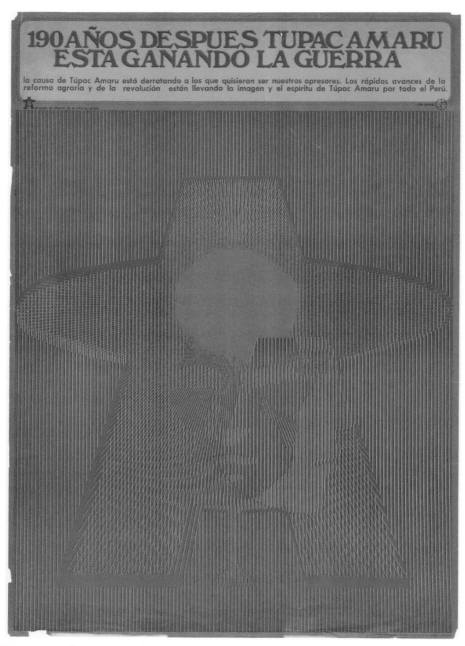

Figure 7.1. Jesús Ruiz Durand, *190 años después Túpac Amaru está ganando la guerra* (*190 years later, Tupac Amaru is winning the war*), 1968–70. Offset print on paper, 100 × 70 cm. Sam L. Slick Collection of Latin American and Iberian Posters, Center for Southwest Research and Special Collections, University of New Mexico.

worn on the forehead of Inca rulers). As Scarlett O'Phelan Godoy (2021, 208–10) notes, equestrian portraits of *caciques* (Indigenous leaders) were exceedingly rare in colonial Peru, with the only surviving example being Mateo Pumacahua in the Battle of Guaqui in 1811. This speaks to the unprecedented nature of the Equestrian Portrait and its unique melding of aesthetic and iconographic traditions. Ninacancha's painting combines three pictorial genres in a single composition: colonial portraits of Indigenous elites wearing Inca-style regalia; representations of Santiago Mataindios (Saint James the Indian-Slayer), one of the most potent religious symbols of the conquest of the Inca; and equestrian portraits of monarchs and viceroys (figures 7.2 and 7.3; Estenssoro 2005, 170). The Equestrian Portrait was sent to La Paz under the direction of Juan de Dios, the *curaca* (Indigenous leader) of Azángaro, in order to drum up support for the rebellion in the south (Durand Flórez 1980–82, 1:3:553). For the Equestrian Portrait, the archival trail ends here; it is unclear whether it survives in Bolivia or whether it was destroyed or covered up after the court proceedings.

The portrait by Antonio Oblitas (hereafter referred to as the Sangarará Portrait) depicted Tupac Amaru under a parasol wearing Inca insignia and holding a *bastón* (staff of power), commemorating the recent victory of Sangarará, which resulted in the deaths of hundreds of royalist soldiers. According to witnesses, on one side of the painting was a church engulfed in flames, with dead and naked bodies represented; the other side represented Indians burning the prison of Sangarará, with one grabbing the hair of the prison guard as the imprisoned were set free.[4] The Sangarará Portrait is an inversion of iconic conquest imagery such as the Virgin of Sunturhuasi, who miraculously appeared to save the Spanish conquistadors from being burned alive during Manco Inca's last-ditch attempt to reclaim the Inca capital in 1536. Inca forces set fire to the chapel in which the Spaniards had taken refuge, but the Virgin Mary extinguished the fire with sand or hail. The most famous rendition of the event is preserved in a canvas attributed to the Cusco School painter Marcos Zapata circa 1740–50, housed at the Complejo Museográfico Enrique Udaondo in Luján, Argentina, although popular versions exist as well, such as an eighteenth-century painting on copper at the Museo Barbosa-Stern that may have circulated within the region (figure 7.4). These eighteenth-century renditions of the events of the conquest, with their clear dichotomy between victors and vanquished, were not without their own share of controversy; the canvas attributed to Zapata, which once hung in the church of El Triunfo next to the cathedral, was allegedly taken down after ten years at the request of Indigenous elites and replaced with a more

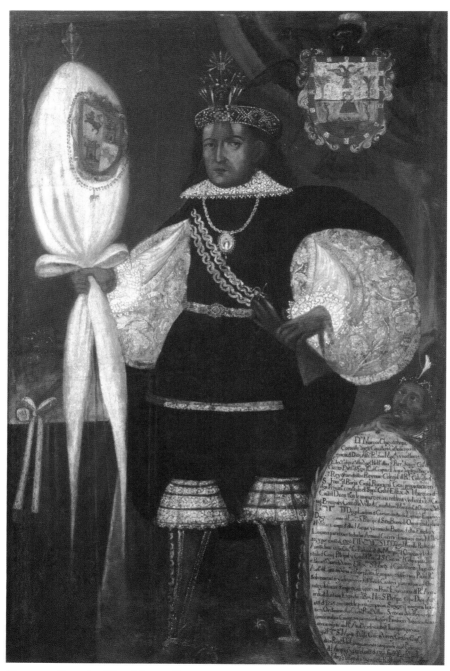

Figure 7.2. *Portrait of Don Marcos Chiguan Topa*, Cusco, Peru, 1740–45. Oil on canvas, 199 × 130 cm. Museo Inka, Cusco, Peru. Photograph by Daniel Giannoni.

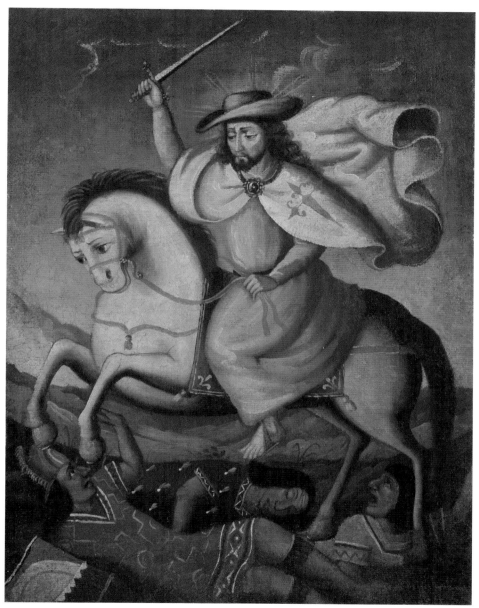

Figure 7.3. *Santiago Mataincas* (Saint James, Inca-Slayer), Cusco, Peru, circa 1600–1800. Oil on canvas, 39 × 30 cm. Courtesy of the Carl and Marilynn Thoma Foundation, photo by Patricio Pueyrredón.

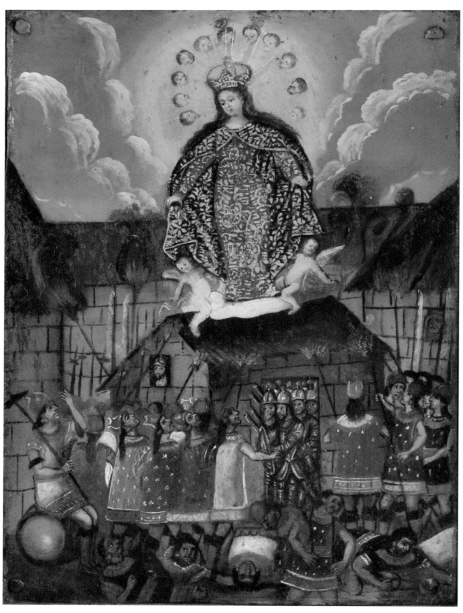

Figure 7.4. *Virgin of Sunturhuasi*, Cusco, Peru, eighteenth century. Oil on metal, 25 × 18.5 cm. Colección Barbosa-Stern, Lima, Peru.

conciliatory image (Alcalá 2004, 150–52; Wuffarden 2005, 207–9; Mujica Pinilla 2008, 114–16; Gisbert [1980] 2018, 287–94).[5]

While little is known of Ninacancha, Oblitas's biography looms large in the story of the Tupac Amaru Rebellion. Antonio Oblitas was formerly owned as a slave by the *corregidor* (magistrate) don Antonio de Arriaga. He was born in Cusco but raised in Arequipa. As an adult he returned to Cusco and married Pancha Valverde (O'Phelan Godoy 2021, 203). On November 10, 1780, Tupac Amaru chose Oblitas to serve as Arriaga's executioner, claiming to be acting under the orders of the king. After numerous failed attempts, Oblitas successfully hanged Arriaga, for which he was allegedly paid forty pesos (Durand Flórez 1980–82, 1:3:563). Oblitas's subsequent entry into the rebel leader's service, after the execution of his master, appears to have also been tied to his freedom, as he is referred to in the criminal proceedings both as *el zambo* Antonio (of Black and Indigenous ancestry) and as a *mulato libre* (free man of mixed Black ancestry) (O'Phelan Godoy 1988, 244). While the precise peregrinations of the Equestrian Portrait remain unclear, the extraordinary social life of the Sangarará Portrait paralleled that of the rebellion's human participants. In fact, don Josef del Valle, commander of the royalist army in Cusco, testified that he saw the painting itself hanging from the gallows of the town of Tinta in March 1781 (Valcárcel 1971, 622).

The act of hanging an escaped criminal in absentia via a material proxy was practiced throughout the early modern world, and usually involved the public burning of effigies or the creation of defaming portraits that would be subsequently burned or destroyed. While death by effigy was a punishment meted out by the Holy Office of the Inquisition for crimes of heresy, the practice also extended to the popular sphere (Corteguera 2012, 13–15). Inquisition records for Lima, Mexico City, the Canary Islands, and other locales across the Spanish Empire document numerous deaths by effigy for political dissidents, heretics, and escaped slaves throughout the colonial period (Lea 1908). This practice reached unprecedented heights in the eighteenth-century Atlantic world, most notably in the cities of Boston and New York, underscoring the transimperial contexts in which remarkably similar revolutionary acts of iconoclasm occurred (Bellion 2019).

The political force of a portrait strung in the gallows in the rural southern Andes thus speaks to a broad investment in the power of images across both early modern Europe and the entangled spaces of the Atlantic world. Portraits were believed to hold the traces of the absent or deceased referent. Royal portraits of Spain's monarchs lent material and visual form to absent kings who would never set foot on American soil. As Alejandra B. Osorio (2017, 38) argues, "Royal simulacra were always publicly displayed in

elaborate ceremonies and understood to contain the king's aura and presence. Indeed, as far as his subjects throughout his vast empire were concerned, these objects *were* the king." The paintings of Tupac Amaru carried the affective and ideological weight of royal portraits, whose rituals of presentation and display had been established in the Andes since the early colonial period. Moreover, their aesthetic kinship with Inca noble portraiture also grounded them in a specifically Indigenous genealogy of representation. As Carolyn Dean (2005, 90) has suggested, the development of elite Indigenous portraiture in the colonial period was itself a reformulation of Inca *huauques* (also *wawkis*), or brother statues—presentational stones that served as receptacles for emendations of the ruler such as fingernails and hair. Yet elite Indigenous portraits nevertheless participated in a framework of colonial governance that accorded special privileges for Andeans of Inca ancestry (Cummins 1991).

Tupac Amaru's painted surrogates exceed the limits of royal Spanish and Indigenous elite portraiture in their aspirations to both Inca sovereignty and royal mandate, lending them a distinct anticolonial tenor. That the Sangarará Portrait itself, rather than an improvisational stuffed effigy, was selected for this ritual of justice suggests that contemporaries recognized it as a highly charged, numinous incarnation of the absent rebel and that seizure of his painted form would precipitate his actual capture and execution. In the minds of witnesses, it worked; immediately after the hanging of the portrait from the gallows, Tupac Amaru was captured in the village of Langui by Ventura Landaeta and Francisco Santa Cruz, two traitors who shackled him until he was taken to Cusco, where he would be publicly executed a little over a month later (Walker 2014, 150).

As we continue to track the peregrinations of the portrait, it appears that by April 22, the painting had moved from the gallows into the courtroom. It was at this point that the painting served as a vehicle for cross-examination and became systematically emptied of its once-spectacular visual presence. The notary's account of the confession of Micaela Bastidas, Tupac Amaru's wife and co-conspirator, confusingly seems to describe the Equestrian Portrait, which Ninacancha allegedly created (yet which Bastidas attributes to Oblitas):

> She was presented with a painting in which her husband is depicted on horseback with royal insignia so that she could state who painted it, who gave him the idea to paint it, [and] for what purpose he was depicted. She responds that it is correct that he was ordered to paint her husband with the royal insignia, that it was the *zambo* Antonio

who painted it, who is now in jail. [She said] that her husband ordered him to paint it, saying that in case he was killed the portrait would remain [to preserve] the memory of the Tupamaros, that this idea came from her husband, and that the purpose was so that it could be seen in the provinces and afterward sent to Spain. (Durand Flórez 1980–82, 2:4:44–45)

During Oblitas's interrogation, the artist confessed to only having painted one portrait—the Sangarará Portrait that was hung in the gallows—and stated that Ninacancha painted the Equestrian Portrait. The notarial account continues,

he was presented with a large portrait of Tupamaro so that he could confirm that it was the same one and explain why he put the royal insignia on it, and the meanings of the paintings on either side of him. He said it to be the same as what he painted; that he placed the insignia on the head as they [indicated] his royal Inca descent and bloodline, and that the rebel had ordered it; the staff, because he always carried it; and that on one side is the expedition of Sangarará representing the burned church, with the flames emanating from it, and various [scenes of] death and others stripped of their clothing; on the other side [was the] prison of Sangarará and the Indians burning it, and another Indian grabbing the prison guard by the hair; and above, an umbrella that the rebel frequently carried, and that all of this was under the orders of the rebel. (Durand Flórez 1980–82, 1:3:558–59)

What can these confessions reveal about contemporaries' beliefs about the power of images? What can they reveal about artistic process and interpretation?

One difference between these accounts is that the questions asked of Bastidas concerned the painting's broader meaning and the aspirations that she and Tupac Amaru had for the portrait. It is telling that she responds that they intended for it to be sent to Spain to preserve the memory of the family, underscoring a cosmopolitan understanding of the power of royal portraiture to serve as material surrogate and alter ego of the sovereign in both life and death. The line of questioning reserved for Oblitas, by contrast, involved rote identification of the painting's symbolism and references. Bastidas is perceived as having greater insight into the painting's larger purpose, while Oblitas is viewed more as a conduit for visually translating the rebel's orders rather than as a creator in his own right. To add further confusion to the story, the rebel claimed in his confession that Oblitas had invented the

scene ("el pintor lo puso de su cabeza"), while Oblitas claimed that he was painting under the strict orders of the rebel (O'Phelan Godoy 2021, 219). It is also significant that he is repeatedly referred to as the *zambo* Antonio, a derogatory racialized qualifier denoting Black and Indigenous ancestry. Yet perhaps we can also read his disavowal of artistic agency as a strategy, albeit an ultimately unsuccessful one, for negotiating a lesser sentence.

The testimony of Hipólito Tupac Amaru, the son of Tupac Amaru and Micaela Bastidas, adds yet more texture to the story of the portrait. He was asked the same questions about the portrait as his mother, to which he responded, per the notary: "it is true that the *zambo* Antonio painted a portrait of his father with the goal of sending it farther south so that the Indians knew of it, and having been presented with a painting, he said it is the same one that said Antonio painted, although the confessant didn't see the whole thing finished, but rather that much of it was still a sketch" (Durand Flórez 1980–82, 2:4:100). This statement offers a rare glimpse into the process of art-making in the colonial Andes, which remains largely invisible to modern viewers due to a lack of surviving sketches (see also chapter 6). Moreover, it alludes to a much earlier chapter in the social life of the portrait, thus underscoring the planning and preparation that went into its completion.

These trial transcriptions offer a rich biography of the Tupac Amaru portrait, from its initial inception as a sketch to its placement in the gallows in Tinta, and finally to its final destination in Cusco's ecclesiastical court. Yet they conceal and confabulate as much as they reveal. It becomes unclear whether Ninacancha painted a portrait at all and, if he did, what its precise appearance or whereabouts might have been. The absence of Ninacancha's own testimony from the documentation of the rebellion precludes a full explanation of the relationship between the two artists and the portraits. While all witnesses are firm on the fact that Oblitas painted the portrait that was placed in the gallows, there are discrepancies in the description of his painting, with Bastidas describing the Equestrian Portrait and others conflating the two. Furthermore, we must keep in mind that these descriptions of the portraits were uttered by participants in the rebellion whose most important objective was to save their own lives. For instance, as Sinclair Thomson (pers. comm., October 2019) suggests, Bastidas's insistence that the portrait was destined for Spain could also be read as a last-ditch attempt to demonstrate loyalty to the Crown. These varying accounts of the portraits can also reveal the divergent ways that participants of differing social strata understood them, pointing to a significant flexibility in the reception of images during periods of political struggle.

The choice of Oblitas as portrait painter should not be written off merely as a matter of convenience. Rather, his central role as an artist in the rebellion merits further consideration, complicating our understanding of artistic identity and artistic patronage in the colonial Andes. Oblitas, to my knowledge, is the only known and named Afro-Indigenous painter in the eighteenth-century Andes, yet he was tasked with creating one of the most significant commissions of his time. This was an unprecedented feat, given the limited opportunities for Black and Afro-Indigenous artists in colonial Peru. *Negros*, *mulatos*, and *zambos* were excluded from the painters' guild in Lima, a practice that likely continued informally in the highlands (Mesa and Gisbert 1982, 310).[6]

To indulge ourselves momentarily in the realm of the impossible, what could have been the impact of the portrait if the rebellion were successful? Much of our discussion remains speculative, for it relies on what Lisa Lowe (2015, 40–41) describes as the "*past conditional temporality* of the 'what could have been,' [which] symbolizes aptly the space of a different kind of thinking, a space of productive attention to the scene of loss." Yet a consideration of the past conditional temporality of Andean rebellions enables us to envision alternative art histories shaped by an anticolonial imaginary that Ninacancha, Oblitas, and their publics had begun to breathe into existence, only to be cut short by their failure and the cultural suppression that occurred in the rebellion's aftermath. The success of the insurgency would have ensured the survival and preservation of the portraits, just as its failure necessitated their disappearance as unruly objects. How would we view Oblitas differently if the painting had survived? If the rebellion had succeeded and Peru had become the first Indigenous-led multiracial republic in the Western Hemisphere, we would likely view Oblitas as the face of a new chapter in the history of Andean art, a portraitist who defied the conventions of the genre, whose racialized status could have precipitated a dramatic shift in systems of art production. Historians have highlighted his critical role as Tupac Amaru's assistant, whose murderous action of hanging Corregidor Antonio de Arriaga in November 1780 set off the rebellion itself. Yet it is only through historical imagining that we can recoup Oblitas's significance as an artist.

Locating our case study within a broader landscape of eighteenth-century anticolonial insurgencies in the Americas points toward potential ways to interrogate and understand the artists and artworks at hand. A brief consideration of artistic production in the aftermath of the Haitian Revolution (1791–1804), the largest slave revolt in modern history, which led to the establishment of the first Black republic in the Western Hemisphere,

offers insights into the "what could have been" of suppressed anticolonial movements elsewhere. News of the Tupac Amaru Rebellion reached Saint-Domingue's shores in the early 1780s, suggesting a basic awareness, however abstract, of rebellions occurring in South America (Thomson 2016, 426n36). Hartman (2008, 11) writes that displacing the authorized account of events that threaten the solvency of empire can be seen as critical recovery work that allows us to reconsider effaced and mutilated pasts (and their material cognates) through the lens of an "otherwise" (see also King, Navarro, and Smith 2020, 12–14). Can we imagine an "otherwise" art history of Andean rebellions through a lateral approach to the historical record rather than a teleological one?

In her masterful analysis of nineteenth-century portraits of the heroes of the Haitian Revolution, Erica Moiah James (2019, 12) argues that these paintings of Haitian sovereigns, in their recasting of Western aesthetics, "reclaimed the place of the subject in art history for themselves." While in Peru the political and cultural repression of the postrebellion era rendered the survival of such works impossible, Haiti, itself a "history of the impossible" in the words of Michel-Rolph Trouillot (1995, 73), activates our imagination to consider alternative outcomes for Andean rebellions and thus open up a space to uncover the kind of insurgent world-making practiced by the aforementioned artists and countless others whose names and aesthetic output elude the archival record. The case of Haiti also presents an alternative to upstreaming models that would assess the portraits as precursors or antecedents to republican portraits and instead sets the political imperatives of Andean insurgencies within a broader transatlantic context of grassroots rebellions, revolts, and wars for liberation (Thomson 2016; Cohen-Aponte 2022). The visual and material dimensions of these interconnections remain largely unexplored but beg for closer consideration; to take one example, pendants bearing the face of Haitian leader Jean-Jacques Dessalines circulated in Rio de Janeiro among enslaved Afro-Brazilians by 1805 (Reis 1993, 48). The aesthetics of liberation cut across imperial and geographic boundaries throughout the eighteenth century, fueled by increased information networks promulgated by sailors, insurgent corsairs, and bureaucrats (Bassi 2017; Soriano 2018). Had the Tupac Amaru Rebellion been successful, we can imagine that portraits, medallions, and other related imagery would have traveled along similar routes and entered into circulation across the Spanish Americas. While some may argue that engaging in this kind of speculative exercise compromises our role as historians by emphasizing what could have been rather than what actually happened, I think it holds tremendous methodological and pedagogical value (e.g., Walker 2012). By tracing the

visionary capacities of these artists through careful art historical and archival analysis, we can see the interconnectedness of anticolonial and abolitionist projects across the eighteenth-century Atlantic world.

A Villain with Many Faces

If Tupac Amaru is a hero without a face, then Charles III could be seen as a villain with infinite faces. The struggle for sovereign representation was integral to the rebellion, reflected in practices of patronage and iconoclasm as well as in the activation of representations of Tupac Amaru and Charles III in social space. Following long-established precedents of the twinned practices of image creation and iconoclasm in the establishment of a new social order, vigorous patronage of portraits of the rebel leader was accompanied by attempts to destroy portraits of the king. While Tupac Amaru himself often claimed to be operating under direct orders of Charles III and upheld the notion of the king as a benevolent monarch, antimonarchism persisted farther south, where more radicalized currents took hold. This formula would become reversed by colonial officials during the postrebellion era, whereby the call for destruction of Inca-themed artworks coincided with the proliferation of royalist imagery in the form of both large-scale portraiture and peace medals (*medallas de la paz*) bearing Charles III's face, which were gifted to caciques who had supported the royalist cause during the rebellion (Cahill 2006; Chao 2014).

One account from Buenos Aires described sympathizers who, upon hearing the news about the rebellion in the north, paid a large sum of money to purchase a portrait of Charles III so that they could burn it in the plaza and dump the remains in the swamp (Lewin 1967, 622). Portraits of Spanish monarchs sutured the disparate spaces of Spain and its overseas possessions via material surrogates that forged temporal commensurability with his living body. While created almost exclusively by local and regional artists due to the time lag of transatlantic travel, these portraits were subject to strict protocols of display, particularly during the sixteenth and seventeenth centuries (Engel 2018, 153–54). Official portraits of kings and viceroys alike were available for viewing only by those with access to the inner quarters of the viceregal palace, and differentiated levels of access were grounded in racial hierarchies (Engel 2013, 212). Such portraits would be viewed by the larger populace during succession and funerary ceremonies in which the monarch's visual simulacrum was brought into the plaza to be celebrated or mourned with great pomp and circumstance (Osorio 2008, 80–102). Yet the shifting terrain of the circulation of royal images by the eighteenth century

may have also made possible in the 1780s what would have been inconceivable in the previous century. Osorio (2008, 97) asserts that greater intimacy with the king's image by a broader cross section of the viceregal population was facilitated through increased circulation of smaller-scale portraits of the king during the eighteenth century. For example, the personal possessions of an individual imprisoned for his role in the Oruro rebellion included six hundred prints bearing the portrait of Charles III, and he possessed dozens of them in his store (Cajías de la Vega 2004, 1194).

There was also one site that afforded nearly all colonial subjects access to the king's image: coins. Beginning in 1772, Charles III launched a recoinage campaign that implemented the use of portrait coins across the entire Spanish Empire (Walton 2002, 178; and see Engel 2018, 165–67). Coins were especially charged objects for their implicit association with increasingly untenable conditions at the Potosí mines. In the eighteenth century, residents of the two Cusco provinces of Quispicanchi and Canas y Canchis, the eventual hotbeds of the rebellion, were subject to the *mit'a* system of forced labor (see chapter 2), required to work the mines on a rotational basis in order to pay off debts with the very silver extracted through their labor (Stavig 1999, 162–206). People used coins to express their grievances against that oppression. To take one example, according to a witness in Mendoza, Argentina, a certain Juan Manuel Barroso sought to burn a painting of Charles III, but due to either not being able to obtain one or not having one on hand, he melted a *peso de cordoncillo* (a coin with a milled edge) instead, claiming that "it was the same thing as burning a portrait" (Lewin 1967, 623). It is interesting here that the witness specified that it was a cordoncillo coin, since the edging circumscribes the image of the king in a way that would be analogous to a frame. While we don't have exact visual accompaniments to these descriptions, numerous examples exist of damaged and defaced coins from 1780 and 1781, some of which were restamped in order to reenter circulation. A two-real coin minted in Potosí in 1780, for instance, reveals excessive damage done to the lower half of Charles III's profile by what appears to be chiseling with a sharp metal tool (figure 7.5). These practices show us the creativity of participants in establishing ontological commensurabilities between disparate images in the service of anticolonial projects.

What did it mean to scratch out the king's face on a coin or melt it to the point of illegibility? Calls to deface or destroy the image of the king constituted a kind of symbolic regicide, in a similar vein to Tupac Amaru's symbolic execution in the gallows of Tinta. While the official rhetoric of the rebellion maintained the notion of corrupt bureaucrats but a benevolent king, not all participants and sympathizers followed this line of thinking. S. Elizabeth

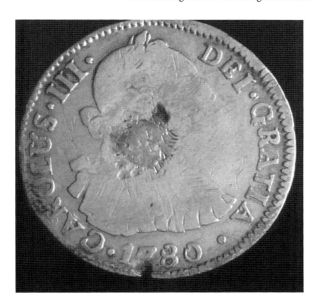

Figure 7.5. Two-real coin, minted at Casa de Moneda, Potosí, 1780. Colección Numismática, Banco de la República de Colombia, Bogotá, accession number NMO2538.

Penry (2019, 168) notes a shift among the popular classes of the southern Andes: "by 1781 rumors began to circulate that the king of Spain was dead, and rebels—*comuneros* as well as some urban Creoles and mestizos—began to seize on the idea of installing a *Peruvian* king, an Inca one, to be precise." Indeed, one account describes rebels Andrés Tupac Amaru (nephew of the original rebel leader) and Julián Apasa (alias Tupac Katari) calling for coins with new figures, presumably of themselves, so that they didn't have to look at the king's face (ANB, Sublevaciones de Indios, vol. 160, fol. 1v). The defacement or reengraving of coins could have symbolized to locals the transfer of monarchy to usher in a new world order, just as countermarked "error coins" marked periods of royal succession (Engel 2018, 166–67).

These interventions into the materiality of the king's portrait, ranging from the spectacular to the quotidian, deserve consideration as artistic gestures in and of themselves. The portraits by Ninacancha and Oblitas, while presumably lost to history, still conform to normative understandings of what constitutes the art object. Can we not also see the anonymous individuals who wielded chisels against the face of the king on colonial coinage as producers of art? Or the burning of a portrait of Charles III in a plaza and the dumping of its remains in a swamp as a performative act? These practices of what Wendy Bellion (2019, 122) calls transatlantic iconoclasm speak to "the uncanny agency of thing-power, the associative force of relics, as well as the symbiosis of sculptural bodies and their nonhuman doubles." Across the eighteenth-century Atlantic sphere, insurgents resorted to a remarkably

similar repertoire of tactical interventions into the material world. The targeted defacement of coins and paintings required intimate knowledge of the mechanisms of viceregal authority and awareness of their performative and iconic power—what Osorio (2017, 38) refers to as a "common ritual grammar"—acquired through shared experiences of baroque urban public spectacle. The defacement of imagery of Charles III can be seen as the initiation of an aesthetic rupture to open up possibilities for an alternative future. These acts are destructive and generative; as they extract from the original work, whether by chisel or fire, they render the object incomplete and thus incapable of realizing its intended hegemonic function. In returning the object back to an unfinished state—exposing its materiality through the object's literal unraveling—rebels interrupted the temporal flow of colonial authority by damaging the vessels through which it was transmitted.

When Is the Artist?

Art history has tended to crystallize artworks into the everlasting present of their completion (Moxey 2013; Nagel and Wood 2010). Yet throughout the early modern world and in colonial Latin America in particular, where reuse of canvases and other materials was necessitated by frequent shortages and economic precarity, the pervasive repainting and retouching of artworks diminish any claims to their authorial or temporal singularity (Mesa and Gisbert 1982, 267; Cohen Suarez 2016, 40–46). We are familiar with several genres of early modern visual alteration. Retouching of portraits occurred in tandem with the shifting biography of the person, such as through the revision of texts in cartouches (Katzew 2020); painting new insignia on the sitter represented entry into coveted institutions or, after death, transformed an earthly individual into a sanctified being (Jasienski 2020). Less explored, however, are politicized interventions into artworks. Periods of crisis—religious conversions, rebellion, revolution, war—often bring a work's multitemporality to the fore by exposing an earlier phase of the image's facture or, conversely, adding a new layer to efface the original image or change its meaning. Rebels and royalists alike intervened into paintings and sculptures to destabilize their claims to fixed subjects or interpretations. These interventions had the power to produce critiques or attach new narratives to given objects. Moments of precarity and transformation, during which objects underwent dramatic changes in form and significance, require us to probe more deeply into not only the *who* but also the *when* of insurgent art histories.

Representations of the Virgen del Carmen (Virgin of Mount Carmel), who served as the patroness of the rebel leadership, cue us in to the nature of artistic practice and improvisation in times of political upheaval. A painting of the Virgen del Carmen at the Church of Santiago Apóstol de Lucre, located in the Quispicanchi province of Cusco, features a male and female figure flanking the Virgin, hands clasped in prayer (figure 7.6). They are both surrounded by flames and have individual tears falling down their cheeks, both common visual cues that demonstrate the cleansing fires of purgatory purging their sins. The painting appears to date to the mid- to late eighteenth century, based on its understated use of gold leaf, the shallow composition, and the squat proportions of the figures surrounding the Virgin, echoing the style of Marcos Zapata and his circle, who were active in the mid-eighteenth century (Mesa and Gisbert 1982, 209–20). The male and female donor figures are nude, per convention for representing souls in purgatory. At least, I wrote as much in the brief catalog entry for the painting for a publication on paintings of colonial Cusco (Cohen Suarez and Montero Quispe 2015, 51). Years later, I saw what I and my coauthor had missed: hiding in plain sight, beneath the roughly painted nudes, are clothed figures. A layer of peach and brown paint hastily covers up late eighteenth-century men's regalia of a slim-fitting overcoat layered over a stiff-collared white shirt on the male figure (figure 7.7). The female figure appears to have worn a shawl with gold leaf decorations along the collar and white lace at the neck and cuffs (figure 7.8). When these figures are compared to the rest of the image, the simplified brushstrokes of the flames, tears, and flesh tones indicate a later intervention by a less-skilled artist.

The addition of a new layer to an image in accordance with the original composition is a far more ambivalent gesture than the type of iconoclastic stripping away of elements from an image that we more readily associate with the disruption of power. And yet, it appears that such modifications were an integral part of postinsurgency Peru. Inventories and account books within churches of the Quispicanchi, Acomayo, and Canas y Canchis provinces, which constituted Tupac Amaru's base of support, contain numerous references to works of art that were retouched or refabricated after the rebellion (Viñuales and Gutiérrez 2014, 325, 339, 354, 373, 418, 465, 492, 558, 580). I have argued elsewhere that the patronage of art and renovation of preexisting images within the church was a way for priests to demonstrate their largesse and even receive special privileges and distinctions in the postrebellion era (Cohen Suarez 2014, 28–31). With this in mind, it seems reasonable to argue that repainted donor figures engulfed in flames might be figures of Indigenous

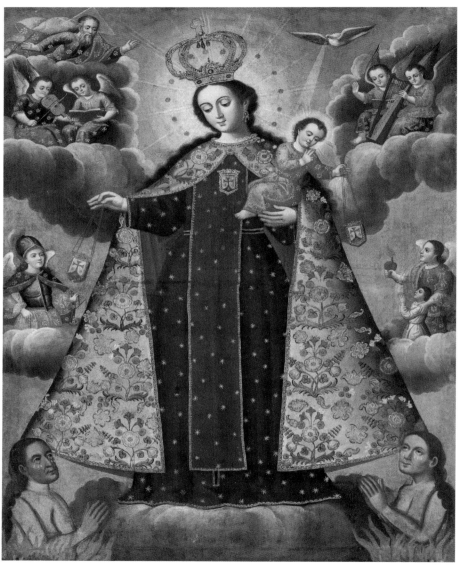

Figure 7.6. *Virgen del Carmen with Souls in Purgatory*, Cusco, Peru, eighteenth century. Oil on canvas, 174 × 123 cm. Church of Lucre, Peru. Photograph by Raúl Montero.

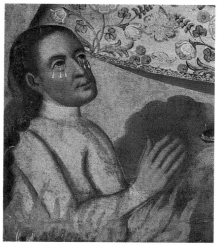

Figure 7.7. Detail, male figure from the bottom left corner of *Virgen del Carmen with Souls in Purgatory*, Cusco, Peru, eighteenth century. Oil on canvas. This soul in purgatory was originally a donor portrait. Photograph by Raúl Montero.

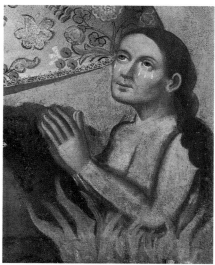

Figure 7.8. Detail, female figure from the bottom right corner of *Virgen del Carmen with Souls in Purgatory*, Cusco, Peru, eighteenth century. Oil on canvas. This soul in purgatory was originally a donor portrait. Photograph by Raúl Montero.

or mestizo elites that had once supported the rebel cause and consequently had become personae non gratae in the postrebellion period. This proposition gains more traction if we consider the importance of the advocation of the Virgen del Carmen for the rebel family and associates. By condemning the clothed, dignified donors to purgatory, the artist-intervener salvaged the canvas from confiscation or more extensive intervention, while signaling the patrons' status as sinners as well as the possibility of their redemption. In fact, the rise in popularity of scenes of tearful souls in purgatory marked a shift in Andean representation. As Maya Stanfield-Mazzi (2011b, 61–68)

demonstrates, these depictions supplanted seventeenth-century traditions of representing skulls and skeletons, which had been discouraged due to fears of encouraging Andean practices of ancestor veneration.

The modification of this simple devotional painting was certainly not an isolated event. Indeed, the repainting of canvases in the postrebellion era occurred under the orders of royal inspector José Antonio de Areche, who sought to eradicate all vestiges of cultural expression relating to the Inca and Andean culture more broadly. In a 1781 decree, he called for the repainting of any portraits of the Inca or their descendants so that "no sign remains [of the original image]" (*de modo que no quede señal*), and instructed that they should be covered up with portraits of the king or other Catholic sovereigns (Durand Flórez 1980–82, 3:1:275; see also Cahill 2006). Areche does not make clear in his decree who should be tasked with the work of painting over canvases, but if we use analogous cases of artworks with sexual content that were seized by the Inquisition in late colonial Mexico, we can posit that owners of artworks would have sent the offending works to local artists and artisans to "correct" the corrupting images (Penyak 2015, 426–29). The discovery of an eighteenth-century portrait of Andean noblewoman Manuela Tupa Amaro (no relation to Condorcanqui) hidden beneath a circa 1781–1800 painting of Christ of the Earthquakes serves as material proof of Areche's decree, even if the act of covering up her portrait may have been taken more as a precautionary measure to prevent its confiscation (Archi, n.d.; Majluf 2015; Cohen-Aponte 2021). If we broaden our definition of a portrait to include small-scale representations of donors, and our definition of "the artist" to include those who retouched and repainted images, we find that Areche's decree had a far greater reach than originally thought. By refocusing our attention on these often overlooked pictorial genres and actors, we can gain a better appreciation for the significant impact of postrebellion censorship campaigns.

A survey of other donor portraits of the Virgin del Carmen, which were under particular scrutiny due to her association with rebel leadership, reveals that the above-mentioned alterations might be part of a larger pattern of retouching, defacement, and overpainting of donor portraits connected to this advocation of the Virgin (Túpac Amaru 1941, 97–98). One such painting, which originally hung in the Church of Yanaoca, a town near the birthplace of Tupac Amaru and Micaela Bastidas, featured donor portraits not only of the rebel couple, but also of rebel *cacica* (female Indigenous leader) Tomasa Tito Condemayta and other associates of the family (figure 7.9). Alfonsina Barrionuevo (1972, 36), who was informed of the Yanaoca painting's anomalies by Juan de la Cruz Salas, a descendant of Clemente Tupac Amaru (the rebel leader's oldest brother), has noted that the brushstrokes for the figures

Figure 7.9. *Virgen del Carmen with Donors*, Cusco, Peru, eighteenth century. Pre-restoration photograph showing the Virgin flanked by a priest and brigadier, along with Indigenous elites of the region. Oil on canvas, dimensions unknown. Originally in the Church of Yanaoca, Peru. Current whereabouts unknown. Wikimedia Commons.

of the priest and brigadier are much thicker than those on the rest of the canvas, suggesting that the figures were added in the nineteenth century around the time of the War of Independence, as would befit the brigadier's uniform (see also Mesa and Gisbert 1982, 285). Indeed, a recent restoration revealed the supposed figure of Tupac Amaru on the left, although the presumed portrait of Micaela Bastidas beneath that of the priest on the right remains covered up (figure 7.10; Gisbert [1980] 2018, 315–16). In the majority of donor portraits where a male-female couple appears, the man is depicted on the left and the woman on the right, thus strengthening the possibility that these portraits originally represented Tupac Amaru and Bastidas (Stanfield-Mazzi 2011a, 439–46). Perhaps Tupac Amaru is no longer a hero without a face, now that his presumed visage has finally surfaced? Sadly, his face only survives as a digital surrogate. The painting has succumbed to yet another episode of erasure and obsolescence; it was stolen not once but twice from the Church of Yanaoca in recent years, and its whereabouts are now unknown.

Conclusion

This essay offers new insights for writing about art's entanglement with political violence, underscoring the gains that can be made through interdisciplinary methodologies for recovering Indigenous and Afro-Indigenous artists, subjects, and publics that have been erased from the official archive. The late eighteenth-century anticolonial insurgencies, while short lived, reveal a wealth of information on the role of artists and patrons in envisioning new political and social imaginaries through both the creation of new genres of art that defied colonial ontologies of the image, and the modification of

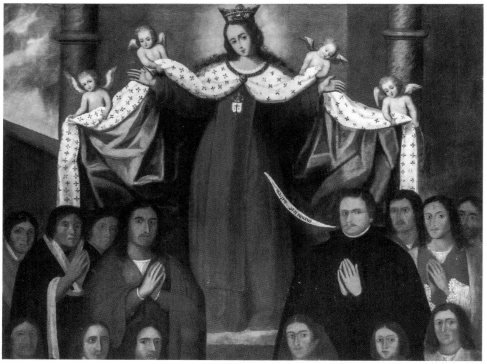

Figure 7.10. *Virgen del Carmen with Donors*, Cusco, Peru, eighteenth century. Postrestoration photograph revealing a possible portrait of Tupac Amaru to the left of the Virgin. Image employed under fair use, from Gisbert (1980) 2018, 316.

preexisting artworks. By expanding our concept of the artist to include not only the original hands that created the first iteration of the artwork, but subsequent artists as well, we can get a fuller picture of the collaborative, contested, and multitemporal character of much of colonial Latin American artistic creation. The disparities of survival of the visual record do not merely concern the fragility of materials; they reflect the imperatives of colonial officials who set the parameters for those objects worthy of preservation and those condemned to obsolescence. The suppression of anticolonial activity at the twilight of Spanish imperial rule involved complex rituals of erasure that included alteration of a plethora of artworks, a small selection of which were featured in this essay. These alterations took on a number of modalities, from retouching to destruction and disappearance. Indeed, the phrase *borrar la memoria* (erase the memory) was an oft-repeated one in the postrebellion documentation. Writing an art history of insurgency thus involves recovering works and artists that were never intended to survive. The extensive

legal records left behind by these rebellions open a window onto the important role that artists played in these uprisings. Oblitas, Ninacancha, and the defacers of portraits and coins emerge as multifaceted political actors who created and intervened on works of art in a moment of acute social conflict. Creative approaches to the visual and archival record can serve as a form of restorative justice for those who have been scorned, vilified, and dispossessed by history, whether these approaches involve historical reimaginings that open up the space of "what could have been" or inspection of effaced images that have been hiding in plain sight, patiently awaiting a closer look.

Acknowledgments

I am grateful to the participants in the 2019 New York University Atlantic World Workshop, the participants in the Beyond Biography symposium, and participants in the 2019 Consortium on the Revolutionary Era conference for feedback on earlier iterations of this essay. I also thank Derek S. Burdette, Maya Stanfield-Mazzi, and Margarita Vargas-Betancourt for their incisive and constructive feedback during the editing stages. Special thanks to my research assistant, María Pautassi Restrepo, for locating references to the royal portraits and coins discussed in this essay, as well as Sigrid Castañeda, curator at the Colección Numismática at the Banco de la República in Bogotá, who offered further context for the defacement and restamping of colonial coins.

Notes

1. The literature on Andean rebellions is vast and has enjoyed renewed scholarly interest in recent years. See, e.g., Cahill 2002; Lewin 1967; O'Phelan Godoy 1988, 1995; Serulnikov 2010; Stavig 1999; Stern 1987; Thomson 2002; and Walker 2014.

2. For examples of innovative approaches to the art historical record of eighteenth-century revolutions, see Clay 2012 and Bellion 2019.

3. One could draw parallels here with José Antonio Aponte's book of paintings that incited a slave rebellion in Cuba in 1812, which only survives today in the form of archival descriptions (Pavez Ojeda 2012; Rodriguez 2012; Rodriguez and Ferrer 2019). On talismanic objects that encoded alternative religiosities whose fate was to be tucked between pages of inquisition records, see Fromont 2020.

4. Juan Carlos Estenssoro (1991, 424) argues that this painting positions Tupac Amaru as a Christlike figure, similar to paintings of the Last Judgment that feature Christ at center with heaven to his right and hell to his left, yet the scant description of the painting makes this a difficult comparison to substantiate, especially since we don't know the positioning of Tupac Amaru relative to the rest of the scene.

5. Scarlett O'Phelan Godoy (2021) has published the most extensive analysis of the Sangarará Portrait to date. My essay supports and acknowledges the vast majority of her findings, while offering additional insights such as the portrait's iconographic similarities to the Virgin of Sunturhuasi imagery, as well as the significance of its placement in the gallows and subsequent role in legal proceedings. I diverge from her conclusion that there was only one portrait, the one by Oblitas; the trial testimony seems to indicate two separate portraits, the Equestrian Portrait and the Sangarará Portrait, as I have described in the text.

6. While Afrodescendant communities were much smaller in the Andean highlands than on the coast, structural inequalities persisted across the viceroyalty (Valenzuela 2013, 396). It would not be until the republican period that Afrodescendant artists in Peru such as José Gil de Castro, Francisco (Pancho) Fierro Palas, and others rose to prominence (Arrelucea Barrantes and Cosamalón Aguilar 2015, 93–97).

Reference List

Alcalá, Luisa Elena. 2004. "Miraculous Apparition of the Virgin in Cuzco." In *The Colonial Andes: Tapestries and Silverwork, 1530–1830*, edited by Elena Phipps, Johanna Hecht, and Cristina Esteras Martín, 150–52. New York: Metropolitan Museum of Art.

ANB (Archivo Nacional de Bolivia), Sucre. Sublevaciones de Indios, vol. 160.

Archi (Archivo Digital de Arte Peruano). n.d. *Manuela Tupa Amaro*, circa 1777. Digital reproduction of painting. https://archi.pe/obra/44192.

Arrelucea Barrantes, Maribel, and Jesús Cosamalón Aguilar, eds. 2015. *La presencia afrodescendiente en el Perú. Siglos XVI–XX*. Lima: Ministerio de Cultura.

Asensio, Raúl H. 2017. *El culto a Túpac Amaru en Cusco durante la revolución velasquista (1968–1975)*. Lima: Instituto de Estudios Peruanos.

Barrionuevo, Alfonsina. 1972. "El verdadero rostro de Túpaq Amaru." *Caretas*, no. 450.

Bassi, Ernesto. 2017. *An Aqueous Territory: Sailor Geographies and New Granada's Transimperial Greater Caribbean World*. Durham, NC: Duke University Press.

Bellion, Wendy. 2019. *Iconoclasm in New York: Revolution to Reenactment*. State College: Pennsylvania State University Press.

Cahill, David. 2002. *From Rebellion to Independence in the Andes: Soundings from Southern Peru, 1750–1830*. Amsterdam: Aksant.

———. 2006. "El Visitador General Areche y su campaña iconoclasta contra la cultura andina." In *Visión y Símbolos: Del virreinato criollo a la República Peruana*, edited by Ramón Mujica Pinilla, 83–111. Lima: Banco de Crédito del Perú.

Cajías de la Vega, Fernando. 2004. *Oruro 1781: Sublevación de indios y rebelión criolla*. Lima: Instituto Francés de Estudios Andinos.

Cant, Anna. 2012. "'Land for Those Who Work It': A Visual Analysis of Agrarian Reform Posters in Velasco's Peru." *Journal of Latin American Studies* 44 (1): 1–37.

Chao, Fernando. 2014. *La sublevación de Túpac Amaru y sus medallas*. Buenos Aires: Academia Nacional de la Historia.

Clay, Richard S. 2012. *Iconoclasm in Revolutionary Paris: The Transformation of Signs*. Oxford: Voltaire Foundation.

Cohen-Aponte, Ananda. 2021. "Imagining Insurgency in Late Colonial Peru." In *Visual Culture and Indigenous Agency in the Early Americas*, edited by Alessia Frassani, 188–210. Leiden: Brill.

———. 2022. "Reimagining Lost Visual Archives of Black and Indigenous Resistance." *Selva*, no. 3. https://selvajournal.org/article/reimagining-lost-visual-archives/.

Cohen Suarez, Ananda. 2014. "Las pinturas murales de la Iglesia de San Pablo de Cacha, Canchis, Perú." *Allpanchis* 23 (77–78): 11–48.

———. 2016. *Heaven, Hell, and Everything in Between: Murals of the Colonial Andes*. Austin: University of Texas Press.

Cohen Suarez, Ananda, and Raúl Montero Quispe, eds. 2015. *Pintura colonial cuzqueña: El esplendor del arte en los Andes*. Cusco: Haynanka Ediciones.

Corteguera, Luis R. 2012. *Death by Effigy: A Case from the Mexican Inquisition*. Philadelphia: University of Pennsylvania Press.

Cummins, Thomas. 1991. "We Are the Other: Peruvian Portraits of Colonial Kurakakuna." In *Transatlantic Encounters: Europeans and Andeans in the Sixteenth Century*, edited by Kenneth J. Andrien and Rolena Adorno, 203–70. Los Angeles: University of California Press.

Cummins, Thomas, Natalia Majluf, Luis Eduardo Wuffarden, Gabriela Ramos Cárdenas, and Elena Phipps, eds. 2005. *Los Incas, reyes del Perú*. Lima: Banco de Crédito del Perú.

Dean, Carolyn. 2005. "Inka Nobles: Portraiture and Paradox in Colonial Peru." In *Exploring New World Imagery: Spanish Colonial Papers from the 2002 Mayer Center Symposium*, edited by Donna Pierce, 80–103. Denver, CO: Denver Art Museum.

Durand Flórez, Luis, ed. 1980–82. *Colección documental del bicentenario de la revolución emancipadora de Túpac Amaru: Los procesos a Túpac Amaru y sus compañeros*. 5 vols. Lima: Comisión Nacional del Bicentenario de la Rebelión Emancipadora de Túpac Amaru.

Engel, Emily A. 2013. "Art and Viceregal Taste in Late Colonial Lima and Buenos Aires." In *Buen Gusto and Classicism in the Visual Cultures of Latin America, 1790–1910*, edited by Paul B. Niell and Stacie G. Widdifield, 206–31. Albuquerque: University of New Mexico Press.

———. 2018. "Changing Faces: Royal Portraiture and the Manipulation of Colonial Bodies in the Viceroyalty of Peru." In *Spanish Royal Patronage, 1412–1804: Portraits as Propaganda*, edited by Ilenia Colón Mendoza and Margaret Ann Zaho, 149–69. Newcastle upon Tyne: Cambridge Scholars.

Estenssoro, Juan Carlos. 1991. "La plástica colonial y sus relaciones con la gran rebelión." *Revista Andina* 9 (2): 415–39.

———. 2005. "Construyendo la memoria: La figura del inca y el reino del Perú, de la conquista a Túpac Amaru II." In Cummins et al. 2005, 93–173.

Fromont, Cécile. 2020. "Paper, Ink, Vodun, and the Inquisition: Tracing Power, Slavery, and Witchcraft in the Early Modern Portuguese Atlantic." *Journal of the American Academy of Religion* 20 (20): 1–45.

Gisbert, Teresa. (1980) 2018. *Iconografía y mitos indígenas en el arte*. 5th ed. La Paz: Biblioteca del Bicentenario de Bolivia.

Hartman, Saidiya. 2008. "Venus in Two Acts." *Small Axe*, no. 26, 1–14.

Hidalgo Lehuedé, Jorge. 1983. "Amarus y cataris: Aspectos mesiánicos de la rebelión indígena de 1781 en Cusco, Chayanta, La Paz y Arica." *Chungara: Revista de Antropología Chilena*, no. 10, 117–37.

James, Erica Moiah. 2019. "Decolonizing Time: Nineteenth-Century Haitian Portraiture and the Critique of Anachronism in Caribbean Art." *Nka: Journal of Contemporary African Art* 44 (1): 8–23.

Jasienski, Adam. 2020. "Converting Portraits: Repainting as Art Making in the Early Modern Hispanic World." *Art Bulletin* 102 (7): 7–30.

Katzew, Ilona. 2020. "Trastoques y elipsis en un retrato de tornaviaje: La ductilidad de los mensajes." In *Tornaviaje: Tránsito artístico entre los virreinatos americanos y la metrópolis*, edited by Fernando Quiles, Pablo F. Amador, and Martha Fernández, 13–32. Seville: Andavira Editora.

King, Tiffany Lethabo, Jenell Navarro, and Andrea Smith. 2020. "Beyond Incommensurability: Toward an Otherwise Stance on Black and Indigenous Relationality." In *Otherwise Worlds: Against Settler Colonialism and Anti-Blackness*, edited by Tiffany Lethabo King, Jenell Navarro, and Andrea Smith, 1–23. Durham, NC: Duke University Press.

Lea, Henry Charles. 1908. *The Inquisition in the Spanish Dependencies: Sicily—Naples—Sardinia—Milan—the Canaries—Mexico—Peru—New Granada*. London: Macmillan.

Lewin, Boleslao. 1967. *La rebelión de Túpac Amaru y los orígenes de la independencia de Hispanoamérica*. 3rd ed. Buenos Aires: Sociedad Editora Latino Americana.

Lituma Agüero, Leopoldo. 2011. *El verdadero rostro de Túpac Amaru (Perú, 1969–1975)*. Lima: Universidad Nacional Mayor de San Marcos.

Lowe, Lisa. 2015. *The Intimacies of Four Continents*. Durham, NC: Duke University Press.

Macera, Pablo. 1975. *Retrato de Tupac Amaru*. Lima: Universidad Nacional Mayor de San Marcos.

Majluf, Natalia. 2015. "Manuela Tupa Amaro, Ñusta." In *La colección Petrus y Verónica Fernandini: El arte de la pintura en los Andes*, edited by Ricardo Kusunoki, 158–85. Lima: Museo de Arte de Lima.

Mesa, José de, and Teresa Gisbert. 1982. *Historia de la pintura cuzqueña*. Vol. 1. Lima: Fundación Banco Wiese.

Moxey, Keith P. F. 2013. *Visual Time: The Image in History*. Durham, NC: Duke University Press.

Mujica Pinilla, Ramón. 2008. "La Virgen de Sunturhuasi." In *Mestizo: Del renacimiento al barroco andino*, edited by José Torres della Pina, 114–16. Lima: Impulso Empresa de Servicios.

Mundy, Barbara E., and Aaron M. Hyman. 2015. "Out of the Shadow of Vasari: Towards a New Model of the 'Artist' in Colonial Latin America." *Colonial Latin American Review* 24 (3): 283–317.

Nagel, Alexander, and Christopher S. Wood. 2010. *Anachronic Renaissance*. New York: Zone Books.

O'Phelan Godoy, Scarlett. 1988. *Un siglo de rebeliones anticoloniales: Perú y Bolivia 1700–1783*. Cusco: Centro de Estudios Rurales Andinos "Bartolomé de Las Casas."

———. 1995. *La gran rebelión en los Andes: De Túpac Amaru a Túpac Catari*. Lima: Petroperu.

———. 2021. "Elementos apocalípticos en la descripción del cuadro-retrato de Túpac Amaru II." In *Mesianismo, reformismo, rebelión: Los Andes en el siglo de la ilustración*, edited by Christine Hunefeldt and Alexandre Belmonte, 199–226. N.p: independently published.

Osorio, Alejandra B. 2008. *Inventing Lima: Baroque Modernity in Peru's South Sea Metropolis*. New York: Palgrave Macmillan.

———. 2017. "Courtly Ceremonies and a Cultural Urban Geography of Power in the Habsburg Spanish Empire." In *Cities and the Circulation of Culture in the Atlantic World: From the Early Modern to Modernism*, edited by Leonard von Morzé, 37–72. Boston: Springer.

Pavez Ojeda, Jorge. 2012. "The 'Painting' of Black History: The Afro-Cuban Codex of José Antonio Aponte (Havana, Cuba, 1812)." In *Written Culture in a Colonial Context: Africa and the Americas, 1500–1900*, edited by Adrien Delmas and Nigel Penn, 283–315. Leiden: Brill.

Penry, S. Elizabeth. 2019. *The People Are King: The Making of an Indigenous Andean Politics*. New York: Oxford University Press.

Penyak, Lee M. 2015. "The Inquisition and Prohibited Sexual Artwork in Late Colonial Mexico." *Colonial Latin American Review* 24 (3): 421–36.

Reis, João José. 1993. *Slave Rebellion in Brazil: The Muslim Uprising of 1835 in Bahia*. Translated by Arthur Brakel. Baltimore, MD: Johns Hopkins University Press.

Rodriguez, Linda M. 2012. "Artistic Production, Race, and History in Colonial Cuba, 1762–1840." PhD diss., Harvard University.

Rodriguez, Linda M., and Ada Ferrer. 2019. "Collaborating with Aponte: Digital Humanities, Art, and the Archive." *SX Archipelagos*, no. 3, 1–16.

Serulnikov, Sergio. 2010. *Revolución en los Andes: La era de Túpac Amaru*. Buenos Aires: Editorial Sudamericana.

Soriano, Cristina. 2018. *Tides of Revolution: Information, Insurgencies, and the Crisis of Colonial Rule in Venezuela*. Albuquerque: University of New Mexico Press.

Stanfield-Mazzi, Maya. 2011a. "Cult, Countenance, and Community: Donor Portraits from the Colonial Andes." *Religion and the Arts* 15:429–59.

———. 2011b. "El complemento artístico a las misas de difuntos en el Perú colonial." *Allpanchis* 43 (77/78): 49–81.

Stavig, Ward. 1999. *The World of Túpac Amaru: Conflict, Community, and Identity in Colonial Peru*. Lincoln: University of Nebraska Press.

Stern, Steve J., ed. 1987. *Resistance, Rebellion, and Consciousness in the Andean Peasant World, 18th to 20th Centuries*. Madison: University of Wisconsin Press.

Thomson, Sinclair. 2002. *We Alone Will Rule: Native Andean Politics in the Age of Insurgency*. Madison: University of Wisconsin Press.

———. 2016. "Sovereignty Disavowed: The Túpac Amaru Revolution in the Atlantic World." *Atlantic Studies* 13 (3): 407–31.

Trouillot, Michel-Rolph. 1995. *Silencing the Past: Power and the Production of History*. Boston: Beacon Press.

Túpac Amaru, Juan Bautista. 1941. *Cuarenta años de cautiverio: Memorias del Inka Juan Bautista Túpac Amaru*. Edited by Francisco A. Loayza. Lima: Librería e Imprenta D. Miranda.

Valcárcel, Daniel. 1970. *El retrato de Túpac Amaru*. Lima: Editorial Rocarme.

———, ed. 1971. *La rebelión de Túpac Amaru*. Vol. 2. Lima: Comisión Nacional del Sequicentenario de la Independencia del Perú.

Valenzuela, Fernando A. 2013. "La debilidad institucional del gremio de pintores en Cusco en el período colonial: Un estudio historiográfico." *Colonial Latin American Historical Review* 1 (4): 381–402.

Viñuales, Graciela María, and Ramón Gutiérrez. 2014. *Historia de los pueblos de indios de Cusco y Apurímac*. Lima: Universidad de Lima.

Walker, Charles. 2012. "Un Inca en Sacsayhuaman: Si Túpac Amaru hubiese tomado el Cuzco (1780–1781)." In *Contra-Historia del Perú: Ensayos de Historia Política Peruana*, edited by Eduardo Dargent and José Ragas, 31–48. Lima: Mitin Editores.

———. 2014. *The Tupac Amaru Rebellion*. Cambridge, MA: Harvard University Press.

Walton, Timothy R. 2002. *The Spanish Treasure Fleets*. Sarasota, FL: Pineapple Press.

Wuffarden, Luis Eduardo. 2005. "La descendencia real y el 'Renacimiento Inca' en el virreinato." In Cummins et al. 2005, 174–251.

8

Paint and Poison

Black Artists and Elite Anxieties in Eighteenth-Century Havana

LINDA MARIE RODRIGUEZ

On August 10, 1791, Pedro Dionisio Muñoz de Carballo stood before the court in Havana, pleading his innocence (ANC 1791, fol. 56r). A week prior, Muñoz de Carballo had been placed under arrest in a public jail, accused of selling poisonous paints at his three *tiendas de mercería* (paint and general merchandise stores) "indistinctly" to "all classes" of people, which, according to the charges against him, had resulted in sicknesses and even deaths (ANC 1791, fol. 1r–1v). The charges suggested a link between Muñoz de Carballo's store and a string of recent notorious murders by enslaved individuals of their enslavers (ANC 1791, fol. 13r, 53r–54r). In previous years, enslaved individuals known as Juan Baptista and Dolores had killed their masters, as had the enslaved women María Martínez and María de los Ángeles, both of whom poisoned their enslavers. The charges against Muñoz de Carballo hinged on the possibility that these people might have purchased the poisonous materials from his stores to commit their crimes, given the highly toxic nature of some of the artist pigments that he sold (ANC 1791, fol. 1v). Muñoz de Carballo's own identity as a free man of color, born to an enslaved mother from Angola and a Spanish father in Almendralejo, Extremadura, Spain, likely heightened suspicions against him.[1] The resulting proceedings continued through the early months of 1792, and the criminal process produced 226 pages of documentary records, currently housed in the Fondo de la Audiencia de Santo Domingo in the Archivo Nacional de Cuba.[2] The proceedings offer crucial insight into the art world of colonial Havana, especially given the general lack of archival information for the study of colonial Cuban art. They confirm the existence of a guild system among painters, inform us of the pigments and materials painters used in their daily labors, and reveal the presence of a division between artists and artisans, while also illustrating

the extent to which men of color dominated the painterly sphere.[3] This insight comes, however, within the context of colonial authorities' suspicion of Black people, both as potential poisoners and as potential suppliers of poisonous materials, underscoring the intersection of race and the artistic sphere in colonial Havana.

On August 4, 1791, Havana mayor Francisco José de Basabe y Cárdenas began the proceedings against Muñoz de Carballo by naming a judicial tribunal, including professors of pharmacy who searched Muñoz de Carballo's stores and home for poisonous substances. Over the course of five days, the tribunal collected testimony about Muñoz de Carballo's operations from the professors of pharmacy, Muñoz de Carballo himself, his shop assistants, the head of the Protomedicato (a colonial medical institution responsible for regulating the medical profession), and a group of painters (López Sánchez 1997, 284–86). Through the August testimony and Muñoz de Carballo's appeals, the proceedings historicize the participation of free men of color in the visual arts at a crucial moment of racial tension on the island. In 1789, the Spanish colonial government had opened the slave trade to foreign merchants for an initial period of two years, the result of a long-term policy of commercial liberalization enacted by the Spanish Bourbon Crown in the wake of the British invasion of Havana in 1762 (Kuethe 1991, 26–28). On November 21, 1791, almost three months after Basabe y Cárdenas had initiated the process against Muñoz de Carballo, Spanish authorities approved an extension of the open trade policy. The policy's architect, *criollo* (American-born descendant of Spaniards) Francisco Arango y Parreño, presented the extension as an opportunity for Cuban planters to expand sugar production and replace that of the neighboring French colony of Saint-Domingue, where production had plummeted due to slave rebellions and unrest (Ferrer 2014, 35–36). The revolts in Saint-Domingue led to what we know as the Haitian Revolution, culminating in the establishment in 1804 of the first Black republic in the Western Hemisphere. The racial tension of early August 4, 1791—the day of Muñoz de Carballo's arrest—worsened following the outbreak of the first slave revolts later that month in Saint-Domingue. A fear of similar uprisings in Cuba permeated the minds of Spanish and *criollo* elites due to the constant stream of "talk about Haiti" that began in Cuba just "days after" the outbreak of the initial revolts (Ferrer 2008, 23). Further, in 1792, for the first time in the history of the island, the combined population of free and enslaved people of color eclipsed the white population in numbers (Childs 2006, 54; Venegas Fornias 2002, 47). The census for that year reported 27,770 free and enslaved people of color out of a total population of 51,307 for Havana, and the trend would continue in the years to come (Sagra

1831, 4). After the turn of the nineteenth century, sugar production in Cuba increased rapidly, as did the importation of enslaved people, whose labor was seen as necessary for the growth of the industry.

The demographic change—that is, the conversion of Havana into a slave society—coincided after the turn of the century with the emergence of aesthetic discourses among white elites that aimed to disenfranchise Black artists, who had previously dominated artistic production in the colony. The literary scholar Simon Gikandi (2011, 17), writing about eighteenth-century Britain, argues that white elite aesthetic discourse, related to the idea of taste in particular, used "culture to conceal the intimate connection between modern subjectivity and the political economy of slavery." Gikandi's work holds fruitful comparison for the turn-of-the-century expansion of the slave trade in Havana, and corresponding attempts by white elites to quarantine aspects of the visual arts from the hands of Black artists. Anxiety surrounding Black dominance of the visual arts resulted in efforts to use aesthetic discourses to legitimize white, *criollo* hegemony. The recently arrived Spanish bishop Juan José Díaz de Espada y Landa (1757–1832) played a crucial role, in conjunction with other Spanish and *criollo* elites, in advocating a reformist aesthetic agenda rooted in a reinvention of the neoclassical style in Cuba (García Pons 1951; Torres-Cuevas 1990). The agenda resulted, in part, in the 1818 opening of the island's first fine arts academy, the Academia de San Alejandro, from which Black students were excluded (Fischer 2004, 74).[4] The Real Sociedad Económica (Royal Economic Society), a local manifestation of Enlightenment Spanish societies dedicated to social and commercial progress, supported the school's foundation (Álvarez Cuartero 2000). Paul Niell (2012, 304–6, 309) argues that instruction at San Alejandro attempted to "inject *buen gusto* [good taste] into the arts of Havana" in order to "wrest artistic production away from people of African descent." Taste embodied an idea of "aesthetic discernment" that "created a dynamic field of social performance and glossed social life with the aura of the modern and the international" for white elites.

The 1791 proceedings do not shed light on the development of ideas of taste as described by Niell, but they do historicize the participation of artists of African descent in the painterly sphere and illustrate the racial anxieties of white elites toward their participation. If we use racial anxiety as a category of historical analysis, following the work of historian Zeb Tortorici (2007, 37), we can understand why white elites reacted to the presence of Black people in the visual arts and why they perceived the artists as a threat, both in 1791 and into the nineteenth century. The art world in 1791 provided an uncomfortable margin for disorder (the poisoning of slaveholders) that threatened

the civic control necessary to increase the slave trade for the sugar economy, serving as a point of departure at the start of the nineteenth century for continued racial anxiety that viewed the Black presence in the arts as disruptive to the island's progress (Tomich 2003, 10). In his arguments in favor of relaxed trade regulations for the importation of slaves, Arango y Parreño had suggested that the resulting increased prosperity would help build locally the "public happiness" that the Spanish Bourbon Crown sought to engender throughout its possessions. Gabriel B. Paquette (2008, 56, 58) describes this idea of public happiness as one that served to "redefine and enlarge the state's overall function in society." Paquette notes that government institutions and policies "were deemed defective if they failed to produce the increase of both subjects and goods": population growth and increased material wealth were viewed as integral to the achievement of public happiness in society. On a local level, historian José Antonio Valdés (2005, 116), writing in 1813 in Havana, called commerce the "most certain spring [*manantial*] of public happiness." Following this logic, a robust commercial sector buttressed the advancement of the arts, and, vice versa, progress in the arts stood as testament to commercial expansion. If prosperity was manifested in and relied on the florescence of the arts, Black labor had to be removed from the artistic realm in order for this nineteenth-century Enlightenment aesthetic agenda to be achieved. As Gikandi (2011, 23) writes, "commerce enabled culture, art, and taste, which were, in turn, deployed as modes of cultivation and politeness, differentiating the subject of taste from the savagery and barbarism of a previous time and of other cultures and experiences." The 1791 proceedings, then, suggest a point of emergence for white elite fears that Black agency jeopardized the development of commerce, as well as its correlate, civilized society.

Specifically, in 1791, Mayor Basabe y Cárdenas's anxiety centered on Muñoz de Carballo as a potentially destabilizing agent, accused of selling the poisons that enabled enslaved persons to challenge the social order by killing their enslavers. The ability of the enslaved to kill their masters endangered the economic basis of the island, as rebellious slaves were an unreliable workforce for the sugar plantations. During the proceedings, Basabe y Cárdenas underscored white fears about Black rebellion, reminding his superiors in the regional Audiencia (high court) that Havana was a place where "black slaves [were] always enemies of their very Masters" (ANC 1791, fol. 83r). Basabe y Cárdenas's concern was shared by other elites in light of the substantial demographic shifts following the precipitous rise in importation of slaves. The mayor centered his charges against Muñoz de Carballo on the man's own identity (a free man of color) and that of his clientele (characterized

by a high volume of free people of color, mostly painters). Basabe y Cárdenas implied that enslaved men and women could have accessed Muñoz de Carballo's stores by posing as painters, who were themselves predominantly free men of color, to buy pigments that were lethal if ingested. Through this logic, artistic practice became a cover for lethal activity. Muñoz de Carballo and the artists of color who patronized his shop belonged to a larger community of free people of color—what the historian Pedro Deschamps Chapeaux (1971) calls a "petit bourgeoisie of color"—who worked in the port city in a variety of spheres but occupied a precarious terrain (see also Barcia 2008; Deschamps Chapeaux and Pérez de la Riva 1974). In 1791, they lived in a city on the cusp of major economic and social transformation where the labor of free men and women of color was a necessary, if suspiciously regarded, component of everyday life.

Black Artists in Colonial Cuba

As few archival documents have surfaced illuminating social aspects of the artistic landscape of colonial society in the decades before and after the 1791 proceedings, the court documents against Muñoz de Carballo give an important window into colonial Cuban art history. Even more crucially, the documents offer insight into the significant presence of Black artists in the colonial period. The few published writings from the period that do acknowledge Black participation in the arts, penned by *criollo* and European authors, frame it as a hinderance to the island's progress. *Criollo* intellectual José Antonio Saco, for example, has had an important impact on the general understanding of the role of Black artists in colonial Cuba. In his 1830 "Memoria sobre la vagancia" (Report on Vagrancy), Saco delineates the causes of vagrancy on the island, including gambling and an excess of festive holidays. Saco (1858, 205) also describes the prejudice in Cuba that associated professions such as carpentry and tailoring with a "fatal stain" because they were mostly exercised by men and women of color. He notes that "among the enormous ills that this unhappy race has brought to our land, one of those has been distancing the arts from our white population. Destined only to mechanical work, they exclusively commanded *all of the trades*, as proper to their condition" (emphasis added).[5] Saco attributes the moral failings of colonial society to Black people as they rob white people of the opportunity to produce honest work. For Saco, artistic production served as a measure, as much as the other fields, of the progress of the colony.

Saco was not, however, the first to write about the participation of Black people in the arts. Anonymous observations included as a preface to the

1774–75 census completed under Captain General Felipe de Fondesviela y Ondeano, Marqués de la Torre (in office 1771–77) confirm Saco's (1858, 394) characterization of the situation: "The arts are the occupation of mulattos and free blacks: few whites are employed in them. The most necessary to human life, like shoemaking, tailoring, and ironsmithing are in fair state; of these the most developed is carpentry, which includes perfectly completed works, and comparable with those of the English. Painting, sculpture, silversmithing, and other arts destined to luxury, are still very backward."[6] According to the earlier anonymous observations, written more than half a century before Saco's essay, the Black presence was well established in Cuba's arts, both those arts "necessary" for human life like shoemaking and carpentry and those destined for "luxury" like painting. Luxury arts, understood within an early eighteenth-century conception, were far from frivolous, but rather were viewed as "indispensable to the material well-being of the nation and to social progress" (Belozerskaya 2005, 3). In this sense, the unidentified author frames the existence of the luxury arts as indicative of the economic health of the island. That they were practiced solely by Black people, however, was a negative indicator. Four years earlier, in 1771, Abbé Guillaume Thomas Raynal (1713–96) made a similar assessment, noting that "the only crafts to be found on the island are the absolutely essential ones. They are in the hands of mulattos or blacks, and they have been very little developed. Joinery alone has reached a remarkable degree of perfection" (Jimack 2006, 164).

The ideas expressed in these three late colonial accounts reveal the mindset that framed the racial anxiety evident in the 1791 proceedings. The observations of Abbé Raynal, the anonymous census writer, and Saco suggest that from the perspective of European and *criollo* observers, the participation of Black people in the arts—here, both liberal and mechanical—deterred the pace of progress of the island and was detrimental to the white population. As already established, late eighteenth-century and early nineteenth-century white writers conceived of economic development, population growth, and public happiness as closely interrelated phenomena. In this context, the elite white response to Black artists and artisans can be understood in part as a reaction to the blemishing of a vital signifier of economic health, and therefore a blemishing of elites' own perceived happiness, both then and in the future.

Painters, Guilds, and the 1791 Proceedings

In the wake of the 1762 British occupation of Havana, almost three decades prior to the proceedings against Muñoz de Carballo, the Spanish embarked

on a campaign of urban refortification that had crucial implications for artists, and for the racialized spatial order of the city. The ramifications of this campaign can be seen in the testimonies of the Muñoz de Carballo proceedings. Britain's ability to take the city in 1762 had revealed weaknesses in Havana's defense system, and the subsequent Spanish campaign focused on the construction of new fortifications outside the city's walls and across the entrance to the bay (Johnson 2001; Kuethe 1986). This construction project also drew official attention to what Guadalupe García (2006, 45) describes as the "ubiquitous and persistent presence of the urban poor" outside the city walls, leading to the development of a *política del orden urbano* (policy of urban order) to organize the city and its environs. The poor population outside the city walls produced anxieties about vagrancy and the threat to public order. As we have already seen with Saco, "vagrancy" had a color in the mind of colonial elites and was closely associated with Blackness. The move to impose order on what was perceived as an unruly poor population thus implied a move to control the Black inhabitants of Havana.

In 1763, as part of this urban renewal initiative, the Spanish Crown put forth an urbanization plan that divided the *intramuros* (area inside the city walls) into districts to be managed by neighborhood inspectors known as *comisarios* (García 2006, 47–48).[7] In March 1770, the *ayuntamiento* (town council) of the city of Havana announced new ordinances, the Actas Capitulares del Ayuntamiento de la Habana (Capitular Acts of the Town Council of Havana), as a way to "better the government and *policía*" of the city (AO-HCH 1770, fol. 40v). Crucial to the framework of Spanish urban planning in the Americas, policía as defined by Richard Kagan included two concepts: "one public, linked to citizenship in an organized polity, the other connected to personal comportment and private life, both inseparable from urban life" (Kagan 2000, 27). The Spanish believed the city to be the locus of civilization, and they acted to ensure it functioned as such. Part of the reorganization of the city included an effort to order the population. In post-1770 Havana, the comisarios functioned as neighborhood watchmen. The town council affirmed that the comisarios would be responsible for ensuring that no one "dedicated themselves only to their vices, without being of any utility to the Republic." In fact, the "principal and most important task" of the comisarios was to guarantee that the city's inhabitants adhered to the ordinances (AO-HCH 1770, fol. 42r, 43r).

Maintaining order meant not only ensuring the cleanliness of the city, the absence of prostitution, and respect for the Sabbath, but also regulating the professional lives of the city's inhabitants. Ordinances stipulated that the comisarios were to establish who made a living through positions in

"Commerce, the liberal Arts, and Mechanical [Arts]" (AOHCH 1770, fol. 46r). They were also to ensure that these individuals proceeded "immediately" to form guilds. The ordinances defined the liberal arts as "Painting, Sculpture, Masonry, and Architecture, to which Silversmiths could be added" (AOHCH 1770, f. 46v). Indeed, later that year, practitioners of these different trades, including a group of painters, presented their guild regulations to the ayuntamiento (AOHCH 1770, fol. 71r, 91r, 94r). On May 11 and June 22, 1770, the notary for the town council reported that he had read the regulations and affirmed that the painters' guild members should report to the comisarios (AOHCH 1770, fol. 71r, 93v).[8]

While the notary's report in the Actas presumably affirms the existence of at least one guild of painters, there is little archival evidence about its functioning after 1770.[9] In the proceedings against Muñoz de Carballo, however, references to a guild system (or at least its structure) appear to confirm that the painters' guild remained in operation. The first evidence of the guild's existence in the Muñoz de Carballo proceedings comes on August 5, 1791, when the tribunal commissioners testified. The resulting testimony reveals the existence of hierarchical structures for the training of painters that a guild would have regulated. That day, José María Sanz, Basabe y Cárdenas's assessor, centered his questioning on ascertaining whether Muñoz de Carballo and his assistants sold to "all classes" of people, meaning Black people, *mulatos*, and individuals who were not *pintores de oficio* (painters by trade). The commissioners included four individuals, known as "ministers," whom Basabe y Cárdenas had named to lead the proceedings, along with the professors of pharmacy. Two ministers, Manuel Milián and Félix Martínez (both natives of Havana), had family members who were painters.[10] I suspect that Sanz selected them as commissioners because of those relationships. Manuel Milián's brother Santiago Milián had apprenticed with an Italian painter known as Juan de Rosas. Manuel Milián asserted that indeed "all classes" of people bought materials from Muñoz de Carballo because apprentices like Santiago purchased what they needed at his shops, as did the journeymen (*oficiales*) who worked for Juan "the Italian" alongside Santiago (ANC 1791, fol. 12v–13v). Minister Félix Martínez's fourteen-year-old son Francisco Martínez was apprenticed to a master painter named Julio Gamarra, a free man of color and inhabitant of Havana. Martínez similarly affirmed that Muñoz de Carballo sold to "all classes" of people because his son had bought from Muñoz de Carballo in the past (ANC 1791, fol. 46v–47r). As apprentices and journeymen purchased materials from Muñoz de Carballo on errands for their master painters, Sanz inquired as to whether Muñoz de Carballo's shop assistants would sell to them if they came without a note (*papel*) from their

respective master painter. Manuel Milián asserted that the shop assistants would not sell to them without the note.

The master-apprentice relationships reported by the ministers at the start of the questioning confirm that a guild system for painters (or something similar to it) functioned in Havana almost twenty years after the ordinances were enacted in 1770. Painters who began as apprentices within the guild structure would have signed contracts detailing the terms of the apprenticeship in the same manner as did their colleagues in other trades. Apprentice contracts for tailors, silversmiths, and leatherworkers, among others, appear in notarial records around this time. Contracts for apprentices to painters, however, do not appear, to my knowledge, in the notarial records, suggesting these arrangements may have been more informal. Still, they most likely followed the standard five-year apprenticeship period of other professions. During that period, the master artisan assumed responsibility to "educate, care for, and maintain [the apprentice], as is the practice with the rest of the apprentices, curing him of any illnesses he may have" (ANC 1777, fol. 220v–21r).

Testimony subsequently delivered by the apprentices and master painters further demonstrates the presence of a guild system in Havana at this moment, a system that had been implemented alongside regulations intended to control and monitor Havana's population. Arguably, within the racialized spatial geography of the city, this effort to order and oversee was particularly linked to elite white concerns about Black "vagrancy" and the control of trades dominated by the city's Black population. It is significant, then, that the testimony of the Muñoz de Carballo proceedings also confirms the dominance of Black and *mulato* painters in the painterly landscape. Santiago Milián and Francisco Martínez testified on August 7 along with their master painters; all four of them answered affirmatively when Sanz asked whether there were indeed "a lot of Black and mulato painters" (ANC 1791, fol. 44r–51v). Muñoz de Carballo, in response to separate questioning, also confirmed that most of the painters were Black and *mulato* (ANC 1791, fol. 42v).

Painters and the Artistic Landscape

In addition to affirming the racial identities of the majority of painters in colonial Havana, the artists also give a sense in the proceedings of their painterly knowledge. In all four of their testimonies, Sanz asked about the necessity of using certain poisonous pigments in their work. Master painter Julio Gamarra's testimony offers perhaps the most insightful response as it reflects the degree of his experience and knowledge gained over a long career. He

explained that orpiment (used to make a yellow color) could be replaced by another pigment, "but the color would not be as fine." Likewise, gamboge (also used for yellow) could be replaced with iron oxide (used for red), "but the color would not be as beautiful" (ANC 1791, fol. 51v).

A lack of archival documentation related to commissions for artworks—and the absence of signed works by any of these painters—presents a challenge to envisioning the bodies of work of Julio Gamarra, Juan de Rosas, Santiago Milián, and Francisco Martínez. As Leandro S. Romero Estébanez (1986) laments with regard to colonial carpentry, we have to acknowledge the limitations of understanding individual creativity.

The same is true of colonial painting: the lack of archival information leaves gaps in our knowledge of this period. The four men likely completed commissions, and worked on contract, in a variety of genres: providing the scenography for the city's first theater (the Coliseo), painting religious works, decorating the ships built in the Royal Shipyard, or completing the mural paintings that decorated an astounding number of residences, churches, and even *cabildo* houses (in Cuba, mutual aid associations for enslaved and free people of color) (Sánchez Martínez 1975; Childs 2013; Howard 1998).

The appearance, however, of a second group of painters in the proceedings—José Nicolás de la Escalera, Antonio Sánchez, Santiago Vergara, and Felipe Lago—suggests divisions in the artistic landscape. Muñoz de Carballo summoned the second group at a later stage in the proceedings as he appealed aspects of Basabe y Cárdenas's decisions, suggesting he hoped the relative prestige of this second group would help support his appeal. By contrast to the four artists already mentioned, some members of this second group of artists left signed, well-known works of art. They also formed part of a group of painters who actively protested guild formation in 1770 because they considered their work to be better than guild work. In this section, I explore the range of materials and pigments sold by Muñoz de Carballo, singling out those deemed poisonous by the professors of pharmacy, before discussing the potential oeuvres of these painters—in other words, how they used the pigments from Muñoz de Carballo's stores.

When Sanz named the commission to explore the charges against Muñoz de Carballo, he included two professors of pharmacy, Antonio Santaella and Francisco Cordero (both from Spain) as expert witnesses. They assisted with the search of Muñoz de Carballo's three stores and home. The stores were located in rented spaces known as *asesorías* (offices) on the first floors of elite *criollo* residences, situated within the city walls (figure 8.1).[11] Muñoz de Carballo, then, was the mixed-race proprietor of a series of stores that catered to a mostly Black and mixed-race clientele, but that were located

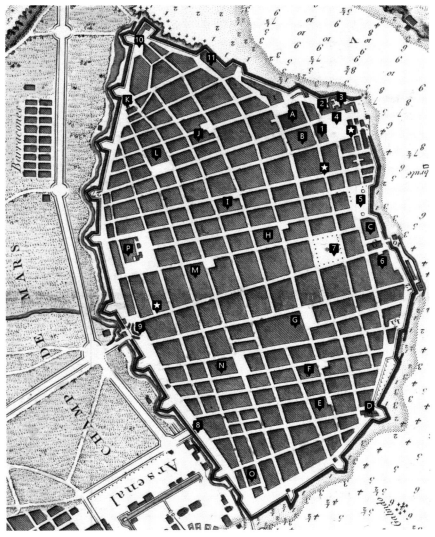

Figure 8.1. José del Río, map of the walled city of Havana, 1798, with Muñoz de Carballo's stores and principal civic/religious buildings indicated. The three asterisks mark Muñoz de Carballo's stores. The numbers mark main civic/military buildings (and principal doors of the city wall): *1*, Government Palace; *2*, Royal Post Office; *3*, Castillo de la Real Fuerza; *4*, Plaza de Armas; *5*, Plaza de San Francisco; *6*, House of the General Commanders of the Navy; *7*, Plaza Nueva; *8*, New Door; *9*, Door of La Muralla (later called La Tierra); *10*, Door of Castillo de la Punta; *11*, Door of San Telmo. The letters indicate major churches and convents: *A*, Cathedral of San Cristóbal; *B*, Convent of Santo Domingo; *C*, Church/Convent of San Francisco; *D*, Church of Paula; *E*, Church of La Merced; *F*, Church of Espíritu Santo; *G*, Church of Santa Clara; *H*, Convent of San Agustín; *I*, Convent of the Capuchins; *J*, Church of San Juan de Díos; *K*, Church of San Ángel; *L*, Convent of Santa Catalina; *M*, Convent of the Descalzas; *N*, Convent of Belén; *O*, Church of San Isidro; *P*, Church of Santo Cristo. Map adapted by Rachel Polinsky from *Plan du port et de la ville de la Havanne: Levé en 1798*, Paris, 1802. 41.0 × 52.4 cm. Map and Imagery Library, University of Florida.

within the elite, white intramuro space of the city, immediately below the homes of the *criollo* building owners. The first store, in the home of the widowed Countess of Gibacoa, faced the recently renovated Plaza de Armas, on the corner of Obispo and Baratillo. Two blocks west and one block south sat the second store, in the home of the Count of Santa María de Loreto, at 153 Mercaderes. The third store, in the asesoría of Juan de Dios Menocal's house, at 60 Ricla Street, was closer to the western city wall, within two blocks of an entrance in the city wall known as the Puerta de la Muralla (Door of the Wall). The two northernmost stores sat near the recently renovated Plaza de Armas, home to two new government buildings. The third store was within easy walking distance of the Royal Shipyard, located just outside the city walls.

Santaella and Cordero reported finding nothing questionable in Muñoz de Carballo's home, but in the stores they found the following poisonous materials: orpiment, gamboge, zinc sulfate, verdigris (both in granules and ground), lead oxide, and borax. These materials represented only a fraction of the many substances that Muñoz de Carballo sold in his three stores (table 8.1; ANC 1791, fol. 7r–11v). Aside from borax, the toxic substances were all pigments used to create paints. If ingested, all of them except for zinc sulfate could cause death. As Julio Gamarra's testimony suggests, orpiment produces a brilliant, yellow tone, but it also emits toxic and foul-smelling fumes. It contains 60 percent arsenic, an element that when ingested is highly poisonous (Eastaugh et al. 2008, 185, 285). Likewise, gamboge, a resin derived from evergreen trees and producing a yellow pigment, is toxic and strongly diuretic. Until the mid-nineteenth century, verdigris made one of the most brilliant green paints available, but it subsequently fell out of use because of its toxicity (Eastaugh et al. 2008, 408). Lead oxide, also highly toxic, produces a red tone. Zinc sulfate, a generic compound, creates white. If ingested, it can produce stomach upset and vomiting. Finally, borax is a salt compound of boric acid and soda used as a pesticide and in manufacturing. If ingested, it can be toxic.

Santaella and Cordero's assessment of these materials as toxic led Basabe y Cárdenas to view them with suspicion for their potential to be used by enslaved men and women against their masters. When Sanz asked Muñoz de Carballo to confirm whether he indeed sold these substances, Muñoz de Carballo replied that his only intent, as mentioned before, was to sell "[the substances] to painters with other paints of all fine classes" (ANC 1791, fol. 19r). Muñoz de Carballo testified that some of the materials came from Spain; he had ordered others from Holland and England via the merchant and banker Pedro Erice (ANC 1791, fol. 19v–20r). Erice was a prominent

Table 8.1. Materials sold or owned by Pedro Dionisio Muñoz de Carballo

Material	Synonym	Modern name
WHITE PIGMENTS		
albayalde	blanco de plomo	lead white
vitriolo blanco		zinc sulfate
RED PIGMENTS		
almagre		red ocher, iron oxide
arcon/ancon	azarcón, minio	lead oxide
bermellón	cinabrio	vermilion, cinnabar, mercuric sulfide
carmín		carmine
sangre de drago		dragon's blood
solimán	mercurio	mercury
BLUE PIGMENTS		
azul de pared[a]		
azul de Prusia	azul de París	Prussian blue
azul de vidrio		
piedra lipis	sulfato cúprico	copper sulfate
GREEN PIGMENTS		
cardenillo	verde gris	verdigris
BLACK PIGMENTS		
agallas		nut galls
YELLOW PIGMENTS		
almártaga	litargirio	lead oxide
bolo arménico	bol	bole
genulí/genali		yellow paste
giallolino	amarillo de plomo	lead-tin yellow
grasilla	sandáraca, rejalgar	sandarac
gutagamba	gamboge	gamboge
jadre de China	orpimento	yellow orpiment, arsenic sulfide
ocre tomino	ocre	yellow ocher
oropimento		orpiment
sombra de Italia	umbra	umber
OTHER		
aceite de abeto	trementina	turpentine
aceite de linaza		linseed oil
aceite de palo	aceite de tung	Tung oil
agua ras	trementina	turpentine
alcaparrasa	caparrosa	copper sulfate
atíncar	bórax	borax
crem tartar	crémor tartaro	potassium bitartrate
espíritu de vino	alcohol	alcohol
goma laca		shellac
piedra lumbre	alumbre	alum
sal amoniaco		ammonium chloride

Note: a. Azul de pared may have been the indigo-dyed clay known in Mesoamerica as azul maya or Maya blue.

financial architect of the slave trade and sugar production in Cuba, a fact that underscores the complex interweaving of racial policies and art-making in colonial Havana.

As suggested in table 8.1, these toxic substances were not the only materials on offer at Muñoz de Carballo's shop. Muñoz de Carballo primarily sold oxidized minerals that produced white, red, blue, yellow, green, and black tones, along with an assortment of mixing and cleaning agents such as oils and alcohols. Artists in other parts of the colonial Spanish Americas used the same pigments. For instance, seventeenth- and eighteenth-century painters in the colonial Andes, like their colleagues in Havana, used *cardenillo* (verdigris) to make green, orpiment for yellow, and vermilion for red, alongside Prussian blue, one of the two blue pigments most employed in Cusco workshops in the eighteenth century (Seldes et al. 1999, 100–123; Seldes et al. 2002). While colonial Andean painters mostly produced religious oil on canvas paintings, in colonial Havana, artists used these pigments in a wider variety of ways. A primary use was most likely the creation of mural paintings, the most popular and widespread form of art at the turn of the nineteenth century in Havana. Murals adorned the facades and interiors of elite residences, churches, and cabildo meeting houses in the city and beyond. In a sample of 108 buildings from the colonial period (approximately 10 percent of the 1,049 extant colonial-era buildings in the formerly walled city), researchers found around half to have mural paintings, and noted the most popular colors for mural paintings during the eighteenth and nineteenth centuries to be ocher, blue, red, and green (González 2020, 42). The conservator Alberto de Tagle (1986), in his analysis of pigments from colonial-era mural paintings, identifies an even richer range of colors such as turquoise blue, brilliant red, red, violet blue, light green, dark green, green, and ocher—and also the specific pigments lead white and *cinabrio* (*bermellón* or vermilion). Muñoz de Carballo sold the latter two along with other pigments that make all the colors Tagle identifies.[12]

Painters utilized different techniques in the creation of mural paintings, including half-fresco painted on recently finished walls and direct application on dried surfaces (Montes Rodríguez 2001, 101; and see Serrano González 2005, 175–77). Mural painting designs ranged enormously, from floor-to-ceiling landscapes to imitations of Mudejar woodwork (deriving from the mixed Islamic and Christian style of al-Andalus) and representations (perhaps portraits) of people in contemporary dress. Numerous travelers to Cuba during this time remarked on the ubiquitous presence of the mural paintings (Baillou 1854, 157; Hazard 1871, 31; Merlin 1844, 8). The US clergyman Abiel Abbot (1829, 126) noted the penchant for "ornamental

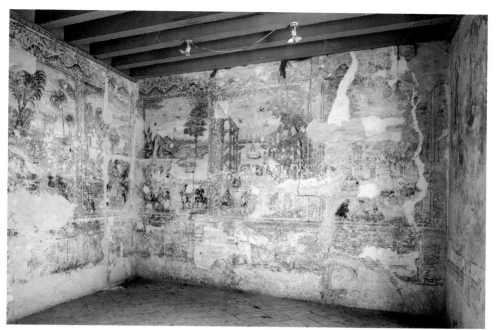

Figure 8.2. Unidentified artist, mural painting of landscapes, Tacón Street 12, Havana, Cuba, circa 1762–68. Fresco. Photograph by Alejandro González.

painting" in the "suburbs" of Havana: "On the fronts of shops and houses, and on plastered walls by the wayside, you continually see painted, birds, and beasts, and creeping things, men and women in their various vocations and amusements, and some things and some images, not strictly forbidden by the letter of the commandment, being like nothing *in heaven above, or in the earth beneath, or in the waters under the earth.*"

By the time of Abbot's visit, mural paintings appear to have been declining in fashion among Havana's elite. A shift in the designs of the mural paintings also appears to have accompanied this change in taste, from large-format drawings of an array of subject matter to more standardized geometric forms. For instance, mural painting designs from the mid- to late eighteenth century ranged from the aforementioned large-scale landscapes as in the houses at Tacón Street 12 (figure 8.2) and Amargura Street 65 (figure 8.3) to intriguing depictions of Greco-Roman gods at Obrapia Street 158 (figure 8.4).[13] Later paintings, dating to after the turn of the nineteenth century, tend to consist of decorative floral elements and arabesques that formed borders or friezes on staircases and walls (figure 8.5). The shift in elite taste, exemplified by the decreasing popularity of murals and standardization of design, may serve as a kind of cultural barometer of the elite anxiety regarding the

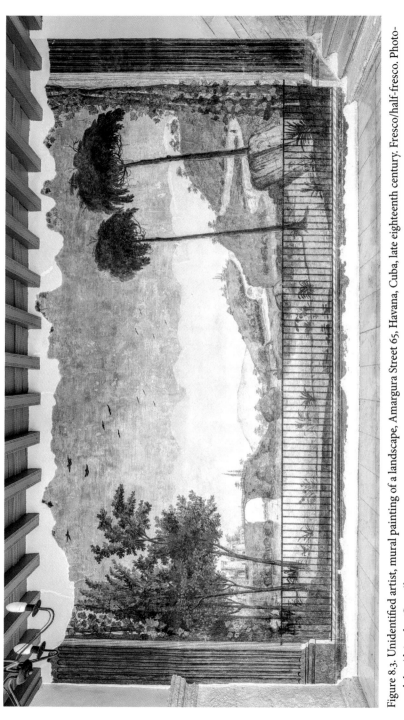

Figure 8.3. Unidentified artist, mural painting of a landscape, Amargura Street 65, Havana, Cuba, late eighteenth century. Fresco/half-fresco. Photograph by Alejandro González.

Black artists who overwhelmingly completed the commissions for the mural paintings (Fischer 2004, 57–76). Perhaps the change in style reflected a shift away from an artistic tradition closely associated with Black artists, correlating to the early nineteenth-century elite *criollo* desire to express "good taste," meaning neoclassical, and white. Research dating the mural paintings conclusively could shed more light on the precise chronology of their rise and fall in popularity and help clarify their relationship to the racial politics of the moment. At the time of Muñoz de Carballo's lawsuit, the shift in elite taste appears to have been already underway, but mural painters continued to complete commissions for the more standardized designs (including in places other than the walled core of Havana).

The first group who testified in the proceedings against Muñoz de Carballo—Juan de Rosas, Julio Gamarra, Francisco Martínez, and Santiago Milián—likely worked at least in part as mural painters; the second, more esteemed group that Muñoz de Carballo brought in later in the proceedings likely did as well. Indeed, the painterly sphere, dating from 1770 to the time of the proceedings, seems to have been large enough to have its own internal divisions. Muñoz de Carballo himself and his three shop assistants, Francisco Antonio Domínguez, Anselmo del Val, and Domingo del Cueto, in their testimony for the proceedings, argue that their painterly clientele completely sustained Muñoz de Carballo's three businesses. The shop assistants all attest that they sold materials principally to painters (with the exception of borax (*atincar*), which was sold to silversmiths). Domínguez, Cueto, and Val's testimonies support the idea that enough painters lived and worked in Havana to keep Muñoz de Carballo's businesses afloat.

By the time Muñoz de Carballo called on the second group of painters to defend his cause, he had already successfully dodged the most serious charges against him. Muñoz de Carballo had repeatedly emphasized his innocence of any wrongdoing, telling Sanz that even as he understood it was unlawful to sell poisonous substances freely, he only knew the materials he sold to be used in painting, and thus never thought to keep them strictly locked away (ANC 1791, fol. 55v). On the same day as his final testimony, August 10, the notary Gerónimo del Rey reported that Muñoz de Carballo and his assistants were released from jail, although the investigation would continue (ANC 1791, fol. 66v). Basabe y Cárdenas also ordered that the stores be returned to Muñoz de Carballo's care, although with the poisonous materials removed.[14] A little over a week later, on August 18, Basabe y Cárdenas emitted the final decision regarding the case: he declared that Muñoz de Carballo, in selling the materials through his assistants, had not committed a true crime, and cited the materials' primary use in painting as his reason for

Figure 8.4. Unidentified artist, detail of mural painting with Greco-Roman figure, Obrapia Street 158, Havana, Cuba, late eighteenth century. Fresco/half-fresco. Photograph by Alejandro González.

Figure 8.5. Unidentified artist, detail of mural painting with floral pattern, Obrapia Street 158, Havana, Cuba, early nineteenth century. Fresco/half-fresco. Photograph by Alejandro González.

not charging Muñoz de Carballo (ANC 1791, fol. 70r). The tribunal had been unable to definitively prove that Muñoz de Carballo had sold the materials used by the enslaved men and women to kill their enslavers and thus could not hold him accountable for these deaths.

Muñoz de Carballo's predicament did not end with the dissolution of the charges, however, as Basabe y Cárdenas endangered the shopkeeper's livelihood by declaring he could no longer sell poisonous materials; it was in this context that Muñoz de Carballo would ultimately call on the second group of painters to testify on his behalf (ANC 1791, fol. 72r). Basabe y Cárdenas explained his reasoning in prohibiting the sale of certain substances, noting that given the existence of a "certain public that needed to be served by slaves," the use of poisonous materials as instruments of murder might reoccur in attempts to "vindicate secrets and resentment" (ANC 1791, fol.

71v). Even if Muñoz de Carballo's wares could not be definitively tied to the murders that had already taken place, from Basabe y Cárdenas's perspective permitting him to continue selling the poisonous materials would mean putting the city's elite, enslaving population at risk. Basabe y Cárdenas argued that just as pharmacists used caution in selling dangerous materials, all necessary measures should be taken to regulate the sale of potential poisons from any store, including forbidding Muñoz de Carballo and his assistants from "being involved in such a business" (ANC 1791, fol. 72r). On August 18, the notary of the tribunal informed Muñoz de Carballo of Basabe y Cárdenas's decision; Muñoz de Carballo handed in the poisonous substances four days later. During the following week, however, Muñoz de Carballo appealed to clarify exactly which substances he was prohibited from offering in his shops, requesting to know "which species I can keep selling to the King, and to the Public, as I had done before" (ANC 1791, fol. 88r). He noted that he had previously sold the goods "for his subsistence and [that] of his family" at "fair prices," and included a list of those pigments and materials for review by the tribunal (ANC 1791, fol. 87r–87v). The lawyer Alonso Suárez, who received Muñoz de Carballo's appeal, called the pharmacists Angel Rubio and Manuel Madruga to appear on August 31 to review Muñoz de Carballo's list. This resulted in a back-and-forth between Muñoz de Carballo and the pharmacists over the following weeks. On September 3, Rubio and Madruga initially prohibited Muñoz de Carballo from selling arsenic, mercury, borax, orpiment, "[or] any other poisonous substance" (ANC 1791, fol. 91r). They also ordered that he not sell any simple or compound medicine unless it was to pharmacists, but noted he could sell materials destined for painting (ANC 1791, fol. 91r). Muñoz de Carballo then asked for further clarification as to what was meant by "any other poisonous substance," noted that he had never sold arsenic or mercury, and challenged the stipulation that medicinal items only be sold to pharmacists (ANC 1791, fol. 95r). He argued that officials had never before prohibited the sale of "medicinal" substances like "indigo, cream of tartar, oak gall, copper sulfate, wood oil, almond oil, and even ethanol" to the general public (ANC 1791, fol. 95v). These were all materials that he appears to have sold in volume to the public at large (ANC 1791, fol. 96r).

In response to the pharmacists' initial prohibitions, Muñoz de Carballo strategized how to prove the integrity of his business conduct in order to resume selling the restricted materials in his store without prohibition. To save his livelihood, he called on his networks in colonial society to testify on his behalf. Among those contacts, Muñoz de Carballo asked four master painters to support him—José Nicolás de la Escalera, Santiago Vergara, Antonio Sánchez, and Felipe Lago—along with the royal naturalist, Antonio

Parra. Muñoz de Carballo relied on the status of the painters and the naturalist to establish his own position, suggesting that "no other proof" than testimonies from Escalera, Vergara, Sánchez, Lago, and Parra would be better to support his claims (ANC 1791, fol. 99r–99v). That Muñoz de Carballo turned to these artists at this difficult moment implies that they inhabited a more prestigious sphere in the artistic landscape than those artists who had testified during the initial stage of the proceedings. Indeed, the five men held significant status within colonial society. Parra compiled the island's first natural history, while Escalera worked as its most prominent painter of religious scenes. Parra, Portuguese by birth, arrived in Cuba in 1763 with Spanish infantry as part of the Crown's effort to refortify the city after the British invasion of the previous year. Parra developed his naturalist leanings in Cuba, undoubtedly influenced by the Spanish Enlightenment interest in cataloging nature and publishing natural histories (Bleichmar 2012). In 1787, he published his *Descripción de diferentes piezas de historia natural las mas del ramo marítimo*, with illustrations by his son Manuel Antonio (viewable online; see Parra 1787). Parra also sold portions of his own collections of specimens of fish, crustaceans, reptiles, and other fauna to the Royal Cabinet of Natural History in Madrid (García González 1989; 1995, 145). In the following years, he continued sending samples of live flora specimens; in 1791, the year that Muñoz de Carballo called on him to testify, Parra sent twenty boxes of specimens to Spain. Above all, Muñoz de Carballo benefited from Parra's reputation and relationship to the Spanish Crown as a local naturalist and respected adviser; Muñoz de Carballo characterized him as the "naturalist of the King."

Escalera (1734–1804) achieved fame as a painter of religious works, although he also worked in many other genres. His birth is registered in a volume of "Baptisms of Whites," where it says he was born to Agustín de Escalera, from Gijón, Spain, and Manuela Domínguez, a "native of this city [of Havana]" (Sánchez Martínez 1981, 150). Escalera painted in a style influenced by baroque drama, as seen in his *Holy Trinity* (figure 8.6), with its crowded composition and intense chiaroscuro. He fulfilled commissions for churches and convents, including the Convent of San Felipe Neri. Escalera completed his most famous commission at the request of José Bayona y Chacón, the Count of Bayona, for the count's church at Santa María del Rosario on the outskirts of Havana (Lugo-Ortiz 2013). Escalera also sketched uniform designs for the local white and Black militias; these designs were then sent by inspector general Alejandro O'Reilly to Julián de Arriaga, secretary of state of the Ministry of Marine Affairs (Ministerio de la Marina) (Romero Estébanez 1986, 6). Escalera counted Spanish officials and *criollo* counts among

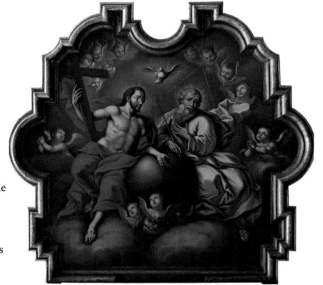

Figure 8.6. José Nicolás de la Escalera, *Holy Trinity*, eighteenth century. Oil on canvas, 180 × 200 cm. Museo Nacional de Bellas Artes, Havana, Cuba. Wikimedia Commons.

his clients, a fact that Muñoz de Carballo likely sought to capitalize on with his request.

In contrast to Parra and Escalera, Vergara and Lago were men of color, and left no signed works. Nonetheless, they belonged, along with Escalera, to the group of painters who had challenged the ordinances requiring guild formation in a letter of May 5, 1770, declaring themselves the "professors of the liberal art of painting." In doing so, they sought to separate their work from the labor of guild artists and artisans. The professors declared that they "should not form part of a guild [being themselves] of the liberal Art [of painting]" (ANC 1770, fol. 192v–94r). Their language indicates they wished their work to be classified as noble, or fine, art, rather than as craft (Bermúdez 1990, 14; Romero Estébanez 1986, 97). Indeed, by the eighteenth century, the idea of the guild was seen as outmoded and had become associated with the mechanical arts. In their letter, the professors demonstrate a desire to introduce boundaries to artistic practice that had not previously existed in Cuba, distancing themselves from the craft associations of the guild concept. At the same time, the artists' work in an array of genres also suggests they did not view specialization in one genre as a prerequisite to their attempt to elevate their art. As such, we might imagine that they also completed commissions for mural paintings. Further, the group's complaint does not seem to be an attempt to distance themselves from the work of Black artists, as they

themselves were majority artists of color. The "professors of the liberal art of painting" may have agreed to strategize to elevate their art, with the letter as a first step, while fulfilling all commissions and supporting themselves and their families in the meantime. Ultimately, however, we do not know what became of the appeal crafted by the Havana "professors." Muñoz de Carballo, twenty-one years later, may not even have been aware of the participation of Escalera, Vergara, and Lago in the protest against guild formation. Nonetheless, his recourse to the trio, as part of a larger group of esteemed members of colonial society, suggests that their participation in the protest in fact reflected their own superior status within Havana's colonial power structure.

Conclusion

The proceedings against Pedro Dionisio Muñoz de Carballo emerged out of and reflected an atmosphere of racially charged suspicion that characterized Havana in 1791. This atmosphere of suspicion centered on Cuba's growing Afrodescendant population, including both enslaved and free individuals, and was made more tense following several notorious cases of enslaved individuals poisoning their enslavers. Muñoz de Carballo caught the attention of the authorities both because he was a free man of color and because his clientele, predominantly painters, were also predominantly men of color. Although racial tensions characterized this late eighteenth-century moment, it was also a time of shifting status for artists. An example is that some endeavored to position themselves as engaged in the liberal rather than mechanical arts. As much as the suspicions noted above had a racial subtext, the jockeying among artists for position and recognition was not itself based on race, at least not at this time, but instead reflected wider professional and educational fault lines. In later decades this desire to distinguish artist from craftsman would develop a more explicitly racial cast as elites tried to claim the painterly professions for themselves in the name of economic growth and social order. The inquiry into Muñoz de Carballo's shops illuminates these complex dynamics in stunning detail, demonstrating the art historical value that can be extracted from judicial archives. Paradoxically, the racial optics of Muñoz de Carballo's arrest and the severe suspicion with which he and his colleagues were treated has made possible the recovery of a vital community of Black artists in eighteenth-century Havana. This case also sheds light on the material-based knowledge shared by artists, artisans, and merchants, and the efforts undertaken by colonial authorities to tightly restrict the sale of potent substances that had the power to create, heal, and kill. The materiality

of paintings is thus bound up in both aesthetic and pharmacological discourses. Further, the circulation of pigments within a multiracial mercantile sphere that included active participation by both enslaved and free Afro-Cubans made the business of artistic creation in Havana particularly fraught and indelibly bound to the transformation of the island into a slave society. A consideration of the 1791 court proceedings offers an unparalleled snapshot into the intersections of race, commerce, and artistic production in colonial Cuba, foreshadowing dramatic shifts in the artistic landscape of the nineteenth century, when white elites sought to reassert control over the aesthetic sphere.

Notes

1. Pedro Dionisio Muñoz de Carballo's baptism is listed on February 26, 1753, in the baptismal records of the Parroquia de Nuestra Señora de la Purificación, Almendralejo, with only his mother identified (libro 13, 1753, fol. 116v). She is listed as an enslaved woman named María Jesús of Angola, baptized in Lisbon. I thank Francisco Zarandieta Arenas, historian of Almendralejo, for providing me with this information. Later in the proceedings, Muñoz de Carballo notes he has been selling to the Real Armada (Royal Navy) since 1782. This is the earliest archival reference I have found to Muñoz de Carballo's presence in Havana; I have not yet been able to pinpoint his arrival date (ANC 1791, fol. 100r).

2. Alberto de Tagle and Carlos Venegas Fornias (2005, 111–13) provide an overview of the proceedings and note their importance for understanding the "social organization of artisans and artists" as well as the materials they used, purchased from Muñoz de Carballo's stores. The two scholars include a useful table with the pigments and other substances mentioned during the course of the proceedings (see also Tagle 1986). The historian Leandro Romero Estébanez (1986) also discussed the proceedings, in his work on the painter José Nicolás de la Escalera.

3. The authors of the principal texts on colonial Cuban art history affirm the predominance of Black artists without much elaboration, with the exception of Jorge Rigol (1982, 35–37). See Barros 2008, 185; Pérez Cisneros 2000, 13; Juan 1974, 14; 1978, 25; Torriente 1954, 27.

4. Luz Merino Acosta (1976, 136) argues that the academy in its first decades focused on forming white artisans, not fine artists.

5. "Entre los enormes males que esta raza infeliz ha traído a nuestro suelo, uno de ellos es haber alejado de las artes a nuestra población blanca. Destinada tan solo al trabajo mecánico, exclusivamente se le encomendaron *todos los oficios*, como propios de su condición."

6. "Las artes son ocupación de los mulatos y negros libres: pocos blancos están empleados en ellas. Las más necesarias a la vida humana, como zapatería, sastrería, herrería se hallan en regular estado; pero a todas hace ventaja la carpintería, de cuya especie se ven obras perfectamente acabadas, y comparables con las de los ingleses. La pintura, escultura, platería y otras artes destinadas al lujo, están todavía muy atrasadas."

7. As part of the plan, the Marqués de la Torre oversaw the naming of streets, numbering of homes, and installation of a system of public lighting (AOHCH 1770, fol. 40r–40v).

8. The regulations unfortunately do not appear in the Actas. I tried to consult the original copies of the Actas but was not granted permission.

9. Guilds certainly existed in Havana prior to the enactment of this order. In the spirit of the reform that characterized post-1762 Havana, the ordinances were intended to register their activity and inculcate a new sense of order. For more on the history of silversmiths and guild activity, see Mejías Álvarez 2004.

10. The other two were Thomas Escobedo, married and a citizen of Havana; and Mathias Gómez, single, from Cadiz. Gomez also worked for the Ministry of Justice (ANC 1791, fol. 738r–41r).

11. Identifying the physical locations of Muñoz de Carballo's stores in these homes presents a challenge. The specific addresses do not appear during the proceedings (and numbering systems have changed since the late eighteenth century). I have located the stores to the extent possible using legal documents related to the owners of the houses. I have cropped the map in figure 8.1 from a 1798 map of Havana by José del Río, a captain in the Spanish Royal Navy, that depicts the coastline around Havana, the entrance to the bay, and the walled city. The original map was also oriented with the south at the top. This cropped version only includes the walled city of Havana and is oriented with north at the top. The civic and religious building locations included here also come from the 1798 map.

12. These pigments appear on 1798 receipts from Muñoz de Carballo's stores for purchases made by a man named Manuel de Toledo. Toledo's receipts included cinabrio, *albayalde* (lead white), *azul de Prusia* (Prussian blue), *azul de París* (Paris blue), *azul de pared* (wall blue), *almagre* (red ocher), and *azarcón* (lead oxide), along with some brushes. In 1799, Muñoz de Carballo filed a motion against the will of don Manuel de Toledo that sought payment owed for these previous purchases (ANC 1799, fol. 3r–17r).

13. Researchers believe that the Tacón Street mural paintings date to 1762–68 based on laboratory analysis. There are twelve scenes, each measuring two meters high by one meter wide (Pardo Olive and Hernández Oliva 1992, 29; Sánchez Triana, González Yanes, and Rodríguez Béquer 2004, 148–51). In 2014, I visited the restoration of the house at Amargura Street 65, where conservators had begun to trace in pencil the outlines of two men in colonial dress. Further research is needed into their possible identities, or possible connections to the tradition of "hieroglyphics," printed cards that celebrated white elites through allegorical images and laudatory texts, often produced as part of funerary celebrations (Rigol 1982, 52). Further, at Obrapia Street 158, also known as the Casa de la Obra Pía, mysterious paintings in a room located on the roof (directly adjacent to the quarters for enslaved laborers) include figures of Justice and Solomon. A painted figure of Justice next to enslaved people's quarters certainly invites speculation, although more research is needed into the possible commissioner of the works and their dates vis-à-vis the building's construction and additions (Juan 1996, 73–74).

14. The poisonous substances removed included verdigris, yellow arsenic, zinc sulfate, and yellow orpiment (ANC 1791, fol. 68r–69v).

Reference List

Abbot, Abiel. 1829. *Letters Written in the Interior of Cuba*. Boston: Bowles and Dearbor.

Álvarez Cuartero, Izaskún. 2000. *Memorias de la ilustración: Las Sociedades Económicas de Amigos del País en Cuba, 1783–1832*. Madrid: Real Sociedad Bascongada de los Amigos del País, Departamento de Publicaciones.

ANC (Archivo Nacional de Cuba), Havana. 1770. Escribanía de Ortega, "Poder," ff. 192v–94r.

———. 1777. Protocolos de Gobierno, "Aprendizaje."

———. 1791. Fondo Audiencia de Santo Domingo, "Testimonio de los autos seguidos de oficio contra el pardo Pedro Muñoz y socios sobre expender efectos corrosivos que se remitan en consulta a la Real Audiencia del Distrito," leg. 114, no. 11.

———. 1799. Escribanía Varios, "Incidente a la testamentaría de D. Manuel de Toledo seguido por Pedro Muñoz, sobre el cobro de 88 pesos 7¾ reales," leg. 965, no. 18254.

AOHCH (Archivo de la Oficina del Historiador de la Ciudad de la Habana), Havana. 1770. Actas Capitulares del Ayuntamiento de la Habana, Trasuntadas, enero de 1700 a 24 de diciembre 1771, libro 37, marzo 15, 1770.

Baillou, Maturin M. 1854. *History of Cuba, or Notes of a Traveler in the Tropics*. Boston: Hobart and Robbins.

Barcia, María del Carmen. 2008. *Los ilustres apellidos: Negros en la Habana colonial*. Havana: Ediciones Boloña.

Barros, Bernardo G. 2008. *Caricatura y crítica de arte*. Havana: Letras Cubanas.

Belozerskaya, Marina. 2005. *Luxury Arts of the Renaissance*. Los Angeles: Getty.

Bermúdez, Jorge R. 1990. *De Gutenberg a Landaluze*. Havana: Editorial Letras Cubanas.

Bleichmar, Daniela. 2012. *Visible Empire: Botanical Expeditions and Visual Culture in the Hispanic Enlightenment*. Chicago: University of Chicago Press.

Childs, Matt D. 2006. *The 1812 Aponte Rebellion in Cuba and the Struggle against Atlantic Slavery*. Chapel Hill: University of North Carolina Press.

———. 2013. "Re-Creating African Ethnic Identities in Cuba." In *The Black Urban Atlantic in the Age of the Slave Trade*, edited by Jorge Cañizares-Esguerra, Matt D. Childs, and James Sidbury, 85–100. Philadelphia: University of Pennsylvania Press.

Deschamps Chapeaux, Pedro. 1971. *El negro en la economía habanera*. Havana: Unión de Escritores y Artistas de Cuba.

Deschamps Chapeaux, Pedro, and Juan Pérez de la Riva. 1974. *Contribución a la historia de la gente sin historia*. Havana: Editorial de Ciencias Sociales.

Eastaugh, Nicholas, Valentine Walsh, Tracey Chaplin, and Ruth Siddall. 2008. *Pigment Compendium: A Dictionary and Optical Microscopy of Historical Pigments*. Amsterdam: Routledge.

Ferrer, Ada. 2008. "Talk about Haiti: The Archive and the Atlantic's Haitian Revolution." In *Tree of Liberty: Cultural Legacies of the Haitian Revolution in the Atlantic World*, edited by Doris L. Garraway, 21–40. Charlottesville: University of Virginia Press.

———. 2014. *Freedom's Mirror: Cuba and Haiti in the Age of Revolution*. Cambridge: Cambridge University Press.

Fischer, Sibylle. 2004. *Modernity Disavowed: Haiti and the Cultures of Slavery in the Age of Revolution*. Durham, NC: Duke University Press.

García, Guadalupe. 2006. "Beyond the Walled City: Urban Expansion in and around Havana, 1828–1909." PhD diss., University of North Carolina at Chapel Hill.

García González, Armando. 1989. *Antonio Parra en la ciencia hispanoamericana del siglo XVIII.* Havana: Editorial Academia.

———. 1995. "La obra botánica de Antonio Parra." *Asclepio* 47 (2): 143–57.

García Pons, César. 1951. *El Obispo Espada y su influencia en la cultura cubana.* Havana: Ministerio de Educación.

Gikandi, Simon. 2011. *Slavery and the Culture of Taste.* Princeton, NJ: Princeton University Press.

González, Alfonso Alfonso. 2020. "La imagen cromática de La Habana." *Arquitectura y Urbanismo* 41 (1): 35–46.

Hazard, Samuel. 1871. *Cuba with Pen and Pencil.* Hartford, CT: Hartford.

Howard, Philip A. 1998. *Changing History: Afro-Cuban Cabildos and Societies of Color in the Nineteenth Century.* Baton Rouge: Louisiana State University Press.

Jimack, Peter. 2006. *A History of the Two Indies: A Translated Selection of Writings from Raynal's Histoire philosophique et politique des* établissements *des Européens dans les deux Indes.* Aldershot, England: Ashgate.

Johnson, Sherry. 2001. *The Social Transformation of Eighteenth-Century Cuba.* Gainesville: University Press of Florida.

Juan, Adelaida de. 1974. *Pintura y grabado coloniales cubanos: Contribución a su estudio.* Havana: Editorial Pueblo y Educación.

———. 1978. *Pintura cubana: Temas y variaciones.* Havana: Unión de Escritores y Artistas de Cuba.

———. 1996. "La pintura olvidada." *Cuba,* May, 72–74.

Kagan, Richard. 2000. *Urban Images of the Hispanic World, 1493–1793.* New Haven, CT: Yale University Press.

Kuethe, Allan J. 1986. *Cuba, 1753–1815: Crown, Military, and Society.* Knoxville: University of Tennessee Press.

———. 1991. "Havana in the Eighteenth Century." In *Atlantic Port Cities: Economy, Culture, Society in the Atlantic World, 1650–1850.* Edited by Franklin W. Knight and Peggy K. Liss, 13–39. Knoxville: University of Tennessee Press.

López Sánchez, José. 1997. *Cuba, medicina y civilización, siglos XVII y XVIII.* Havana: Editorial Científico-Técnica.

Lugo-Ortiz, Agnes. 2013. "Between Violence and Redemption: Slave Portraiture in Early Plantation Cuba." In *Slave Portraiture in the Atlantic World,* edited by Agnes Lugo-Ortiz and Angela Rosenthal, 201–26. Cambridge: Cambridge University Press.

Mejías Álvarez, María Jesús. 2004. "Plateros Cubanos: siglos XVI, XVII y XVIII. Notas para un catálogo." *Laboratorio de arte* 17:241–54.

Merino Acosta, Luz. 1976. "Apuntes para el estudio de la academia de San Alejandro." *Revista de la Biblioteca Nacional José Martí* 18 (1): 117–42.

Merlin, María de las Mercedes Santa Cruz y Montalvo. 1844. *Viaje a La Habana.* Madrid: Imprenta de la Sociedad Literaria y Tipográfica.

Montes Rodríguez, María del Carmen. 2001. "Pintura mural colonial en la Habana Vieja." *Boletín del Gabinete de Arqueología* 1 (1): 100–106.

Niell, Paul. 2012. "Founding the Academy of San Alejandro and the Politics of Taste in Late Colonial Havana, Cuba." *Colonial Latin American Review* 21 (2): 293–318.

Paquette, Gabriel B. 2008. *Enlightenment, Governance and Reform in Spain and Its Empire, 1759–1808*. New York: Palgrave Macmillan.

Pardo Olive, Irma, and Carlos Alberto Hernández Oliva. 1992. "La casa Tacón no. 12: Estudio histórico-arqueológico." Gabinete de Arqueología, Havana.

Pérez Cisneros, Guy. 2000. *Características de la evolución de la pintura en Cuba*. Havana: Editorial Pueblo y Educación.

Rigol, Jorge. 1982. *Apuntes sobre la pintura y el grabado en Cuba (de los orígenes a 1927)*. Havana: Editorial Letras Cubanas.

Romero Estébanez, Leandro S. 1986. "José Nicolás de Escalera, un artista artesano." Paper presented at the Simposio de la Ciudad de La Habana, Oficina del Historiador de la Ciudad de La Habana.

Saco, José Antonio, ed. 1858. *Colección de papeles científicos, históricos, políticos y de otros ramos sobre la isla de Cuba*. Vol. 1. Paris: Imprenta D'Aubusson y Kugelmann.

Sagra, Ramón de la. 1831. *Historia económico-política y estadística de la isla de Cuba ó sea de sus progresos en la población, la agricultura, el comercio y las rentas*. Havana: Imprenta de las Viudas de Arazoza y Soler.

Sánchez Martínez, Guillermo. 1975. "Comienzos del arte escenográfico en Cuba." *Revista de la Biblioteca Nacional José Martí* 2:99–117.

———. 1981. "Un pintor cubano del XVIII: José Nicolás de Escalera y Domínguez." *Revista de la Biblioteca Nacional José Martí* 23:143–52.

Sánchez Triana, Azul, Tania González Yanes, and Acelia Rodríguez Béquer. 2004. "Excepcionales pinturas murales en Tacón no. 12." *Boletín del Gabinete de Arqueología* 3:148–53.

Seldes, Alicia M., José Emilio Burucúa, Marta S. Maier, Gonzalo Abad, Andrea Jáuregui, and Gabriela Siracusano. 1999. "Blue Pigments in South American Painting, 1610–1780." *Journal of American Institute for Conservation* 38 (2): 100–123.

Seldes, Alicia M., José Emilio Burucúa, Gabriela Siracusano, Marta S. Maier, and Gonzalo E. Abad. 2002. "Green, Yellow, and Red Pigments in South American Painting, 1610–1780." *Journal of American Institute for Conservation* 41 (3): 225–42.

Serrano González, Elisa. 2005. "Apuntes y reflexiones sobre la pintura mural colonial en la villa de San Cristóbal de La Habana." *Boletín del Gabinete de Arqueología* 4:173–80.

Tagle, Alberto de. 1986. "Estudio físico-químico de pinturas decorativas murales en la Habana colonial." In *Memorias del IV simposio de la cultura de la ciudad de la Habana*, 19–24. Havana: Dirección Provincial de Cultura.

Tagle, Alberto de, and Carlos Venegas Fornias. 2005. "Intrigues and Trade in Painting Materials in 18th-Century Havana." In *Art of the Past: Sources and Reconstruction; Proceedings of the First Symposium of the Art Technological Source Research Study Group*, edited by Mark Clarke, Joyce Townsend, and Ad Stijnman, 111–13. London: Archetype.

Tomich, Dale. 2003. "The Wealth of Empire: Francisco Arango y Parreño, Political Economy, and the Second Slavery in Cuba." *Comparative Studies in Society and History* 45 (1): 4–28.

Torres-Cuevas, Eduardo. 1990. *Obispo Espada: Ilustración, reforma y antiesclavismo*. Havana: Editorial de Ciencias Sociales.

Torriente, Loló de la. 1954. *Estudio de las artes plásticas en Cuba.* Havana: Impresores Oscar García S. A.

Tortorici, Zeb. 2007. "'Heran Todos Putos': Sodomitical Subcultures and Disordered Desire in Early Colonial Mexico." *Ethnohistory* 54 (1): 35–67.

Valdés, José Antonio. 2005. *Primeros historiadores del siglo XIX.* Havana: Imagen Contemporánea.

Venegas Fornias, Carlos. 2002. *Cuba y sus pueblos: Censos y mapas de los siglos XVIII y XIX.* Havana: Centro de Investigación y Desarrollo de la Cultura Cubana Juan Marinello.

9

Conclusion

Artistic Presences in Colonial Latin America

AARON M. HYMAN AND BARBARA E. MUNDY

Histories oriented around the figure of the artist have played a central role in the development of art history as a discipline, and this is true both for histories of European art and for those of art produced in colonial Latin America. Such a model of writing history has its roots in the work of the Italian Renaissance author Giorgio Vasari, whose *Lives of the Artists* pioneered what we (following Gabriele Guercio [2006]) termed "the life-work model" (Mundy and Hyman 2015). The life-work paradigm emphasizes specific artists' singular creative capacities. In Italy, and in several other early modern regions in turn, period writers created lists of those artists they deemed most important, and collectors and subsequent critics generally followed their lead as they bought and wrote. But over the centuries, the application of this framework also tended to favor artists who offered the most robust archives—comprising an artistic oeuvre, working materials (like sketches and proposals) that illustrated the creative development of ideas, and contemporary documentation such as contracts and letters from intimates and patrons.

This artist-centered model was subsequently taken up in the nineteenth and early twentieth centuries to narrate the art of colonial Latin America, and it still offers a widely deployed heuristic. Yet, as we have argued, such an approach finds a mismatch with the social circumstances of the colonial period, the documentation that survives, and the extant works of art. Colonialism's legacy includes incomplete artistic oeuvres and a documentation of artists' careers and professional relationships at once slight and patchy. The archive also reflects the caste divides of the period, which resulted in artists at the top echelons of colonial society (often identified in contemporary documents as *españoles* or as *criollos*, that is, Spaniards or men of Spanish

descent born in the Americas) being more represented than those below (*in-dios*, then increasingly joined by *mulatos* and mestizos and others identified as mixed-race over the course of the colonial period).

Susan Verdi Webster (2017), who was a source of inspiration for this volume, has confronted such archival silences in her masterful study of artistic production in colonial Quito, *Lettered Artists and the Languages of Empire*, which emerged from her decades-long work in that colonial center's archives. Her research into the century following the imposition of colonial rule allowed her to identify practicing artists. Working from archival sources, many of them notarial contracts, Webster sketched out the picture of an art world in this former Inca capital. Among the painters she was able to identify, however, few have known oeuvres. Moreover, the unevenness of the documents often makes it difficult to know whether a given artist's work might have been particularly valued or his production notably widespread. Webster's tenacious thoroughness—a triumph of her approach—allowed her to use what she found to reconstruct local geographies of artistic practice, as well as artists' participation in communal modes of self-fashioning. But it remains the case that even the most rigorously attentive archival endeavor can refuse to offer up artists meeting the expectations of a Vasarian model.

The chapters in *Collective Creativity and Artistic Agency in Colonial Latin America* were written against this backdrop, responding to a prompt issued by the editors to wrestle with the problem of biography—so central to the self-understanding and development of the discipline—and its application within art historical accounts of colonial Latin America. As we will discuss, many of the authors attend carefully to a mismatch between traditional art historical methods and the lack of Indigenous presence in the archival record, as well as to the alternative patterns of artistic production that emerged in the early decades of colonization. The authors also address an increasingly pressing issue for art history of this moment: the question of how emergent early modern discourses of race intersected with the execution and reception of art objects, as well as the construction of artistic subjectivities. "Race," of course, might well be considered an anachronistic concept to apply to much of the colonial period given that the linkages perceived between genotype, physiognomy, and social category were not fully hardened until well after the inception of colonialism in the Americas. But the castes well known to Latin Americanists were foundational to conceiving and organizing a hierarchical society and thus offer prototypes for later racial ideologies. Indeed, we see a particular strength in the ways that these essays, as a group, work at the intersection of artistic, Indigenous, and other categories of identity. We thus here attempt to sketch out these essays' several through lines, particularly around

the question of intersectional identities; we also identify potential blind spots in the broader field to which these essays respond. In so doing, we propose steps forward in the still-nascent creation of an art history of colonial Latin America.

Indigenous Absence

By the 1970s, an emergent methodological tide centered on the recovery of the lives and work of Indigenous artists was reshaping the contours of Latin American art histories. Such recovery dovetails with broader contemporary trends and calls to decenter hegemonic European perspectives across the humanities, and in this volume it animates the chapters by Maya Stanfield-Mazzi, Jennifer R. Saracino, and Margarita Vargas-Betancourt. Since postcolonial archives rarely provide fleshed-out biographies of Indigenous creators, these authors use other strategies to recover or reconstruct artistic subjectivities. Stanfield-Mazzi follows a path blazed by the legal historian Silvio Zavala (1984–85) to look at how Habsburg legal codes created Indigenous subjects. She reinterprets a well-known riot of 1564 in Mexico City, wherein urban residents rose up to protest the burden of tribute, as a means by which artists demanded economic freedom. In so doing, she argues that escaping the grinding duty to deliver tribute allowed these subjects a degree of economic mobility essential for the creation of an Indigenous artisan class and a sense of self as belonging to that class. Drawing on a different type of colonial document, the will, Vargas-Betancourt reconstructs the economic network of an Indigenous woman in Tlatelolco (a part of Mexico City). The will's highly formulaic language, a type of list, is not especially revealing about artworks as material products and commodities, but Vargas-Betancourt is able to use this documentation to identify and draw out Indigenous women's wide participation in urban markets and as intermediaries for luxury goods. In doing so, she broadens the scope of her inquiry from the figure of the artist or craftsperson to a broader network of people brought together through the production and distribution of artistic goods. Saracino, in contrast, sets artworks at the center of her argument, carefully interpreting three manuscripts created in sixteenth-century Mexico City to argue for a fundamentally "collaborative nature of cultural production" that undergirded an interwoven intellectual world. Like Stanfield-Mazzi, she offers the tantalizing idea that artistic production was an avenue for social mobility. When taken together, these three chapters reveal the very human motivations in the development of the art world, and raise new possibilities for understanding its trajectory. Perhaps Indigenous women with talent and creative ambition—including

vendors like Angelina Martina—were pushed into roles other than art "creator" because access to the new centers for advanced education like the Colegio de Santa Cruz in Tlatelolco were off limits to them. Perhaps the presence of the Colegio channeled Indigenous intellectual activity away from painting and featherworking, high-status jobs of the fifteenth century, and toward alphabetic writing, whose mastery offered new opportunities. And perhaps the painters participating in the 1564 riot, who knew that earlier generations of painters would have been exempt from tribute, were simply attempting to reclaim a status that they had lost.

Notably, these three chapters center on Mexico City, the capital of New Spain, formerly known as Tenochtitlan, the Aztec capital. As seat of both the viceroy and the Audiencia (high court), not to mention its three *cabildos* (town councils), Mexico City was home to dozens of official notaries who ran busy offices. If documents were crude oil, Mexico City would have been a gusher. Yet such richness of documentation, especially given its concentration relative to other Indigenous-majority centers, raises its own questions. Each of the essays is grounded in traditional historical archives and thus implicated in those archives' many exclusions, both early modern and modern. Vargas-Betancourt is able to document female participation in the economic exchanges that were recognized (and valued) by the colonial state, like formal markets. But how much female knowledge and craft production will always lie beyond the limits of the paper archive? In addition, one might ask how much Habsburg legal codes, and the notarial formulas that stemmed from them, shaped Indigenous subjectivities. To put it differently: did notaries create artists? And, if so, should we also now recognize the formative role that they played?

Ananda Cohen-Aponte's essay on the now-lost but once-powerful portraits of the rebel leader Tupac Amaru takes up the thread of subaltern creativity two centuries later, and she is able to draw on a surfeit of documentary evidence produced by a threatened and terrified colonial administration. These documents allow her to recover the names of Simón Ninacancha, an Indigenous artist, and Antonio Oblitas, a formerly enslaved person, who were charged with painting two portraits of Tupac Amaru, neither of which survives. Royal officials hung Oblitas's portrait in the gallows, a form of punishment both in effigy (of its subject) and as proxy (of the artist himself). Such a chapter invites us to consider how insurgent efforts against an imperial regime can result in, at once, a surfeit of archival presence and a near-total destruction of a visual corpus, a particular form of colonial frustration for the Vasarian life-work model.

Racial Categories, Artistic Production

While art history might most privilege the authored work and its robust documentation, the early modern Catholic Church counters with its preference for the acheiropoieton—that is, the image of a sacred being believed to have been created without human intervention. Among Latin America's most important acheiropoietic images is the Virgin of Guadalupe, now held at the shrine of Tepeyac in Mexico City. Modern art history, particularly of colonial Latin America, has come to be wary of such authorless narratives and the acheiropoieton's historical assignment to the category of divinely made things. Increasingly, art historians now attempt to reattach specific artists to such objects. In contrast, some chapters in this volume track the process of Indigenous erasure over the course of the colonial period by documenting moments in which a rhetoric of acheiropoietic production severed artists from their creations.

The Virgin of Guadalupe image was accepted, in the sixteenth century, to have been created by Marcos Cipac de Aquino, a talented Indigenous painter (Peterson 2005). But by the seventeenth century, Aquino's role had been overwritten by another narrative—the *Nican mopohua*, published in 1649. In this account, the Virgin Mary authorized her image to appear on the cloak of a poor Indigenous man, Juan Diego, and divine forces carried this out. The new tale of acheiropoietic origin circulated widely in printed texts and painted cycles that consolidated this version of the story. There are two salient features of this change in narrative. First, the painting was transformed from a depiction formed by human hands to a miraculous manifestation. But second, in that process, indigeneity was recast: an active creator was supplanted with a passive (even initially unwilling or skeptical) witness to the miracle. Moreover, as Derek S. Burdette describes in his essay, this historical dynamic of reassigning attribution from Indigenous artists to divine protagonists also occurred around subsequent acts of restoration or renovation that were increasingly deemed the products of heavenly intervention.

Processes in which human makers were substituted with the divine, however, gave rise to opportunities for other colonial artists, though notably not Indigenous ones. Clara Bargellini (2004), Jaime Cuadriello (2002), and others have elsewhere suggested that the acheiropoietic nature of the Virgin of Guadalupe needed to be continually affirmed. Burdette builds on this point in this volume by looking at cases in which artists were called on to inspect miraculous images. Painters like Miguel Cabrera were in this way able to capitalize on the possession of technical expertise, creating moments to elevate artistic status through its performance and display. Indigenous erasure

thus had compounding consequences: it intensified sacrality, and it also allowed other (often nonnative) artists to profit both in terms of reputation and by remuneration related to ensuing demands for verification.

The diminishment of Indigenous creators was not, however, merely a side effect of verification processes or simply an oversight, as the case study by Emily C. Floyd makes clear. Rather, Indigenous erasure could be an essential component of high-status artistic self-fashioning. Floyd's chapter discusses the publication of the 1644 devotional text the *Corona de la divinissima María*. Its author, Juan María de Guevara y Cantos, commissioned a painting of the Virgin and then an engraving of that painting to accompany his text. However, while the text describes the painting at length, it names the painter only as an *indio pintor* (Indian painter). The omission of a proper name downplayed that artist's agency in the creation of the image, and Guevara y Cantos underscored his own role in channeling the divine instead: he "attributes the successful realization of the image . . . not to the artist, but rather to his own ritualized actions of prayer and to the subsequent intervention of the Virgin Mary." Floyd attempts to rectify that silence. In piecing together iconographic and historical evidence, she makes the case for attributing the picture to the painter Mateo Mexía; while Mexía's caste status is slightly unclear, Guevara y Cantos's assignment of *indio* status to him seems to have made him easy to ignore.

These elisions were not simply the result of a spiritual economy that needed to obfuscate human origins, as the chapter by Linda Marie Rodriguez describes. Rodriguez's promising contributions to the art history of Cuba were sadly cut short by her untimely death in 2018. Her chapter is set in late eighteenth-century Havana, and analyzes the legal case against the Black pigment dealer Pedro Dionisio Muñoz de Carballo. He was accused of selling pigments whose poisonous properties might have allowed enslaved persons to murder their owners. This case reveals how the law, undergirded by racist ideologies, could be used against Black artists and others involved in artistic production who had achieved a degree of social standing or even renown. Rodriguez situates this incident against the backdrop of a historical moment wherein Cuban *criollos* thought in increasingly racialized terms, given recent revolts of enslaved communities on Saint-Domingue and their own continued exploitation of Black bodies (usually enslaved ones).

In reading across these essays, we see that the special expertise artists had with materials, necessary for the mastery of their craft, could be weaponized against Black practitioners but mobilized to enhance the status of those of other castes. Burdette, in his case study of the 1677 examination of the Señor de Ixmiquilpan, describes this kind of deep knowledge of materials and their

relations as allowing high-caste artists to evaluate the veracity of the divine image and in so doing bolster their own prestige. In Cuba, over a century later, when similar material knowledge was achieved by Muñoz—who collected and sold pigments within a transatlantic arena—it could, as Rodriguez lays out, be taken up and used to accuse him of nefarious dealings and potential complicity in murder. That is, when a Black actor of this period showed the same kind of competencies as his white counterparts, racist ideologies not only barred these from being interpreted in the same positive light but also could be mobilized to undercut his status and even incarcerate him.

Intersectionality

This collection of essays primes our attention to the potential for art historical recovery of Indigenous presence and agency. We do wish to note, however, that this focus has come to be something of a methodological and theoretical default in writing the art history of colonial Latin America. Anglophone literature on colonial art has frequently taken Indigenous experience and subjectivity as its prime focus, leading to some of the largest areas of growth in the field—debates about "hybridity," extensive work on pre-Hispanic and colonial codices, and particular attention to non-European materials and techniques, featherwork chief among them. We worry about an associated risk, knowing full well that to some this may sound like an exquisitely ironic (or even welcome) concern: will indigeneity be the only artistic experience that one is expected to account for in studying art produced in colonial Latin America? As the subfield gains increasing attention within the discipline—in no small part because of the imperative to look beyond Europe—such a course should not be taken unthinkingly.

In this light, the essays by Burdette, Floyd, and Cohen-Aponte play an important role in asking us to think about a broader spectrum of identity formation. Cohen-Aponte's essay makes clear how many colonial social actors, be they *zambo* painters (of Black and Indigenous ancestry) or the wife of the rebel leader (named in some documents as *española*), participated in the visual culture of insurgency against imperial regimes. Burdette reconstructs for us scenes of communal inspection—when artists came together to materially interrogate miracle-working or miraculously made images. The vast majority of artists involved in such technical verifications identified as *criollos*. Moreover, Burdette makes the persuasive case that the most famous technical inspection, that of the Virgin of Guadalupe in 1751, which catapulted the figure of Miguel Cabrera to even greater fame through his subsequent publication about the event, should be considered an outlier. We

should see these events, Burdette suggests, as not only augmenting the fame of already accomplished artists but also, and just as importantly, fostering group identity formation in the first place.

Parsing colonial artistic identity in this way raises questions: How did expert standing achieved and broadcast through the material inspection of cult images intersect with the *criollo* or even peninsular backgrounds of these artists? And did elite *criollo* artists consider this sort of spotlight sufficient to their aims? These are not easy questions to answer, to be sure. They also square imprecisely with recent attempts to position such artists as fundamentally concerned, like their European counterparts, with the status of the visual arts as "liberal" rather than "mechanical." But the questions also underscore how colonial art history is unpracticed—compared to, say, literary studies, which has intensively examined figures like Sor Juana Inés de la Cruz and Carlos de Sigüenza y Góngora—at attending to the intersection between professional (artistic) and *criollo* identities within the matrix of a broader transatlantic culture.

Floyd's essay raises a related set of concerns in tracking the efforts of the Spaniard Guevara y Cantos to have his book celebrating the Virgin published in the Viceroyalty of Peru in the seventeenth century. As we have discussed, the question of Indigenous erasure figures prominently in this story. But a rather extensive collaboration, conversely, recorded the names of multiple other artists. For Guevara y Cantos not only found a local goldsmith, the Spanish-born Diego de Figueroa, to engrave some of the book's plates but also seems to have commissioned the Madrid-based engraver Juan de Courbes to cut the rest of the plates. Floyd's, then, is a story of colonial artistic production that resulted from a transatlantic artistic collaboration and one in which Iberian identity stands at the fore. Guevara y Cantos organized the labor of a fellow Spaniard in the Americas and an engraver living in the heart of empire on the Iberian Peninsula. This essay thus implicitly asks us to account for how European artistic identity manifested, or could be constructed, when it was displaced from the metropole to colonial spaces. What did it mean, in other words, to be a European creator at a remove from Europe?

In sum, the essays in this volume point the way toward thinking about artistic subjectivities in Latin America—and in other parts of the world—as situational, contingent, and intersectional. In finding that these essays suggest that the category of "artist" might be even more necessary to the present moment than it was to Vasari in the sixteenth century or to a young art history at the outset of the twentieth, we see both a notable shift from the claims of our 2015 article and a measure of its resonance. If identity will be the

clarion call (or perhaps siren song) that the field will follow, biography will perforce play a fundamental role. But for that to happen, art historians will need to be maximally self-reflexive about the limits of the archives on which they depend, and attentive to the ways that subjects themselves avoided or took advantage of social roles on offer and were aided or constrained by their positions—of geography, of gender, of race, of age—within the Spanish imperium.

When we wrote about the "shadow of Vasari," we used shadow figuratively, to mean an influence casting a spell over both the category of the artist and the life-work model through which the construction of Europe's artistic figures came to exist in the historical record. But we can also conjure the shadow differently, in a Platonic vein, and think of the artists that we find in the archive as themselves akin to shadows, ones projected on the wall of the cave in which we as historians are prisoners; shackled to the present moment, our gazes fixed ahead, we can see some of them with sharp, contoured profiles, while others, at the margins, seem little more than small lumpish shapes. But unlike Plato's prisoners, entrapped since birth, we should know better than to accept even the clearest outlines as reality. In other words, we would be remiss if we did not think of the ways those shapes and shadows are cast by an archive and the ways our own perception has been mediated by early modes of art historical thinking.

While we know better than to imagine a transparent window of truth or to think we have the ability to leap across the historical distances that separate us from the artists of the past, an art history of Latin America might still be served from thinking harder about how best to perceive the once-marginal shapes on the distant zones of the wall—the traces of artists most distorted by partial archives of the kind we routinely encounter across Latin America. More to the point, we may most need to train ourselves to recognize and accept that the sharp artistic contours that once set the standard for archival proof are themselves no less skewed by the archive that sustains them. Yet instead of seeing the archive's distortions as leading to little more than a compromised art history, we suggest that tracing the relationships figured in the shadows may ultimately yield a different point of view, one less constrained by normative historiographic modes of seeing, and allow us to chart a different world of artistic practice.

In that process, however, the "artist" remains an obviously useful, even indispensable, category for a critical art history of Latin America. Today, as in the past, the term insists on artistic creation as an embodied practice—carried out by mortals anchored in space and time. As a noun, it can be tethered to (and untethered from) the identifying adjectives that the Latin American

archive delivers far more frequently than names (*español, indio, zambo*) and others that it does not or does only infrequently (iconoclastic, heretical, unnamed). Such associations—both those authorized by the archive and those not—may also serve as starting points for confronting the past and its inequities in ways that respond to the pressures of the present.

Reference List

Bargellini, Clara. 2004. "Originality and Invention in the Painting of New Spain." In *Painting a New World: Mexican Art and Life, 1521–1821*, edited by Clara Bargellini, Donna Pierce, and Rogelio Ruiz Gomar, 79–91. Denver, CO: Denver Art Museum.

Cuadriello, Jaime, ed. 2002. *El divino pintor: La creación de María de Guadalupe en el taller celestial.* Mexico City: Museo de la Basílica de Guadalupe.

Guercio, Gabriele. 2006. *Art as Existence: The Artist's Monograph and Its Project.* Cambridge: MIT Press.

Mundy, Barbara E., and Aaron M. Hyman. 2015. "Out of the Shadow of Vasari: Towards a New Model of the 'Artist' in Colonial Latin America." *Colonial Latin American Review* 24 (3): 283–317.

Peterson, Jeanette Favrot. 2005. "Creating the Virgin of Guadalupe: The Cloth, the Artist, and Sources in Sixteenth-Century New Spain." *Americas* 61:571–610.

Webster, Susan Verdi. 2017. *Lettered Artists and the Languages of Empire: Painters and the Profession in Early Colonial Quito.* Austin: University of Texas Press.

Zavala, Silvio. 1984–85. *El servicio personal de los indios en la Nueva España.* Vols. 1 and 2. Mexico City: El Colegio de México, Centro de Estudios Históricos.

Contributors

Derek S. Burdette is assistant professor of art history at the University of Florida. His research focuses on the intersections of art, religion, and colonialism in Latin America, and in particular on the social history of miraculous imagery in and around Mexico City. His essays have appeared in *Colonial Latin American Review* and in the edited volume *Visualizing Sensuous Suffering and Affective Pain in Early Modern Europe and the Spanish Americas.*

Ananda Cohen-Aponte is associate professor of history of art at Cornell University. She is author of *Heaven, Hell, and Everything in Between: Murals of the Colonial Andes,* and editor of *Pintura colonial cusqueña: El esplendor del arte en los Andes/Paintings of Colonial Cusco: Artistic Splendor in the Andes* (published as separate Spanish- and English-language editions). Her articles have appeared in the journals *Colonial Latin American Review, Allpanchis, RES: Anthropology and Aesthetics, Art Journal,* and *Latin American and Latinx Visual Culture,* among others. Her current book project explores the intersections between art and anticolonial uprisings in eighteenth-century Peru and Bolivia.

Emily C. Floyd is lecturer of visual culture before 1700 at University College London. She is editor and curator at the Center for the Study of Material and Visual Cultures of Religion (MAVCOR) at Yale University. Her articles have appeared in *Material Religion, Print Quarterly,* and *Latin American and Latinx Visual Culture.*

Aaron M. Hyman is assistant professor in the Department of the History of Art at Johns Hopkins University and author of *Rubens in Repeat: The Logic of the Copy in Colonial Latin America.*

Barbara E. Mundy is the Donald and Martha Robertson Chair in Latin American Art History at Tulane University. Her scholarship dwells in zones of contact between native peoples and settler colonists as they forged new visual cultures in the Americas. Her most recent book, *The Death of Aztec*

Tenochtitlan, the Life of Mexico City, draws on Indigenous texts and representations to counter a colonialist historiography and to argue for the city's nature as an Indigenous city through the sixteenth century.

Linda Marie Rodriguez (1978–2018) received her PhD from Harvard University in 2012. Her dissertation, supported by the Social Science Research Council International Dissertation Research Fellowship, addresses the works of art of two free men of color who lived in late eighteenth- and early nineteenth-century Havana, Cuba. She created the website Digital Aponte, dedicated to the work of one of those artists, José Antonio Aponte.

Jennifer R. Saracino completed her joint PhD in art history and Latin American studies at Tulane University and is assistant professor of art history at the University of Arizona. Her current book project focuses on the Uppsala Map of Mexico-Tenochtitlan (c. 1540), the earliest known map of Mexico City painted by Indigenous artists after the Spanish conquest. Her work has been published in *Imago Mundi, Artl@s Bulletin,* and *Mapping Nature across the Americas.*

Maya Stanfield-Mazzi is professor of art history at the University of Florida. She is the author of *Object and Apparition: Envisioning the Christian Divine in the Colonial Andes* and *Clothing the New World Church: Liturgical Textiles of Spanish America, 1520–1820.* Her articles have appeared in *Current Anthropology, Hispanic Research Journal, Colonial Latin American Review, Religion and the Arts,* and the *Americas,* and she wrote bibliographic essays on painting in the Viceroyalty of Peru and Andean textiles for Oxford Bibliographies Online.

Margarita Vargas-Betancourt is the Latin American and Caribbean Special Collections Librarian at the University of Florida. She obtained her PhD in Latin American studies from Tulane University, and her BA in Hispanic literature and languages from the National Autonomous University of Mexico. Margarita uses her background on colonialism to identify and highlight the hidden voices in archives and to serve and empower Latino students. Her latest coauthored publication, "Contesting Colonial Library Practices of Accessibility and Representation" in the book *Archives and Special Collections as Sites of Contestation,* obtained the 2022 Latin American Studies Association (LASA) Archives Section Award for Best Article.

Index

Page numbers in *italics* indicate illustrations.

Abbot, Abiel, 212–13
Academia de San Alejandro, 201
Academy of San Carlos, 114
Acheiropoieta, 115, 125, 232
Adobe, sale of, 99
Ahuizotl, 87
Altepetl (ethnic state), 86; and social continuity, 87–88
Alvarado Huanitzin, Diego de, 25–26, *27*
Amanteca (featherworkers), 72, 86–87. *See also* Feathers; Featherwork
Amaro, Manuela Tupa, 190
Amerindians. *See* Indigenous people
Anales de Juan Bautista, 11, 33, 48n6
Anderson, Arthur J. O., 59–60
Andes Mountains: Charles III, imagery of, 183–86; overview of rebellions, 169–71; politicized alterations of art, 186–91; as site of painting, 137–38; Tupac Amaru rebellion, 169, 171–83. *See also* Inca Empire
Angulo, Nicolás de, 119
Annunciation (Mexía), *148*, 155
Anzaldúa, Gloria, 2, 80
Apasa, Julián, 185
Arango y Parreño, Francisco, 200, 202
Areche, José Antonio de, 190
Arenas, Bartolomé de, 123, 125
Arias, Santa, 36
Arriaga, Antonio de, 177, 181
Arriaga, Julián de, 219
Artist-as-maker paradigm, 114–18
Artistic practice, boundaries of, 220–21
Artists: anonymity of, 141, 162–63; Black artists in colonial Cuba, 203–4; ethnic/racial identity and social status, 120–21, 133, 160–64, 180, 181, 232–34, 236–37; as expert witnesses, 109, 112–13, 118–31, 218–19; humanness of, 3; "Indian artist" as constructed idea, 160; and literacy, 163; as members of artisan class, 7; "passing" and artists' ethnic identity, 128–29, 164; pigments used by, 199, 207–8, 210–12, *211;* rates of pay for, 6; role in colonial society, 1–2; signatures on work, 162–63; social capital and socioeconomic status, 7–8, 132–33. *See also* Guild systems; Painters
Atahualpa (Inca ruler), 3, 21, 161
Atiencia, Diego de, 160
Audiencia (high court), 3, 30, 36, 202, 231
Authors' methodologies, 9–11
Axayacatl, 75
Aztec Empire: cosmovision and philosophy, 63; pictographic manuscripts, 60, 65; role of artist in society, 7, 19, 29; Spanish conquest, 55; status of craft specialists, 19–20, 24; *tlacuiloque,* status of, 60–61

Badiano, Juan, 63
Badianus Herbal, 11–12, 62–67, *64*
Bargellini, Clara, 5, 232
Barrionuevo, Alfonsina, 190
Barroso, Juan Manuel, 184
Basabe y Cárdenas, José de, 200, 202–3, 206, 208, 210, 215, 217–18
Bastidas, Micaela, 171, 178–80, 190–91
Baudot, Georges, 57
Bayona y Chacón, José, 219
Becerra Tanco, Luis, 144
Bejarano, Alonso, 59
Bejarano, Francisco, 145, *146*, 156
Bellion, Wendy, 185
Beyond the Lettered City (Rappaport and Cummins), 53–54
Black artists: Antonio Oblitas's status in Rebellion-era Peru, 177; archival descriptions of work, 169; in colonial Cuba, 200–204; and guild membership, 23, 28, 181; in Latin America, 8. *See also* Muñoz de Carballo, Pedro Dionisio; Oblitas, Antonio

Boone, Elizabeth Hill, 62
Borderlands (*mestizaje* spaces), 2
Borrar la memoria (erase the memory),
191–92
Burdette, Derek S., 8, 9, 12–13, 232, 233–35

Cabrera, Miguel, 114–18, 128, 232–33, 234–35
Cáceres, Berta, 15
Calmecac (pre-Hispanic school), 56–57, 60,
62, 76
Calnek, Edward E., 72
Camelid-fiber tapestry, *38, 40*
Carballo, David, 99–100
Carducho, Vicente, 4
Carpenters, 18, 30, 41, 113
Carrera, Magali M., 128
Cartography, 70, 72. *See also* Uppsala Map
Casa del Marqués, 69
Catholicism: art in colonial contexts, 5;
Catholic ideology, 3; missionaries and the
arts, 24–25, 55
Ceinos, Francisco, 36
Ceramicists. *See* Potters
Cerda, Juan Bautista de la, 43, *44*
Cerón de Alvarado, Martín, 94
Cerralvo, Marqués de (viceroy), 92
Chachapoyas, Peru, 46
Charles III, 183–86
Charles V, 31, 69
Chiguan Topa, Marcos, *174*
Chimú kingdom, 21, 41
Chonefc, Juan, 46
Christianity: Christian doctrine and art, 6;
Christian heritage of artists, 22–23; conver-
sion of Indigenous people, 25, 28, 42, 55.
See also Catholicism
Chuquiray Garibay, Javier, 8
Chut, Alonso, 41
Cipac de Aquino, Marcos, 33, *34, 47,* 121, 232
Cloth, as medium of exchange, 90
Clovio, Giulio, 43
Códice Aubin. *See* Xiuhpohualli of Tenochtit-
lan Codex
Cohen-Aponte, Ananda, 5–6, 7, 9, 13–14, 231,
234
Coinage, 184, *185*
Colegio de San Juan Evangelista, Quito, 25
Colegio de Santa Cruz: background and

overview, 53–57, 231; Badianus Herbal, 62–67,
64; collaborative nature of graphic output,
74–75; education for Indigenous people,
55; Florentine Codex, 58–62, *73;* graduated
authority, 57; Indigenous contributions to
higher education, 75–76; Uppsala Map,
67–74, *68, 71, 74*
Colonialism: colonial art, 4; colonialist views of
time and space, 10; and lack of Indigenous
documentation, 3–4, 9–10, 228–29; two
"republic" model, 31
Condemayta, Tomasa Tito, 190
Conrado, Thomás, 119, 134n1
Contracts for artworks, 4, 6, 39–40, 171, 207,
228, 229
Copies contrasted with originals, 138, 143–44,
153, 160–61, 165–66. See also *Corona de la
divinissima María* (Guevara y Cantos)
Cordero, Francisco, 208, 210
Corona de la divinissima María (Guevara y
Cantos), 13, 233; artists' ethnic identities,
159–64; engraving contrasted with painting,
144–59; Guevara y Cantos's description,
142–44; painting of the Virgin's face, 140–41;
patron's role, 140–44; timeline of produc-
tion, 156
Correa, Juan, 128
Cortés, Hernán, 62, 69, 72
Cotton capes, 89–92, *91,* 114
Council of Trent, 108, 110
Courbes, Juan de, 156, 159, 163–64, 235
COVID-19 pandemic, 15
Craftsmen, shift to artisan status, 18
"Critical fabulation," 13, 170–71
Crown of the Virgin (Courbes), *158*
Cruz, Juana Inés de la, 235
Cruz, Martín de la, 63, 65
Cruz Salas, Juan de la, 190
Cuadriello, Jaime, 232
Cuba. *See* Havana, Cuba
Cuenca, Ecuador, 137–38, 147, 153–54
Cueto, Domingo del, 215
Cuiris, Juan, 43, *45*
Cuirixan, Jusepe, 47
Cummins, Tom, 53–54
Cusco, Peru, 41–42
Cusco School of Painting, 6, 173, 187
Cusi Rimay, María, 40

Dean, Carolyn, 178
The Death of Aztec Tenochtitlan, the Life of Mexico City (Mundy), 10
Decolonialism: approach to art history, 14–15; foundational principles, 1–2
"Decolonizing the Global Renaissance" (Cohen-Aponte), 5–6
del Valle, Josef, 177
Deschamps Chapeaux, Pedro, 203
Dessalines, Jean-Jacques, 182
de Vos, Maerten, 138
Díaz del Castillo, Bernal, 29, 72
Dibble, Charles E., 59–60
Diccionario de la lengua náhuatl o mexicana (Siméon), 65
Diego, Juan, 114, 232
Díez de la Barrera, Juan, 121
Dios, Juan de, 173
Domestic households, 99–101
Domínguez, Francisco Antonio, 215
Domínguez, Manuela, 219

Education for Indigenous peoples, 29. *See also* Colegio de Santa Cruz
Effigy, death by, 177–78
Encomienda system, 24–25, 30, 87
Engravers, 161, 162. *See also* Figueroa, Diego de
Enlightenment thinking and empirical evidence, 127–31
Ensambladores (joiners), 113, 123–24, 129, 130
Enslavement, 2; in Cuba, 14; and guild system in Spain, 23; of Indigenous people, 24, 25; Indigenous slavery, decline and abolishment, 28, 29, 48n4; murders of enslavers, 199; slave rebellions, 200; slave trade, 14; sugar economy in Cuba, 200–202; white fears of Black rebellion, 202–3
Epiphanius, 142
Equestrian Portrait of Tupac Amaru, 171, 173, 177, 178–79
Erasure: acheiropoieta removed from the artists, 232–33; "erase the memory" (*borrar la memoria*), 191–92; of Indigenous artists, 230–31, 233, 235; recovery of Indigenous presence, 234
Erice, Pedro, 210, 212
Escalera, Agustín de, 219

Escalera, José Nicolás de la, 208, 218, 219–20
Espada y Landa, Juan José Díaz de, 201
Eurocentrism, 1, 2; and authors' methodologies, 9–10; colonialist views of time and space, 10; gendered activities in Florentine Codex, 81; models of artistry, 57
Expert witnesses, artists as, 109, 112–13, 118–31, 218–19

"Factualization" of miracles, 108, 109–13, 118, 129
Feathers: feather mosaics, 20, 40, 43; iridescence of, 95, 97; and military insignia, 93–95; ritual significance of, 92–93; and social position, 93
Featherwork: in Catholic liturgical settings, 95; featherworkers (*amanteca*), 72, 86–87
Ferdinand of Castile, 22
Fernando VI, 128
Figueroa, Diego de: background as artist, 160–65; contrasted with Mexía's work, 147, 153–56, 164; engraving work on *Corona*, 145, 147, 160; Guevara y Cantos's description of work, 143; illustrations of work, *139, 152, 163*; signature of artist, 138, 162–64, *163*; true portrait for *Corona*, 138
Fishermen as artisans, 41, 46
Florentine Codex, 11–12, 43, 58–62, *73, 91*; artisans and merchants, 86–87; gendered activities in, 81; Indigenous artists, 59; women's roles in Tlatelolco, 83–86, *84, 85*
Floyd, Emily C., 7, 8, 13, 233, 234, 235
Floyd, George, 15
Fondesviela y Ondeano, Felipe de, 204
Franciscan order. *See* Colegio de Santa Cruz
Francisco de Arobe, 43
Francisco de Siles, 118
Fraud in devotional imagery, 109, 129–30
Fuenlabrada, Nicolás de, 119, 134n1
Fuentes, Andrés de, 123

Gallque, Andrés Sánchez, 43, 47
Gamarra, Julio, 206, 207–8, 210, 215
Gante, Pedro de, 24, 25, 27, 31, 33, 35, 55
García, Guadalupe, 205
Genaro García 30, *32*
Gender roles, 2, 101–2. *See also* Women
General History of the Things of New Spain, 58. *See also* Florentine Codex

Gikandi, Simon, 201, 202
Goldsmiths, 31, 35–36, 48n5, 162
Gómez de Cervantes, Gonzalo, 92
González de Cuenca, Dr. Gregorio, 41
Gourd bowl (*jícara*) production, 97, 99
Gregory I (Saint and Pope), 25, *27*
Guaman Poma de Ayala, Felipe, 4–5, *5*
Guevara y Cantos, Juan María de, 13, 137–38,
 233, 235. See also *Corona de la divinissima*
 (Guevara y Cantos)
Guild systems: access for Indians and Black
 people, 28, 31, 181; for artists, 6; contrasted
 with liberal Arts, 220–21; and family
 linkages in Inca cities, 41–42; in Havana,
 Cuba, 204–7; in Italy, 18; master-apprentice
 relationships in Cuba, 206–7; mentioned
 in Muñoz de Carballo trial, 206; painters'
 guild, San Juan Moyotlán, 33; and racialized
 politics, 113, 121, 133; in Spain, 21–23; in
 viceregal capitals, 26, 28
Guzmán, Esteban de, 30

Habsburg legal codes, 230, 231
Haitian Revolution, 13–14, 181–82, 200
Harth-Terré, Emilio, 160–61
Hartman, Saidiya, 170–71, 182
Hassig, Debra, 66
Havana, Cuba: Black artists in colonial Cuba,
 203–4; guild system for painters, 204–7;
 map, *209;* neoclassical style, 201; painting as
 profession, 207–21; refortification of, 204–5;
 sugar economy and enslaved people, 14,
 200–202
Historia general de las cosas de Nueva España,
 58. See also Florentine Codex
Huauques (Inca brother statues), 178
Hyman, Aaron M., 4, 5, 14, 53, 109, 118

Ibarra, José de, 128, 130, 131
Icnotzin, Juan, 33
Images, power of, 177–78, 179
Inca Empire: family linkages, 41–42; and heri-
 tage, 161–162; *huauques* (brother statues),
 178; models for camelid-fiber tapestry,
 40; role of artist in society, 3, 7; status of
 craft specialists, 20–21. See also Andes
 Mountains
Indigenous artisans: request for freedom from
 labor tribute, 35–36; right to remuneration

for work, 30–31; under two "republic"
 model, 31
Indigenous artists: absence of archival
 evidence, 230–31; anonymity of, 137; as
 copyists, 160; portraiture, 178; race as
 marker for, 6; role in colonial society, 5–6;
 1688 petition, 6; slavery and Amerindians'
 legal rights, 8
Indigenous artists' rights: advancement in
 New Spain after 1550, 29–39; craft special-
 ists in Aztec and Inca Empires, 19–21; craft
 specialists in Spain, 21–24; human rights
 in the Americas pre-1550, 24–26; labor
 tribute, 29–33; right of mobility, 46–47; shift
 from craft specialist to artisan status, 18–19;
 Spanish attitudes toward Indigenous crafts,
 26–29; at turn of seventeenth century,
 42–47; in viceroyalty of Peru, 39–42
Indigenous medicine, 62–63, 65–66
Indigenous people: and basic human rights,
 18; and conversion, 159–60; humanity
 and Amerindian right to freedom, 24–25;
 "Indian artist" as constructed idea, 160;
 Indigenous rights, 46; Indigenous rulers,
 87–88; Spanish perceptions of, 30; women's
 roles, 12, 101–2, 230–31
Indio as ethnic label, 2, 28, 30, 42, 47–48,
 161–64
Informaciónes jurídicas and miraculous imag-
 ery, 110–13
Inquisition, 128, 177, 190
Insurgencies and artwork, 169. *See also* Tupac
 Amaru Rebellion
Intersectionality, 234–37; political violence and
 art, 13–14; of professional and ethnic identi-
 ties, 133, 200, 235
Isabella of Castile, 22
Ixiptlayotl (deity's essence), 92, 97

Jacobita, Martin, 59
Jaguar-skin capes, 91
James, Erica Moiah, 182
James I of Aragon, 22
Jesus at the Age of Twelve (Juan Bautista), *44*
Jewish artisans in Spain, 23
Jícara (gourd bowl) production, 97, 99
Jiménez, don Juan, 94
Joiners (*ensambladores*), 113, 123–24, 129, 130
Juan de Pareja, 23

Juárez, Joseph, 123
"Just war," 28

Kagan, Richard, 205
Kamayuqkuna (craft specialists), 20–21, 48n2
Killkakuna (purposeful marks on surfaces), 21
Katari Rebellion, 169
Katzew, Ilona, 128
Klein, Cecelia F., 89

Labor, forced (*mit'a* system), 184
Laborers, increasing demands on, 35
Labor tribute, 29–33, 43
La conquista de Jerusalén, 95
La Conquistadora (Marian image), 111
Lago, Felipe, 208, 218, 220
Lake Chalco, 82
Lake Texcoco, 46, 81–82
Lake Xaltocan, 82
Lake Xochimilco, 82
Lake Zumpango, 82
Landaeta, Ventura, 178
Las Casas, Bartolomé de, 19, 25; arguments for
 rights of Amerindians, 28
Law, natural law contrasted with "law of na-
 tions," 28–29
Lettered Artists and the Languages of Empire
 (Webster), 229
Libellus de Medicinalibus Indorum Herbis, 63.
 See also Badianus Herbal
Life of the Virgin (Epiphanius), 142
Life-work model, 4, 8–9, 115, 118, 228, 231, 236
Lime, sale of, 99
Literacy, 25, 43, 53–54, 59, 163
Lives of the Artists (Vasari), 4, 228
Llicllas (women's mantles), *38,* 40
Llonef, Juan, 46
López Austin, Alfredo, 72
López de Ávalos, Sebastián, 119
Lord of Ixmiquilpan crucifix, 121–27, *122*
Lord of the Reparations (Señor de los Desa-
 gravios), 127–31
Lowe, Lisa, 181
Lugones, María, 2, 80

Macera, Pablo, 171
Madruga, Manuel, 218
Magaloni Kerpel, Diana, 59, 70
Magnificat anima mea dominum (Figueroa), *152*

Maguey cloth, 90, 91–92
Maldonado, Antonio, 123–24
Mancera, Marqués de, 119
Manifestadores (tabernacles), 97
"Manness" and artistic approaches, 3
Mapa Uppsala. *See* Uppsala Map
Map-making, 70, 72
Map of Santa Cruz, 67. *See also* Uppsala Map
Maravilla americana (Cabrera), 115, *116*
Martina, Angelina, 12, 231; blue-dyed fabric,
 90; diversified household goods in will, 97,
 99; domestic household, 100; and Indig-
 enous women's roles, 101–2; jaguar-skin
 cape, 91; religiosity of, 100–101; trade activ-
 ity of, 91–92; will of, 89
Martínez, Félix, 206
Martínez, Francisco, 128, 130, 206, 207, 208, 215
Martínez del Mazo, Juan Bautista, 23
Mass of Saint Gregory, 25, *27,* 95
Materia medica, 63. *See also* Badianus Herbal
Matienzo, Juan de, 40
Mat makers, 46
Medallas de la paz (peace medals), 183
Medicine, Indigenous, 62–63, 65–66
Medrano, María de, 161
Mendieta, Gerónimo de, 63
Mendoza, Antonio de, 25–26, 46, 56, 69
Mendoza de Austria Moctezuma, Diego, 97
Mestizaje spaces, 2
Mexía, Mateo, 138, 145, 147, 153–55, 160–164,
 165; illustrations, *148, 149, 150, 151*
Mexico City, 80, 231; Franciscan convent,
 24–25; Indigenous contributions to, 10;
 Indigenous districts during viceroyalty,
 81–82; streets designated for specific
 artisans, 46. *See also* Colegio de Santa Cruz;
 Mexico-Tenochtitlan
Mexico-Tenochtitlan, 69
Michoacán, Mexico, 42–43
Milián, Manuel, 206, 207
Milián, Santiago, 206, 207, 208, 215
Military insignia, 93–95
Miraculous imagery in artwork: after Council
 of Trent, 110; artist-as-maker paradigm,
 114–18; artistic expertise, 127–31; artists as
 expert witnesses, 112–13, 118–27; empirical
 evidence and Enlightenment ideals, 127–31;
 factualization of miracles, 108, *109*–13, 118,
 129; and fraud, 109, 129–30; *informaciónes*

Miraculous imagery in artwork—*continued*
jurídicas, 110–13; Protestant reactions to,
109; Señor de Ixmiquilpan crucifix, 121–27,
122; Señor de los Desagravios (Lord of the
Reparations), 127–31; use of term "miracu-
lous," 108
Mit'a system (forced labor), 184
Mobility, right of, 46–47
Molina, Alonso de, 64, 65
Montúfar, Alonso de, 95
Moteuczoma II, 25
Mundy, Barbara E., 4, 5, 10, 14, 53, 109, 118
Muñoz de Carballo, Pedro Dionisio: appeal of
case, 218–19; ethnic/racial identity, 199–200,
202–3, 233–34; home and stores of, 208, 210,
212, 223n11; and painters' guilds, 206–7; wit-
nesses at trial, 212–21
Mural painting, 212–15, *213, 214, 216, 217*
Muslim artisans in Spain, 23

Nahua culture: image-making, 59–60; nobility,
87–88
Nahuatl language: *Anales de Juan Bautista,* 33;
at Colegio de Santa Cruz, 54; in Florentine
Codex, 85; Nahuatl translations, 12; trans-
lated into Latin for Badianus Herbal, 63, 64;
used by Catholic missionaries, 55; used for
elite objects, 88; used today, 76n1; word for
"scribe," 60
Native American and Indigenous Studies
(NAIS), 9–10
Natural law, 28–29
Navarro, José Gabriel, 155
New Conquest History (NCH), 9–10
New Indian History, 10
New Philology, 10
New Spain: artists' rights, 19, 29–39, 46; artists'
roles, 109, 110–13, 120; Colegio de Santa
Cruz, 55–56; Franciscan order, 55; Indigenous
crafts, attitudes toward, 26–29; Indigenous
medicine in, 62–63; Indigenous women's
roles, 101–2; New Laws of 1542, 25
Nican mopohua (1649 account of Virgin of
Guadalupe), 232
Niell, Paul, 201
Ninacancha, Simón, 171, 179, 180, 231

Oblitas, Antonio, 171, 173, 177, 179–80, 181, 231
Ocampo, Salvador de, 129

O'Phelan Godoy, Scarlett, 173
O'Reilly, Alejandro, 219
Orizaba, Count and Countess of, 127
Osorio, Alejandra B., 177–78, 184, 186
Our Lady of Guadalupe (1531 image on
cloak): Cabrera's examination, 114–18;
Francisco de Siles examination (1666),
118–21
"Out of the Shadow of Vasari" (Mundy and
Hyman), 4, 53, 109

Pacheco, Francisco, 4
Painters: guild ordinances in Quito, 42;
painters' guild, San Juan Moyotlán, 33;
pigments used, 199, 207–8, 210–12, *211. See
also* Artists; Guild systems
Paquette, Gabriel B., 202
Parra, Antonio, 218–19
Pasña, María, 161
"Passing" and artists' ethnic identity, 128–29,
164
Peace medals (*medallas de la paz*), 183
Penry, S. Elizabeth, 184–85
Perea, Luis de, 119
Peru: Chachapoyas, Peru, 46; distinctive
crafts, 40; Indigenous artists' rights, 39–42;
postrebellion era, 181–83; and right of mo-
bility, 46; Trujillo as craft center, 41; Tupac
Amaru Rebellion, 13–14, 169, 171–81
Peterson, Jeanette Favrot, 61
Petronila de Turcio, doña, 90
Pharmacopoeia. *See* Badianus Herbal
Philip II, 95
Pigments, poisonous, 199, 207–8, 210–12, *211*
Plaza Mayor, Mexico-Tenochtitlan, 67, 69
Poblete, Juan de la, 119
Pochteca (Aztec merchant class), 12, 72–73, *73,
74,* 86–87, 90. *See also* Martina, Angelina
Poisonous pigments in art materials, 199,
207–8, 210–12, *211*
Pope Benedict XIV, 115
Pope Paul III, 25
Portrait of Don Marcos Chiguan Topa, 174
Portraiture: on coinage, 184; defacement of,
183–86; portrait art, 13; retouching of, 186,
190; and royalist imagery, 183–84; "true
portraits," 137–39, 142, 155–56
Potters, 21, 41, 43, 46
Pumacahua, Mateo, 173

Q'ompi (camelid-fiber tapestry), 38, 40
Quauhtzin Tlacatecatl, Martín, 97
Quijano, Aníbal, 1
Quilca (graphic production), 3–4
Quispe Asarpay, Ana, 40
Quito, Ecuador, 41–42, 147, 161; art world of, 16th and 17th centuries, 3; Colegio de San Juan Evangelista, 25

Racialized identities: as marker for Indigenous artists, 6; "passing," 128–29, 164; race-based labor hierarchies, 8, 29; in Spain, 22–23
Racism: Black artists in colonial Cuba, 203–4; in guild system, 113; hierarchies in colonial society, 8, 228–30; against Indigenous artists, 6, 233; racial categories and artistic production, 201–2, 232–34; and urban poor in Havana, Cuba, 205
Ramírez de Contreras, Laureano, 124
Ramírez de Fuenleal, Sebastián, 56
Ramos, Gabriela, 40, 47
Rappaport, Joanne, 53–54
Raynal, Guillaume Thomas, 204
Real Sociedad Económica (Royal Economic Society), 201
Reducciones (designated towns), 42
Ref, Pedro, 46
Repartimiento (forced labor tribute), 29, 31, 33, 43
Révolution des métiers (revolution of the professions), 23
Rey, Gerónimo del, 215
Reyes García, Luis, 33
Rodriguez, Linda Marie, 7, 8, 9, 14, 233–34
Rodríguez Juárez brothers, 128
Romero Estébanez, Leandro. S., 208
Rosas, Juan de, 206, 208, 215
Rostworowski de Diez Canseco, María, 40–42
Roxas, Juan de, 129
Royal Economic Society (Real Sociedad Económica), 201
Rubens, Peter Paul, 138
Rubio, Angel, 218
Rudolph II, 43
Russo, Alessandra, 19, 28, 95, 97

Saco, José Antonio, 203–4
Sahagún, Bernardino de, 56–59, 63, 72, 75, 86, 91, 97

Saint-Domingue, 200, 233
Saint Francis and the Tertiaries (Mexía), 151, 156, 163
Saint Michael Archangel (Mexía), 150, 163
Salguero, Juan, 119, 123
San Buenaventura, Pedro de, 59
Sánchez, Antonio, 208, 218
Sánchez, Miguel, 144
Sánchez Gallque, Andrés, 3
Sánchez Salmerón, Juan, 119, 123
Sandoval, Juan Cano, 124
Sangarará Portrait of Tupac Amaru, 173, 177–78, 179
San José de Belén de los Naturales, 24–25, 39, 55
Santa Cruz, Alonso de, 67, 69
Santa Cruz, Francisco, 178
Santaella, Antonio, 208, 210
Santiago, Antonio de, 92
Santiago, Francisca María de, 92
Santiago Mataincas (Saint James, Inca-Slayer), 175
Santiago Mataindios (Saint James the Indian-Slayer), 173
Sanz, José María, 206, 207
Saracino, Jennifer R., 8, 9, 11–12, 230
Sculptors, 5, 107–8, 113, 121, 123–4; and related professions, 18, 21, 113; ethnic and racial identity, 8, 121, 133, 161; in Aztec Empire, 30; in Spain, 22; status of profession, 113, 127, 133. See also Artists; Guild systems
Señor de Ixmiquilpan crucifix, 121–27, 122
Señor de los Desagravios (Lord of the Repara-tions), 127–31
Señor de Totolapan (crucifix), 111
Sepúlveda, Juan Ginés de, 28
Sigerist, Henry, 63
Sigüenza y Góngora, Carlos de, 235
Silversmiths, 21, 41, 43, 47, 160–61
Siméon, Rémi, 65
Slavery. See Enslavement
Somonte, Joseph, 129–30
Spain: guild system in, 21–23; role of artists, 4; status of craft specialists, 21–24. See also Colonialism; New Spain
Stanfield-Mazzi, Maya, 8, 9, 11, 92, 189–90, 230
Suárez, Alonso, 218
Sublimis Deus (Pope Paul III), 25, 26
Sugar economy in Cuba, 200–202

Tagle, Alberto de, 212

Tailors, 31, 46, 207

Tapestries. *See* Camelid-fiber tapestry

Tawantinsuyu. *See* Inca Empire

Taylor, William, 109, 111

Tehuetzquititzin, Diego de San Francisco, 30–31, *32, 35*

Tenochtitlan, 20, 231. *See also* Aztec Empire

Tenochtitlan-Tlatelolco, 10

Thomassin, Philippe, 43

Thomson, Sinclair, 180

Tilmatli (cotton cloaks), 83; that with image of Our Lady of Guadalupe, *34,* 114, 115, 118–21, 125, 144. *See also* Cotton capes

Titicih (healers and herbalists), 12, 66

Tlacuiloque (Nahua artists), 20, 33, 39, 54, 59–62, 66

Tlahuiztli (costumes), 93–94

Tlamatinime (wise persons), 56–57, 61–62, 66, 76n4

Tlatelolco, 20, 55, 72; *Diorama of Tlatelolco's Market, 83;* market and commerce, 81–82; women's roles, 81–86. *See also* Aztec Empire; Colegio de Santa Cruz

Tlatelolco Codex, 95, *96, 97, 98*

Toledo, Francisco de, 42, 46–47

Toltecah (artistic class), 60–61

Toltec ancestors, 60

Toltec people, 20. *See also* Aztec Empire

Toqapu (Inca geometric designs), *38, 40*

Toral, Francisco de, 58

Tortorici, Zeb, 201

Toussaint, Manuel, 69, 120

Tribute: *encomienda* system, 24, 87; freedom from in Peru, 41; monetary, 35; protests against, 230; *repartimiento* (forced labor tribute), 29–33, 43; tribute negotiations, Mexico City, 35–36

Triple Alliance, 72, 76n1, 82, 93

Triumph of the Risen Christ (Mexía), *149,* 155–56, 159

Trouillot, Michel-Rolph, 182

True Portrait of the Virgin Mary (Figueroa), 137–40, *139,* 144–59, *163*

"True portraits," 137–39, 142, 155–56

Trujillo, Peru, 41

Tupac Amaru, 187, 190–91

Tupac Amaru, Andrés, 185

Tupac Amaru, Clemente, 190

Tupac Amaru, Hipólito, 180

Tupac Amaru, José Gabriel Condorcanqui, 171, *172,* 187, 190–91, *192*

Tupac Amaru Rebellion, 13–14, 169, 171–83

Tupac Katari, 185

Tuyru Túpac, Juan Tomás, 8, 161

Uppsala Map, 67–74, *68, 71, 74*

Urbanization and craft specialization, 19, 42, 205

Urban planning in Havana, Cuba, 204–6

Val, Anselmo del, 215

Valdés, José Antonio, 202

Valenzuela, Fernando, 6

Valeriano, Antonio, 59, 75

Valladolid debate (1550–51), 28

Valverde, Pancha, 177

Vargas, Leonor María de, 153

Vargas-Betancourt, Margarita, 8, 9, 12, 230–31

Vasari, Giorgio, 4, 228

Vasarian model, 5–6; challenges to, 10, 235–36

Velasco, Alonso Alberto de, 125

Velasco, Luis de (1550–1564), 30–31, 39, 46

Velasco, Luis de (1590–1595), 43, 95

Velasco Alvarado, General Juan, 171

Velázquez, Diego, 23

Verdaderos retratos (true portraits) of images, 107

Vergara, Santiago, 208, 218, 220

Viceroyalty of New Spain. *See* New Spain

Vidal, Fernando, 108, 112

Virgen del Carmen (Virgin of Mount Carmel), 187

Virgen del Carmen with Donors, 190–191, *191, 192*

Virgen del Carmen with Souls in Purgatory, 188, *189*

The Virgin Mary Weeping (Cuiris), *45*

Virgin of Guadalupe (Cabrera), *117*

Virgin of Guadalupe (Cipac de Aquino), 33, *34*

Virgin of Mount Carmel (Virgen del Carmen), 187

Virgin of Sunturhuasi, 173, *176,* 193–94n5

Vocabulario (Molina), 65

Webster, Susan Verdi, 2–3, 41–42, 43, 53, 155, 164, 229

Williams, Barbara, 65

Winston, Jessica, 142
Women: and guild system in Spain, 22, 48n1; Indigenous women's roles, 12, 101–2, 230–31; roles in colonial art, 8; roles in colonial economy, Mexico City, 80–81; roles in Tlatelolca, 82–86; and sale of production materials, 99
Woodworkers, 113, 132

Xacoba, doña María, 91
Xiuhpohualli of Tenochtitlan Codex, 36, 37, 39, 47
Xiuhtecutli (fire god), 93, 94

Yracu, Juan, 43

Zapata, Marcos, 173, 187
Zárate, Alonso de, 119
Zavala, Silvio, 30, 39, 230
Zócalo, Mexico City, 69
Zumárraga, Juan de, 56, 114